Developing the Higher Education Curriculum

Developing the Higher Education Curriculum

Research-based Education in Practice

Edited by Brent Carnell and Dilly Fung

First published in 2017 by
UCL Press
University College London
Gower Street
London WC1E 6BT

Available to download free: www.ucl.ac.uk/ucl-press

ISBN: 978–1–78735–089–2 (Hbk.)
ISBN: 978–1–78735–088–5 (Pbk.)
ISBN: 978–1–78735–087–8 (PDF)
ISBN: 978–1–78735–090–8 (epub)
ISBN: 978–1–78735–091–5 (mobi)
ISBN: 978–1–78735–092–2 (html)
DOI: https://doi.org/10.14324/111.9781787350878

Contents

List of figures

List of tables

List of contributors

Sharon Boyd is Lecturer in Distance Student Learning. Sharon is Director of the postgraduate Certificate in Advanced Veterinary Practice, and programme coordinator for the MVetSci in Advanced Clinical Practice. Her remit includes study skills support for online distance postgraduate students, and her research areas include distance and sustainable education. She is course leader for the postgraduate Academic Study Skills course and co-leads on the online postgraduate peer tutor scheme. She is a member of the Research Skills teaching team.

Fiona J. L. Brown is Academic Support Librarian for Veterinary Medicine, Roslin Institute and Biological Sciences. Fiona was appointed Liaison/Academic Support Librarian for Veterinary Medicine in 2001. Her role includes the design, delivery and evaluation of information skills training for staff and students, in face-to-face, printed and electronic delivery formats. She is interested in information literacy, scholarly communication, and historical veterinary library collections. She is a member of the Research Skills teaching team.

Chris Browne is a Lecturer in Systems Engineering at The Australian National University, where he currently convenes interdisciplinary Vice-Chancellor's courses and the capstone engineering design project. His research includes innovative pedagogies, professional practice and system dynamics principles. He completed a B.Eng/Asian Studies (2009) and a PhD (2015) in engineering education at ANU. He is a Fellow of the Higher Education Academy (2014), a Tuckwell Fellow (2015), and was awarded an Australian Award for University Teaching (2014).

Brent Carnell is a Senior Teaching Fellow at both The Arena Centre for Research-based Education and The Bartlett School of Architecture, UCL, UK. He is a lead on the institutional research-based education strategy UCL Connected Curriculum. His research interests are varied, and he has disseminated work in *Assessment & Evaluation in Higher Education, Geographical Research, Gender, Place*

and Culture, Harvard Design Magazine, and *Home Cultures,* as well as in edited books, including his recently published edited book *Sexuality and Gender at Home.*

Helen Chatterjee is Professor of Biology in the Division of Biosciences, School of Life and Medical Sciences and Head of Teaching and Research at UCL Culture, UCL. She is a primatologist with a particular interest in the evolution of Southeast Asian primates and has a longstanding interest in university museums and the use of collections in object-based learning as well as to promote health and wellbeing.

Elizabeth Cleaver is Director of Learning and Teaching at the University of the West of England. She previously worked at the University of Hull where she led the development of the Curriculum 2016+ approach to curricular and pedagogic design and enhancement. Her wider interests lie in the building of connections between teaching and research in academic settings and, in particular, in supporting colleagues to develop disciplinary pedagogies and disciplinary approaches to educational enquiry.

Robert Cockcroft is an Assistant Professor in the Department of Physics and Astronomy at Western University, Ontario, Canada. His second postdoctoral research fellowship was at the MacPherson Institute (formerly MIIETL), where he worked with a number of Student Scholars including Sabrina Kirby.

Corony Edwards pursued a successful academic career in English Language at the University of Birmingham before being appointed as the University's Director of Educational Development in 2006. In 2012 she moved to the University of Exeter as Head of Education Quality and Enhancement. In 2016 she set up as a freelancer, offering her services to the sector as an independent consultant. She is a Principal Fellow of the HEA, and has significant experience of leading institutional quality enhancement and assurance activities and projects.

Shelley Fielden is the interprofessional education coordinator for the Leeds Institute of Medical Education, University of Leeds, UK. She is responsible for developing, delivering, evaluating and sustaining interprofessional education for students from various health and social care programmes across Yorkshire and Humberside.

Dilly Fung is Professor of Higher Education Development and Academic Director of the Arena Centre for Research-based Education at UCL. A Principal Fellow of the Higher Education Academy, she leads a series of ambitious initiatives designed to connect student learning with research at UCL and beyond. Her recent UCL Press monograph, *A Connected*

Curriculum for Higher Education (Fung 2017), explores the unity of research and teaching in curriculum design. Other recent work includes an analysis of ways in which job families and career opportunities are changing in research-intensive institutions (Fung and Gordon 2016), and a position paper by the League of European Research Universities (LERU) looking at educational excellence in Europe's leading research-intensive universities (Fung, Besters-Dilger and van der Vaart 2017). She speaks regularly in the UK and internationally on these themes.

Andrew Gardiner is Senior Lecturer at the University of Edinburgh's Royal (Dick) School of Veterinary Studies. After working as a GP companion animal vet in private practice and for animal welfare charities for 14 years, Andrew returned to the R(D)SVS as Clinical Lecturer in 2008 (Senior Lecturer from 2014) in the Veterinary Medicine Education Development division. He is the course leader for the Research Skills course.

Lori Goff is the Associate Director of Programme and Educational Development at the MacPherson Institute for Leadership, Innovation and Excellence in Teaching at McMaster University. She partners with students in much of her work and research on topics that include curriculum development, quality assurance, educational development, leadership, and peer mentoring in university settings.

Nick Grindle is Senior Teaching Fellow at the Arena Centre for Research-based Education, UCL. Over the past six years he's developed a series of projects about how students learn with objects and in particular how they learn in gallery and study room environments, based in part on his teaching as an art historian.

Leonie Hannan is a Research Fellow at the School of History, Anthropology, Philosophy and Politics, Queen's University Belfast. She is a social and cultural historian working on themes relating to material culture, gender, intellectual life and the history of the home. She has a professional background in museums and heritage and has conducted research into the value of heritage objects in teaching and learning contexts.

Zeeshan Haqqee is a student scholar for the MacPherson Institute for Leadership, Innovation, and Excellence in Teaching, where he studies the impact and perceptions of peer mentorship in academia. He graduated from McMaster University with a Bachelor of Science degree in Biology & Psychology, and is now pursuing a Masters in Psychology, Neuroscience & Behaviour at McMaster University.

Denise Hawkes is the EdD Programme Leader at UCL Institute of Education. She contributes to the taught aspects of the EdD Programme and the Research Training Programme offered to all UCL Institute of Education Research students. Denise Hawkes is an applied economist. Her research on broadly applied social economics is truly multidisciplinary, using econometric techniques to investigate labour economics, social policy and economic demography.

Henk Huijser is an Educational Developer in the Academic Enhancement Center at Xi'an Jiaotong-Liverpool University. Henk has a PhD in screen and media studies, but has worked as an educational developer in Australia, the Arabian Gulf and China since 2005. He has published widely in both the areas of learning and teaching in higher education, and media and cultural studies. For more information please visit: http://henkhuijser.webs.com/.

Alison James is Professor of Learning and Teaching at the University of Winchester. A National Teaching Fellow and Principal Fellow of the Higher Education Academy, her principal interests are in identity and self-construction in learning; alternative, creative and playful pedagogies and the place of play in higher education. She is the author, with Professor Stephen Brookfield, of *Engaging Imagination: Helping Students become Creative and Reflective Thinkers*.

Dawn Johnson has worked in education, including compulsory and post compulsory, for the past 32 years. She is currently Director of the Certificate in Professional Studies in Higher Education at Xi'an Jiaotong-Liverpool University, and previously worked as an Academic Developer at the University of Central Lancashire and the University of Cumbria in the UK. In her current role she is actively involved in the academic support and development of colleagues at XJTLU.

Thomas Kador is Teaching Fellow in Public and Cultural Engagement at UCL Culture. He has a background in archaeology and chemical engineering with a strong interest in heritage pedagogics, including object-based learning, everyday practice – especially movement, mobility and migration – and social change in the past as well as the benefits of haptic engagements for learners with specific learning difficulties and public and community-based approaches to heritage.

Eileen Kennedy is a Senior Research Associate with the Centre for Global Higher Education at UCL Institute of Education, researching the transformative potential of MOOCs and contrasting online pedagogies.

Eileen is part of the Learning Technologies Unit at UCL IOE and works with UCL's Digital Education Futures team on learning technology development projects.

Sabrina Kirby is a graduate of McMaster University's Arts and Science Programme, and is currently pursuing graduate studies in Information Science at the University of Toronto. During her time at McMaster, Sabrina worked as Student Scholar at the MacPherson Institute (then known as the McMaster Institute for Innovation and Excellence in Teaching and Learning). She was a co-presenter at MIIETL's December 2015 'Cultivating Communities' conference, and was a co-facilitator of the May 2016 Summer Institute.

Kris Knorr is the Programme Area Lead for Educational Development at McMaster's MacPherson Institute for Leadership, Innovation, and Excellence in Teaching. Some current research projects include exploring motivators and barriers to participation in educational development, benefits and challenges of peer mentoring in science education, and exploring the possibilities and potentials of students as partners in teaching and learning in post-secondary education.

Alison Ledger developed an interest in interprofessional work and learning through her previous roles as a music therapy practitioner and academic. At the University of Leeds, she leads the BSc in Applied Health (Medical Education) programme and supervises clinical education research at undergraduate and postgraduate levels.

Alexandra Liu is a recent graduate from McMaster University's Bachelor of Health Sciences (Honours) programme, with a specialisation in Global Health. As a past Research Assistant and Student Scholar with the MacPherson Institute, Alexandra is interested in interdisciplinary research, and incorporates her research practices and findings from her time at the MacPherson Institute into her current projects.

Elizabeth Marquis is an Assistant Professor in McMaster University's Arts and Science Programme, and Associate Director (Research) of McMaster's MacPherson Institute for Leadership, Innovation, and Excellence in Teaching. Much of her teaching and learning scholarship focuses on student-staff partnership, and she currently oversees McMaster's Student Partners Programme.

Mike McLinden has over 25 years' experience of working in schools and Higher Education (HE), with extensive experience of curriculum design, delivery and evaluation. He has a broad research interest in professional

learning and pedagogy in HE and has been involved in a range of funded pedagogical projects in partnership with colleagues in the sector. This includes Strand Lead (Part Time Learners) for the 'Flexible Pedagogies' project funded by the Higher Education Academy (HEA). Mike was conferred the status of 'Principal Fellow of the Higher Education Academy' (PFHEA) in 2013.

Rachel E. Milner is a teaching professor at the University of Alberta. She has a PhD from the University of Cambridge and was a postdoctoral fellow in biochemistry with the Alberta Heritage Foundation for Medical Research. She has more than 16 years' experience in a teaching-intensive academic position, in the Faculty of Medicine and Dentistry, University of Alberta. Her post focuses on teaching, student advising, and exploring programme design and delivery.

Carolyn Morton is Lecturer in Professional Studies. Carolyn has clinical expertise in veterinary anaesthesia and analgesia, clinical skills and professional skills teaching. She is a member of the Research Skills teaching team at the University of Edinburgh's Royal (Dick) School of Veterinary Studies.

Darren N. Nesbeth is a Lecturer at the UCL Department of Biochemical Engineering and has supervised UCL iGEM teams since 2009. Darren's laboratory develops synthetic biology techniques for engineering yeast, bacterial and mammalian cells to improve their industrial performance. Darren teaches synthetic biology and molecular bioscience to Biochemical Engineering undergraduate and masters students and 'DIY' synthetic biology to students taking the UCL Bachelor of Arts and Sciences (BASc) programme.

Tim Neumann leads the Learning Technologies Unit at the UCL Institute of Education, providing academic advice on enhancing online and blended learning practices. Based at the UCL Knowledge Lab, he teaches fully online on postgraduate degree modules. With a background in media production and distance education, his research interests focus on web conferencing, communication and online pedagogy.

Jessie Paterson is Lecturer in Student Learning, Royal (Dick) Veterinary School. Jessie has a strong interest in student support with a particular focus on academic support, leading the School's Study Skills Team. She is course organiser for the Professional & Clinical Skills courses for first year and graduate entry students and is a member of the teaching team for the Research Skills course and Academic Skills for postgraduate students.

Claire Phillips is Senior Lecturer at the University of Edinburgh's Royal (Dick) School of Veterinary Studies. Claire qualified as a veterinary surgeon from the University of Edinburgh. She spent seven years in mixed and small animal general veterinary practice before returning to Edinburgh where she gained her PhD. She lectured in Veterinary Nursing in Dumfries and Galloway before being appointed Lecturer in Veterinary Microbiology at Edinburgh in 1999. In 2006 she was appointed Veterinary Clinical Lecturer in Small Animal Practice and became Senior Lecturer in 2009. She has been Deputy Director of Veterinary Teaching since 2010, Director of Quality since 2014 and is a member of the University Court. Her interests are in the areas of anatomy, clinical skills, communication skills and curriculum development. Her research interests are in admissions and assessment.

Varun Puri is a fourth year undergraduate student in the Arts & Science Programme at McMaster University. He has been an ongoing member of the student partners programme at the MacPherson Institute since its inception, also his first year of studies.

Lynn Quinn is an Associate Professor in the Centre for Higher Education Research, Teaching and Learning at Rhodes University in South Africa. She has been involved in the field of Academic Development since 1995. She was integral to the development of a Postgraduate Diploma in Higher Education for lecturers and one for academic developers. Her research interests include academic staff development and developers, curriculum, assessment and quality. She supervises masters and doctoral students in the field of Higher Education Studies.

Iain J. Robbé is a medical practitioner (MB, BS, 1980) for human animal patients. He holds Masters degrees in public health (University of London, 1985) and in medical education with distinction (University of Wales, 2001). He has been in independent practice since 2012 as a Clinical Medical Educationist holding part-time contracts with Memorial University, Newfoundland, the Centre for Medical Education, Dundee University, and the veterinary schools at Edinburgh University and Nottingham University.

Steve Rowett works at UCL, where he leads a small team exploring technologies that may have a significant impact on higher education over the coming years. A particular current focus is technology to enable the UCL Connected Curriculum. Current interests include social networks and

more open VLEs, blogging and student creation, student partnerships, and learning analytics.

Fiona Strawbridge has led the Digital Education team at UCL since its inception in 2002, providing both strategic leadership and overseeing operational support for both e-learning and the broader student digital experience. Fiona also works with UCISA, having chaired their Digital Skills and Development group; she runs the annual Spotlight on Digital Capabilities conference. Before moving into digital education Fiona was an academic, leading a degree programme in Remote Sensing and GIS at Bath Spa University.

Ben Thomas is Senior Lecturer in History of Art at the University of Kent, where he convenes the MA Curating. He carries out research on the graphic arts and has published on, and curated exhibitions of, historical and contemporary prints. He founded the Kent Print Collection in 2005, and has been awarded Kent's Humanities Teaching Prize and the Barbara Morris Prize for his work with the collection, and with Kent's Studio 3 Gallery. He is committed to developing practice-based teaching approaches as part of university education.

Jo-Anne Vorster is head of the Centre for Higher Education Research, Teaching and Learning at Rhodes University in South Africa. She has been working in the field of Academic Development since 1992. Since 2000 she has been involved in the development and teaching of a Postgraduate Diploma in Higher Education for lecturers from Rhodes and other South African universities. She is interested in the role of knowledge in shaping the curriculum, staff development of academics as well as the formal induction of academic developers. She supervises masters and doctoral students in the field of Higher Education Studies.

James Wilson is Director of the Academic Enhancement Centre at XJTLU where he oversees all academic development including Technology Enhanced Learning across the University. James has worked in various teaching and development fields such as Academic Development, English for Academic Purposes and Educational Technology. He has worked in the UK, Finland, Portugal and now China. His current research interests are in the role of Educational Development and the Scholarship of Learning and Teaching.

Derek Wills is involved in strategic project development at the University of Hull, UK, and recently led their Curriculum 2016+ programme to

refresh all undergraduate and postgraduate provision. After an initial career in research and development at BA Systems he returned to Higher Education at Hull and published extensively in the field of computer science. Prior to his current position he held the roles of Head of Computer Science and Dean of Science at the University.

Yao Wu is the Centre Administrator of the Academic Enhancement Centre at Xi'an Jiaotong-Liverpool University. She has worked on the Summer Undergraduate Research Fellowship (SURF) project since 2013. Prior to XJTLU, Yao was a Chinese language teacher at the Confucius Institute of Portland State University for two years, where she also completed her Master studies in Curriculum and Instruction.

Jianmei Xie is a qualified teacher and was a Lecturer in Language Education at the Guangdong University of Foreign Studies, China, prior to doing her PhD in Education in the Graduate School of Education, University of Exeter, UK. Before joining Xi'an Jiaotong-Liverpool University, she was a post-doctoral educational researcher in the College of Social Science and International Studies and Associate Lecturer in Mandarin Chinese in the Department of Modern Languages at the University of Exeter.

Editors' introduction
Developing the higher education curriculum
Research-based education in practice

Brent Carnell and Dilly Fung

Introduction

Illustrating the Connected Curriculum approach, a distinctive research-based education model for developing programmes of study in higher education (Fung 2017; Fung and Carnell 2017), this book showcases a range of innovative practices from across the higher education sector. The following chapters shine a light on different disciplinary and institutional contexts, offering insights into ways of enriching students' learning experiences. Together, the practical case studies point the way towards building communities of scholarly enquiry that challenge old divisions between research and teaching, between researcher, teacher and learner, and between higher education institutions and society.

Higher education scholar Dilly Fung (2017) presents the Connected Curriculum on one level as a simple visual framework (Figure 0.1), designed to act as a stimulus for constructive dialogue about how degree programmes – both undergraduate and postgraduate – are designed, and about how students learn.

The framework comprises a core educational principle – that students should learn predominantly through research and critical enquiry, rather than by passively receiving accepted knowledge – and six related dimensions of practice, to which we will return below. Importantly, however, this framing also speaks to fundamental departmental and

institutional values and to the cultures in which those programmes are situated. The underpinning 'connections' approach reflects a values-based, philosophical commitment to the advancement of global human knowledge, understanding and wellbeing. Through critical dialogue and creative, collaborative practice, Fung argues, we can take up the challenge of breaking down 'longstanding divisions between research and education', in order to 'build stronger bridges between research, education, professional practice and society' (Fung 2017: 156).

The six dimensions of the framework (Figure 0.1) include connecting students directly with researchers, encouraging students to make connections between different disciplinary perspectives, and empowering them to engage external audiences with the findings of their enquiry. The core principle, that of students learning actively through research and enquiry, reflects a commitment to 'research-based' education, rather than to curricula which are simply informed by or about research.

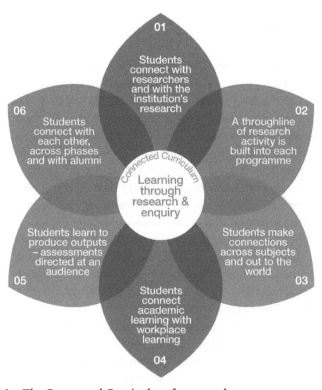

Fig. 0.1 The Connected Curriculum framework

The term 'research-based' is drawn from work by Healey and Jenkins (2009), whose characterisation of four different ways of engaging students with research has been influential in the literature in this field. Healey and Jenkins distinguish between 'research-led' programmes, in which students learn about current research in the discipline; 'research-oriented', whereby students develop research skills and techniques; 'research-tutored', where students engage in research discussions, and finally 'research-based' programmes, in which students themselves undertake research and enquiry-based activities (Healey and Jenkins 2009: 6). The four areas of practice are not mutually exclusive, of course – in fact, all are valuable – but the research-*based* approach emphasises the importance for students' development of active, engaged, enquiry-based learning. It gives agency to students (Levy and Petrulis 2012), positioning them individually and collectively as both critics and creative producers. It also enables them to develop a wide range of research-related insights, qualities and skills and, in doing so, move towards understanding the edges of established knowledge (Fung 2017; Fung, Besters-Dilger and van der Vaart 2017).

It is far from simple to establish a simple causal link between research-based approaches to teaching and 'effective' student learning (Elken and Wollscheid 2016). This is because of the huge number of variables at play when such approaches are studied. These variables are found, for example, in student demographics; in students' prior learning experiences; in disciplinary and departmental contexts and cultures; in the communication styles and assumptions of those who are teaching or facilitating learning; and, very importantly, in the design of the research-based activities in relation to the types of desired learning outcomes. However, a growing body of studies across the disciplines is showing how valuable and effective research-based approaches can be (Barnett 2005; Blair 2015; Brew 2006; Chang 2005; Kreber 2009; Healey and Jenkins 2009; Walkington 2015). Studies by Nobel prize-winning physicist Carl Wieman and his colleagues offer some very promising evidence that active, enquiry-based approaches lead to highly effective learning (see, for example, Wieman and Gilbert 2015). Other studies highlight the importance of structuring the parameters of students' enquiry well, so that while they are encouraged to critique established knowledge and develop new, creative approaches, they are also supported by peers, for example through collaborative group work, and by engaging in structured dialogue with more experienced scholars (Blessinger and Carfora 2014; Levy and Petrulis 2012; Spronken-Smith and Walker 2010; Wood

2010). Active enquiry can be challenging for students at first – being a passive listener in a lecture theatre may seem like an easier option – but where students are gradually exposed to greater levels of freedom and challenge, the benefits to their levels of understanding, confidence and skills are considerable.

Surrounding this core educational principle are the six related dimensions of practice (Figure 0.1). In her open access monograph, Fung (2017) explores each dimension in detail, providing examples of specific learning activities and practical curriculum design possibilities that exemplify each one. Here we will highlight two of the most stretching dimensions: the second and fifth.

The second dimension of the Connected Curriculum is that of building a connected 'throughline' of enquiry-based activity into each programme of study. This provides a structure for gradually building research skills that are vital for both academic study and professional life. It also empowers students to take ownership of their learning and their developing personal and professional identity, and articulate their own, overall learning story. Practical approaches in relation to this dimension include designing into each level of study a 'Connections' module, which explicitly challenges students to make connections between apparently diverse elements of their degree programme, and introducing a programme-wide Showcase Portfolio, which enables students to revisit, select, develop, curate and comment analytically on the body of work they have produced (Fung 2017: Chapter 4).

The fifth dimension is also of key importance. This focuses on the production of outputs: assessments directed at an audience. Here, university educators are challenged to include elements of student assessment that are explicitly addressed to, and may even be developed in partnership with, audiences beyond the university – individuals or groups who already have an interest in the topic, or who can benefit from becoming engaged with it. Such an approach helps students to develop a wide range of communication forms and skills, including vital digital practices. Students can be assessed, for example, through making film documentaries or websites, writing articles for specific journals, presenting their work at a student conference, or running an event which engages the public (Fung 2017: Chapter 7).

We revisit all six dimensions now by reproducing a number of questions for departments (researchers, educators, professional staff and students) and their students to discuss, in relation to each one (Table 0.1).

Table 0.1 The Connected Curriculum in 20 questions

Dimensions	Key questions for departments and programme teams
Core principle **Students learn through research and enquiry**	1. Are students encountering specific questions addressed by researchers and learning to articulate their own research questions, at every level of study? 2. Can we adjust our teaching methods, student assessments and other aspects of departmental practice to prioritise engaging all students actively in research and critical enquiry?
Dimension 1 **Students connect with researchers and with the institution's research**	3. Do students have regular opportunities to learn about the institution's research, and other current research relevant to their studies? 4. Are students meeting with researchers and engaging with their work? 5. Are students exploring the intellectual, policy-related, practical and ethical challenges associated with current research, and recognising their relevance to professional life more widely?
Dimension 2 **A throughline of research activity is built into each programme**	6. Is there a well designed core sequence of modules, units and/or learning activities through which students steadily build their research skills and understandings, and is this explicit to students? 7. Are students explicitly challenged to make intellectual connections between different elements of their programme? 8. Can students have some flexibility and even take risks with their research-related activities, for example by working towards a Showcase Portfolio for which they can curate their best work?
Dimension 3 **Students make connections across disciplines and out to the world**	9. Is the programme of study structured so that students need to step outside their home discipline(s) and see through at least one other disciplinary lens? 10. Are students required to make explicit connections between disciplinary perspectives, for example by collaborating with students of other disciplines to analyse evidence and issues? 11. Through making interdisciplinary connections, are students challenged to address complex global challenges?

(Continued)

Table 0.1 (Contd)

Dimensions	Key questions for departments and programme teams
Dimension 4 **Students connect academic learning with workplace learning**	12. Are all students on the programme(s) able to analyse the ways in which their academic learning is relevant to the world of work? 13. Do students have explicit opportunities to prepare for the workplace, for example through meeting alumni, shadowing, and work placements, and where appropriate through critiquing the notions of work and professionalism in society? 14. Can students articulate effectively the skills and knowledge they have developed through their research-related activities and through their wider studies and experiences, and showcase these to future employers?
Dimension 5 **Students learn to produce outputs: assessments directed at an audience**	15. Are some student assessments outward-facing, directed at an audience, thereby enabling them to connect with local and/or wider communities (whether online or face-to-face)? 16. Are student assessments across the programme suitably varied, enabling them to develop a range of skills including expertise in digital practices and communications? 17. Are students required to revisit and use feedback on their tasks, both formative and summative, in order to improve their work?
Dimension 6 **Students connect with each other, across phases and with alumni**	18. Do students have frequent opportunities to meet and participate in collaborative enquiry with one another in diverse groups? 19. Are they building connections with students in other year groups, for example through events or mentoring schemes? 20. Can students meet and learn from diverse alumni, and build a strong sense of belonging to an inclusive research and learning community?

Adapted from Fung 2017: 146.

We are keen to emphasise here that these questions are designed to provoke wide-ranging discussion. The Connected Curriculum framework (Figure 0.1) and these associated questions are *not* designed to restrict thinking about curriculum and about institutional cultures. Instead, they are a stimulus for building a broad spectrum of dynamic

new critiques and practices that suit the relevant disciplinary and institutional cultures. The Connected Curriculum framework was integrated into UCL (University College London) institutional strategy (UCLa 2017), and the range and depth of discussions and curriculum design innovations resulting from engaging with it has proved very promising (Fung 2017: Chapter 9).

The chapters that follow, from UCL authors as well as contributors from many other institutions, present a variety of practices that highlight the diversity of approaches implied by Connected Curriculum framing. These include two very important, related areas of values-based activity:

1. Including students as partners and co-creators in their learning and research communities, so that they are empowered to challenge the status quo and bring about creative, evidence-based changes in their institution's practices (see, for example, Bovill, Cook-Sather and Felton 2011; Dunne and Zandstra 2011; Healey, Flint and Harrington 2014); and
2. Challenging Eurocentric, male-dominated curriculum content, and building curricula that represent fairly the work of marginalised scholars (UCLb 2017).

The Connected Curriculum approach is thus about more than curriculum design: it opens windows onto deeper themes, including the nature of knowledge and its contribution to society, and is a catalyst for exploration of values and purposes. We argue that developing and enhancing student education in the higher education sector is not just a question of improving learning design, as important as this is. It is about critically and constructively addressing deeper questions about what we mean by 'good' education in a challenging era. What are universities trying to achieve, for whom, and according to whose values? Can institutions keep a strong focus on values, promoting evidence-based critical enquiry at a time when the mass media present a kaleidoscope of facts, 'alternative facts', news and 'fake news'?

The values underpinning the Connected Curriculum include a principled commitment to the unity of teaching and research; a commitment to building democratic human relations and inclusive communities; and a commitment to focusing its activity, both research and education, on the advancement of the global common good (UNESCO 2015). The associated practices are varied, innovative and creative – as evidenced by the following chapters.

The book's chapters

The 15 chapters in this collection are contributions from a diverse range of authors offering research-based education interventions to curricula. Some chapters are firmly based in a subject-discipline – including art history, biochemistry, education, engineering, fashion and design, healthcare and veterinary sciences. While there are inevitable oversights in a compact edited volume, the collection goes some way (though could go further) to reach across geopolitical regions, with contributions from Australia, Canada, China, England, Scotland and South Africa.

In Chapter 1, **Corony Edwards and Mike McLinden** focus on ways of developing student links between research and teaching, in a range of disciplines, so that their learning journey is rich and engaging. They argue that linking research and teaching enables programmes to attain 'pedagogic resonance' between course design, learning activities and disciplinary approaches. Their model of pedagogic resonance aims to ensure that there is alignment between students' experience of a given learning *design* and learning *experience* within a specific *discipline*. Not only do the case studies show the varied ways research-informed learning can play out in programmes, but the challenges suggest ways others can learn from and implement enhancements to curricula.

Rachel Milner (Chapter 2) outlines a research-intensive approach, 15 years in the making, to an undergraduate biochemistry programme at the University of Alberta, Canada, which has clear parallels with the Connected Curriculum. This holistic approach to education, Milner points out, encourages students to learn through research and enquiry, through a series of research modules across the undergraduate programme. The development has led to a cultural shift in the department, which now rewards contributions to education. Lack of reward and recognition in this area has been a surprising oversight in many universities, Milner argues (see also Fung and Gordon 2016). The department now also offers sustained funding to cover the costs associated with undergraduate research. After outlining the rationale for developing a research-intensive curriculum, Milner notes the practical factors and design interventions necessary for the success of the initiative and focuses on the implications for other departments, disciplines and universities.

James Wilson, Yao Wu, Jianmei Xie, Dawn Johnson and Henk Huijser (Chapter 3) offer a case study of a research-based curriculum intervention at Xi'an Jiaotong-Liverpool University. The authors outline

both the benefits and challenges of the research-oriented opportunities afforded by the 10-week Summer Undergraduate Research Fellowship (SURF) initiative. Although these opportunities are voluntary and outside the formal curriculum, they reflect the principles of the Connected Curriculum framework. In particular SURF offers opportunities to student groups, allowing them to connect with staff and learn about the institution's research, to develop their research and critical thinking skills, and to share their research with a wider community, for example through a poster exhibition. Based at a joint UK–China research-intensive university, located in Suzhou, China, the authors highlight the adaptability of research-based models to different institutional and national contexts.

Thomas Kador, Helen Chatterjee and Leonie Hannan (Chapter 4) focus their chapter on object-based learning, which, like the core principle of the Connected Curriculum (learning through research and enquiry), is a curriculum design approach based on shared discovery and collaboration. Integrating objects into the learning process, especially from museums and collections, is a catalyst for empowering students to think about the production of knowledge. The authors argue that object-based learning can deconstruct unhelpful and inaccurate binary thinking between those who traditionally produce knowledge in the university (academic researchers) and those who passively receive that knowledge (students). Through engaging objects in a research-based environment, students generate original research and make a valuable contribution to the field. The authors highlight the benefits of students participating in object-based learning; they also discuss practical issues arising from engaging objects from UCL's collections and museums. Finally, they draw on student feedback to illustrate the profound effect object-based learning has on students' curiosity and development.

Recognising the importance (and often requirement of professional-regulating bodies) of foundation research and professionalism skills, Sharon Boyd, Andrew Gardiner, Claire Phillips, Jessie Paterson, Carolyn Morton, Fiona J. L. Brown and Iain J. Robbé (Chapter 5) outline an embedded research skills training course. Taken in the second year of a five-year veterinary science undergraduate programme, this curriculum feature prepares students for subsequent independent research projects, as well as for a thriving career. The design has clear links to the Connected Curriculum, with an emphasis on outward-facing public assessment (for example, poster presentations, exhibitions and blogs), on connections with both other students (for example through

peer assessment), and on the world of work. The Research Skills course creates the opportunity early on in the programme for students to develop their communication, interpersonal and leadership skills and, importantly, to be part of a research community of practice. The authors offer practical tips and advice and share lessons learned; their case study is wide reaching, with relevance to disciplines well beyond veterinary science.

Darren N. Nesbeth (Chapter 6) presents a case study on curriculum intervention in molecular biology at UCL. His topic is student participation in an annual international research event – the International Genetically Engineered Machines (iGEM) competition. Students work together and form connections across the STEM disciplines (Science, Technology, Engineering and Mathematics) to carry out a synthetic biology research project. The competition structure encourages teams to develop skills around computer modelling, laboratory practice, safe ethical practices, public engagement, website design and presentation skills (put to the test at the Jamboree event and exhibition). The collaboration requirements prepare students for common modes of working in commercial settings. Using an accessible trademarked DNA sequencing device, students with varying knowledge can engage in seemingly complex research processes that were previously out of reach for undergraduates. The investigations undertaken by students on iGEM connect work in academia with that of industry, resulting in patented and groundbreaking research.

In Chapter 7, **Nicholas Grindle and Ben Thomas** focus on the benefits to student learning in an object-based and practice-based setting. They outline a research-based art curation module, part of the Kent Print Collection at the University of Kent. Drawing on the module's development over 10 years, the chapter shows the multiple benefits, including: increased motivation; leaving a legacy; engaging with previous cohorts' collections; producing an exhibition for an external audience; connecting with employers and the general public; and learning the extensive employability skills that come with engaging in an assessment activity that parallels the kinds of practice expected in students' future careers. The regular exhibitions mounted enable students to manage the entire process. The authors thus offer practical applications of research-based education and the connections students are able to create as a result of their active learning.

Denise Hawkes (Chapter 8) shares curriculum development work supported by funding from the Connected Curriculum initiative. This chapter outlines the development of online resources for research

projects in a professional doctorate programme at the UCL Institute of Education. Focusing on students at the thesis stage, Hawkes shows how creating online support enables students to learn practical skills and insights, while encouraging them to develop a self-sustaining community of practice that facilitates peer dialogue and support across cohorts, and geographical distances. The Education Doctorate programme is often completed part-time and by those with busy full-time careers in higher education, and student feedback shows that this online support is a much-valued way of forming connections and developing knowledge. Hawkes' account reminds us that digital platforms in general are incredibly valuable, and will undoubtedly become increasingly important as we move towards more connective, research-based educational approaches (see also Chapter 13 in this volume).

Lynn Quinn and Jo-Anne Vorster (Chapter 9) outline how higher education *can* and *should* evolve to acknowledge the lived experiences and knowledges constructed in the global South. They focus on the changing context of higher education in South Africa following the fall of apartheid in 1994, and on the most recent passionate student protests calling for decolonisation of the curricula. Through outlining a number of case studies of enhanced curricula, Quinn and Vorster show how features of curriculum design can challenge learning dominated by the global North in general and European thinkers in particular; this new focus is more clearly connected to the lived experiences of the black majority. For example, students are encouraged to discuss learned topics in their African mother tongue, as well as in English. This helps shift the focus from an education designed to ensure that middle-class white students feel at home to one where local cultures are respected and valued. The examples and 'stories' outlined in the chapter offer practical ways of decolonising curricula in a variety of disciplines and contexts, relevant to educators well beyond the South African university system.

In Chapter 10, **Elizabeth Cleaver and Derek Wills** outline an institutional strategic change project from design through to implementation. Curriculum 2016+, at the University of Hull, UK, asks programme teams to come together to evaluate their education provision by thinking about programme themes, 'big ideas' and outcomes and the suitability of pedagogic approaches. Importantly, this approach centres on the student experience, with a rewrite of the programme documentation for students – making the implicit ('big ideas', approaches to teaching, and assessments) explicit – with the goal of giving graduates the necessary skills for successful careers. Through thinking about the design of programmes, staff members were also encouraged to make explicit

connection between their teaching and research, as well as coherent connections across disciplinary communities and to the world of work. The chapter goes on to outline how three programme teams adopted the strategic approach in their local disciplinary context, reviewing and designing change into their programmes of study.

Alison James (Chapter 11) makes explicit the links between research, enquiry and communities of practice. Learning by connecting, making and doing are approaches that employ social models of enquiry. Taking this as her focus, James looks at social learning in the creative disciplines, including fashion, arts, design and media. The chapter outlines how these disciplines demand human-centred learning which is best done by doing, making and getting stuck in – in other words, by enacting a constructionist model that develops both students themselves and their external links with the wider world. It is through the connective opportunities fostered by social learning that students can learn the skills needed for a thriving future and successful career, actively shaping their own education and development. The chapter offers several short vignettes of social learning from the University of the Arts London.

Shelley Fielden and Alison Ledger (Chapter 12) take as their focus the connections afforded by interprofessional healthcare education (IPE). Two case studies of IPE at the University of Leeds are outlined; one is unassessed and voluntary, the other is assessed and mandatory. The curriculum design features afford students multiple opportunities to connect with a range of universities and professions. Through themes such as patient safety, students, facilitators and patients come together in workshops and other settings. Along with the opportunity to network and learn to work with other professionals, healthcare students put into practice a range of learned key skills. The chapter outlines the difficulties, challenges and practicalities of organising this complex yet clearly beneficial set of connective opportunities for students. Student feedback suggests interacting with professionals is a key driver in high satisfaction.

In Chapter 13, **Eileen Kennedy, Tim Neumann, Steve Rowett and Fiona Strawbridge** explore the use of digital technology as an enabler in a thriving research-based education environment. Drawing on extensive research over two years with the community at UCL, which entailed investigating and examining the existing online learning environment, the authors arrive at a manifesto of sorts, outlining the demands for the future of virtual learning. 'UCL Together', their proposal for a 'Connected Learning Environment', will be a confederation of systems that will integrate with virtual learning environment (VLE) Moodle, including media creation, file storage, Wikipedia, video conferencing

and personal student webspace. It will also include a social network to enable connections between staff and students. The authors argue that this platform will help rigid boundaries become porous, allowing connections to be made across and through modules; such a system would allow, for instance, prospective students to sample course material, as well as enable connections with alumni and the world of business.

In Chapter 14, **Elizabeth Marquis, Zeeshan Haqqee, Sabrina Kirby, Alexandra Liu, Varun Puri, Robert Cockcroft, Lori Goff and Kris Knorr** focus on the Students as Partners initiative at McMaster University (Hamilton, Canada). They highlight the ways in which this institution-wide programme affords students opportunities to engage in research within and beyond the formal curriculum. Students engage in the scholarship of teaching and learning (SoTL) through their partnership with staff, as co-enquirers. In so doing, they conduct research, co-author papers, and present at national and international conferences. The chapter outlines the challenges of developing meaningful partnerships devoid of hierarchical structures. Student partnership is presented as a threshold concept for teaching and learning, and the authors characterise four case studies of partnership projects to highlight the experiences of both staff and students.

Keeping with the theme of students as partners, **Chris Browne** (Chapter 15) outlines an engineering curricular intervention at the Australian National University. The 'jigsaw model' encourages active student partnership and engagement, through small-group teaching and research, on a second year undergraduate programme. Students act as facilitators in the design of learning activities, which they then teach to their peers in tutorial setting. This requires research into the disciplinary content, and also pedagogic research into the scholarship of teaching and learning. Students learn content in tutorials and bring this back to both group projects, thereby building up a scaffold, or jigsaw, of knowledge. Sharing this with the group, students develop a dossier of knowledge and skills with which they can take on individual projects. The jigsaw classroom provides the structure for both course delivery and scaffolds assessment tasks, with students as active partners in enquiry-based learning, moving through identifying, producing, authoring and pursuing modes.

Finally, Chapter 16 offers 12 short vignettes of practice, to highlight a further series of ways in which engaging students with research and enquiry can enrich their learning experiences, preparing them not only for more advanced academic learning, but also for professional roles in complex, rapidly changing social contexts.

1
Cultivating student expectations of a research-informed curriculum

Developing and promoting pedagogic resonance in the undergraduate student learning pathway

Corony Edwards and Mike McLinden, with Sarah Cooper,
Helen Hewertson, Emma Kelly, David Sands and Alison Stokes

Introduction

While the integration of research and teaching can provide valuable ways of enhancing a student learning experience, establishing such links can be complex and challenging given different practices and levels of understanding of 'research-based education' and 'research-informed teaching' within and between disciplines. Further, it is increasingly recognised that effective integration does not happen automatically and requires proactive steps on the part of tutors (McLinden et al. 2015). In this chapter, we examine the nature of the challenges and deliberate steps that can be taken to cultivate a rich variety of research-teaching links from the earliest stages in the student learning pathway. We see this as being the key means to ensuring there is 'pedagogic resonance' (e.g. Polias 2010) between the perspectives that inform the course design (learning *design*), the learning activities the students will engage in (learning *experience*) and the practices and traditions of the discipline into which the students are being inducted (learning *discipline*). Drawing on relevant literature, we provide an overview of the types of research-informed teaching

that undergraduate students may experience at a university. We outline how a framework of research-informed teaching descriptors could be used as tools to inform the curriculum design process and to support student induction and transitions. We then draw on invited case studies to illustrate ways in which research-informed teaching can foster student engagement, so that students learn their discipline through a curriculum that has *pedagogic resonance*. Each case study illustrates how practitioners have designed their curricula to ensure students become increasingly active and self-directed participants in the process of acting and 'thinking as' a researcher in their discipline from an early stage in their learning pathway. We conclude by summarising the key challenges, and offer some approaches to achieving more active student engagement in a 'Connected Curriculum' (Fung and Carnell 2017; Fung 2017) that is both research-informed and pedagogically resonant.

Research and teaching links in higher education

Over the last two decades there has been extensive exploration of the links between teaching and research in higher education. Key contributors include, among others, Neumann (1994), Boyer (1998), Brew (2003; 2006; 2010), Griffiths (2004), Jenkins and Healey (2005), Robertson (2007), Spronken-Smith and Walker (2010), Land and Gordon (2015), and more recently, the UK government, who in their white paper on teaching excellence in higher education acknowledge that, 'For too long, teaching has been the poor cousin of research. Skewed incentives have led to a progressive decline in the relative status of teaching as an activity' (Department for Business, Innovation and Skills 2016: 12). As reported by Cleaver, Lintern and McLinden (2014), a frequently cited example is the typology developed by Griffiths (2004), subsequently presented by Jenkins and Healey (2005) as four distinct approaches linking teaching and research, namely teaching that it is 'research-led'; 'research-oriented'; 'research-based' and 'research-tutored' (see the introduction to this collection for definitions of these terms).

Jenkins and Healey (2005) report that learning and teaching activities frequently involve a mixture of these four approaches, with the particular blend dependent on the context in which an activity is structured. Embedding research-informed teaching into the curriculum is not

considered to be straightforward, however. The 'nexus' between research and teaching is complex and influenced by a wide range of factors, such as departmental structural arrangements for organising research and teaching activities, and a potential gap in making connections between staff research outputs and students' learning when this research is too far ahead of the undergraduate curriculum to be accessible to students (e.g. Jenkins 2004). Jenkins (2004) argues that students tend to vary in their attitudes towards research depending on their academic orientation to their studies, noting that disciplinary variations occur, with teaching–research relations shaped by how disciplinary communities conceive the nature of knowledge, research and teaching, the forms of pedagogy and curricula in different disciplines and, for some, the impact of professional organisations and student interests on the content and practices of the disciplines. This view is supported by the findings of an institutional survey conducted among academic staff and students at a research-intensive institution in the UK, which investigated how research-informed teaching

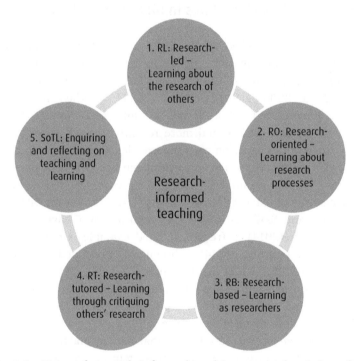

Fig. 1.1 Types of research-informed teaching approaches (adapted from Griffiths 2004 and Healey 2005)

is understood and practised across different disciplines in the university (McLinden et al. 2015). The survey employed an amalgamation of the Griffiths (2004) and Healey (2005) categories in asking respondents to select the type of 'research-informed' teaching they used in relation to five broad headings (Figure 1.1):

1. *Research-led (RL)*: Students learning 'about' the research of others.
2. *Research-oriented (RO)*: Students learning about research processes.
3. *Research-based (RB)*: Students learning as researchers.
4. *Research-tutored (RT)*: Students critiquing others' research.
5. *Scholarship of teaching and learning (SoTL)*: Enquiring and reflecting on teaching and learning.

Case studies of research-informed teaching

In April 2016, we distributed a call via our professional networks for volunteers to act as case study leads for four disciplines (Humanities, applied Social Sciences, a 'pure' Science and an applied Science). Leads were recruited for Humanities, Law, Criminology, Physics and Earth Sciences. A template was provided for the leads to capture examples of research-informed approaches to teaching and learning ('RIT') in their respective disciplines. Interviews were conducted with the leads through Skype to identify defining characteristics and research practices for each discipline. The call resulted in 25 contributions.[1] Given space limitations, we present here one example to illustrate research-informed programme design beyond the level of the single module, with connected, staged and planned inclusion of research-informed teaching throughout the programme. In the penultimate section below we draw on this and four further examples to show how pedagogic resonance can be achieved through alignment of the learning 'discipline', 'design' and 'experience'.

Table 1.1 shows how the five variants of research-informed teaching are embedded in a BA English programme at De Montfort University with combinations of two or more of the variants often used, and explicit links apparent between modules within and across years of study.

Table 1.1 Example of connected, discipline-focused, research-informed curriculum (Humanities: BA English). Contributed by Deborah Cartmell, De Montfort University
→ Indicates an activity that progresses from the previous year (sequential coherence), for both topic and research-informed approach

Year 1	Year 2	Year 3
Shakespeare is taught on a compulsory introductory course in four strands, including 'adaptation' (a key area of research at DMU). Adaptation is taught by academic staff and PhD students working in the field, using key publications of the school, including two international journals edited by members of staff. (RL, RO) Students are introduced to a range of approaches to Shakespeare's plays, looking at Shakespeare through dramatists' adaptations and taught by published scholars in both Shakespeare and adaptation. (RL) Students start with a structured staff led project, then progress to a more independent, student led project. Year 1 scaffolding takes the form of staff setting the research questions, and providing online resources.	→ Students can elect to take a 30-credit option in Rewriting Film and Literature which continues from the first year and draws on the module leader's specialist interest in Victorian adaptations. The module leader's book on adaptations of *Wuthering Heights* is a key text. (RL) The range of texts widens and students are encouraged to challenge the views of their tutors and others. (RT) The tasks become more independently designed; students work in groups to reflect on different approaches to a text and its adaptation. (RL/RO/RB) → Students find their own articles to answer a staff set research question.	→ Students can further their interest in adaptation by taking a 15-credit module in Radical Contemporary Adaptations and/or Studies in Literature and Film, utilising the Centre for Adaptations' most recent research outputs. (RL) → In the final essays on the adaptations modules and in the undergraduate dissertation students set their own research questions and choose appropriate texts for study. This is a deliberately planned 3-year programme for developing independent research skills. (RB) The work involves the interrogation of different methodologies and the practical application of these. Students may opt to write screenplays with their own critical reflections on these. (RO/RB) Students present their work at a 'Dissertation Conference' and take turns leading discussions in the 3rd year Adaptation module. They are able to both teach and learn from their peers, developing skills in presenting and responding to research. (SoTL)

Although details of the programme-specific manifestations of research-informed teaching were not collected in the McLinden et al. study (2015), the survey revealed different practices and levels of understanding among students and staff as to the nature of research-informed teaching both generically and within different disciplines. A key conclusion of the project was that, however well justified the claims to be *offering* 'research-informed' teaching, there is a risk of disappointing the expectations of the students if staff are unable to explain when and why they are being taught through a range of 'research-informed' approaches, appropriate to their disciplines, since it cannot be assumed that without such explanation, students will recognise research-informed teaching when they experience it. This observation is reflected in Brew's (2010: 44–5) report of research at Monash University, Australia, where she cites 'evidence that many of the University's initiatives in research-led teaching were initially teacher centred [and there was] … realization that the concept … was by no means clear, and developing understanding needed to be worked on continually'. In spite of this, Brew also reports that 'there was growing evidence that these activities resulted in improvements in students' awareness of research in the university'. McLinden et al. (2015) recommend developing resources to promote greater awareness of research-informed teaching approaches supported with examples of good practice for staff and students, and ensuring students are made aware of the different types of research-informed teaching and associated skills they will experience, with reminders of this throughout their programme of study. We consider next how, from a student perspective, the different types of research-informed teaching approaches can be conceptualised, and expectations and understandings suitably cultivated.

Cultivating student expectations of research-informed teaching

As noted above, research-informed teaching can be conceptualised in various ways leading to differences in understanding, expectations and experiences. In Figure 1.2, we present an overview of the types of research-informed teaching approaches that undergraduate students may experience during their studies, but described *from a student's perspective*.

The figure is offered as a tool for use with students, to highlight the characteristics of the different approaches. We suggest that this generic model may serve as a resource to draw on, first as a prompt for

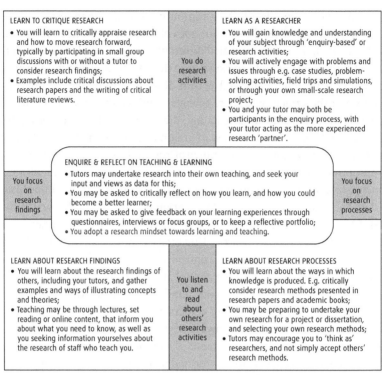

LEARN TO CRITIQUE RESEARCH		LEARN AS A RESEARCHER
• You will learn to critically appraise research and how to move research forward, typically by participating in small group discussions with or without a tutor to consider research findings; • Examples include critical discussions about research papers and the writing of critical literature reviews.	You do research activities	• You will gain knowledge and understanding of your subject through 'enquiry-based' or research activities; • You will actively engage with problems and issues through e.g. case studies, problem-solving activities, field trips and simulations, or through your own small-scale research project; • You and your tutor may both be participants in the enquiry process, with your tutor acting as the more experienced research 'partner'.

ENQUIRE & REFLECT ON TEACHING & LEARNING

You focus on research findings

• Tutors may undertake research into their own teaching, and seek your input and views as data for this;
• You may be asked to critically reflect on how you learn, and how you could become a better learner;
• You may be asked to give feedback on your learning experiences through questionnaires, interviews or focus groups, or to keep a reflective portfolio;
• You adopt a research mindset towards learning and teaching.

You focus on research processes

LEARN ABOUT RESEARCH FINDINGS		LEARN ABOUT RESEARCH PROCESSES
• You will learn about the research findings of others, including your tutors, and gather examples and ways of illustrating concepts and theories; • Teaching may be through lectures, set reading or online content, that inform you about what you need to know, as well as you seeking information yourselves about the research of staff who teach you.	You listen to and read about others' research activities	• You will learn about the ways in which knowledge is produced. E.g. critically consider research methods presented in research papers and academic books; • You may be preparing to undertake your own research for a project or dissertation, and selecting your own research methods; • Tutors may encourage you to 'think as' researchers, and not simply accept others' research methods.

Fig. 1.2 Approaches to research-informed learning described from a student perspective (adapted from McLinden et al. 2015)

programme and module leads when considering the range of learning activity designs they will include in their courses, and secondly, if augmented with discipline-specific examples, as an aid to student induction and transition. Talking through this model with newly arrived students could assist with explaining the pedagogy they will encounter, making explicit how research is embedded into their programme as part of the learning design, thus helping to cultivate expectations from the outset.

Attention to the *process* by which students gain knowledge and understanding of their discipline requires particular consideration, since it is through engagement in discipline-appropriate learning activities that the learning experience becomes 'pedagogically resonant'. While traditional, transmission-based lectures may form a part of this process (akin to conference presentations for staff, for example), they could offer an impoverished 'learning diet' unless balanced with other ways of engaging with research.

In our discussion thus far, we have moved from generic conceptions of the different expressions of the research-teaching nexus towards a practical consideration of how these might be experienced by an undergraduate student during a programme of study. In relating this experience to the notion of 'pedagogic resonance', we propose that by making the learning *design* explicit, we can cultivate appropriate expectations of students' research-informed learning *experience*. We have also suggested that programme and module leads can draw on the research-informed teaching frameworks to inspire a more connected, research-informed curriculum design. We have made limited reference thus far, however, to *disciplinary* considerations which we argue are an integral component of a curriculum that has pedagogic resonance. With reference to our case studies, we consider next some of the particular disciplinary orientations and traditions that shape the precise nature of the pedagogically resonant learning *design* and *experience* at programme level.

Pedagogic resonance and disciplinary considerations

In this section, we draw on the notion of 'pedagogic resonance' to elucidate the alignment between curriculum elements and how these are experienced by students *within their chosen discipline*. The term 'pedagogic resonance' has been variously defined. As examples, Trigwell and Shale (2004: 529) discuss 'the bridge between teacher knowledge and student learning', while Polias (2010: 42) uses the term to describe how teaching approaches and resources can 'work in unison so they do not confuse the student but instead make the learning pathway more effective and efficient'. If we want students to fulfil their academic potential, this is a highly desirable condition for maximising learning, to which we should aspire. Our interpretation of the term in relation to the 'Connected Curriculum' (Fung and Carnell 2017), is from the *student* perspective, in seeking to ensure resonance between three components: the learning *design* (aspects of course design, including intended learning outcomes, selection and sequencing of subject content, time allocation, resources, teaching modes, assessment design and criteria, etc.), the student's learning *experience* (the learning and assessment activities students actually engage in, including interactions with tutors and other learners, and the cognitive processes these engender) and the practices and traditions of the learning *discipline* into which the students

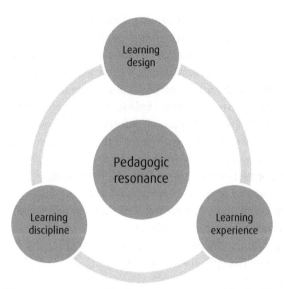

Fig. 1.3 The components of 'pedagogic resonance' in the 'Connected Curriculum'

are being inducted, including research traditions and practices, values and ethics, and underlying epistemologies and ontologies (Figure 1.3).

This notion of resonance builds on, but goes beyond, the concepts of 'synchronic coherence' (how the learning on a number of separate, but synchronously taught, modules is experienced) and 'sequential coherence' (how the learning of a topic at the beginning of a course relates to the learning of the same topic later in the course) (Wallace 1991:153). It also differs from, but needs to be supported by, the now familiar concept of 'constructive alignment' of course design (Biggs 2003), where the intended learning outcomes, learning activities and assessment design must align. In our interpretation, disciplinary cultures, practices, values and traditions can intersect with considerations of both coherence and constructive alignment through the programme-wide adoption of research-informed approaches to teaching and learning.

The deliberate and progressive integration of a range of research-informed approaches into the learning design and activities of all stages of an undergraduate programme of study, as illustrated in the previous section, is, we contend, integral to ensuring that pedagogic resonance is fully achieved and experienced by students, with the learning benefits that it aims to bring. Furthermore, in seeking to promote 'pedagogic resonance' between the components outlined in Figure 1.3, we argue

it is important to find meaningful ways to make our own thinking as tutors and learning designers explicit to students. The process of explicating our thinking pushes us to clarify and test our own logic, as well as helping learners to engage with activities that they may initially find alien and challenging. This suggests that in terms of suitably cultivating learner expectations, induction into research-informed teaching and learning must be embedded into the earliest stages of the learning pathway, as part of a wider, supported transition process, with opportunities frequently and repeatedly provided throughout the programme to consolidate these ideas and to ensure alignment between learner expectations and their actual experience. We consider next how the components outlined in Figure 1.3 can be drawn upon to examine how research-informed teaching activities are embedded into the case study discipline programmes.

Pedagogic resonance in the disciplinary case studies

Humanities (English)

Learning discipline. The case study lead described Humanities as a group of disciplines with 'fuzzy identity' (Chan 2016: 1657), where the defining characteristics relate to a cluster of intellectual skills. Humanities disciplines, including English, focus on understanding interconnections, seeing the bigger picture, and the realities and the consequences of actions. Reflexivity and awareness of multiple perceptions are threshold concepts. Mixed methods are often used in research, with scholars tending to start with very open questions, seeking to uncover and understand complexity. Critical thinking, ways of being able to explore and come to understand the world are fundamental.

Learning design. Chan (2016: 1667) envisages constructing the Humanities curriculum to help develop a subject identity, through activities such as 'capstone projects which integrate and consolidate subject knowledge', similar to the dissertation in the UK, and also through the use of discussions and debates which address students' academic discipline identities, and their purpose in the wider social context of the 'real world'. In our case study (Table 1.1) we see the inclusion of a dissertation as the culmination of three years of deliberately designed preparation, where students are scaffolded through an increasingly independent approach to conducting and presenting research. Tutors model 'Humanities' research

questions in years 1 and 2, before students are asked to set their own research questions.

Learning experience. Characteristics of a discipline-focused learning experience can be seen in the series of English 'Adaptation' modules which run from years 1 to 3, in the course of which students experience all of the fundamental variations of research-informed learning, from learning about research findings and processes in year 1, to more active participation in the critiquing and challenging of views in year 2, to the undertaking of independent research or adaptation, and critical reflection on this process, in year 3.

Law

Learning discipline. Law is both a profession and an academic discipline with a vibrant research community, which draws on 'a wide range of methods and techniques, some of which are specific to the discipline but some of which are drawn from the humanities and social sciences' (QAA 2015: 6). Furthermore, 'Law [is] a human creation… that is subject to the ethics and values of those that make and apply it' (QAA 2015: 6). The case study lead for Law explained how her school bases its identity on the core values of access to justice, pursuit of excellence and internationalisation, for example.

Learning design. As a vocational subject, Law focuses on the development of the wide variety of skills and knowledge students need to develop in order to be successful legal professionals. 'Doing' is seen as an effective mechanism for achieving this. Of the 10 case study contributions, there were many rich examples of modules that combined authentic research and other skills needed by a practising lawyer through extended simulations or authentic activities linked to the professional practice of the module lead. Co-curricular opportunities for authentic 'lawyering' also abounded, through work placements and *pro bono* work; mooting was offered as a typical example for students to 'do' law in a simulated environment. Academics underpin their teaching with their own experiences of 'doing' the law, as well as their more conventional academic research and writing. These practices are designed not only to inform students' legal knowledge but also to engender an appreciation for wider issues (e.g., commercial awareness, cultural sensitivity and politics) and the development of softer skills relevant to 'lawyering'.

Learning experience. Students are expected to critique both academic and government research, and research undertaken by other

students. Group work participation fosters a collaborative and mutually supportive environment for constructive criticism and subsequent improvement. Students experience situations that require a deep consideration of the ethical issues noted as being a defining characteristic of the discipline. For example, one course introduces students to human rights and *pro bono* work in optional year 1 seminars, with some students undertaking UK-based *pro bono* work in the form of minor casework and research tasks; in year 2 they can apply for an international internship, followed in the final year with a dissertation option.

Criminology

Learning discipline. As a relatively young discipline, Criminology represents a federation of established disciplines with different identities and epistemologies, described by the case study lead as a 'rendez-vous' subject. The range of disciplinary approaches brought by the staff is seen as an asset, as students are consciously exposed to a range of perspectives and research practices – a 'melting pot' of history, politics, international relations, crime, security studies, sociology, law and psychology.

Learning design. The case study programme team have developed a clear focus (and boundaries) to the subject for their programme in order to manage the diversity of subject perspectives, with a number of clear themes creating coherence for both staff and students. For example, research is a theme introduced from the start of year 1, with different disciplinary approaches covered within this. Workshop-style support is the main teaching mode for the research modules in years 1 and 2, with the level of challenge increasing from highly scaffolded, interactive introductions to research methods (year 1) to group assessed projects in year 2, and a popular, optional research project (dissertation) in year 3. Learning and assessment modes are designed to foster interaction, engagement and development of transferrable skills.

Learning experience. Students develop the capacity to appreciate different viewpoints and to understand that there is no absolute 'right' way of doing things. Many students arrive with a narrow view of the world and an often naïve, single viewpoint; by the end of year 1, they can appreciate diversity of views (a threshold concept), and by year 3, can take their own standpoint and ownership for their position. Diverse assessment modes (simulations, poster presentations,

podcasts, journalistic pieces, group project reports) foster student engagement and enable the acquisition of transferrable skills as well as subject knowledge.

Physics

Learning discipline. The case study lead described how two views of Physics prevail: as a theoretical, mathematically-based subject that investigates the laws of the physical universe, in a quest to understand how the universe works, and as a more practical subject that connects maths with the physical world through experimentation and application. Physics, as a science, is considered to be not just a 'body of knowledge' to be learned, but a process of systematically testing theories against the evidence. Physics is fundamentally a quantitative discipline that adopts a reductionist perspective, aiming to identify, clarify and simplify principles and laws, and test these through empirical observation. Physics is thus about solving problems. Of note is the Quality Assurance Agency (QAA) (2008: 2) description of Physics as 'a demanding discipline. A deep understanding of the frontiers of physics often requires advanced knowledge, which cannot necessarily be acquired during a bachelor's ... degree programme'.

Learning design. In seeking to develop students' thinking as physicists, undergraduate programmes tend to reflect the QAA subject benchmark guidance: learning is typically viewed as incremental, lending itself to 'systematic exposition and the ordered and structured acquisition of knowledge', with practical skills, including an appreciation of the link between theory and experiment, also being developed (QAA 2008: 5). A range of teaching and learning methods are used to achieve this, including flipped lectures, group tutorial work, practical work, computer simulations, electronic resources, project work (some of which may be team-based), and activities devoted to generic and subject-specific skills development. The case study lead challenged the view that the foundations must be established before students can do research (normally in Physics programmes research comes in the later stages of a course), stating that aspects of research can be introduced at a much earlier stage. Tutors can help students to develop conceptual understanding that moves them towards developing a more coherent conceptual framework and 'investigative habits of mind' (c.f. 'learning about research processes' and 'learning to think as a researcher').

Learning experience. An example of students developing an 'investigative habit of mind' is seen in a quantum mechanics course where understanding is developed through a series of simulations. Students engage in a process of research, in that they have to interact with the simulations and do something with the material. Learning is scaffolded through directed activity. The learning experience is practice-based and includes application of maths to the physical world while practical skills are also developed. In another example, flipped lectures provide an opportunity to engage students in 'qualitative reasoning', an important part of the mental process of modelling in Physics, rather than simply use lecture time to transmit 'the body of knowledge' that students must acquire. In a third example, group-based experimental problem solving is introduced in year 2, where students work in small groups to solve a set experimental problems over a number of weeks. By having to design and execute the experiment themselves, students discover that there is no such thing as a perfect experiment, and gain a better understanding of the complexities of experimental physics and experimental uncertainty. Following this, final year students undertake a project involving a real investigation, experimental, computational or theoretical. The investigative skills developed in the second year are thus deployed and further enhanced.

Earth Sciences

Learning discipline. Earth Sciences is an interdisciplinary subject that investigates the workings of the Earth and its different systems. It is a historical subject in that it seeks to understand what happened in the past in order to understand what is happening in the present and predict what might happen in the future. While boundaries with related disciplines were described as 'porous' by the case study lead, much of the advancement in knowledge and understanding in these subject areas is founded on accurate observation and recording in the field, investigating evidence for processes that take place on large physical and long-term time scales that cannot be observed directly. Observation and visualisation are a central theme. Knowledge generation is based on inference to develop multiple working hypotheses to explain observed phenomena, and research methods span the spectrum of quantitative and qualitative approaches. Earth scientists rely less on the scientific method than other

scientific disciplines but they do develop specific habits of mind, e.g. spatial thinking, temporal reasoning, systems thinking and gradual building up of layers of knowledge and understanding through collaboration between scholars from different disciplines.

Learning design. To develop an understanding of Earth Sciences, students need significant, immersive exposure to field-based learning and assessment (which presents an access challenge for some students with disabilities). The integration of fieldwork with other learning methods is seen as key to achieving skills such as the ability to visualise and extrapolate data in three dimensions, or understanding the application of practical methodologies. Developing field-related practical and research skills is essential. A range of research approaches are introduced and developed throughout the three-year undergraduate programme.

Learning experience. The QAA benchmark statement mandates that completion of a programme of fieldwork is compulsory for all students graduating from geoscience programmes, and for accredited programmes, the Geological Society of London stipulates a minimum number of days that must be spent in the field. From day 1 students keep a field notebook – a skill they develop over three years. Year 1 field activities are prescribed in some detail; by year 2, students should know what they need to record and how, and by the time they start their final year independent project (creating a geological map), they have the necessary skills in place. These include the ability to look at things on different scales, to extrapolate from 2-D to 3-D and possibly the 4th dimension of time ('visual penetrative ability'), to develop multiple working hypotheses and seek evidence to support or reject hypotheses. Students learn to work with others as members of a group, develop discipline-specific technical vocabulary, and skills in using specialist equipment.

Conclusion: addressing challenges to research-informed teaching

In this chapter we have proposed a model of pedagogic resonance that seeks to ensure there is alignment between students' experience of a given learning *design* and learning *experience* within a given *discipline*. To conclude, we identify three significant challenges in relation to achieving such resonance through embedding research-informed teaching across the undergraduate curriculum.

Challenge 1: Understanding research-informed teaching and learning

As noted above, there is evidence to indicate that while there is substantial activity by staff in relation to the linkage between research and teaching, this is not always clear to students, and may be experienced by them in a piecemeal and confusing way. Brew (2010: 147) notes that:

> While there is a good deal of research that has examined the levels and kinds of learning that take place within inquiry-based learning contexts, there is relatively little that examines students' perceptions... The little research that has been conducted suggests that students respond differently according to the discipline in which the inquiry-based learning is situated (Abrandt Dahlgren and Dahlgren 2002) and according to their epistemological beliefs (Tsai 2000).

While particular groups of students may or may not benefit from the full range of research-informed approaches to teaching, a key issue to address, therefore, is a lack of understanding among both staff and students of what research-informed teaching is and how it relates to their current or future learning experience (McLinden and Edwards 2011). We have offered in this chapter some explanations of research-informed teaching and learning, illustrated with examples from a range of disciplines, which we hope will prove useful in elucidating the various manifestations of such teaching approaches.

Challenge 2: Cultivating student expectations and supporting transition to research-informed teaching and learning

McLinden et al. (2015) report that a particular challenge in embedding research-informed teaching and learning is in finding effective ways to cultivate students' expectations at an appropriate point in the learning pathway, so they recognise and appreciate the relevance of the links between research and teaching in relation to their particular disciplinary learning experiences, and approach their programme of study feeling confident and prepared. We have suggested a framework in this chapter that could function as a useful tool to support student induction and transition both at the start of their undergraduate programme and at key points throughout it. The case studies outlined show how these generic descriptions can be 'translated' into programme-specific illustrations of the research-informed teaching and learning experience that students can expect.

Challenge 3: Achieving pedagogic resonance through systematically embedding research-informed teaching and learning across the entire curriculum

In this chapter, we have argued that we need to take our efforts to practise research-informed teaching and learning even further, as the key to achieving pedagogic resonance through *deliberate*, connected and coherent embedding of the full range of research-informed teaching approaches across the entire undergraduate programme – something that may be difficult to achieve as a retrospective adjustment to an existing programme. We propose the achievement of pedagogic resonance as the outcome of a curriculum that is not only constructively aligned, but that is also rendered accessible and meaningful through the use of research-informed approaches to align learning *design, experience* and *discipline*.

The case studies we have presented provide evidence of the disciplinary practice that is already being undertaken in the sector, with inbuilt pedagogic resonance as an emerging or fully embedded design feature. A key challenge for the wider sector now is to develop and promote similar practice in disciplinary appropriate ways. Only thus we contend, will we succeed in fully engaging our students as active participants in their induction as members of our respective disciplinary communities.

Acknowledgements

We are very grateful to the following case study leads:

- Law and Criminology: Sarah Cooper and Emma Kelly, Birmingham City University.
- Humanities: Helen Hewertson, University of Central Lancashire.
- Physics: David Sands, University of Hull.
- Earth Sciences: Alison Stokes, University of Plymouth.

We would also like to thank those, too numerous to mention here, who contributed case studies via these leads. These are available at: http://www.coronyedwards.co.uk.

2
Development of a connected curriculum in biochemistry at a large, research-intensive university in Canada

Rachel E. Milner

Introduction

In this chapter I describe the development of a research-intensive undergraduate curriculum in biochemistry at the University of Alberta, Canada. In the last decade and a half, our department has made significant changes to its teaching programme with the specific goal of improving students' experiences through increased and improved research opportunities. Our focus has been on enabling active critical enquiry throughout our programme, and on early immersion of our students in a research and learning community. We have described our teaching programme as research-intensive, to capture these objectives. The programme design is in keeping with the institutional objectives stated by University College London (UCL) – a university leading in this area (Arthur 2014):

> At University College London, our top strategic priority for the next 20 years is to close the divide between teaching and research. We want to integrate research into every stage of an undergraduate degree, moving from research-led to research-based teaching.

UCL has used the term 'Connected Curriculum' to describe their institution-wide initiative to ensure that all its students are able to learn through participating in research and enquiry at all levels of their programme of study (UCL Teaching and Learning Portal: Connected Curriculum; Fung 2017). Throughout this chapter, I use the descriptor 'research-intensive' for our programme, but I consider our goals and purposes aligned with those of UCL's Connected Curriculum initiative.

There are three major focus points in this chapter, the first of which is our rationale for development of a research-intensive curriculum. The second is a discussion of the factors which had a particular impact for our programme, namely ensuring that research opportunities are embedded effectively, integrating service teaching into our programme, and recognising students' research experiences officially. The final focus of the chapter is on implications for institutions which truly wish to support undergraduate research initiatives, specifically the need for recognised and valued teaching-intensive academic positions, and the need for appropriate operational funding.

Context

The University of Alberta is a large, research-intensive university ranked among the top five universities in Canada and the top 100 in the world (QS World University Rankings n.d.; CWUR 2016). It has five campuses with a combined graduate and undergraduate enrolment of more than 37,000 students (*UAlbertaFacts* n.d.). The Department of Biochemistry is housed in the Faculty of Medicine and Dentistry, which is considered one of the world's top medical schools (Times Higher Education Supplement World Rankings, 2010–2011). The department has a strong research history with a broad range of research interests, from structural to molecular to cellular biology. Through historical anomaly rather than design, our undergraduate programme (BSc in Biochemistry) is offered through the Faculty of Science but is created, managed and taught by academic staff in the Faculty of Medicine and Dentistry. Approximately 25 students per year graduate from our programme, but the department also teaches introductory 'service' courses for more than 2,500 students in other programmes (Department of Biochemistry, *Always to Excel* n.d.)

The rationale for a connected curriculum in biochemistry

Biochemists are defined by their research practices

There are a number of factors which have influenced our work in developing a research-intensive curriculum for our undergraduate programme. One of these, and perhaps the most important, is the simple question 'What is biochemistry?' As a research biochemist who has subsequently spent more than 20 years thinking about how best to teach biochemistry, and as director of an undergraduate programme, I have participated in many discussions with colleagues on this question. It arises regularly because biochemistry is a broad discipline and there is no clear consensus among biochemists as to what knowledge the subject does or does not include. At the University of Alberta, we have PhD 'biochemists' located in departments of chemistry, engineering, medicine, pharmacology, cell biology and microbiology. At the same time, we have professors in the Department of Biochemistry who were trained as chemists, cell biologists, microbiologists, pharmacologists and biophysicists. In North America, biochemistry instructors may be located in Faculties of Medicine, Departments of Chemistry, or Departments of Biology, among other places.

Our existential angst as biochemists has a notable influence in determining the curriculum of an undergraduate programme in biochemistry because it is entirely debatable which particular didactic courses would be necessary to qualify a student as a biochemist. In contrast, the approaches and practices of a biochemist are easily identified. Biochemists practice an 'imaginary' science, exploring life processes at the molecular level. They use physical and chemical data to construct models, visualising invisible molecules and their interactions with one another. Indeed, the abstract concepts of biochemistry are now communicated almost entirely through diagrammatic images, models and maps (Schonborn and Anderson 2010) and it is argued that biochemistry has moved from being a mathematical-logical to a visual-logical science (Habraken 2004). This phenomenon has been reflected in biochemistry classrooms to the extent that visualisations have become a 'main vehicle of communication' (Ferreira and Arroio 2009). That is, the processes of collecting physical and chemical data and then creating models based on those data are critical to 'being a biochemist'. Without this level of exploration, without engagement in the modelling process, the student is not a biochemist. More simply put, with respect to biochemistry and

being a biochemist (with apologies to Sartre), to do is to be. Only *through* conducting research in biochemistry can one *be* a biochemist.

Research is a high-impact practice in undergraduate education

Another factor that has influenced our curriculum development is growing recognition in North America that research-intensive undergraduate programmes are a 'necessary thing'. This began with the Boyer Commission Report (1998). The report, *Reinventing Undergraduate Education: A Blueprint for America's Research Universities*, which was released only two years prior to the start of our curriculum reconstruction project, presented 10 recommendations for 'the radical reconstruction of undergraduate education at research universities in the United States'. It argued that 'undergraduates at research universities too often have been short-changed and a new model of undergraduate education is needed'. The commission's 10 recommendations were:

> *(1) make research-based learning the standard; (2) construct an inquiry-based freshman year; (3) build on the freshman foundation; (4) remove barriers to interdisciplinary education; (5) link communication skills and course work; (6) use information technology creatively; (7) culminate with a capstone experience; (8) educate graduate students as apprentice teachers; (9) change faculty reward systems; and (10) cultivate a sense of community.*

There has been some progress in undergraduate education in North America since the Boyer Commission Report was released. There is an increasing tendency towards engaging students in *authentic* research, especially in science and engineering disciplines (Sadler and McKinney 2010) and the positive effects of undergraduate research experiences are now recorded as systematic data (Loppato 2010). In a report from the National Survey on Student Engagement (NSSE 2015) certain practices are designated as high impact in relation to their positive influence on student learning. These practices, such as involvement in authentic research experiences, are noted to 'demand considerable time and effort, facilitate learning outside of the classroom, require meaningful interactions with faculty and students, encourage collaboration with diverse others, and provide frequent and substantive feedback'. NSSE founding director George Kuh recommends that institutions should aspire for all students to participate

in at least two high-impact practices over the course of their under-graduate experience.

The structure of our research-intensive curriculum: programmes, courses and credit requirements

At the University of Alberta, a 'programme' describes the subject matter of the degree. For example, students who meet the requirements of our programme graduate with a BSc in Biochemistry. A standard undergraduate programme in the Faculty of Science requires completion of 40 distinct 'courses' (120 credits, *120) which can be completed in four years. Each programme specifies required and optional courses, minimum course-load requirements and minimum acceptable academic performance. The academic year is divided into two terms, Fall (September to December) and Winter (January to April). Within this structural framework, students have traditionally taken five courses in each term for a total of *30 per academic year. However, in recent years, as student debt increases and more students work while studying, it is more common to see students taking four courses in the Fall and Winter terms, for a total of *24, with one or two additional courses in Spring (May–June) and Summer (July–August) special sessions.

Specific course requirements for the BSc in Biochemistry: 2000–2001 and 2015–2016

In their first year most students take foundational (100-level) science courses such as chemistry, physics, mathematics, biology and English. In particular, chemistry is a critical prerequisite for biochemistry so students in our programme normally take their first course in biochemistry in the Fall term of their second year (200-level). Therefore, our specific programme curriculum extends through only three academic years with 200, 300 and 400-level courses.

The change in the structure of our programme since we began work on this project is illustrated in Figure 2.1. In 2000–2001, the programme was largely didactic, with a single 400-level capstone research project (*6) and seven didactic 400-level courses. The capstone research project was intended only for students considering graduate studies and a career in research, and it had as prerequisites only two introductory (200-level) biochemistry courses and an undergraduate

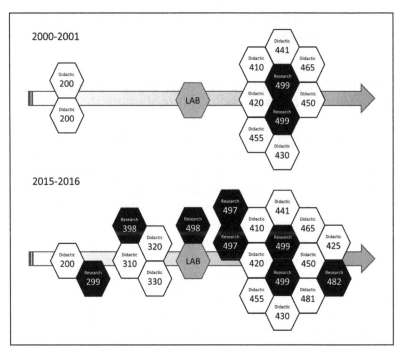

Fig. 2.1 The Biochemistry Programme in 2000–2001 and 2015–2016

This diagram illustrates changes in the number, academic level and credit weight of didactic and research courses available to students in the biochemistry programme since 2000–2001. Each white hexagon represents a didactic course with *3 credit weight. The 400-level didactic courses rely on the 200- and 300-level didactic courses as prerequisites. The grey hexagon labelled LAB represents the undergraduate laboratory 'boot camp' (*6) which is important preparation for the 400-level research courses. Each black hexagon represents a research course with *3 credit weight: where two are connected, the research course in question has *6 credit weight. Research courses do not normally have other research courses as prerequisites. Research opportunities for credit are now available at all levels (200, 300 and 400) enabling early and prolonged integration of undergraduate students in the department's research community.

laboratory course (LAB). In 2015–2016 our programme is quite different (Figure 2.1). We have broadened and deepened our introduction to the subject matter by converting the two introductory didactic courses (200-level) into four foundational courses, one at the 200-level and

three at the 300-level. In addition, we have embedded research courses at all levels, with multiple options for research at the 400-level.

Important factors in the design of our research-intensive curriculum

There were three major factors which influenced specific choices we made in developing our research-intensive curriculum:

- thinking about embedding research effectively;
- integrating service teaching into our curriculum; and
- recognising the students' experience officially.

Embedding research effectively: several new courses, time and a laboratory boot camp

Deciding to embed research in an undergraduate programme is easy, given current prevailing thought in the field of higher education, but knowing how best to do that is more complex. There are a number of factors that were important to us. Firstly, we felt that 'research-based learning' means enabling students to participate in research rather than simply learning about it in didactic classes. That means creating new undergraduate research courses, for credit. In addition, these experiences must be embedded throughout a programme, rather than creating a single 'capstone' course, and they should be sustained, because the length of time a student is engaged in research determines the extent to which they gain a deep and real understanding of what they are doing (Sadler and McKinney 2010).

With these factors and objectives in mind, our approach has been to develop and re-define a number of research courses and to embed them at all levels of the curriculum (Figure 2.1, 2015–2016). By creating a number of courses offered at different times in the academic year, with different credit values and varying duration, we have tried to optimise opportuntity for students to participate. Given that students' ways of knowing or thinking typically evolve during the undergraduate years (Donald 2004), we have also tried to ensure that involvement in the research process is at a level appropriate for the academic level of the student. That is, our expectations and objectives are directly related to the typical independence and ability of students at that level in their programme.

The research courses we added to the programme provide students with access to supervised, authentic research experiences as a part of

a larger team of investigators. Students typically contact a potential supervisor in whose work they are interested and are generally supervised by post-doctoral researchers or senior graduate students. In addition to their own work in the lab, students will normally spend time at lab meetings and research group meetings. Importantly, students are free to select a supervisor from within the Department of Biochemistry (most) or from other departments on campus. We feel that this option is important for our students, given the breadth of the discipline.

When creating or redesigning our research courses, we did not forget the importance of providing appropriate time. According to the NSSE Report (2015), involvement in authentic research experiences demands considerable time and effort and this is certainly true in biochemistry, where laboratory research can be technically difficult and painstaking, with experiments failing often even for experienced researchers. This reality necessitates careful consideration and adjustment of the course weight or credit value, to reflect the hours of work required to complete a research project. Disappointingly, this kind of course-weighting adjustment can still be controversial among academics who think of learning in terms of the number of lecture hours per week.

The first and arguably most important decision for us in development of our research-intensive undergraduate curriculum was whether or not to offer a laboratory/research skills course for students, and if so, where to include it in the curriculum. We debated the purpose of laboratory courses in general, and wondered whether or not this purpose differs in a research-focused curriculum. I have heard academics in disciplines which require significant technical skills argue that 'anyone with any brains can learn the techniques as they go'. While this argument is intended to promote authentic research experiences instead of stilted laboratory exercises, we decided that it denies students the advantages of getting technical training prior to their immersion in research. As noted above, effective research experiences for undergraduates require significant time. However, developing the skills necessary to complete technically challenging experiments also takes significant time. While these skills can be developed when a student is working on a research project, the research project is likely to be far more rewarding, and the data more reliable, if the student has already learned basic techniques and is confident in their laboratory skills. Given this, we developed a full-year biochemistry laboratory course (Figure 2.1, LAB). This course, which was implemented in 2000–2001, provides our students with valuable time to refine their skills – the time commitment is recognised with course credits.

We consider the introduction of our laboratory training course to have been pivotal in the success of the current research-intensive programme structure. As Sadler and McKinney (2010) noted in their review of scientific research opportunities for undergraduate students, 'Authentic research represents a significant departure from typical undergraduate laboratory courses'. Our laboratory skills course also represents a significant departure from a typical undergraduate laboratory. This course focuses on the development of extensive and reliable laboratory skills rather than the completion of experiments to illustrate scientific facts. It is a prerequisite course for the two major directed-research project courses currently available to our students (Figure 2.1, 497 and 499). In the LAB, our students practise and perfect their use of a wide variety of techniques used in the department's research laboratories and they are given ample opportunity to trouble-shoot and to think through technical problems. The course is also designed to encourage students to practise fundamental behaviours required by successful researchers in biochemistry, such as keeping a good laboratory notebook and developing proper organisational skills to ensure the validity and reliability of data collected.

Integrating service teaching into our curriculum

A major issue for us in the redesign of our curriculum was developing introductory didactic courses that must simultaneously meet multiple purposes. Biochemistry is a foundational subject matter in various disciplines, and at our institution students from more than 20 distinct programmes (such as medical sciences, pharmacy, kinesiology, nutrition and dental hygiene) are required to take introductory/survey level courses in biochemistry. These students, who will never be 'biochemists', bring with them diverse and distinct interests, motivations and prerequisite knowledge. Our introductory courses are important for the non-specialists we serve and for those in our programme. Our own students require a deep understanding of the didactic content if their parallel research experiences are to have meaning, and our service population require a solid foundation for further studies in their own programmes.

Our guiding philosophy in the development of introductory didactic courses was that course content should be limited, and carefully selected, to favour understanding of basic concepts and to provide appropriate time for substantive engagement. This approach is based on work by Sundberg and Dini (1994) who compared two introductory biology courses, one for science majors (rigorous, content-intensive) and the other for non-science

majors (basic concept understanding, details de-emphasised). They found that 'Rigorous, content intensive instruction, characteristic of the majors' course, was less effective at promoting student understanding of concepts and had a generally negative impact on student attitude'. We were aware that our two, 200-level didactic courses (Figure 2.1, 2000–2001) were content-intensive and disliked by almost everyone regardless of their programme. Given this, we created a new course structure (Figure 2.1, 2015–2016), which consists of a single 200-level survey course followed directly by three more-specialised 300-level courses. It was necessary to create three courses in order to properly cover the wide range of material encompassed by the term 'biochemistry'. This is a notably different approach than is normal in most institutions of higher education in Canada, where introductory biochemistry is almost always covered in only two terms. Our approach doubles the time available for students to study and engage with the subject matter. This enables students in our programme to develop a far greater understanding of the subject matter, which enhances their parallel research experiences. Students who are not in our programme are free to select any number of the 200-level and 300-level courses, depending on their particular interest and discipline. Overall, this new introductory course structure has been a success and students provide us with extremely positive feedback about their classroom experiences.

Recognising student experience: an embedded Certificate in Biomedical Research

We are proud to offer students the chance to engage deeply with research in biochemistry through our new curriculum. We also recognise that it is important for students' transcripts to show exactly what they have achieved in their studies. Because of this, we collaborated with colleagues in other departments in the Faculty of Medicine and Dentistry to create an embedded Certificate in Biomedical Research.

Certificates at the University of Alberta are intended to recognise student achievement in particular areas of focus more clearly. An embedded certificate implies that the requirements of the certificate can be met by students during the completion of their regular degree programme. The Certificate in Biomedical Research was approved by the University of Alberta Academic Standards Committee, under delegated authority from the General Faculties Council. Programme and Certificate approval mechanisms at the University of Alberta are based on existing mature programmes and/or approval processes at the four major universities

in Alberta (University of Alberta, University of Calgary, University of Lethbridge and Athabasca University). All approval processes at the universities include department, faculty and university approval, and they reflect discussions among the four universities, the government of Alberta and the Campus Alberta Quality Council (CAQC).

The Certificate in Biomedical Research is available to undergraduates who participate in a minimum number of the research courses now available to them and it recognises the development of significant research skills in the disciplines of biochemistry, cell biology, pharmacology and physiology, or other life and health science programmes. The certificate recognises the student's technical skills, general research skills, through courses which explore the biomedical research literature, and participation in a minimum of three terms in one or more biomedical research projects. Students are awarded the Certificate concurrently with their degree and it is inscribed on their transcript.

Implications for the institution in the success of a research-intensive curriculum

Figure 2.1 illustrates the evolution of our research-intensive curriculum in biochemistry, starting with the implementation of the undergraduate laboratory 'boot camp' (LAB) in 2000–2001 and continuing, most recently, with the implementation of the 200-level research experience (299) in 2015–2016. Our research-intensive curriculum, as it is now, has been 15 years in the making. There are solid arguments that this duration is not a problem, per se, because undergraduate programmes should always be undergoing change, review, exploration and improvement, and are never 'finished'. However, change can be facilitated and institutions of higher education have both the responsibility and the ability to enable improvements in the undergraduate educational experiences they provide. Each institution of higher education has unique structural and organisational factors that may facilitate or impede programme development. For the Department of Biochemistry at the University of Alberta, two major factors continue to have an impact on the quality of our research-intensive curriculum. These are:

- recognition of teaching-intensive academic positions as critical in this kind of work; and
- provision of appropriate operational funding for undergraduate research.

Teaching-intensive academic positions

We have known for a long time that proper recognition of educators is necessary if an institution truly wishes to develop quality programming. In the Boyer Commission Report (1998), the ninth recommendation is to 'change faculty reward systems'. In 'Learning Our Lesson: Review of Quality Teaching in Higher Education', Henard (2010) refers to the importance of support of faculty from the institution:

> *The institutions need to develop innovative approaches to measuring the impact of their support on quality teaching. They are still struggling to understand the causal link between their engagement in teaching and the quality of learning outcomes.* (Henard 2010: 11)

Sadly, many research-intensive institutions are still unsure, or unwilling, to reward and recognise educators and education-focused leaders (Fung and Gordon 2016). The University of Alberta has engaged enthusiastically in debate about the relationship between teaching and research at research-intensive universities, and in its recent Comprehensive Institutional Plan (2016), the University acknowledges the importance of high-impact educational experiences for students, as well as its obligation to provide these kinds of experiences: 'Teaching and learning practices have shifted… to more opportunities to co-create and engage with knowledge…' (7).

Despite this, the University of Alberta, like other research-intensive institutions across the world, is struggling to define and accept academic roles that are teaching-focused. In particular, research-intensive institutions frequently hesitate to create and support teaching-intensive academic positions.

This is a problem, because substantive engagement in educational development requires time, which is not available for academic staff required to defend their role as a researcher. We cannot continue to require academics to follow identical, rigid job descriptions. Instead, we must allow for an individual to change focus and roles over their career. If we value teaching programmes and care about their quality, we must value the work of faculty in curriculum design and educational development. To value this work is to recognise it in faculty reward systems and to allow academics to focus on these areas without fear of 'punishment' for reduced research productivity. To value this work is to recognise, create and support teaching-focused academic positions that are equal to research-focused academic positions, that is, to create a teaching-intensive stream.

At the University of Alberta, there are different attitudes towards a teaching-intensive stream of academic staff. The Faculty of Medicine and Dentistry has embraced these academic positions and has supported the Department of Biochemistry in its work on curriculum development by recognising and rewarding the work that has been done. We have been able to develop our research-intensive curriculum with such success because Chairs of our department have chosen to value teaching equally with research as an academic contribution. The importance of Chairs in supporting educational reform is noted by Henard (2010):

> The success of any quality initiative supported by the institution depends mainly on the commitment of the heads of departments. The heads of departments are the main drivers helping the quality teaching spirit to spread and allowing operational implementation. (65)

The role of Chairs is critical, but they need institutional support. In other faculties and departments at the University of Alberta, there is not such support for teaching-intensive academic positions. Indeed, in response to growing enrolment and shrinking per-student funding, a common response across North America has been the rapid expansion of contract teaching positions, rather than either traditional research and teaching tenure-track positions or even new, teaching-focused tenure-track positions. At the University of Alberta, nearly 1,000 contract academic staff are employed each year to teach (mainly) introductory level classes, and they work without the job security, compensation and benefits of their tenured or tenure-track counterparts (University of Alberta Students' Union 2016). This ensures that teaching programmes are little more than a collection of courses delivered by an 'underclass' of academic employee, and it can only compromise a department's ability to think seriously about its curriculum and to undertake the significant work required to implement major curriculum reform.

The institutional approach to teaching-intensive academic positions varies across Canada, with many institutions creating teaching-streams in recent years. The University of Toronto, for example, has a clearly defined teaching-stream academic appointment (University of Toronto 2015). Approximately half of the Canadian universities that belong to the U15 Group of Canadian Research Universities (U15) have some form of teaching stream (with tenure). However, these positions vary significantly; the total number of individuals in these positions appears to be relatively small, and the remuneration for these positions seems to be notably less

than that for individuals in traditional academic positions. The University of Alberta Students' Union (2016) recently proposed that the General Faculties Council Committee on the Learning Environment establish a sub-committee to explore the opportunities and challenges of supporting teaching-intensive academic positions more broadly across campus at the University of Alberta. Our students understand the connection between the educational opportunities available at an institution and the direct ways in which that institution rewards educational work.

Many argue that teaching and research are inextricably linked such that academics must be engaged in active research programmes in order to provide the best learning opportunities for students (Riddell 2016). This position appears to have some validity, as many students choose the University of Alberta *because* it is a research-intensive institution and they are looking for a research-intensive undergraduate experience. However, the argument is simplistic: When an academic chooses to focus on educational development and teaching, this does not mean that their work must now exclude all connection with research. The opposite is true, because when given time an academic has the ability to do the necessary work to create, support and continually improve the curriculum, thus connecting students with the research experiences they seek. This argument also fails to take account of the different levels of student learning within an undergraduate curriculum (Donald 2004). Cross-fertilisation and mutual enrichment between teaching and research do not occur spontaneously simply because an individual runs a research programme. On the contrary, in our discipline those running research programmes usually suffer from a notable shortage of time to devote to the students in their classroom, much less to do the necessary work to create an effective programme curriculum.

Operational funding for undergraduate research

An important and unsurprising institutional barrier to maintaining the quality of our research-intensive curriculum is funding. In biochemistry, and other medical science disciplines, research is costly. With the best will in the world, faculty may not be able to support undergraduate students in research because this work requires reagents and equipment that might be limited and thus more usefully directed to a graduate student's project. Supervisors need funding for undergraduate research, and for the Department of Biochemistry at the University of Alberta this has not been forthcoming. We are in danger of losing some of the gains we have made because of a lack of financial support for these courses. Our institution has no mechanism for transferring even a fraction of a

student's registration fees to contribute to the costs of running under-graduate research courses. Some of the courses in our new curriculum are already struggling to survive, including the popular Design and Construction of Synthetic Biological Systems. This course is built around the iGEM competition (International Genetically Engineered Machines) held every November at MIT and it will be a sad loss for students at the University of Alberta if it cannot be sustained.

If the University of Alberta, like other institutions, truly values this kind of programme structure, they must recognise the costs. Alternative funding models for these kinds of programmes require exploration, and this includes serious reconsideration of standard funding models which support labs for all large-enrolment, introductory science courses, yet provide no funding for research courses. A research-intensive curriculum in our discipline can only survive if it is adequately supported by an institution prepared to make changes to the 'old way of doing things'.

Summary

This chapter describes the development of a research-intensive undergraduate curriculum in biochemistry at the University of Alberta, which shares the objectives encompassed in UCL's Connected Curriculum project. Over a 15-year period we have incorporated research opportunities for our students at all levels of the programme, moving successfully from research-led teaching to research-based teaching (Arthur 2014). Our work has been enabled specifically by Faculty and Departmental leaders who recognise teaching-intensive academic positions and who have rewarded educational development as important academic work. The continued success of our programme depends, to a large extent, on whether or not the University of Alberta is prepared to support research-led teaching across the entire institution. If it does wish to do this, it must revisit its resourcing practices.

Acknowledgements

Three Chairs of the Department of Biochemistry have helped 'the quality teaching spirit to spread'. During their tenures as Chair, Professors B. Sykes, M. Michalak and C. Holmes (current) have supported and encouraged this work to the fullest extent possible given the institutional and financial barriers that they have faced.

3
Inspiring learning through research and enquiry

The Summer Undergraduate Research Fellowship (SURF) at Xi'an Jiaotong-Liverpool University (XJTLU)

James Wilson, Yao Wu, Jianmei Xie, Dawn Johnson and Henk Huijser

Introduction

Research skills can be seen as an umbrella term for a range of skills, such as problem solving, critical thinking and analysis. Since the latter part of last century, there has been an increasing concern in the higher education sector, and among governments and employers, about whether university graduates were being adequately prepared for current working environments and demands of the twenty-first century (Katkin 2003). In the US, this concern culminated most influentially in the work of the Boyer Commission on Educating Undergraduates in the Research University (1998). However, similar concerns have been voiced in other national contexts. More recently for example, in the UK context, Michael Arthur (2014), president and provost of UCL, has noted the urgent need to bridge the perceived divide between teaching and research, arguing that to do so requires the integration of research into every stage of undergraduate degrees. He identifies three main benefits or motivations for doing so:

> One motivation is to help equip graduates with skills such as critical thinking and problem solving that will aid them in the workplace. Another is to help students feel inspired and valued. A third

is to help UCL in the increasingly fierce and global competition for the best students and researchers, by leveraging the university's huge research power in close support of its teaching.

This very much applies in the current Chinese context. China is engaged in significant educational reform (Ryan 2011), and the founding of Xi'an Jiaotong-Liverpool University (XJTLU) and its approaches to learning and teaching is one of the logical developments. This applies in particular to its focus on research-led teaching, and the Summer Undergraduate Research Fellowship (SURF) initiative at XJTLU in turn is an example of this focus.

XJTLU is a joint venture between Xi'an Jiaotong University in China, and the University of Liverpool in the UK, based in Suzhou, China. It merges two different higher education systems. Thus, the university offers four-year rather than three-year degree programmes, to accommodate both Chinese law and English language level expectations. Within this context, SURF offers opportunities for a select group of undergraduate students to work on research projects for 10 weeks during the summer period. While not directly integrated into university programmes, SURF provides students with the opportunity to develop practical research skills related to knowledge they have acquired in class (Healey, Jenkins and Lea 2014). It aims to provide students with an authentic research experience. The key objectives of SURF are:

- to stimulate active research interest and creativity of undergraduate students;
- to provide an opportunity for undergraduate students to support academic staff in their research;
- to provide an opportunity for undergraduate students to develop their practical skills and to apply knowledge acquired in class;
- to provide an opportunity for undergraduate students to present their research findings internally and externally, and to develop presentation skills;
- to boost the reputation of XJTLU's students and student research in the Suzhou region and Jiangsu province where the university is located.

All students are required to present results of their projects at a university-organised event, which involves a public poster presentation. At the end of the event faculty-based winners and overall winners are

announced, based on a vote from a jury, comprised of academic staff from each faculty, and students elect what they view as the best poster. In this chapter, we demonstrate that the SURF initiative aligns closely with UCL's Connected Curriculum framework (Fung 2016; Fung 2017). For example, (1) it allows students to connect with staff at XJTLU and learn about ongoing research; (2) it provides step-by-step guidance and learning activities; (3) some projects are interdisciplinary, allowing students to make conceptual connections between their own subject and other disciplines; (4) students can connect academic learning with wider learning and skills, for example, teamwork, project management, creativity, enterprise and leadership; (5) students can connect with external audiences through their poster presentations; and (6) through working on their projects, students often gain a sense of belonging, of being part of a learning community at XJTLU and beyond. However, SURF is not integrated into undergraduate degrees in the way Arthur (2014) imagines, and is rather based on voluntary participation, which imposes certain limitations.

Overall, we see SURF as a first step in a process of developing a broader research-based learning and teaching approach at XJTLU (Gibbs 2014), and we argue that UCL's Connected Curriculum framework is highly applicable in this transnational context.

Research-led teaching and learning in a Chinese context

Research-based teaching in the context of Chinese higher education is part of a wider agenda of education reform, which is concerned with moving away from teacher-centred and exam-focused approaches (Wang and Byram 2011) towards more active learning and student-centred approaches. As Jin and Cortazzi (2011a: 2) note, China has in recent years officially emphasised 'quality education', including 'a turn to more modern approaches to teaching and learning, including learner-centred ones'. Thus, educational reforms in China in recent times,

> have emphasised more active participation from learners in classrooms and collaboration in learning tasks, together with developing a wider range of learning strategies and students' ability to learn independently and with greater autonomy. (Jin and Cortazzi 2011b: 67)

However, such changes do not necessarily have much impact in the short term, for 'the reform of teaching methodology does not necessarily go hand in hand with a change in teachers' beliefs, especially where these are closely linked to cultural heritage' (Li and Cutting 2011: 40). Seah (2011: 172) touches on this when he asks, 'if students are expected to take more initiative in the learning process, to what extent will teachers be prepared for students to pose "what if" or "why" questions during lessons?' It is not our intention here to draw a binary between 'Chinese' and 'Western' approaches to learning and teaching (Yuan and Xie 2013; Wang 2013). Rather, we explore the kinds of teaching approaches that would be conducive to research-based teaching, which involves posing plenty of 'what if' and 'why' questions; precisely the kinds of questions that students and teachers are expected to ask in a research-based learning and teaching environment. Furthermore, 'undergraduate students' participation in hands-on research is widely believed to encourage students to pursue advanced degrees and careers in science, technology, engineering, and mathematics fields' (Russell, Hancock and McCullough 2007: 548), which in turn is seen by many governments, including the Chinese government, as important in driving (economic) development (Rui 2015). SURF offers early opportunities for hands-on research experience. In addition, it creates a situation whereby 'students' projects are derived from the academic staff research interests, [which] helps create a learning environment in which research and teaching are integrated' (Al-Atabi, Shamel and Lim 2013), which in turn is seen as mutually beneficial.

According to the XJTLU website (XJTLU 2016), if (as a student) you choose to study at XJTLU, you can expect to be:

- encouraged to develop and test your own ideas;
- exposed to the ideas and challenges of your classmates;
- ready to question received opinion, including the opinion of your teacher; and
- equipped with the skills to pursue your own research, by means of projects, dissertations and theses.

This clearly has a research-led focus, which suggests research-related skills such as critical thinking, analysis and problem solving.

Of course, there are different levels of research-led teaching and the various widely cited versions of Healey and Jenkins' model (2009;

Jenkins and Healey 2005) allow us to distinguish between different levels of 'research' that students are actually engaged in. This runs along a continuum from students as an audience (research-oriented and research-led) to students being active participants in research (research-tutored and research-based) (Healey and Jenkins 2009: 7). The most ideal end of the spectrum, as implied in their model, is 'research-based', whereby students undertake research independently or as part of a team. This in turn raises the question of the development of research skills in the curriculum. In Healey and Jenkins's model (2009: 7) this is covered in the 'research-oriented' part of the model, which consists of 'developing research skills and techniques'. The development of research skills is important in relation to SURF, as SURF aims to offer an 'authentic research experience', in some cases at first year level, but not necessarily any research skills training. Indeed, research skills training at XJTLU is explicitly tied to postgraduate research at masters or doctoral level. At undergraduate level, this skills development is largely implied rather than systematically applied across curricula, for example in the form of a consistent teaching approach such as enquiry-based or problem-based learning (Blessinger and Carfora 2015; Henderson 2016). In relation to SURF, then, research skills are largely assumed or there is an implicit expectation that SURF supervisors will teach such skills. SURF nevertheless offers an environment where students potentially 'are themselves involved in staff research activity, and not just as willing participants in yet another student survey on pedagogic practice, but as active contributors to and/or beneficiaries of that research' (Fuller, Mellor and Entwistle 2014: 384–5). This aligns nicely with some of the benefits of undergraduate research that the Boyer Commission identified.

Initially, the key point that the Boyer Commission (1998: 5) made was that universities were 'shortchanging' their students in several ways, 'most notably the prevalence of models of teaching and learning that fail to engage students, enable them to make connections across spheres of knowledge, or enhance their development of critical skills' (Katkin 2003: 21). This realisation then led to 10 key recommendations in their report (Boyer Commission 1998) that relate to SURF in various ways:

1. Make research-based learning the standard – XJTLU equivalent: promotion of a research-led teaching approach, which is not yet systematically implemented, as noted above.
2. Construct an enquiry-based first year – XJTLU equivalent: SURF is the most explicit example, but is not integrated in the curriculum, so an enquiry-based first year is still dependent on individual

lecturers, which in turn requires a significant shift in some lecturers' sense of their 'teacher identity' (Li and Cutting 2011).

3. Build on the first year foundation – XJTLU equivalent: a number of students return to SURF in the second or third year, which implies a symbiotic relationship between what they learn in their programmes of study and their SURF projects, and they straddle different elements of Healey and Jenkins' model (2009).

4. Remove barriers to interdisciplinary education – XJTLU equivalent: apart from SURF, degree programmes are more likely to stay within their disciplinary silos. Not coincidently, it is SURF's relative 'disconnect' from degree programmes that allows for this potential interdisciplinarity.

5. Link communication skills and course work – XJTLU equivalent: SURF stimulates students to communicate their research outcomes in a public event, in the form of a poster presentation, and to an interdisciplinary audience.

6. Use information technology creatively – XJTLU equivalent: there is a university-wide push (coordinated from within the Academic Enhancement Centre by the Educational Technologies team) to use information technology creatively, including in SURF.

7. Culminate with a capstone experience – XJTLU equivalent: all students at XJTLU are required to do a final year project, which involves independent research, giving SURF students a distinct advantage.

8. Educate graduate students as apprentice teachers – XJTLU equivalent: some PhD students are involved in mentoring SURF students.

9. Change faculty reward systems – XJTLU equivalent: SURF would benefit from more direct incentives for lecturers to get involved.

10. Cultivate a sense of community – XJTLU equivalent: SURF plays a key part in developing a sense of a university-wide research community.

While there are clear ways in which XJTLU can be seen to address most of the Boyer Commission's recommendations to some extent, especially through SURF, there are still significant challenges. For example, while SURF has many benefits for those who choose to participate in it, it is ultimately students' own choice. Moreover, there are not necessarily enough SURF supervisors available nor sufficient funding, so entry into SURF is a competitive process and not every

applicant gets to take part. Thus, only selected students gain this valuable research experience, and even then, they do not earn any direct credit from it towards their degree. Katkin (2003: 27), writing about the impact of the Boyer Commission's Report on undergraduate research, identifies two main challenges: 1) involving significantly more students and determining which students to target; and 2) expanding the pool of qualified [and willing] supervisors and identifying new venues and new resources to support their work. These challenges apply directly to SURF. However, if research-based learning and teaching were to be more systematically implemented across all degree programmes at XJTLU, for example in the form of a consistent enquiry-based and/or problem-based learning approach, it would overcome the first challenge to a significant extent, and it would tackle the first three of the Boyer Commission's recommendations head-on. However, it would also require a significant shift from a teacher-centred, exam-based approach to learning and teaching (Seah 2011), towards a more active learning and research-based approach. Furthermore, it would need to address the often perceived divide between research and teaching, between the teacher as an authority figure and 'dispenser of knowledge' on the one hand, and that same teacher as a 'research partner', on the other (Schapper and Mayson 2010).

Finally, there are two more related issues. Firstly, in our arguments, there is an underlying assumption that 'doing research' and having a 'research experience' at undergraduate level is inherently valuable. However, even though we believe strongly in the beneficial outcomes of an undergraduate research experience, Katkin's (2003) warning, that some would question whether engaging all students in research activity is even desirable, in a context of large student numbers and a related emphasis on direct employment-related skills, should be considered. The other issue relates to different understandings of what research means, to both students and lecturers. Healey and Jenkins (2009) make distinctions between different levels of research activity, and there is a lot of slippage between these different levels of research with lecturers sometimes assuming that they are operating at the research-based level, when in fact they are engaged in research-oriented or research-led levels. The same applies to students. Murdoch-Eaton et al. (2010: e152) found that while 'undergraduates recognise the benefits of research experience [they] need a realistic understanding of the research process'. SURF is designed to provide them with such an understanding.

Evaluating SURF at XJTLU

Methodology

For this study, a mixed-methods research design and approach (surveys, interviews and focus groups) was used, with a primarily qualitative focus, as the aim was to reflect upon a particular instance of educational practice, in this case SURF at XJTLU (Freebody 2006). This study also incorporated the student voice, as we were interested in student perceptions about research in general and about SURF in particular, including student experiences. This study was approved by XJTLU's human research ethics committee and all participants in the study have provided their written signed consent.

Data were collected from a wide range of SURF participants:

- One survey was sent out to SURF alumni from the past three years, to get a sense of the longer term impact of SURF – Responses: 38.
- One survey was sent to new SURF students in 2016, to gauge the reasons why students want to engage in SURF projects and their initial expectations – Responses: 65.
- One survey was sent to academics who acted as SURF Poster Day Judges and Marshals – Responses: 18.
- Two focus groups (four students each) were conducted with returning SURF students. Data collection took place at the beginning of the 2016 SURF period, which explains why no focus groups were conducted with current SURF students, as they had not started yet. However, their voices were captured by the survey mentioned above.
- Two in-depth interviews were conducted with returning SURF supervisors.
- Two in-depth interviews were conducted with first time SURF supervisors in 2016.

SURF in numbers

XJTLU initiated SURF for all departments in 2012, when 36 research projects from eight different departments were carried out during the summer by year 1 to 3 undergraduate students, under the close supervision of academics. Since then SURF has rapidly gained popularity across the campus. From 2013, the university has allocated half a million RMB

(around US$75,000) for around 70 SURF projects and 150 student fellowships every year. For some projects, one student may work closely with one supervisor, while for others academics and students from different departments work together for up to 10 weeks on projects that are interdisciplinary to varying degrees.

SURF starts every year at the beginning of the second semester by calling for proposals from all academics. Tentative SURF projects are then selected for ethics assessment. Once a list of SURF projects is finalised, an announcement is made for all year 1 to 3 students to apply, and students are subsequently selected by supervisors. During the SURF period, the university organises mid-summer social get-together events for SURF students, as well as a more formal workshop about developing a public academic poster presentation. At the end of each SURF period, a SURF Poster Day is held to allow students to come together to showcase the results of their research projects. This is an increasingly popular event, attended by the broader university community. From 2012 to 2016, more than 600 XJTLU students have worked on research projects, choosing to stay on campus over the summer, making the SURF application process more competitive every time.

Starting in 2016, an international student scheme was piloted under which a non-XJTLU international student was accepted to come to the university to participate in one of the research projects. This summer, a year 3 student from Italy came to XJTLU and collaborated with XJTLU students on a Mathematics project. This scheme is expected to be expanded next year.

What follows is an analysis of the data, broadly based around the themes in the Connected Curriculum framework (Fung and Carnell 2017; Fung 2017).

Theme 1: Connecting with staff and learning about research

In the surveys, students were asked why they participated in SURF. Most students expressed their interest in learning about research from academics, both in terms of the research subject and research methods. Responses to open-ended questions included: 'to enrich my research experience'; 'to improve my laboratory skills'; 'to do research under the guidance of the brilliant professors', and so on. SURF students are able to connect with experienced academics as 'research partners' for a period of two months. This creates highly valuable opportunities for aspiring undergraduate research students.

SURF supervisors were similarly positive about this opportunity to connect with students on a deeper, more meaningful level. One returning supervisor noted:

> I think it's great, for both me and my students, they can learn to do research on real cutting edge projects, be trained in the lab in terms of safety, lab skills and time management. The students also get a great opportunity during the poster session to present their work to a diverse range of people, which is great for their future careers. (Supervisor A)

However, some supervisors expressed a level of frustration and divergent expectations in this respect. For example, one first time supervisor (Supervisor B) suggested that the students liked the idea of research, but had very little understanding of what research entails in reality. This supervisor expected the students to come into the project with a certain level of research skills, which was not reflected in reality. He did not feel it was his role to teach them such skills.

Judging from the survey data, many supervisors have a different perspective than Supervisor B's thoughts. The following survey responses reflect a common theme in this respect: 'Not only were research skills improved [during SURF], but it also brought me a great vision of what research looks like'; and 'SURF is a great opportunity to gain a deeper understanding about research.'

Theme 2: Step-by-step guidance and learning activities

Usually, at the beginning of SURF, supervisors and students meet and propose the project plan for the 10-week duration; then, they meet regularly as needed. Students received step-by-step guidance during the projects as a fundamental part of the SURF process, which, as noted above by Supervisor B, was not necessarily everyone's expectation of the process. Student responses during the focus groups with returning students included: 'My supervisor was really helpful in providing daily feedback. He kept tabs on every activity related to the project and would come up with suggestions on problems we encountered'; 'He helped us a lot in theoretical field and with the hardware and we held a regular meeting every week for us to discuss our process and obstacles'.

The step-by-step guidance in particular was commonly mentioned in the survey responses. At XJTLU, undergraduates are required

to do a Final Year Project (FYP), and especially the previous SURF students frequently mentioned that the step-by-step guidance they received during their SURF experience gave them a distinct advantage in their FYPs.

Theme 3: Students making connections

Not only do academics get to know students' learning styles better, but students are also able to pursue interdisciplinary research and make connections with students and staff from other departments, an opportunity often not available in their degree programmes. In SURF, academics and students with very different backgrounds commonly work together on the basis of similar research interests. For example, 2015's winning SURF project demonstrated a successful collaboration between a Mathematics supervisor and two Computer Science students. Also, 2016's overall SURF winner was a collaboration between the Department of Urban Planning and Design and the International Business School.

However, divergent expectations mean that this does not always work. Supervisor B talked for example about students not really understanding that their project was in essence a humanities-focused project that relied on research around client behaviour, while the students expected a more technical-based project based around design skills. Thus, while potentially cross-disciplinary connections were made by students, the feedback from this supervisor drew attention to the importance of spelling out clear expectations.

Furthermore, not all projects necessarily lend themselves to interdisciplinary approaches, while yet others are not necessarily appropriate for first year students. As Supervisor C notes:

> In chemistry we only allow students who have successfully completed their second year to participate in the SURF projects: this is mainly due to safety, but they also need a theoretical basis in chemistry. After the second year they should have the basics, and I can fill in the gaps on project specific material.

He touches on a common dilemma around project- and enquiry-based learning, where lecturers often feel they need to explicitly *teach* subject-specific material first to provide students with a firm grounding, especially where research involves a certain amount of risk (Blessinger and

Carfora 2015). Others argue that interdisciplinary connections and projects cannot start early enough, and many SURF projects therefore involve first year students (Huijser and Kek 2016).

Theme 4: Connecting academic learning with workplace skills

Some supervisors explicitly embed practical workplace skills in their supervision. For example, one returning supervisor (Supervisor C) noted that in his first SURF meeting with students, they arrived 20 minutes early. This was the first time for these keen students to realise that arriving too early may impede other people's pre-arranged schedule. Thus, while being keen fits well with their identity as a student, it fits less well with their new (SURF) identity as a 'professional research partner'. Of course, this is a highly valuable lesson in itself.

Generic workplace skills, such as teamwork, critical thinking, communication skills and creativity, are key elements of SURF projects. In the focus groups, students mentioned frequently that working in a team on complicated projects was a very rewarding experience. Students learn how to negotiate with team members, combine and merge different goals of the team, communicate effectively and share the research results with a wide audience. When asked about their fondest SURF memory, many SURF alumni mentioned teamwork: 'Teamwork is the most valuable thing that I have learned'; 'cooperating with partners'; 'I worked with my fellow teammates to figure out some software and solve the problem'. One student put it like this: 'The most valuable thing was how to work in a group. This is something that I cannot learn from books and I have to experience it myself', suggesting that this skill can only be acquired by actually working in a team on a project, which is what most SURF projects are about.

From a supervisory point of view, there is perception by some that these generic workplace skills are learned 'on the job', and that SURF provides a perfect opportunity for this. As Supervisor B put it: 'It's quite ad hoc, because you don't have a lot of time actually to teach them these things. So you have to see what they want to do… It's very much learning on the job.' Students may not get many opportunities in their regular degree programmes to acquire such 'on the job' skills.

Theme 5: Producing output directed at an audience

In addition to the SURF Poster Day, where project achievements are presented and celebrated in public, some SURF reports have been turned into successful conference papers or publications, which is a valuable experience for undergraduate students. Focus group responses include: 'I significantly enjoyed the academic atmosphere through that conference'; 'a conference paper was published and a patent was claimed by our research team.' SURF creates many opportunities for first-time research-based experiences for students, like attending an academic conference, or applying for a patent.

Theme 6: Students become part of a wider learning community

SURF allows students to become part of a research community at XJTLU early in their student life, where learning happens in a research-led tradition, rather than through direct teaching as is more common in their regular degree programmes. Supervisor A compared SURF to his own student experience: 'As an undergraduate student I took part in a similar scheme, the Carnegie scholarship for Scottish students, and I worked in the lab, but we had no poster session at the end.'

Finally, supervisors sometimes recruit PhD candidates who are working on other research projects to support undergraduates' SURF projects as well, and function as mentors. This further extends the network and links undergraduates into a wider XJTLU learning community.

Conclusion

The SURF journey at XJTLU has taken an interesting path of development and achievement since its inception in 2012. It is evident from the feedback from both students and staff that collaboration, teamwork, community building and skills development have been the core benefits derived from participation in the SURF programme. It has also been noticeable for those involved in the development of the SURF programme over the past few years how the quality of the research, the students' communication skills and the poster dynamics and design have consistently improved. As is highlighted by a senior academic on the XJTLU website, 'I think our students' work matches anything going on at the top international universities around the world. To look at the

posters, you wouldn't guess that they were made by undergraduates and not established researchers' (Professor David O'Connor, Dean of Research and Graduate Studies at XJTLU).

SURF appears to be an effective way of providing undergraduates with an 'authentic' student research experience, which is validated by the feedback in this evaluation. The addition of a poster presentation at the end of the period facilitates the development of generic skills that support the more specific disciplinary-based ones learned from the collaboration with their supervisors. As evidenced in the student feedback, SURF has benefited them in the development of their Final Year Projects and has given them a distinct advantage over peers without this experience. Furthermore, it is one of the core factors for success in receiving offers of postgraduate study at prestigious universities around the world.

Analysing the evaluation data through the Connected Curriculum lens has also identified challenges that an innovative project such as SURF brings, thus requiring constant evaluation and change. Major foci for the future will be to examine avenues of funding in order to be able to offer a SURF experience to more students at XJTLU and the widening of the SURF umbrella to embrace a larger international student participation. Ultimately, the lessons learned from the SURF programme could be used to develop a more integrative approach to developing research skills as part of undergraduate programmes, which would also align closely with the earlier-mentioned higher education reform agenda in China. Providing students with the opportunity to become involved in research-focused projects at an early stage in their undergraduate studies can only enhance their skills and knowledge, and generate a context in which enquiry, critical thinking and reflection is at the heart of their education.

4
The materials of life

Making meaning through object-based learning in twenty-first century higher education

Thomas Kador, Helen Chatterjee and Leonie Hannan

Introduction

In a Connected Curriculum the aim is to 'integrate research into every stage of an undergraduate degree, moving from research-led to research-based teaching' (Arthur, cited in Fung and Carnell 2015). In the light of this statement, what are the best approaches for facilitating learning experiences based on research and enquiry? One possible approach is perhaps counter-intuitive and that is to remove some of the firm (support) structures within which learning at higher education – and especially at undergraduate level – takes place. These structures tend to be predicated on the academic expert, both asking the questions and then also providing (or at least already knowing) the answers. If instead we open up the opportunity to students asking their own questions, and thus risking that we, the 'experts', might not have all the answers, we can begin to collaboratively explore much more fundamental issues. This would not only benefit the students' learning experience but also the way universities generate knowledge more generally. However, traditional academic structures do not lend themselves well to this collaborative approach and even the architecture of most university campuses reinforces the division between expert teachers and novice students. For example, most lecture theatres are built with a clear focus on one central figure. Working within this environment and acknowledging that a genuine research-based education will require a cultural as well as practical

shift, the question is: what are the steps we can take to facilitate this shift within our own areas of teaching? Our answer to this question is, to integrate physical objects, and especially those from museums and collections, into the learning activities we design.

This chapter will set out the case for the strengths of object-based learning (OBL) as an approach that moves the learner and their own engagement with the material world centre stage to the learning process, and thus allows them to take charge of their own learning experience and the meanings they may construct from it. Put simply, learning with objects is by default both research-based and active (Bonwell and Eison 1991).

The pedagogical context of object-based learning

To begin with, it might be useful to outline what OBL means. OBL is a relatively recently coined term to characterise a pedagogy that prioritises facilitated interaction with material culture to enhance critical thinking and the acquisition of key skills (Chatterjee et al. 2015; Dhus 2010). Material culture is a very broad concept that includes everyday objects, documents, works of art, biological specimens and artefacts, to name but a few (Buchli 2002). Therefore, OBL can be successfully undertaken with all sorts of objects and materials, including things that may be found in people's homes or even their rubbish bins. In this chapter we will focus primarily on the value of objects (items, specimens, things)[1] from formally curated collections such as those from museums and in the first instance our discussion will centre on material from UCL's own university museums and teaching/research collections. Fundamentally, however, we wish to make the case for the use of objects in learning activities not just for subjects and disciplines that have traditionally drawn on collections, such as anthropology, archaeology, art history and geology, but across the full spectrum of academic disciplines taught at university.

The pedagogical value of OBL is based on sound educational theory and here we shall briefly outline some of the most salient elements of this theoretical background. Objects can be viewed from many different perspectives to reveal multiple, and sometimes contradictory, meanings. On encountering an object, especially one they have never seen before, a learner may start by asking relatively basic questions; such as what is it, what is it made of and where did it come from? However, these questions will lead the learner on a path towards confronting ever more complex considerations, which may concern the historical contexts,

social relationships and biography of the object, as well as its (multiple) cultural meanings and values. Students can discover these new investigative avenues for themselves, as they respond to the prompts the object raises and can begin to make their own meaning through their concrete experiences with it. Kolb (1984) identified the importance of such concrete experiences and opportunities to test and refine ideas in order to understand theoretical concepts. In turn, Hein (1998) has explicitly recognised the significance of Kolb's 'experiential learning cycle' in relation to museum collections. What is more, learners often benefit from their object encounters not just on their own. Material culture can be a catalyst for social interaction, as encounters with objects inspire conversation and encourage people to share their experiences and ideas (Rowe 2002). The pedagogical benefits of social learning – people learning from each other when doing activities in a group setting – have long been recognised (Vygotsky 1978; 1986) and OBL plays very directly into the power of social and peer learning. The varied perspectives on the same object that different members of a group may have and the opportunity to share and discus them, can be an eye-opening experience.

Learning with objects also operates well within Gardner's theory of multiple intelligences (Gardner 1993), as material culture can be explored utilising most of our senses. In the context of the above discussion on social learning, OBL lends itself extremely well to students with particular strengths in interpersonal intelligence. But more broadly, in contrast to traditional teaching styles that tend to foreground the learners' use of their verbal and visual senses, object handling provides opportunities to engage through touch (Chatterjee 2008) and thus allows learners whose strengths lie in kinaesthetic or bodily intelligence to succeed. By extension, tactile object learning offers opportunities for the considerable proportion of the population – including among the UK and European student body – who experience specific learning difficulties, such as dyslexia, dyspraxia and ADD/ADHD (British Dyslexia Association 2016; Pennington 1991; Riddick 2009: 12; Zabell and Everatt 2002).

Directly engaging with objects is a very physical and haptic experience (Candlin 2008; Tiballi 2015); it allows students to relate theoretical concepts to something applied and tangible. For example, being able to look closely and compare and contrast a number of zoological specimens can make plain seemingly complex taxonomical relationships between different species. Such transformative insights, which open up 'a new and previously inaccessible way of thinking about something [...] without which the learner cannot progress' are referred to

as 'threshold concepts' (Meyer and Land 2003; 2005). Objects demand that learners master these concepts before they can move on and engage with a topic on a higher level. Moreover, objects often have a certain aesthetic appeal to learners' natural curiosity. If an object-based activity forms part of a larger problem, task or project that students work on, once their interest is awoken they tend to be so focused on their task that the learning of difficult concepts can take place almost unnoticed and seemingly with ease.

There is an increasing body of literature that attests to the benefits of using hands-on object engagements in learning. Much of it is summarised in the contributions to a recent volume dedicated to OBL in higher education (Chatterjee and Hannan 2015) and, from a UCL perspective, Sharp and colleagues (2015) provide a useful overview of recent OBL research conducted at this institution. Consequently, we refer readers interested in the evidence base concerning the pedagogical efficacy of OBL to these publications. Whereas in the present chapter, we will focus on some of the practical issues associated with creating OBL opportunities, based on several examples and case studies from our practice at UCL Culture, the department responsible for the university's museums and collections comprising a diverse range of materials and artefacts (see below and Kador et al. forthcoming).

Creating OBL opportunities

We argue that there is no discipline for which material culture could not be employed as part of innovative teaching and wish to challenge any sceptical reader to suggest a subject or topic to which the use of material culture could not contribute in some way. Below we present a number of practical examples and case studies to illustrate several possibilities of how objects can be successfully utilised in academic practice across a wide spectrum of fields from the Arts/Humanities, Social, Natural and Life Sciences.

At UCL, academics and teachers who are interested in utilising material culture for their teaching and learning activities have at their disposal three public museums and several additional collections of objects and artefacts relating to a broad range of disciplines from Anthropology to Zoology and totalling over 800,000 items (as well as the library special collections). While the UCL museums hold many rare, unique and valuable items, all of the collections are teaching collections in the first instance. This means that most of these objects can be used for

learning activities. Clearly, using real museum objects means that there is always a balance to be struck between curatorial concerns of preserving the objects and pedagogical ones of maximising the learning opportunities they afford. Having said that, this tension can in itself be turned into a valuable learning experience, for example through discussions on the necessity of wearing gloves to handle certain objects and how this may affect the tactile experience of the handling (Willcocks 2015).

Also, as mentioned at the start of this chapter, OBL is not confined to museum objects and, therefore, even university teachers who do not have ready access to a curated collection can employ a material culture focused approach. Moreover, many local and civic museums would be happy to support higher education institutions in exploring the use of their collections for teaching and learning in a collaborative way and in the UK there is a specific Museum University Partnership Initiative (MUPI) to facilitate this (Bonacchi and Willcocks 2016). Therefore, colleagues at institutions without their own collections would be well advised to contact their local museum to investigate this possibility. To illustrate this, the last of our three case studies presented below will draw on one such collaboration, where UCL Culture, as a university museum service, helped develop and facilitated a visit from another higher education institution to access one of our collections for an OBL project. The following examples provide a range of possibilities for including the use of collections within a connected curriculum. The first will provide the 'gold standard', of an entire module situated within a collections setting.

Learning our Object Lessons

'Object Lessons: communicating knowledge through collections' is a second year module on UCL's Bachelor of Arts and Sciences (BASc) undergraduate degree programme. The module is led by (staff from) UCL Culture and is designed entirely in an OBL framework. In a forthcoming publication we outline the practical aspects of this module, how it is structured and how it relates to research-based education (Kador et al. forthcoming). Here we will focus on the specific role that learning directly with objects plays within this module.

'Object Lessons' runs for one academic term (usually in the spring), thus lasting around 11 weeks and comprises three weekly contact hours – a one-hour lecture and a two-hour seminar. The lectures are delivered by a range of object and material culture specialists, including archaeologists, anthropologists, museum curators and digital

technology experts. They introduce the students to different disciplinary perspectives on objects and also allow them, in line with the first dimension of the Connected Curriculum framework, to connect with different researchers and the institution's (world-leading) research (Fung and Carnell 2017; Fung 2017). However, it is in the seminars where the students are directly confronted with objects.

In the first seminar, students are introduced to a broad range of objects drawn from across UCL's collections. To a large degree, these are objects that will look unfamiliar to the students; this allows them to develop their confidence in safe object handling and also to sharpen their observation, interpretive and analysis skills (Figure 4.1). One of the key qualities that students get to practise in this session is how to look at things 'slowly' (Roberts 2013), with the aim of reaching deeper understandings and asking more interesting questions. The seminar also highlights the importance of drawing, for cognition and information processing (Ingold 2011), which has special significance for objects that cannot be touched or safely handled (due to their material properties, size or fragility), including most artworks (Tiballi 2015). These newly gained and refined skills prepare the students for the second week, when each of them is personally allocated a different object, from

Fig. 4.1 Students on the UCL Bachelor of Arts and Sciences module 'Object Lessons' working with objects and specimens from UCL Museums and Collections. Photograph: Mike Osaer

a UCL museum, collection or the library's special collections. This could be an archaeological or ethnographic artefact, an artwork, a rare book or manuscript, a scientific object or a zoological specimen. In line with the third dimension of the Connected Curriculum, objects are selected to facilitate interdisciplinary encounters. Students whose wider programme pathway is predominantly science focused might be assigned an ethnographic object or an artwork, while those taking mainly arts/humanities subjects might be given a scientific instrument or zoological specimen. They are thus forced to operate outside their disciplinary comfort zones. Applying their newly acquired observation, interpretation and analysis skills, students are tasked with conducting independent research on their object, using both the object itself and the museum records as primary research material and making use of more than one disciplinary framework. From then on they are treated like any other research visitor using UCL's collections, and have to make appointments with the respective curator for their follow-up visits to engage in more detailed object research. This echoes the fourth dimension of the Connected Curriculum, allowing students to connect academic learning to real-world, workplace learning. Student feedback highlights the benefits of this. For example, one student stated, 'I really enjoyed getting access to such interesting objects and learning through them and through the curators was a very stimulating experience' (extracts from BASc2001 student evaluations, March 2016).

Their close engagement with one particular object in its wider context provides the basis for the students' first assessment, which takes the form of an object report (like a curator might produce) or a book proposal styled on a pitch an author might write for a popular science publisher. For the second assessment, students work in teams of five, bringing together their individual objects from the first task, with the objective of developing a virtual exhibition from this collection of five 'randomly assembled objects'. The exhibitions are to be curated within a digital platform called *MyPortfolio* (https://myportfolio.ucl.ac.uk/). In their groups the students must agree on a theme for their exhibition and on a target audience, at which their exhibition will be primarily aimed and that might be especially interested in their collection. At the end of term they get the opportunity to pitch their exhibition to the rest of the class, and indeed the wider public, as part of a presentation day.

Both the first and the second assessments on 'Object Lessons' align well with Connected Curriculum dimension 5, in that they are outward facing and directed at an audience. The second task in particular also relates closely to the sixth dimension, connecting students

with each other, in group work. Moreover, frequently, they also engage with fellow students from different years on the BASc programme, to test their exhibition ideas, thus connecting with students from different phases.

Finally, 'Object Lessons' does not operate in isolation and relates closely to other core and optional modules on the BASc degree programme, providing a throughline of activity across the programme, as encapsulated by Connected Curriculum dimension 2. This is directly reflected in student feedback where many stated that their first year modules *Approaches to Knowledge* and *Interdisciplinary Research Methods* (both part of the BASc degree programme) provided a 'logical foundation', as they helped 'to create and understand abstract connections between objects, events, people [and] ideas' and 'learning skills for learning and doing research from multiple perspectives' (extracts from BASc2001 student evaluations, March 2016).

More generally, feedback from 'Object Lessons' reflects the effectiveness of this way of learning. One student described it as a 'very interesting and unique module [that] has potential to be one of the best BASc modules' (extract from BASc2001 student evaluations March 2016). Another student characterised it as 'mind-opening, a good introduction to museum curation and it brings us new perspectives to view things around us'. The student continues, 'I like this very much as we can really touch and learn a real thing and connect them with the culture context' (extract from BASc2001 student evaluations, March 2015).

When creating research-based learning activities it is important to acknowledge that the culture shift involved, often associated with an apparent lack in structure, as discussed at the start of this chapter, can also be intimidating to students. However, this in itself can become a valuable learning experience, as expressed by another 'Object Lessons' student:

> There was a lot of flexibility in terms of how to 'interpret' the object report, which at first seemed very daunting. In the end, it ended up being a good learning process, having to figure out yourself how to best structure the assignment according to your object (extract from BASc2001 student evaluations, March 2015).

Once students have discovered their own capabilities, they realise the opportunities a student-centred education affords. 'I really enjoyed going about the university more – visiting the different exhibitions and being

given the freedom to go on our own to visit the new places' (extract from BASc2001 student evaluations, March 2016). The ability to follow their own curiosity and (being granted) the freedom to explore, as expressed by some of the 'Object Lesson' students, are fundamental elements of a research-based education, which OBL and especially collection-based teaching can foster extremely well.

The art of brain science

While the above example relates to a module that allows students to engage directly and closely with material culture for an entire academic term, it must be recognised that most programmes of study do not have the capacity to include entire modules based on object engagements and that 'Object Lessons' is a special case, supporting all six dimensions of the Connected Curriculum. Consequently, most of the OBL activities currently provided at UCL are one-off visits (to museums), workshops, seminars or project-based assignments, using the collections for one specific purpose or element of a module. In this context, one of the main interests of UCL Culture is to forge 'less obvious' links with subjects or disciplines that would not traditionally draw on collections, such as those from the natural or social sciences.

A recent example of this is the second year undergraduate Brain and Behaviour module that forms part of the BA/BSc Psychology with Education programme at the UCL Institute of Education. A conversation with the module coordinator at a (UCL Arena) staff training event led to an exploration of how UCL Culture could support a seminar focusing on specific neurological conditions. We responded by bringing together a number of artworks from the UCL Art Museum with two brain speci-mens, one 'healthy' and one 'diseased', from the UCL Pathology Museum. The artworks included three large anatomical watercolour paintings (Figure 4.2) by renowned surgeon and gifted artist, Sir Charles Bell (1774–1842), two oil pastels of WWI facial reconstruction surgery by the former Slade Professor (and British Army draughtsman) Henry Tonks (1862–1937) and an abstract, early computer-generated artwork from the 1960s by Slade scholar Pauline Aitken, titled *In the Beginning was the Secret Brain*. In small groups students had the opportunity to engage with each of these objects and find the connections between the artworks and the brain specimens as well as comparing the healthy and injured brain and discussing the likely symptoms the patient would have presented with after sustaining their brain injury.

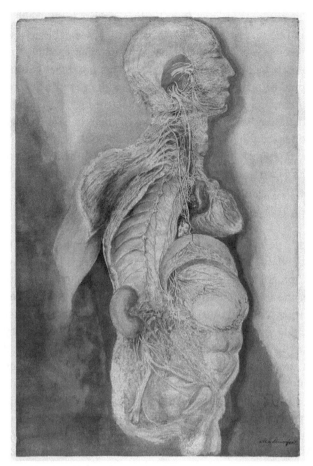

Fig. 4.2 Charles Bell (c1830). Nervous system of the head and trunk.
Watercolour, graphite and iron gall ink on paper. 1000 x 500mm. ©
UCL Art Museum, University College London

These hands-on tasks were followed by two presentations, the first
by psychologist (and module leader) Frances Knight on the key areas of
the brain and the second by clinical psychiatrist, Bernice Knight, about
two common neurological conditions (epilepsy and Parkinson's disease)
and current neuropsychiatric approaches to treating them. For these
presentations, students still had the benefit of the two brain specimens
to help them identify the regions of the brain discussed and allow them
to make connections to the previous task. In combination, the activi-
ties at this seminar covered the first, third and fourth dimensions of the
Connected Curriculum (see above, Fung 2017 and Fung and Carnell

2017). The students learned from leading experts in the fields of brain science and neuropsychiatry respectively; they were able to investigate links between psychology, psychiatry, surgery/anatomy and fine art and got to connect this learning to real-world and workplace settings, such as a hospital or health centre. Moreover, student feedback for the session was unanimously positive. In particular, the impact of holding a real brain in their hands (for most of them for the first time) and being able to identify on it the different regions (i.e. frontal lobe, temporal lobe, parietal lobe, occipital lobe, cerebellum, etc.), which had represented the focus of large parts of the module, had a transformative effect on them.

Illustrating Galton's 'missing' objects

As already referred to above, UCL Culture also supports many external partners and higher education institutions in developing innovative learning, practice and research opportunities for their students. For example, the Petrie Museum of Egyptian Archaeology has an annual collaboration with the University of the Arts London (UAL), Central St Martin's, that gives second year fine art students the opportunity to create new artworks in response to the museum's collections and culminating in an annual exhibition of their works in the museum's gallery.

UCL Culture also supports the creation of OBL opportunities for external students through using the collections in more formal settings, such as providing input and support in the development of teaching and learning opportunities, ranging from one-off visits to entire course units. A recent example of such a collaboration is the 'Responding to External Briefs' unit on the BA Illustration from the University of Creative Arts, Farnham. For this collaboration third year Illustration students – already skilled illustrators – visited UCL's Galton collection (www.ucl.ac.uk/museums/galton), which contains the personal effects and custom-made instruments owned and used by Victorian scientist Sir Francis Galton. While Galton's work was far-reaching with implications for contemporary meteorology, biology and crime science, his legacy is problematic and he is nowadays primarily associated with his championing of eugenics (Challis 2013). Thus in turn his racist credentials also cast his collection of objects in a difficult light, which necessarily represents an important element of the educational uses of this material (see Kador et al. forthcoming; Nyhan et al. 2014).

After receiving an introduction to Galton's life and the background of the collection by its curator, Subhadra Das, and then having had the opportunity to examine some of Galton's objects close up, the students

were presented with their brief. This was to either visually tell the story of (all or part of) Galton's life or to provide illustrations of some of the more conceptual aspects of his work in statistics and psychology; in particular, focusing on twin studies, mental visualisations and anthro-pometry (Galton 1884; 1907). The latter are areas for which there are few (if any) physical objects in the collection; therefore the students were tasked with producing illustrations designed to help people grasp abstract concepts at the centre of Galton's work that may otherwise be difficult to understand.

The final (assessable) output for the unit was 'an ambitious body of high quality work' responding to the brief (Figure 4.3a and 4.3b), along with the preparatory work of the same, such as sketchbooks, drawings, drafts and mock-ups as well as a research file, personal reflection and reflective journal. To achieve this, students had a follow-up visit to the collection and could draw on its curator's extensive knowledge of both the collection and Francis Galton's biography. The ultimate objective of the brief was that the students' work can be added to the suite of teaching resources for the Galton collection and its website.

Along the lines of the Connected Curriculum, this unit relates directly to dimensions one, three, four and five; through giving students the opportunity to discuss their projects with the curator and Galton specialist, Subhadra Das, through making connections across the various subjects that combine Galton's many interests and with their own field of illustration, through connecting their learning with a professional brief, based closely on a workplace scenario and through producing an assessable output directly aimed at an audience (Fung and Carnell 2017).

Discussion and conclusions

The examples presented here demonstrate how object-based learning at any level – whether concerning an entire academic module or just a single seminar – almost by default, necessitates a research- and enquiry-based approach to learning and how it can be easily related to most, if not all, dimensions of the Connected Curriculum. The cornerstones of creating such object-based encounters for students are the availability of curated university collections or other collections available for hands-on learning and the curatorial staff whose knowledge and expertise is invaluable to allow academics to embed the material within learning activities. This therefore stresses the value of the cultural assets and resources that many universities hold and the importance of maintaining and looking

Fig. 4.3a and 4.3b Example of a student's work with the UCL Galton Collection from the University of Creative Arts BA Illustration module, 'Responding to External Briefs'. This example presents the 'young Galton's expedition to West Africa and the inspiring events that happened whilst he was there'. © 2017 Catherine Paiano

after them, but crucially also opening them up to the student population to spark their curiosity and allow them to engage, learn, research and make their own meanings with these collections.

In periods when finances are under pressure, cultural resources can appear like luxuries that organisations can ill afford. However, to anyone believing in the effectiveness of student-centred, active and enquiry-based learning and that higher education should be re-oriented firmly in that direction, it is surely obvious that collections-based teaching should be at the centre of this process. Moreover, from a student perspective, as both research in this area – referred to earlier in this chapter – and the above examples have illustrated, object-based learning also helps students to develop not only subject-specific competencies but also substantial transferable skills, such as observation, articulation, communication and presentation, which will benefit them in an extremely competitive labour market.

Finally, there is one ingredient with strong pedagogical benefits that can be difficult to attain but seems to come very easily to museums: the power of wonder. Teaching with museums and their objects has the potential to surprise our students, which has significant potential from an educational perspective (Kearns 2015), specifically igniting an inquisitive mind-set and a drive to discover. There is a growing body of writing testifying to the pedagogical benefits and possibilities offered by object-based encounters. This includes formal publications (Chatterjee 2008; Chatterjee and Hannan 2015; Paris 2002), blog posts (e.g. http://blogs.ucl.ac.uk/museums/; http://blogs.reading.ac.uk/oblhe/) and social media (including several twitter handles and YouTube videos, such as those by UCL[2], Manchester Metropolitan University[3], Phoenix Art Museum[4] and the Royal Ontario Museum[5]). However, much OBL work taking place at UK and international universities goes entirely unpublished. Even within UCL alone there over 150 modules that UCL Culture supports every academic year with objects, venues and expertise. Consequently, this chapter has just scratched the surface in its attempt to provide a selection of the learning that takes place that utilises university collections. However, the examples presented here hopefully provide a useful illustration, outlining how OBL can work in practice. Moreover, we hope this can inspire educators new to this approach to begin developing their own object-based learning activities.

We have chosen these specific examples as they demonstrate how OBL works well within the dimensions of the Connected Curriculum. In addition to very naturally facilitating research-based education and problem-based learning, OBL's effectiveness lies in the combination of

the power of touch, the power of 'slow looking' and the power of wonder. In the fast-paced world of twenty-first century Western Europe, surprising students with one or a selection of strange and unfamiliar objects and giving them the space to explore at close range by looking, touching and even smelling, provides an immersive learning experience that places students at the centre of generating new modes of knowing. In this context, academic programmes providing object-based learning opportunities as part of an active, research-based and student-centred curriculum have the potential to transform how learning takes place in higher education.

Acknowledgements

We would like to express our gratitude to all the people who have supported the work presented in this contribution, especially the museum and collections curators at UCL and the students of 'Object Lessons', 'Brain and Behaviour' and 'Responding to External Briefs', as well as Frances Knight, Subhadra Das, George Richards, Argyro Tsavala and Catherine Paiano.

5

Foundation skills for veterinary medical research

Sharon Boyd, Andrew Gardiner, Claire Phillips, Jessie Paterson, Carolyn Morton, Fiona J. L. Brown and Iain J. Robbé

Introduction

Research skills are essential for students in all disciplines (Dwyer 2001; Trigwell 2005; Healey et al. 2010). For veterinary professionals, these essential skills are recognised nationally and internationally, promoted by professional bodies (Royal College of Veterinary Surgeons 2015; American Veterinary Medical Association 2016) and must be explicitly demonstrated in the curriculum.

This chapter will focus on a Research Skills course (~120 students per year) integrated within the five-year undergraduate veterinary medical degree at the Royal (Dick) School of Veterinary Studies (RDSVS), University of Edinburgh. This second-year course is the first step in developing student research skills. Skills such as information management, critical enquiry and public engagement are enhanced, with the aim of preparing students for future research.

The design of the course specifically encourages students to make connections, both within the discipline and more broadly. It is student-led, with opportunities for student groups to meet with staff and discuss progress. This learning dialogue enhances confidence in professional communication which is essential, both for workplace learning and developing individual research projects in later years. The course is structured as a group project assignment, with students selecting a topic beyond the taught veterinary curriculum. This encourages students

to make interdisciplinary connections beyond the programme; this approach can therefore be readily adapted.

This chapter will begin with an overview of the theory underpinning the development of a research community of practice (Wenger 1998). This will be followed by an outline of the Bachelor of Veterinary Medicine and Surgery (BVM&S) programme. We will consider the structure of the Research Skills course and how key elements integrate research within the curriculum. Core to this is the inculcation of students to the veterinary research community, and the support mechanisms used to achieve this will be reviewed. The chapter will conclude with a reflection on future developments and indication of how this process can be extended to other disciplines.

Developing a research community of practice

In the case of veterinary practice, as with many vocational areas (Andrew, Tolson and Ferguson, 2008), the goal is to develop a community of practice comprised of lifelong researchers who can critically review current research, align with previous knowledge and identify gaps in understanding. Evidence-based veterinary medicine (EBVM), with its concomitant requirements to understand the derivation and robustness of the evidence, is a central ethos to the clinical approach taken by veterinary professionals, and this is embedded within veterinary medical learning and teaching.

It is recognised that veterinary medical education involves the formation of professional identity through enculturation and situated learning (Lave and Wenger 1991). Students are welcomed as part of the professional community of practice at a 'white coat' ceremony at the start of their degree programme. In this Research Skills course, learners form groups and create a community of practice in the context of their project. Situating their learning in the group allows each individual to move from peripheral participation to active engagement in the research, consistent with Lave and Wenger (1991).

Furthermore, peripheral participation through listening to the introductory lecture and reading the course handbook develops propositional knowledge (Eraut 2000). Active engagement through forming a group, choosing a topic, self-determining whether to talk with researchers and course staff, and submitting their proposal, begins the development of procedural knowledge (Eraut 2000). Meeting additional requirements of the course including submitting the items for assessment shows procedural knowledge through demonstrating learner

competence. This procedural knowledge will be developed further through the individual research project from year 3 onwards, and through their involvement in research as part of their continuing professional development (RCVS 2016).

Linn et al. (2015) report how reflection is a core element to allow students to develop their practices, synthesise their results, consider how they will take their conclusions forward and recognise new strengths related to their careers. Reflective practice is an important professional skill – students reflect through a portfolio and peer feedback; staff through the course review committee and by reflection-in-action (Schön 1991) in their professional practices.

These processes of reflection, enculturation and situated learning link with the Learning Partnerships Model proposed by Baxter-Magolda (2009), whose principles are to validate learners' ability to know, situate learning in experience and define learning as 'mutually constructing meaning'. Integrating research-based activities into the curriculum serves to support students as they undergo the transition from school student to student researcher to veterinary professional. This transition is modelled in the approach to developing research skills described by Sambell (2008).

Structure of the BVM&S degree programme

The BVM&S degree is a five-year professional veterinary programme, with a four-year programme for graduate entry students holding an appropriate Biological or Animal Science Honours degree, with the final year being taught at masters level. For students on the five-year programme, key research-skill components include the Research Skills group project in year 2 and the individual research project in years 3 to 5. Graduate entry students on the four-year programme bring research experience from their previous studies and thus are not required to complete this course.

Students complete workplace learning, or extra-mural studies, through their time on the programme. This comprises a set amount of non-clinical (12 weeks) and clinical (26 weeks) placements. These placements give students the opportunity to develop skills through hands-on activity, e.g. animal handling (animal husbandry), surgical and laboratory skills (clinical). Students submit reports on their placements providing a route for developing reflective practice. This process aligns with the apprenticeship research model described by Zimbardi

and Myatt (2014); in the case of veterinary students on placement, their supervisor may be a clinician working as an academic staff member or in an external practice. The veterinary network is not differentiated into 'academic research' versus 'professional practice', but is rather an integrated community of practice.

There is significant challenge in fulfilling the joint requirements of creating masters-level graduates, with critical thinking and creative knowledge acquisition, alongside the profession-specific knowledge and practical competences required by the Royal College of Veterinary Surgeons (RCVS 2015). Fully embedded research skills training is the most practical and effective way of achieving this.

In their report for the Higher Education Academy, Healey and Jenkins (2009) review the four elements of the teaching research model developed by Healey (2005). Student engagement in research can be through research-tutored, research-led, research-orientated or research-based modalities. As recommended by Healey and Jenkins, a range of teaching and learning methods are used in the curriculum to ensure students have experience of all four aspects. Research-led and -tutored practices often result in the student as 'audience', with research-oriented and -based practices seeing the student as a participant.

Research Skills course

We concur with Healey and Jenkins (2009) that the four routes to engagement outlined above are not independent. By including methods such as peer- and small-group teaching (Bell, Paterson and Warman, 2014), we endeavour to include as much research-tutored student participation as possible. Baxter-Magolda (2009) highlights two key problems with building a learning partnership which apply to any new undertaking: perceived institutional barriers and rigid assessment processes. Institutional barriers preventing the integration of additional activities or research projects can be policy-led, or can be the result of staff perception: 'we can't do that because it's not permitted'. We are fortunate that we do not experience institutional barriers; we have robust assessment processes and are positively encouraged to be varied and forward-thinking in assessment methods, including student-led and -assessed summative assessments.

Instead, we have a heavy curriculum requiring measured, 'efficient' integration of research. It must be seen as relevant by our students to engage them so they gain the most from the experience in both the

short and long term. Through lecture, practical, project and workplace activities, students are encouraged to develop their professional skills. Students are aware from the outset that the methods and techniques used in their studies form the foundation of their professional work.

The Research Skills course is a 10-credit SCQF Level 8 (Scottish Qualification Framework 2016) course taken in the second year of the five-year undergraduate programme. The aim is to develop students' skills in:

- acquisition and organisation of knowledge;
- presentation of a body of knowledge in a structured and interesting way;
- correct source referencing and formatting;
- communication between team members;
- team management, time management and allocation of tasks; and
- peer assessment and feedback.

The course was based on an earlier student-select project, and was re-designed in 2015 in response to student feedback and changing institutional strategic policy. Students were asked to develop projects which draw on their work-based practical experiences with animal species through the lens of socially-responsible and sustainable themes. These themes included ethics, technology, cultural influences, socio-economics, One-Health/One-Wellbeing and local/global issues. The choice of these topics made the course aim of exploring themes that affect and connect animals, people, societies, countries and the world as a whole more explicit. It resonated with institutional strategy and policy (University of Edinburgh 2016), and guidance issued by the Higher Education Academy and Quality Assurance Agency (HEA and QAA 2014) on improving sustainability literacy in all students.

It is essential that the research focuses around an authentic task that is clearly aligned with the discipline. The authentic task is a key element to foster engagement in particularly goal-led students working on a very intense, full-time professional degree programme. The student-selected projects provide a clear opportunity for students to participate in research-based activities, drawing on the research content to address questions or problems associated with veterinary medicine (see Box 5.1). The course also provides an important element of free choice in an otherwise predetermined curriculum.

Box 5.1 A selection of titles from student projects to demonstrate the range of topics covered in the Research Skills course.

One Health: an approach to the global management of zoonotic diseases in farm animals

Economics versus ethics in horse racing

Why donkeys? How their welfare impacts the economy and well-being of the local community

The Engineer vs. The Farmer; are high technology procedures economically beneficial to the livestock industry?

Exploring the ethics in Animal-Assisted Therapy (AAT)

Are UK pig farms bringing home the bacon? An evaluation of the evolving pig industry across the globe.

War, what is it good for? The effect of civil war on wildlife and comparison of safeguarding strategies

Sustainability of *Felis silvestris silvestris* (Scottish Wildcat)

Through the Research Skills course, we seek to reduce anxiety and develop confidence by connecting students with a wider staff network. It allows the teaching team to share their own research experiences with students, as this passion and professional interest has been shown to have a positive influence on students participating in research-teaching activities (Dwyer 2001; Trigwell 2005; Healey et al. 2010). This is the first step in becoming part of the research community within the RDSVS and the wider veterinary community of practice. The goal was to help students to build their confidence in communicating as part of the research community (Adedokun et al. 2013). As such, the assessment submission was in four parts: an abstract, a group blog, a poster and a group presentation. The abstract and poster presentation follow the same format as the Veterinary Education (VetEd) Symposium (https://vetedsymposium.org/), clearly demonstrating to students how they are developing skills which have a practical application in their career.

Through the requirement for core skills in presenting and writing, the students are introduced to searching for and finding relevant information on their topic to produce a cohesive assessed piece. Information Skills sessions separate to the Research Skills course explain the additional value to the students of being able to search systematically for information. The sessions introduce the topic of EBVM, which is built on further as they progress through the degree.

Furthermore, the American Veterinary Medical Association's (2016) Standard for Information resources includes a requirement that students are able to retrieve and evaluate information. One of the aims of the information literacy sessions is to encourage students to see value in using different, subject-specific databases when searching for information, to critique sources and integrate these in their final submission. Undergraduate students are familiar with search engines such as Google and may not believe that searching bibliographic databases adds anything. Grindlay, Brennan and Dean (2012) evaluated several databases to determine which provided the most comprehensive veterinary coverage and recommended that CAB Abstracts (http://www.cabi.org/publishing-products/online-information-resources/cab-abstracts/) gave the most comprehensive coverage of veterinary literature. The Research Skills course provides a key opportunity to put these information literacy skills into practice.

The following section will describe the Research Skills course structure in more detail to illustrate how this makes effective use of a small part of the curriculum to develop student research confidence.

Course design

As stated previously, the Research Skills course is a 10-credit contribution to the second year. It helps prepare students for the individual research project of third through to final year. This course is structured as a group project, recognising that much research work in the clinical, applied or pure sciences is collaborative in nature. In this section, we will look at the staff support, structure, assessment and feedback aspects of the course.

Staff support

Dwyer (2001) found one of the key negatives reported by research students is poor staff availability. Levy and Petrulis (2012: 91) report the need for support and guidance in research activities, what they term 'bounded independence' where students can retain a sense of autonomy while knowing that support is there should they require it.

Eight members of staff form an interdisciplinary team drawn from across the school, including clinical and support academics, research staff and information scientists. A further interdisciplinary approach is demonstrated through the appointment of the course's external

examiner who comes from medicine for human animal patients. This examiner has accreditation in public health medicine and a background in medical education and contributes to quality assurance of the course through commenting on standards regarding the processes of teaching and assessment.

In this course, because the project is student-led, teaching staff act as support contacts and assessors. At the outset, staff comment on draft abstracts and this starts a dialogue with students. Students have opportunities to meet with staff and discuss their projects. Students can also approach a member of the teaching team directly, can connect through the course administrator, and can attend a non-compulsory timetabled drop-in session. Meetings with staff are voluntary; it is up to the student whether they take these up or not. In 2015, almost one third of the groups (nine out of thirty groups) chose to attend the drop-in session. There was no evidence indicating whether attendance improved the final result. However, the course and student team reported that it was important the option was provided should students wish to avail of it. Many of the free-text comments in the course evaluation feedback thanked individual staff members for their approachability and advice.

By providing multiple routes to connect, our goal is to reduce the negative impact described by Healey et al. (2010) where staff were unavailable due to time pressure. It also allows students to see staff as individuals (Dwyer 2001), thus reducing anxiety in communicating their ideas.

Structure

As per Levy and Petrulis (2012), in this project the students focus more on research as 'information gathering' or reporting on current research in the discipline. This fosters an open 'discover-oriented' research approach as recommended by Spronken-Smith and Walker (2010). Students work collaboratively on their first research project. This learning approach provides space for learning from peers and from staff (Trigwell 2005), and marks the first step in building connections with the veterinary research community. The task requires effective collaboration, with all the compromise and latitude required to reach a unified output and thus closely mirrors veterinary professional practice. The course and project follows the five-step process outlined below.

1. **Introductory lecture:** the course leader gives an introductory lecture outlining the purpose of the course and practical aspects of the project. This ensures that all students are given

information on assessment and timescales at the same time. Students have the opportunity to ask questions about the project, and can see examples of projects from previous years.

2. **Forming a research group:** students self-select their group (n=4) or ask to be placed in a random group by the course administrator. Students who have not selected a group by a specific deadline are placed in a group by the course administrator.

3. **Choosing a topic:** students are invited to select a group topic of their choice, incorporating the sustainability and species-specific themes as described earlier. The only restriction is that the topic should not focus on material directly related to their studies as the goal is to encourage research beyond the set curriculum.

4. **Abstract submission:** once the group is formed and topic chosen, the next step is to submit an abstract of between 100 and 200 words. This must be approved by the teaching team before the students can begin work, and is the first opportunity to gain feedback on their research proposal. Two members of the teaching team independently provide feedback; this is collated before being returned to the students.

5. **Group-work:** the group-working process includes peer assessment and feedback through a tool called WebPA (http://www.ed.ac.uk/information-services/learning-technology/assessment/webpa). The tool is specifically designed to facilitate peer marking against a set of group criteria, e.g. participation, information skills, communication. This deals with the concern surrounding 'free riders' reported by Trigwell (2005). Two different modes of group-working have been observed: groups which divide the topic, work individually and come together at the end, and groups who work more collaboratively throughout the process. Students are not given specific guidance on how the group should carry out the work, and are therefore free to choose the approach which works best for them. As yet, no difference has been observed in the results of groups who take one approach over another, though this is noted for ongoing observation. The mode of group communication is not recorded; students report this can be face-to-face, using electronic modes of communication, or a mixture of both.

The final group presentation of the project is described in more detail in the next section.

Assessment

The group project assessment comprises the abstract (formative feedback), presentation (10 per cent of the final mark), poster (20 per cent) and blog (70 per cent), allowing students to develop skills in presenting to a range of audiences. This 'bilingual' skill effectively tests the breadth and depth of the student's understanding of the topic.

As mentioned previously, the poster presentation is similar in format to that used by a recognised veterinary education conference. The group blog was added in response to feedback from students in the previous year and is in line with the RCVS' initiative to encourage clinical research by practitioners. The blog allows the students to expand on the topic in greater detail than permitted in the presentation. It developed collaboration among the group, and leadership skills through the ability to move towards a compromise/consensus. The potential public nature of blogging required students to consider the appropriateness of the material published and thus develop a moral/ethical responsibility and empathy with a wider perspective and differing sensibilities.

Formative feedback is provided via the abstract submission; assessed elements are the poster, presentation and blog.

- **Abstract:** Students are made aware from the outset that the abstract can be adapted as the project progresses, depending on the outcome of their research. As a result, the final abstract may have evolved, while providing a clear and concise introduction to the presentation and blog. It also provides an early opportunity for formative feedback to assist students in developing their project, which students report as being helpful in course feedback (see the next section on feedback).
- **Poster presentation:** Students present their posters in a lecture theatre to an audience of their peers and staff. The staff cohort includes at least two members of the teaching team (the assessors) and colleagues. Posters are displayed in the atrium over a one-week period to be viewed by students, staff and visitors to the veterinary school and on-campus veterinary hospitals.
- **WordPress blog:** This tool was used effectively by colleagues in medical education for student projects. The team could therefore be confident that the tool would be suitable and straightforward to use. The blog was kept private, ensuring that it was visible only to staff and students in the appropriate group.

It could be locked for editing during the marking period, and received marks and feedback independently from two members of the teaching team.

Feedback

Levy and Petrulis (2012) emphasise the importance of the sense of ownership a student feels when they have the opportunity to select the area they wish to study. In addition to directing the topic, students also join staff in a liaison committee during the course to discuss what is working and what could be improved for future years. In the case of the Research Skills course, students are aware that they will not be involved in the course in the following year. However, they are always keen to feed forward, and the course team ensure they see how their recommendations are put into action. Based on feedback (Table 5.1), free-text comments and course review, the following adaptations will be investigated and incorporated where possible:

- Timetable change to move the course into the second semester at a time students have identified as being more appropriate due to fewer assessments.
- WebPA will be used to provide formative peer feedback earlier in the project process, allowing students to improve their group-working skills as the project progresses.
- More explicit links will be made to the students' extra-mural placements, highlighting how their reports can be used to inspire more in-depth research into this area of their professional development. The goal is to encourage students to take ownership of both the placement and the project.

Table 5.1 Key student responses taken from course evaluation survey (n=108; 90 per cent response rate)

Question	Response
I managed to join a group project that interested me	Definitely Agreed (61.4%) Agreed (27.8%)
The feedback on our draft abstract was useful	Definitely Agreed (34.3%) Agreed (42.6%)
I felt that support and advice was on offer if needed	Definitely Agreed (38.9%) Agreed (30.6%)
Overall, I found the course intellectually stimulating	Definitely Agreed (34.6%) Agreed (32.7%)

- In the first year of using the blog, we encountered a conundrum in deciding whether to make these public as our colleagues in medicine had done. As outlined previously, public engagement and effective communication are key professionalism issues. We felt that we had not clearly outlined the considerations students should take into account before making their blogs live, e.g. use of copyright-cleared images, and potential impact of emotive and sensitive material on animal welfare. We elected to keep these private within the network for the first year, and to work in collaboration with colleagues in research public engagement to define a policy for future years.
- Audience feedback will be facilitated, resulting in a 'People's Choice' award. This is in response to requests from staff, students and visitors to the campus who wished to comment and reward the research on display in the atrium and in the presentations. An invitation to attend the presentations will be extended to students and staff in human medicine and biomedical research to provide an external (to the programme) professional audience.
- Collaboration is extending beyond the programme in our use of peer assessment for group work and inclusion of sustainability themes. Our colleagues in medicine and social sciences wish to include the sustainability themes in similar projects they undertake; we are working with them to take that development forward. Colleagues in the business school have proposed a more effective use of the peer-assessment process which we will integrate. Students group-assess against criteria halfway through the project, rather than at the end. This feedback is then used to encourage each team member to improve their group-working skills for the remainder of the project.

Each of these developments is connected to the development of the student as part of the research and veterinary professional community at the institution.

Discussion and summary

The previous iteration of this course, called Student Selected Component 1 (SSC1), had run for a number of years. It generally received consistent feedback from a significant number of students which questioned

the relevance of SSC1 to the veterinary programme. It was interesting that some students would make this comment while at the same time remarking that they had enjoyed the 'freedom' that SSC1 provided, with its overall stipulation that the projects must not touch on *any* aspect of veterinary medicine at all. In the highly content-driven veterinary course, they enjoyed being able to research a topic of their own choice. An issue with SSC1 might be termed 'The Loch Ness Monster problem', i.e. the tendency of students to choose a certain type of project (and Loch Ness Monster projects featured rather frequently). When done well, these projects could be interesting and insightful; however, when done superficially they resembled secondary school-type projects and had little depth or analysis.

In reinventing the course, the intention was to preserve the freedom of SSC1 but allow the students to feel that this was linked to the BVM&S programme by allowing interaction with veterinary-related topics, *provided* these engaged with the deliberately wide-ranging and interdisciplinary intentions of the new course, with its themes of ethics, sustainability, socio-economics, etc. The new framing of the course ensured students had to think in different ways, seeing and exploiting connections. It encouraged them to tap into animal-related subjects but in ways which were quite far removed from traditional bioscience approaches. Additionally, the new format provided the opportunity for students to explore a mix of evidence-based and value-based subjects (a good example being sustainability) in contrast to the more positivist slant of their other subjects in the preclinical sciences. We feel this is an important feature of the course because graduates entering clinical practice (as the majority will do) will in fact be operating in a world where evidence- and value-based decisions often collide. The vocational nature of the veterinary degree, and ever-expanding scientific clinical knowledge, means that there is little room to introduce course options in disciplines that traditionally encourage scholarship centred around value systems, e.g. humanities and philosophy.

The first year of transition was interesting. The project titles were imaginative and sometimes surprising (see Box 5.1), and it was very clear from the blogs and oral presentations that most students had engaged. Student feedback was decidedly better, and included a suggestion from students for placing the course later in the academic year, which made good sense as the students at this point had a slightly lighter timetable and were already involved in another course (Animal Body 4) which also aimed to promote synthesis, this time

across traditional preclinical science subjects. Some synergy between these two very different courses, but with rather similar aims, is expected in coming years.

While the Research Skills course directly taps into the RCVS requirements to produce research literate graduates/professionals, the course provides a hub for the development of a number of additional key graduate attributes. This is a rare early opportunity for the students to develop their communication, interpersonal and leadership skills authentically, rather than in the more typical simulated environments in other parts of the degree. The output will exemplify the ability of the students to recognise their social and professional accountability for the appropriateness of the material across the range of audiences, and thereby develops empathy for alternative perspectives along with moral and ethical responsibility. Self-reflection and skills associated with peer assessment extend beyond the university environment to professional practice and all of these taken together become the fundamental professional and graduate attributes that should create dynamic graduates, equipped to enter a wide range of roles within and outside the veterinary profession although this is impossible to measure or assess (Hughes and Barrie 2010).

Practical hints for those contemplating trying a similar course would be to start on a small scale by introducing an activity to a pre-existing course. This will embed the new way of working within a familiar context especially if efforts are made to show relevance and application, including application in practice and the world beyond academia. Students should be supported appropriately as, depending on their school education, they may have focused on a certain discipline (e.g. humanities, sciences) from an early stage. Providing examples can help, but one of the merits of the group approach is that ideas are likely to bounce between students and help them to think creatively once that initial impetus is obtained. Inter- and cross-disciplinarity is a major theme and aspiration in most academic institutions, so giving them examples of such approaches in action is likely to help, and by exploring conference sites, webinars and other media, students will gain an appreciation of how different subject specialists can work and talk together.

6
Connecting the curriculum with the iGEM student research competition

Darren N. Nesbeth

Introduction

The International Genetically Engineered Machines (iGEM) competition is an annual activity in which undergraduate and postgraduate university students from different degree programmes are encouraged to form teams and develop their laboratory, computer and communication skills through exploring a project of their choice, with clear links to research-based education. Students can apply to join an iGEM team during any year of their degree course but most often UCL iGEM team members have completed at least one year of undergraduate study. The Connected Curriculum Framework is a university-wide initiative at UCL with the goal of empowering students to learn through active participation in research and enquiry (Fung 2017). At the UCL Biochemical Engineering Department, iGEM participation has been harnessed as a driver for this institutional agenda. This chapter will provide a brief disciplinary background and a discussion of the ways in which iGEM has enabled and energised a Connected Curriculum approach. The Connected Curriculum Framework is defined by six themes, or 'dimensions' (Fung 2016; Fung 2017). These dimensions can be briefly summarised as: dimension 1: enabling students to connect with researchers and with the institution's research; dimension 2: providing a 'throughline' of research in a programme of study; dimension 3: encouraging students to make connections across subjects and out to the world; dimension 4: providing students with opportunities to connect academic

learning with workplace learning; dimension 5: providing students with opportunities to learn to produce outputs directed at an audience; and dimension 6: encouraging students to connect with each other, across phases and with alumni.

The iGEM competition is large and successful (300 teams participated in 2016) and, though interdisciplinary in nature, it is principally led by science, technology, engineering and mathematics (STEM) topics. However, the iGEM concept – small, multidisciplinary, student teams working on self-defined projects – potentially can map onto non-STEM disciplines or disciplines that encompass STEM but are led by the Arts and Humanities. The discussion that follows highlights how the UCL iGEM programme actively delivers dimensions 1, 2, 3, 5 and 6 of the Connected Curriculum framework (Fung 2017). Workplace learning (dimension 4) is not a distinct iGEM activity but entrepreneurship does play a key role in the UCL iGEM experience and to date two spinout companies have been founded from UCL iGEM teams (Table 6.1).

The discipline of synthetic biology and the connected curriculum

Making connections across a curriculum is increasingly recognised as an effective way to help students acquire skills, knowledge and insight in a given subject or discipline. Most academic disciplines are made up of a collection of distinct areas of knowledge and practice, and because of this there can be an organisational inclination to teach disciplines in a process akin to sequentially dipping students in and out of different silos. With this approach connections between silos are implied and hinted at but rarely explored in a way that has impact for students.

In common with many academic disciplines, synthetic biology can be difficult to define and has fuzzy borders with other disciplines. For many research-intensive academic institutions, synthetic biology could be in principle taught by assembling a selection of pre-extant courses available across multiple departments and divisions. Arguably a better approach is to make explicit connections across courses and to make those connections credible and meaningful for students. Activities such as iGEM give students the opportunity, autonomy and guidance to make these connections themselves.

Table 6.1 iGEM teams supported by UCL Biochemical Engineering

Year	Team	Awards/notes
2009	Stress Busters (UG)	Silver Medal
2010	Hypoxon (UG)	Gold Medal
2011	*E. coili (UG)*	Bronze Medal
2012	Plastic Republic (UG)	Gold Medal
		Top-ranked UK Team at World Championship Jamboree
		Best Presentation Award Winner
		First BioBrick™ submitted by members of the public
		(with London BioHackspace)
	Morph Bioinformatics (Entrepreneurship)	Founded spin-out company Morph Bioinformatics
2013	Spotless Mind (UG)	Gold Medal
	Spectra (PG)	Silver Medal
		Top-ranked PG UK iGEM Team at European Jamboree
	Darwin Toolbox	Founded spin-out company Bento Bioworks
	(Entrepreneurship)	
	Mature Papyrum	*UCL Academy school team*
	(High School)	First UK school to attend iGEM Jamboree
2014	Goodbye Azo-Dye (PG)	Gold Medal
	Cyano-Busters (High School)	*UCL Academy school team*
	Juicy Print	*London BioHackspace team*
	(Community Lab)	First UK community lab to attend iGEM Jamboree
2015	Mind the Gut (PG)	Gold Medal
		Top-ranked PG UK iGEM Team at Jamboree
		Best PG Entrepreneurship Award Winner
		Best Composite BioBrick™ Award Nominee
2016	BioSynthAge (UG)	Gold Medal
		Best Entrepreneurship Award Nominee
		Best Therapeutic Award Nominee
		Best Composite BioBrick™ Award Nominee

Biochemical engineering

The disciplinary provenance of biochemical engineering makes it a natural fit for the aims and objectives of synthetic biology and iGEM, defined below. The emergence of biochemical engineering from chemical engineering was necessitated by the new products and processes of the biotechnology industry (Shamlou et al. 1998). As the need for biological knowledge and expertise increased, the demand for biochemical engineering to become a distinct discipline grew.

Masters of Engineering

In the United Kingdom, the Masters of Engineering (MEng) degree was launched in 1980 with intended learning outcomes (ILOs) that encompass both academic standards and the accreditation requirements set by professional engineering bodies such as the Institution of Chemical Engineers (IChemE). Typically, such accreditation standards place a premium on students' demonstrating teamwork skills and independent, creative thinking. At the UCL Biochemical Engineering Department staff experience developing MEng programmes informed their view of iGEM as a potentially highly valuable student activity. UCL Biochemical Engineering, with the support of the UCL Faculty of Engineering Sciences, has hosted UCL iGEM teams since 2009, providing full laboratory facilities and sponsorship.

Synthetic biology

Synthetic biology has recently emerged as an academic discipline that forms the philosophical underpinning of the iGEM competition. It can be defined as the application of engineering principles to biological material in order to design biological devices that do not exist in nature (Kwok 2010; Nesbeth 2016). From around 2005 onwards the retail cost of DNA synthesis and DNA sequencing has continued to fall significantly. This has created favourable conditions for the expansion and development of the discipline of synthetic biology. Low cost synthesis, or 'writing', of DNA gives synthetic biologists capabilities for assembling DNA at scales that were previously impossible. This has led researchers to assemble the entire complement of DNA needed to control a living cell, known as a cell's genome, and use such designed, synthetically originated DNA to generate an entirely synthetic organism (Lartigue et al. 2009).

iGEM is an interdisciplinary science competition that was first organised by the Massachusetts Institute of Technology (MIT), USA, and has since become an independent foundation. In the early years of operation, iGEM participants were mainly undergraduate and postgraduate university students, with a small number of secondary schools also participating (Campos 2012). Participation has since widened to include community laboratories run by members of the public. The competition structure encourages teams to carry out research projects that encompass computer modelling, public engagement, website design, exploration of ethical issues, standardisation of biology, artistic expression and molecular biology (Figure 6.1). The typical schedule of UCL iGEM activity is set out in Figure 6.1, and a UCL iGEM cycle extends from

(a)

Wiki website	Collaboration	Human Practices	Experimentation	Poster and Presentation
Create a wiki page with clear attribution of each aspect of the project. This page must clearly attribute work done by the students and distinguish it from work done by others, including host labs, advisors, instructors, sponsors, professional website designers, artists, and commercial services.	Credibly helped any registered iGEM team from high school, a different track, another university, or another institution in a significant way by, for example, mentoring a new team, characterizing a part, debugging a construct, modeling/simulating their system or helping validate a software/hardware solution to a synbio problem.	Demonstrate how the team has identified, investigated, and addressed how issues such as ethics, sustainability, social justice, safety, security, and intellectual property rights intersect with their chosen project. This activity could focus on education, public engagement, public policy issues.	Construct a novel BioBrick and submit it to the Registry of Standard Biological Parts. Experimentally demonstrate the function of a novel BioBrick constructed by the team. Improve an important element of an already existing BioBrick.	Design, print and display a poster at the Jamboree event. Give a 25 minute presentation at the Jamboree event setting out the team's achievements and also discuss the project in a question and answer session.

(b)

	Life Sciences	MAPS	Medicine	Built Env	Engineering	CSM	KCL	West.
2009	●				●●			
2010	●●●	●			●●●●●	●		
2011	●●●	●●	●●		●●●●●			●
2012	●●●●	●	●	●	●●●●●● ●●●			
2013	●●●●●●	●●●	●●	●	●●●●●●●●	●		
2014	●●●●●●● ●●●●	●●●●● ●●	●●		●●●●●● ●●●●●●			
2015	●●●●●●●	●●●			●●●●● ●			

● PG student
● iGEM alumnus
● UG student

(c)

November	December	January	February	March	April	May	June	July	August	September	October
Update iGEM Moodle page. Advertise via posters email lists and announcements	Review applications. Prepare shortlists.	Conduct Interviews and agree final team roster.	Preliminary team meetings to discuss synthetic biology and iGEM.	Meetings to discuss project requirements with respect to iGEM constraints. Plan summer availability ahead of exam period.	iGEM pause due to Easter break and Exams.	iGEM pause due to Exams.	Phased start of full time iGEM activity as team members return from exam period. Agree project scope.	Define laboratory research priorities. Finalise assignment of team roles or 'champions' of aspects of the project.	Take forward all elements of the project ideally in parallel. Finalise DNA assembly needs.	Focus on strategy for data capture for new and improved BioBrick™ constructs. Refine wiki website design and content.	Submission of new and improved BioBrick™ constructs to the Registry. Completion of wiki design and content. Present at Jamboree.

Fig. 6.1 UCL iGEM activities, schedule and participants. A) Major types of student activity required by iGEM. B) Faculties from which UCL iGEM students have been drawn, plus student participants from Central Saint Martin's College (CSM), King's College London (KCL) and the University of Westminster (West.). C) Typical annual schedule of UCL iGEM organisation and activities

November to October of the following year. The competition concludes with students attending a large event, the 'iGEM Jamboree', in October/November to present their work. Most participating universities design a curriculum that enables students to gain a valuable educational experience from iGEM participation.

The group-work and collaboration requirements of iGEM prepare students for common modes of working in commercial settings, where small, interdisciplinary teams of employees/contractors/licensees work towards defined goals with set deadlines. Such business-oriented, group-based approaches to project management have also been reported to be effective in educational settings (Gaudet et al. 2010).

A core requirement of iGEM is that teams submit DNA constructs that conform to a set standard for their construction, known as the BioBrick™ standard. Construction using the BioBrick™ standard tends to be less technically demanding than standard molecular biology methods. As a result, iGEM teams can be recruited from students studying disciplines beyond science and engineering. Sources such as the *Synthetic Biology Handbook* (Nesbeth 2016) provide a detailed introduction to the discipline of synthetic biology and technical elements of the iGEM competition, including the BioBrick™ standard, for readers interested in exploring the topic further.

Designing a throughline of synthetic biology into the UCL iGEM programme

A programme of basic molecular biology and synthetic biology teaching is designed so that students' learning builds on previous learning in a throughline of research activity. This begins with traditional transmission of content. The programme then progresses through to students defining and advancing their project in the laboratory, while engaging in cycles of feedback and discussion of challenges and achievements with staff and peers. UCL iGEM team recruitment is open to the entire university. On average, the recruitment results in a team composed of 40 per cent students from the Biochemical Engineering Department, 40 per cent students from the UCL School of Life and Medical Sciences and 20 per cent from other disciplines, ranging from social sciences, physical sciences, arts and humanities. Basic molecular biology and synthetic biology, particularly the roles of the BioBrick™ standard and low-cost DNA synthesis, comprise the scaffold of knowledge within the iGEM programme from which all other areas and topics extend.

Teaching foundational molecular biology

The molecular biology curriculum for UCL iGEM has been structured in a manner that approximates the 'spiral' approach to curriculum design as described by Harden and Stamper (1999). In a spiral curriculum design topics are revisited, levels of difficulty increase as topics are revisited and new learning relates to previous learning as student competency is assessed to have increased.

This 'spiral' approach (Bruner 1960; Coelho and Moles 2016) is often recommended for molecular biology teaching (Anderson and Rogan 2011). The theme of 'engineering biology' is revisited repeatedly in deepening exploration of the chemical and informational structure of DNA. A series of lectures or whiteboard-and-pen 'project hack' days are typically scheduled with the aim of introducing the basic science and, critically, informally assessing the knowledge base that already exists within the team. Once students' level of knowledge has been appraised, a series of tasks will be set for sub-teams in which team members are grouped so that knowledge can be shared by peer-teaching (Benè and Bergus 2014).

Teaching foundational synthetic biology

Understanding the fundamentals of molecular biology equips the students to take the first steps in defining their project. The laboratory element of their iGEM project must be achieved using DNA molecules that comply with the BioBrick™ standard. Teaching of this standard is delivered by lecture and seminar complemented by the exhaustive online resources provided by the iGEM Foundation and their online Registry of Standard Biological Parts (http://parts.igem.org/Main_Page). This teaching shifts from transmission to interaction over a series of workshops and 'project hack' sessions in which students explore their project proposals with academic staff. Importantly, these discussions must explore topics beyond the BioBrick™ standard, particularly when considering potential impacts of the project on stakeholders in wider society. However, any project must ultimately find expression in the form of several designed BioBrick™-compliant DNA molecules so the concept runs through the programme from start to finish.

Progression along the synthetic biology throughline

The UCL iGEM programme begins with delivery principally via lecture and seminar. The teaching goal at this stage is for students to gain knowledge of the type of DNA-based tools they will design and use in

the project. Next there is a transition to peer-teaching while project ideas are developed. This is followed by discussion and debate with academic staff when final project topic choices must be made. At this stage the students should finalise the DNA tools they need to design and how they will be constructed in the laboratory. For the remainder of the programme students access online resources and work collaboratively with academic staff and student peers to manage the designs and construction of the DNA tools needed for the project. The connected sequence of learning activities – lecture, workshop, project definition, project progress, researcher partnership – serves to establish an effective throughline of staff-led teaching and student-led research activity.

UCL iGEM students connecting with staff and their research

Synthetic biology staff members from across UCL support iGEM students through regular meetings and providing feedback on student project proposals and presentations. These interactions also provide staff with the opportunity to present their research interests to students and to facilitate connections with other UCL staff whose research interests match the students' project. The first responsibility of UCL iGEM academic staff (including in some cases doctoral students) is to provide a safe environment for undergraduate students to participate in iGEM. This includes ensuring the outputs of an iGEM project, such as bacterial strains or web page content, are also safe and appropriate (McNamara et al. 2014). Arguably the next essential function for academic supervisory staff is to link iGEM students with relevant researchers from across UCL. Establishing these links is frequently key to iGEM success.

Student learning through iGEM research and enquiry

Classic teaching modalities alone, such as the lecture and the practical demonstration (Anderson and Rogan 2011), are often not sufficient for preparing students for modern research degrees and employment in research settings. Participation in iGEM brings an added dimension by virtue of the high degree of student autonomy it engenders. The very real and important sense of 'ownership' UCL iGEM team members have for their project can be a potent motivator for achieving these competencies. Inevitably mistakes are made along the way as deadlines approach and

the pressure students place themselves under mounts. Overall this gives iGEM students a unique opportunity to hone their research skills by proposing research, gathering data and then learning to report their data clearly.

In much conventional university teaching, a three-stage arc of learning progresses from a lecture/transmission stage, then to instructor-directed research and finally a stage when students are granted research autonomy. The following examples typify research collaborations that arise between UCL iGEM undergraduate students and UCL staff. Such collaborations improve upon the conventional learning arc in that student-led research is encouraged from the very start of the activity.

Genetic modification of microglial cells

The 2013 team 'Spotless Mind' proposed the use of re-designed microglial cells to address Alzheimer's disease. Natural microglial cells patrol brain tissue and help maintain the healthy function of neuronal cells. In Alzheimer's disease, it has been suggested that microglial cells detect and migrate to plaques (regions of damage) associated with the disease, and upon encountering plaques bring about harmful inflammation. Engineered microglial cells would be modified such that, upon arriving at plaques, they would secrete factors that suppress harmful inflammation.

Enabling this research therefore required that staff contacts be established across multiple silos of the university teaching and research organisational structures. In this case a stable microglial cell line, SV40 (Applied Biological Materials, Richmond, Canada) was identified for the project and links were established with Robin Ketteler of the UCL Medical Research Council Laboratory for Molecular Cell Biology to explore use of a Nucleofector™ device (Lonza, Amboise, France) for the team to attempt genetic modification of the microglial cells.

Gut on a chip

The 2015 team 'Mind the Gut' explored routes by which engineered probiotic bacteria (EPB) could be used to detect chemical signatures in the human gut that signal different mood states in the brain. Compounds that improve mood would then be produced by EPB in response to those

chemicals. The team sought to mimic the environment in which EPB would interact with human gut cells. A step towards this was to reconstruct a microfluidic device, based on the design by Kim et al. (2012), by working extensively with Ya-Yu Chiang in the laboratory of Professor Nicolas Szita.

A common dynamic in practical teaching is for context to be supplied solely by instructors. An unspoken bargain is struck between students and instructors in which students accept their de facto disenfranchisement from the context of the practical. In return for this, students' expectations that a practical will 'work' (i.e. yield ample, explainable data) are given tacit approval. A less passive option, exemplified in the two examples above, is for students to be empowered to define context themselves. Throughout UCL iGEM, empowering students in this has always had an energising effect, evidenced by the time and focus given to projects. The corollary of this is that projects may not 'work' by the above definition. However, when the time comes to judge whether a project has worked or not, student skills have already been developed and competencies enhanced.

UCL iGEM students learning to produce outputs

Students must meet a number of outputs that engage a range of audiences to be eligible for iGEM assessment. They must: produce a comprehensive wiki-based website; deposit biological material and data on the Registry of Standard Biological Parts; present a research poster at the iGEM finals 'Jamboree' event in Boston, USA and also give a 20-minute presentation at the Jamboree; followed by a five-minute question and answer session. iGEM assessment follows a summative model in which fulfilment of a defined list of tasks determines qualification for a given iGEM medal category: gold, silver, bronze or no medal. Judges drawn from the global synthetic biology community, alongside a variety of other stakeholders in the field, assess team performance (Campbell 2005). An electronic scoring table system has emerged as the preferred iGEM scoring method since 2011, as it was assessed to be the fairest and most flexible approach. Via this scoring table a medal status is determined for all participating teams that attend the Jamboree event.

Formative iGEM assessment (Willis et al. 2002) is provided by mechanisms such as i) feedback statements from iGEM judges; ii)

reflection and discussion within the UCL supervisory team; and iii) discussion between supervisors and team members. Consensus arising from these evaluations (Nicholls 2002) informs structure and selection decisions for the subsequent iGEM cycle.

The iGEM Jamboree event – 3–4 days in Boston, USA

All iGEM teams must provide a full account of their achievements on a wiki website. Technical details of a team's BioBrick™ plasmids must be provided on their wiki and inputted to the Registry of Standard Biological Parts (often referred to as just 'Registry') at the relevant profile pages for the BioBrick™ plasmids a team has deposited. Critically, technical team achievements garner zero credit unless reported on both their wiki site and the Registry.

Medal qualification is primarily based on scrutiny of a team's wiki site, which must fulfil a set of stated criteria. Teams must also give a 20-minute presentation and produce a poster that they can competently discuss with judges and delegates. This 'live' interaction with judges is a valuable opportunity for students to develop the key research skills of effective presentation of data, responding to intellectual challenge from peers and public speaking.

UCL iGEM students as partners with UCL academic staff

In a conventional lecture setting, students and staff have clearly distinct roles as the transmitters and receivers of knowledge. When students participate independently in research their relationship with staff is transformed to that of 'fellow travellers' (Jones 2005), partners working together towards a common purpose. The process of transition from passive receivers to partners poses the challenge of helping students develop new skills and understanding, while also ensuring students experience the risks and rewards of research autonomy. These goals can diverge or converge through the lifetime of an iGEM project, depending on factors such as topic choice and prior experiences of team members and supervisory students.

This potential dichotomy between transmission-based or participation-based learning echoes the discussion by Neville (1999) of whether 'direction' or 'facilitation' is the more effective role for teachers to adopt. For instance, directing research topic choices for iGEM

can deprive students of a sense of ownership of their project, whereas facilitating the process of shortlisting projects allows students and staff to work together as authentic partners. In contrast, much time in the laboratory can be lost 'reinventing the wheel' if directive teaching is not provided.

UCL iGEM teams are afforded the opportunity to work closely with full-time members of academic staff, post-doctoral research assistants (PDRAs) and doctoral students throughout the period of the competition. As the research direction of the project is student-led, this provides students with the opportunity to experience research as an active, collaborative partner as opposed to a passive receiver of information.

Teams are assisted in approaching UCL researchers for their input at all stages of a project: from brainstorming and scoping, to experimental design, data capture, troubleshooting and data reporting. In this way students learn specific techniques or areas of theory, pragmatic details such as preparing and printing posters and how all these new experiences interplay and link within the lifetime of a project. Applications such as Slack (https://slack.com) and Google Docs (https://www.google.co.uk/docs/about), which work seamlessly across mobile and desktop devices, enable effective collaborative work and project management of teams whose members are widely dispersed geographically. This powerful connectivity makes it easier than ever for students to make meaningful contributions to iGEM, even if they cannot remain on campus through the summer stage of an iGEM cycle (Figure 6.1).

Developing approaches to iGEM team supervision

iGEM supervision varies across the hundreds of universities that participate in the competition each year. At UCL the principal supervisor provides scientific guidance and extensive 'behind the scenes' work toward securing funding and facilities. Small group work (Gaudet et al. 2010) and problem-based learning (Carrió et al. 2016) are core elements of UCL iGEM, important skills needed for success in the competition and in students' future careers. Although different teaching styles (Jones 2005) may be appropriate for the diverse range of tasks required for iGEM (Figure 6.1), three core approaches have emerged and each is set out briefly in the following sections.

Encouraging intra-group and alumni collaboration

Experienced staff members must provide knowledge and insight for students to help steer nascent projects to realistic goals. However, this is not the only effective mode of project examination by the team. Inescapably, the presence of academic staff renders project discussions more time-limited and formal than student-only interactions. Providing a student-only space to discuss decisions that will be crucial to the mission and identity of the team is key to establishing students' sense of ownership of their project.

Providing a cadre of student peers that includes UCL iGEM alumni means the students can still have directed and facilitated discussions, while maintaining the student-led autonomy of the project. Student peers can provide the information and also the informality that helps foster intra-group collaboration. In this way iGEM teaching is delivered by peer-supported learning (Micari and Drane 2011) as well as partnership with academic staff. Figure 6.1B details the numbers of postgraduate students and iGEM alumni involved in UCL iGEM each year. Every UCL iGEM team since 2010 has benefited from peer-support and peer-teaching in this way. Inevitably students can also benefit from access to their peers in discussion of future career choices and opportunities.

Providing a local context for team activities and deadlines

iGEM defines structure for teams via a comprehensive online content provision, including archived websites for many previous teams and competitions (http://igem.org/Previous_iGEM_Competitions). However, the fact remains that an iGEM cycle stretches across 12 months, from applying for team membership through to attending the Jamboree event. Consequently, for much of an iGEM cycle the Jamboree is distant in terms of both time and location. A real danger when context is so temporally and geographically remote is that it becomes effectively absent altogether. Such a context void, if not filled by a local framework, can siphon off student motivation. Regular meetings with team supervisors, plus presentations in semi-formal settings, help to establish a meaningful routine of in-project reviews and feedback that encourages planning and helps progress.

Embedding group autonomy

Dolmans et al. (2003) suggest the extent to which student learning is 'self-directed' positively correlates with attainment of learning

outcomes. This self-directed ethos is promoted within UCL iGEM by granting the team autonomy in terms of both the topic the team elects to investigate and the experiments and activities undertaken. When considering projects iGEM teams are also encouraged to address real-world problems (Balmer and Bulphin 2013), in common with many problem-based learning (PBL) approaches to teaching and learning (Norman and Schmidt 2016).

The three approaches above, tested and developed over several cycles of UCL participation in iGEM, favour partnership between students and academic staff. Perhaps paradoxically, encouraging student independence strongly enables the formation of authentic research partnerships between students and staff. When students trust that staff will defend and support their creative vision, they tend to be more open to the unfamiliar experience of working in a research partnership. This contrasts with alternative modes where research projects are defined and directed by staff and the student's role can be limited to completion of externally set targets and goals.

UCL iGEM students making connections across subjects and beyond the academy

Student collaboration has been reported as being beneficial to student attainment (Scheufele, Blesius and Lester 2007; Singaram et al. 2011) and providing evidence of credible inter-team collaboration has become a formal iGEM success criterion over time. The iGEM team wiki sites also function as a medium for communication and collaboration between teams and evidence suggests that such internet-based approaches are highly effective drivers of collaboration (Collier 2010; Sampaio-Maia et al. 2014; Ostermayer and Donaldson 2015).

Core values shared by iGEM and the Connected Curriculum framework (Fung 2016) are the importance of encouraging students to be aware of their social responsibility as global citizens and to consider the ethical, social and legal implications of their work. An important feature of iGEM is the core requirement that teams make credible links outside of the academy to explore potential societal impacts of their work. This stipulation has become known as 'Human Practices' and has been summarised by the director of iGEM judging, Peter Carr: 'Human Practices is the study of how your work affects the world, and how the world affects your work.' In response, UCL iGEM teams have initiated many

compelling interactions with organisations outside academia to engage with real-world stakeholders. Two examples discussed below illustrate UCL iGEM students' human practice activities and how they have led to the formation of connections with wider society.

Biohacking and the laptop laboratory

The 2012 team, 'Plastic Republic', explored the feasibility of designing a bacterium capable of persisting in the world's oceans and degrading waste plastics. As part of the project students initiated contact with members of the public who use the 'London BioHackspace' community laboratory in Hackney, East London. This collaboration represents somewhat of a landmark in synthetic biology (Borg et al. 2016) as it led members of the BioHackspace to design and assemble their own BioBrick™ (serial number BBa_K729016), which became the first ever BioBrick™ submitted to the iGEM Registry of Standard Biological Parts by members of the public.

The do-it-yourself ethos of the BioHackspace led a group of 2012 UCL iGEM alumni to found the company Bento Bio (https://www.bento.bio), which has developed a laptop-sized molecular biology laboratory for retail to the general public. Bethan Wolfenden and Philipp Boeing were 2012 UCL iGEM team members and used the 2013 iGEM Entrepreneurship (iGEM-E) competition to take the first steps in founding Bento Bio, then known as Darwin Toolbox. Like other UCL iGEM alumni, Philipp and Bethan have been closely involved in the design and implementation of subsequent UCL iGEM cycles, partnering with team members and supervisors to develop iGEM training and teaching. They also contribute a guest lecture on the UCL Bachelor of Arts and Sciences course, BENG3071 Open Source Synthetic Biology, presenting case studies drawn from their experiences with Bento Bio, synthetic biology and iGEM.

Mental health and medicine: Open Mind Night

The 2015 project, 'Mind the Gut', dealt with issues of mental health and featured the design of a genetic circuit within a probiotic bacterium that could help decrease the negative side-effects commonly experienced by patients taking certain classes of sedative. To explore how mental health is treated, and the impacts of mental health medication, the team established links with the mental health and arts charity,

CoolTan Arts (www.cooltanarts.org.uk). An event was co-organised with CoolTan Arts to exhibit artwork produced by people suffering from mental distress and to discuss synthetic biology approaches to addressing mental health.

The team also worked with the Mental Fight Club (http://mentalfightclub.com), an organisation that explores creative routes to addressing the challenges of mental health and ill-health. Interactions with Mental Fight Club, CoolTan Arts and others inspired the team to host a public 'Open Mind' event which mixed performance, such as singing, poetry and stand-up comedy, with honest and open narratives of mental illness. Frank accounts of mental health challenges, provided in a remarkably brave manner by members of the public, served to highlight the real human connections between research and research impact.

Why connecting beyond the university can improve the student experience

The 'human practices' element of iGEM invites students to expand their definition of what a project is, to see it as something more than the process of gathering data for discussion exclusively with academic staff. Projects such as 'Mind the Gut' and 'Darwin Toolbox' typify the passion and commitment displayed by UCL iGEM students taking their own projects to authentic stakeholders outside of the academy. During the process of planning and delivering these engagement activities students tend to develop a much richer and more expansive sense of what is possible and just how 'real' research can be. Research is no longer merely a different form of assessment in a narrow educational context, but a basic human activity with the potential to engage and impact communities.

Principles that have emerged from UCL iGEM 2009–2016

Trusting students to decide their own research directions, encouraging interdisciplinarity and expanding scope beyond the university, can all improve learning in multiple different disciplines and settings beyond iGEM and synthetic biology. Student experience should be prioritised, even if this means students may experience frustration and disappointment as well as excitement and curiosity. Keeping student experience at

the heart of a student-led, research-led, team activity is not always easy. Organisations that can keep student experience at the heart of their connected curricula will find that the resulting enhancement of learning enriches not only the immediate cohort of students, but also their peers, alumni, the institution's teaching and research culture, and the wider community.

7

Curating connections in the art history curriculum

Nicholas Grindle and Ben Thomas

> The act of curating, at its most basic, is about connecting. (Obrist 2015: 1)

Introduction

In recent years 'connecting' has proven a powerful way of rethinking how people learn in educational settings, including in both universities and museums. The teacher's or curator's job is not to impart information but to make it possible for the learner to construct their own understanding of the topic.

Constructivist pedagogy now dominates discussion of formal education. Its impact on curating has been slower to emerge but is proving to be equally profound. In his widely-cited sketch of the 'constructivist museum', George Hein noted that:

> the logical structure for any subject matter and the way it is presented to the viewer depend not on the characteristics of the subject or on the properties of the objects on display, but on the educational needs of the visitor. (Hein 1999: 76–7)

Galleries and art collections have been viewed as less concerned with transmitting authoritative views than museums (Pringle 2006: 7–9) and less has been written about the impact that constructivist pedagogy might have in these areas. Sue Cross and Emily Pringle, writing

independently about learning in galleries and from different perspectives and backgrounds, each draw attention to themes that feature prominently in any discussion of constructivist education: learning as a facilitated process, the need to understand the needs and habits of individual learners, the importance of learning in a social setting and the role of co-construction, the generation of multiple interpretations and the testing of those interpretations against the visual evidence (Pringle 2006; Cross 2009: 143–52).

Curating offers one model for conceiving how the university curriculum can shape a student's engagement with the subject in a way that leads to the generation of meaning not only for the student but also for her companions, including the teacher. As Hans Ulrich Obrist notes, 'The act of curating at its most basic is simply about connecting ... the task of curating is to create junctions, to allow different elements to touch' (Obrist 2015: 1).

But a crucial question emerges at this point. Who is making the connections? In other words, who is the curator? The shifts in understanding and practice of curating described above point to the emergence of a new model of personalised learning in a curriculum that is curated by the student. Raphael Hallet has noted how the emergence in recent years of a highly social, image-based digital environment means that students come to university with spaces of curation and display already quite well honed (Hallett 2016). It would be a mistake, however, to think that this means we should give the curriculum entirely over to students. Hallet's point is that curating is crucial because in its revised form it models the co-creation of knowledge: it describes the partnership between those with expert subject knowledge and those 'digital natives' who are already expert in visualising knowledge to build their own understanding of the subject in new and exciting ways. This in turn leads to the exciting prospect that students are able to take their experience of digital curation and managing an online identity and work with subject experts in presenting the outcomes of their collaboration to an outside audience.

The best way to explore how curation works as a means of knowledge co-creation is to look in detail at an example: art historian, curator and print specialist Ben Thomas's partnership with students to co-curate the Kent Print Collection at the University of Kent. In this chapter we consider why Ben's work has proven so successful, and what it tells us about students as curators of their own curricula – and, in particular, of the ways that students learn to produce outputs directed at an audience.

Curating as a model for learning

If curating offers a model for thinking about how researchers and students work together to make connections between different subjects, between university and the workplace, and between assessed work and external audiences, it also offers a history on which these ambitions can draw. Curating increasingly describes the practice not only of the gallery professional, but also of the artist themselves as well as the visitor. It is therefore not surprising that contemporary art has shown a great deal of interest in forms of engagement, such as collecting and display, that pre-date the establishment in the nineteenth century of large galleries and museums that enshrined a grand narrative of a nation's progress. In the words of one university-based curator: 'Traditional audiences [...] expect you to be the one who knows everything. That's *not* how it works in higher education' (Willcocks 2016; our italics).

Some of the characteristics of pre-modern museums, such as their capacity to provide a fully embodied experience where the visitor can feel and handle the objects, and the organisation of space around a central area for study, have re-emerged in university museums as part of what might be called the 'curricular turn' that started in the United States in the late 1990s and is expressed in the UK as 'object-based learning'. Universities in the United States witnessed a growth in campus-based museums in the second half of the twentieth century, fuelled in large part by private bequests and donations. Subsequent funding for outreach to schools and the local community has recently been matched by funding for work with students and staff within the university (Bradley 2009). Dedicated spaces, variously named 'study centres', 'study galleries', 'object study rooms', 'teaching exhibition galleries', 'laboratories', have been created to help staff and students engage more closely with objects, including works of art (Hammond 2006; Tishman, McKinney and Straughn 2007; Bradley 2009). The emphasis has been on a partnership between study centre curators, staff teaching their discipline, and students, to turn a space traditionally associated with the authoritative communication of grand narrative into a more student-centred environment, and going some way to realising Hein's vision of a constructivist museum.

University museums in the United Kingdom have developed in different circumstances to those in the US, and here greater attention has been paid to the pedagogical benefits of 'object-based learning'. The scholarship of object-based learning has been pioneered at UCL and is in its early stages, but its investigations have suggested that learning with objects is an effective way of

realising two key conditions of effective learning as set out in constructivist pedagogy: turning learning from an individual to a social experience, and broadening the focus from cognitive activity alone, to include a wider range of skills and competencies (Chatterjee, Hannan and Thomson 2015). These findings echo what Jean Lave and Etienne Wenger have written about 'situated learning' and how 'opportunities for learning are, more often than not, given structure by work practices instead of by strongly asymmetrical master-apprentice relations' (Lave and Wenger 1991, 93). This is borne out by case studies of students learning about objects through learning to be curators. For example, Alexandra Woodall observed that when students were confronted with an uncurated collection they were obliged to learn about how museums worked in order to make sense of objects whose meaning and significance was obscure because they had not been classified (Woodall 2015). These findings suggest that rather than putting people off, curatorial practices are a key way in which learning can be made meaningful through the situations in which it takes place. In our opinion this nicely captures the ways in which curating offers a very practical model for thinking about how researchers and students might use a connected curriculum to forge connections between different subjects, practices and audiences.

Educational research offers strong support for the efficacy of student curating as a model for promoting complex and authentic learning. Elizabeth McDowell's analysis of an art history module where students curated an online exhibition showed it was almost unique among a large number of projects in meeting all six of their criteria for how assessment can support learning (McDowell et al. 2006: 14). They noted that curating as a mode of learning was successful because it:

- emphasises authenticity and complexity in content and methods of assessment;
- uses high-stakes summative assessment rigorously but sparingly;
- provides opportunities to practise prior to summative assessment;
- is rich in feedback derived from formal mechanisms;
- provides a continuous flow of informal feedback on 'how they are doing'; and
- presents opportunities to direct and evaluate one's own learning.

McDowell's findings are echoed by others (Knight and Yorke 2003: 83; Grindle and Fredericksen 2010; for a student perspective see Littlewood and Wyatt-Livesley 2016).

Theories of learning seem to offer powerful support for the efficacy of curating as a means of connecting the curriculum and this is backed up by the evidence from case studies. As long ago as 2007 educators and curators in the US were discussing curating initiatives under the title 'Curricular connections'. It therefore comes as a shock to find that curators do not have many positive things to say about student curation. Bringing in students as full partners has been described as a 'tricky proposition' that is 'difficult to pull off' (Bradley 2009). Janet Marstine's analysis of ideal learning experience for student curators describes the process as 'messy', in a bid to acknowledge the unrehearsed and risky but potentially rewarding nature of such projects (Marstine 2007). Marstine observes that the examples cited by the literature as a resounding success can be found exclusively in 'elite private colleges with significant funding for pedagogical initiatives' (for an example, see Rodgers 2015) and suggests that one reason for the success of projects at these institutions is that they are able to offer small funds for the purchase of prints or photographs to be used in exhibitions that will be added to the permanent collection (Marstine 2007).

What follows is an account of the Kent Print Collection project and the related Print Collecting and Curating module at the University of Kent from the perspective of its convener Ben Thomas. As Ben shows, involving students in the formation of the collection and linking this to a structured curatorial project has proved to be a means of successfully negotiating some of the challenges identified in earlier attempts to use curating as a means of connecting the curriculum.

Connecting the curriculum with the Kent Print Collection

The Kent Print Collection was established during the summer of 2005 when, with extraordinary beginner's luck, Ben purchased from the art dealer P. Y. Chin in London's Portobello Market an impression of *Christ and the Adulteress*, an engraving made in 1575 by the first female print-maker Diana of Mantua, working after a design by Raphael's pupil Giulio Romano. During a period of study leave Ben noticed that the prices for Old Master prints had dropped and that he was able to acquire works of art by artists that he was researching. This got Ben thinking about how putting together a small collection of museum-standard prints might prove a rewarding exercise for his students. Since taking Kent's Post Graduate Certificate in Higher Education programme Ben had been wrestling with the problem of how Art History might be taught in ways

that were 'student-centred' and which fostered 'deep learning' by involving students in an active process of discovery (Ramsden 2003). Working in a School of Arts alongside colleagues in Drama and Film he could see how practice-based learning, whether performance or film-making, fitted naturally into the programmes they taught, tapping into the creativity of students to enhance their learning. Perhaps collecting, and then curating the results of that collecting, could be the art historical equivalent? Fortunately, the then Head of the School of Arts, Professor Jill Davies, saw the potential in this idea and allotted £1,000 towards beginning the collection – leading to the acquisition of the Diana of Mantua along with 14 other prints. Ben then designed the module Print Collecting and Curating, putting the module specifications through the necessary learning and teaching committees, not without some search-ing questions about the viability and nature of the experiment proposed. This module is now in its tenth year, and ran for the sixth time in Spring 2017 with over 30 students enrolled. The module is very demanding on Ben's time and so does not run every year.

Students begin the module by studying the existing print col-lection to identify its strengths and weaknesses, learning about print techniques and the history of printmaking in the process. By using the associated 'handling collection' – several hundred genuine prints of low monetary value used for training students how to identify print tech-niques – this is a fully interactive process. Then, working individually or in small groups of two or three, they write an exhibition proposal containing a rationale, budget and proposed list of loans and purchases (30 per cent of the overall grade). Not only must the proposed exhibi-tion be art historically rigorous, it has to be inspiring and accessible to a wider public, and also feasible logistically within tight budgetary and time constraints – the students face the formidable challenge of putting on a show with £3,000 in a little over three months. The exhibition pro-posals that receive a first-class grade, judged against these criteria, are then presented at a class meeting or 'hustings', where the students as a group vote to adopt one winning proposal. This means that students effectively choose the subject of the module, and therefore that the lec-turer's role is more about advising and training than simply delivering module content.

Once an exhibition proposal has been adopted the pace of the mod-ule shifts with classes resembling focused business meetings with agen-das that reflect the interlocking deadlines that suddenly loom large. Typically the group splits into three: a curating team which develops the exhibition concept, identifying potential loans and purchases, and

carrying out research and interviews; a marketing team which tackles design tasks (posters, websites, the form of the catalogue) and publicity (press releases, social media, education programmes); and a finance team which manages the budget, negotiates purchases of prints, fundraises, deals with copyright issues and insurance, and handles logistical arrangements such as transport. Every aspect of the winning proposal is analysed and often rethought and reformed, with good ideas from other proposals being integrated into the project. Frequently the work of one group will stall while another group attempts to resolve a problem: for example, the marketing team cannot produce a basic exhibition design to go on banners, posters and websites until the curating team have decided the exhibition's title and chosen a leading image, and the finance team have then secured permission and paid any reproduction fee for the use of that image. Working through the sometimes complex ramifications of their decision-making processes, the students learn the value of teamwork and how to be creative while negotiating real constraints. They learn to accept constructive criticism in the spirit in which it is offered, and to be respectful of each other's opinions. Often mistakes are made – for example, a large banner for the exterior of the gallery was once printed with a costly spelling error that proof-readers had missed – but each mistake is a learning opportunity. This is undoubtedly the most demanding and stressful part of the process and it is here that the support and experience of the teacher on the module, and also of the partners we work with, is most telling.

After the list of works of art in the exhibition has been finalised, the delivery date for loans has been fixed, prints have been sent to the framers, the catalogue delivered to the printer, and the invitations to the private view have been sent out, the module then enters a more reflective stage with students working on their Log Books (40 per cent of the overall grade). These contain analytical sections on the art historical significance of the exhibition, but also self-reflective passages that consider the skills developed through the experience of working on it. Students document their own individual contributions to the project, which might include drafting press releases, interviewing artists, writing catalogue entries, arranging the transport of artworks, or sending emails and visiting galleries as part of loan negotiations. The next major task is the installation of the exhibition – now held in the University of Kent's Studio 3 Gallery, but before 2010 in Keynes College and at the Museum of Canterbury. At this point the curating team usually finds that the careful plans made for the hang, which at first were balsa wood architectural models but now use 3D

digital imaging, do not match the experience of arranging the works in the actual gallery space. Working with the Kent Estates team the students direct the hang and the lighting, and install other additional elements such as vitrines or stencilled lettering on walls. The private view is a celebratory occasion filled with justifiable pride at achieving a remarkable feat, but it is not the end of the module. The exhibition has to be invigilated, events and educational visits are arranged, and then finally the borrowed works need to be returned and the gallery cleared. The students all receive the same mark for the exhibition considered as a whole (20 per cent of the overall grade), a sometimes controversial feature of the module but one which motivates teamwork, and which is mitigated by a grade for individual contribution to the project (10 per cent of the overall grade).

To date five exhibitions have been organised as a result of running the Print Collecting and Curating module, and three further exhibitions were arranged by students in closely related but extra-curricular work. The Kent Print Collection's inaugural exhibition was curated by 11 undergraduate students working voluntarily with the 14 prints purchased in 2005 that made up the fledgling collection.

The first time that the Print Collecting and Curating module ran in Spring Term 2007 it resulted in the exhibition *Dreams and Nightmares*, held first on the university campus and then at the Museum of Canterbury (Thomas 2007). Here a larger group of 20 students worked together to develop the exhibition concept from an initial proposal devised by one member of the group, Claire Inglis. Thematic exhibitions have proved popular with student curators as they allow for a relatively wide range of prints to be selected, hence ensuring flexibility when delivering an exhibition to a tight deadline while also appealing to a broad audience.

Reacting against the rather sombre imagery of *Dreams and Nightmares*, the next group of 21 students to take the Print Collecting and Curating module adopted a proposal about humour in prints that led to the exhibition *The Art of Comedy* (held in 2008 on campus and at the Museum of Canterbury) (Thomas 2008). In developing the exhibition concept students were able to draw on research carried out in Kent's Drama department, with the expert in stand-up comedy Oliver Double bringing them quickly up to speed on the history and theory of comedy. In this way the development of an exhibition proposal led naturally to interdisciplinary exchanges.

The next exhibition based on the Kent Print Collection occurred in 2010 and took place in Studio 3 Gallery in the Jarman Building, the newly built home of Kent's School of Arts. This large 'white cube' style

gallery is perhaps Canterbury's most impressive exhibition space, and seemed to demand a shift in scale and ambition. The 22 students taking the module decided to focus on contemporary art in order to develop an area of relative weakness in the collection, and also in reaction to the prevailing Old Master feel of previous exhibitions. The criteria for including artists in this show was that they had some connection with the county of Kent, and this led to an eclectic and revealing show that brought together a roster of artists that included Frank Auerbach, Peter Blake and Michael Craig-Martin. The knowingly kitsch title *Krikey! Kentemporary Prints* marked a different style of curating on the part of the students: less British Museum and more Saatchi Gallery (Chan 2010). This show also witnessed a move away from purchases and towards loans, with the majority of works on display lent by leading commercial galleries. The exhibition was insured for over £250,000, showing that the students' artistic interests and ambition were not matched by the £3,000 budget they had to operate with. Nevertheless, they were able to fundraise to acquire prints by artists such as Ian Davenport and Tracey Emin for the collection. Impressed by the energy and purpose of the students, the artist Humphrey Ocean RA generously lent from his own collection and opened the exhibition.

Two further student-curated exhibitions were included in the Studio 3 Gallery schedule: *Double Take: The Art of Printmaking* in 2012, and *Underexposed: Female Artists and the Medium of Print* in 2014. The earlier exhibition happened because Professor Jo Stockham of the Royal College of Art invited our students to explore the RCA's impressive collection of prints. The second exhibition, *Underexposed*, grew out of an exhibition proposal that had been developed for the Print Collecting and Curating module: a proposal that recognised the curious fact that while the first print purchased for the collection was made by a woman, and all of the subsequent acquisitions were made by largely female undergraduates for specific exhibition projects, the Kent Print Collection had unintentionally reproduced the gender bias in favour of male artists that is so evident in more established art collections (Chiverton and Dickens 2014). It was also a landmark show for Studio 3 Gallery in being the first ever to be supported by a loan from a national museum, the V&A, prompting a national security inspection of the gallery, and a chance for the students to participate in the rigorous loan procedures required at this level.

The diversity of themes tackled by students was further demonstrated by the fifth Kent Print Collection exhibition, which took place in 2013 when 22 students developed an exhibition on fame and

the obsession with celebrities, evident in art inspired by Andy Warhol. The sixth and most recent exhibition of the Kent Print Collection took place in 2015 and was inspired by a Philosophy of Art module taught at Kent by Hans Maes entitled 'Exposed: The Aesthetics of the Body, Sexuality and Erotic Art'. Students who had taken this module wanted to explore, by curating an exhibition of prints, the philosophical question of whether sexually explicit imagery could be defined as art. The resulting exhibition was titled *Beautifully Obscene: The History of the Erotic Print* and raised obvious challenges for the student curators which they met by deftly avoiding sensationalism and maintaining high scholarly standards (with catalogue essays commissioned from leading researchers in the field of erotic art).

In devising the module Print Collecting and Curating Ben hoped to foster 'deep learning' in Art History through the practice-based activities of collecting and curating. To this end he was keen for the exhibition exercise not to be a simulation but to involve real works of art. What he did not anticipate was how opening up the module beyond the classroom would give it a real momentum of its own, stimulating academic enquiry that is genuinely interdisciplinary and enquiry-led and which also led students to develop practical skills such as fundraising, managing a budget and negotiating (to name but three). Connecting academic learning with workplace learning has afforded many students their first experience of the type of work that they might pursue as a career. What has made it so effective is that it results from experiences that are integral to the teaching of Art History and is not simply an additional emphasis on 'transferable skills'; anecdotal evidence suggests it carries more impact with employers than generic skills training.

The catalogues published by students have attracted positive reviews in leading journals dedicated to print studies, such as *Print Quarterly* and *Printmaking Today*, and were described in 2012 by *Art in Print* as 'exemplary'. Exemplary, that is, as print scholarship, not as student work. The fact that students will graduate from the module as published authors has certainly motivated them to raise the quality of their writing, aware that they are leaving a lasting legacy and not simply turning in an essay. The legacy issue is felt more broadly by students taking the module, with each new class of students determined to maintain the standards established by their predecessors and to leave the collection enhanced. In this way a virtuous circle operates with each cohort of students learning from past classes and nurturing future learning. From the teacher's point of view there is enormous satisfaction to be had from students thinking beyond the short-term goal of meeting an

essay deadline and believing that their studies will have an impact in the wider world and acting accordingly.

Finally, it is worth mentioning how the Print Collecting and Curating module and the Kent Print Collection have had a wider impact on the curriculum at Kent. Other practice-based modules have been developed involving photography, drawing, visual arts writing and internships in professional organisations. Prints from the collection are also routinely used in teaching more traditional modules, for example on Renaissance or Baroque art. The decision of the School of Arts to invest in a gallery space when it moved into the Jarman Building in 2010 was in large part due to the potential for enhancing educational attainment demonstrated by the Print Collecting and Curating module. The gallery's programme has involved a number of high profile artists, and this in turn has led to generous donations to the print collection – for example, Art & Language gave a set of their *Maps to Indicate...* prints following an exhibition in Studio 3 Gallery in 2011. An MA Curating was established four years ago, where postgraduate curators participate in a year-long curating project modelled on the Print Collecting and Curating module but not confined to prints. At the time of writing, the current exhibition in Studio 3 Gallery is *Curio: Sites of Wonder*, a contemporary meditation on the cabinet of curiosities, which was curated by the MA team – two of whom graduated from the undergraduate curating module. Even the 'handling collection' is now employed in the assessment of applicants during recruitment or 'UCAS' days in 'speed curating' exercises that have replaced formal interviews. Drawing ultimately on the imagination and creativity of students, the Kent Print Collection project has grown organically, forging unexpected and exciting connections across the curriculum and beyond.

Conclusion

The foregoing outline of the Print Collecting and Curation module shows how it meets all the points identified by McDowell as crucial aspects of an environment that allows assessment to promote effective learning (McDowell et al. 2006). It further promotes student learning by successfully addressing two other key issues that the literature has suggested can cause problems.

Bradley notes that 'it remains a tricky proposition to bring students in as full partners in museum functions', but cites some successful examples where students have been able to add to the collections they are

curating (Bradley 2009). This suggests that there is a potential for a clash between student curators and guardians of the (permanent) collection, which could disrupt the staff–student partnership. The Print Collecting and Curating module circumvents this issue because the works acquired for the exhibition with the funds made available by the university will be accessioned into the Kent Print Collection. This leads to a neat alignment between curating, collecting and the collection, a connection reinforced by the module convenor also taking responsibility for the Print Collection. How this hitherto cheerful arrangement will continue in the future as the Collection grows remains to be seen, and may emerge as one of the pedagogical challenges facing the module convenor. As Bradley suggests, the institutionalisation of the collection has the potential to alter the nature of the staff–student partnership.

A second issue raised by the recent literature is about the learning potential represented by physical environments. Claims continue to be made that 'the benefits of digitisation are obvious' but this has been often been disputed (DCMS 2016: 38). By making everything available, online environments can remove the opportunities for serendipitous learning by channelling the possibilities of where researchers can search (Hammond 2006). The materiality of the activity, from the dealers in Portobello Road to the exhibition space itself, creates a practical – that is to say, practice-based – environment that shapes what and how the students choose to learn. It also situates the module convenor's own curatorial expertise as part of this landscape of practice, rather than as an object for the students to admire from a distance and reproduce as best they can. Furthermore, working with unclassified material encourages students to learn about how to classify things and gain an understanding of how collections work. The handling collection is a key resource here as micro-curating activities using the collection serve to engage prospective students and can be used as a resource by teachers from any subject wishing to explore the potential of curating to foster a more connected student experience.

8

Developing online resources to support student research theses and dissertations

Evidence from the EdD at the UCL Institute of Education

Denise Hawkes

Introduction

Professional doctorates aim to enable experienced professionals to gain doctoral level academic research skills through research based within students' working environments (QAA 2011), allowing students to make an original contribution through exploring a problem of practice identified in the candidates' workplace. Of all the professional doctorates, the EdD is one of the most established within the UK (Mellors-Bourne, Robinson and Metcalf 2016) and the most studied in the academic literature, although relatively little is written about the online support for the thesis stage of the programme (Hawkes and Yerrabati forthcoming).

The Doctor in Education (EdD) programme has been running at the UCL Institute of Education since 1996. The programme consists first of a year of taught modules, in professionalism in education and research design/methods, which build up a portfolio of practice, followed by a 20,000-word Institution-Focused Study (IFS) which sets out the problem of practice the doctoral candidate faces and the context within which this happens. Finally, the student writes a 45,000-word thesis which attempts to address the problem of practice through a piece

of academic research. The aim of the EdD programme is for the candidate to make a contribution to professional practice through work on the three parts of the programme (portfolio, IFS and thesis) (UCL Institute of Education 2016).

This chapter reports on our experience of improving the online resources for our students at the thesis stage of the EdD programme. The development was funded through a Connected Curriculum staff-led grant motivated by student feedback.[1]

I was the principle investigator and worked with two colleagues on this development project. Through online forum posts, students were encouraged to provide their thoughts on the content and future resources they would like developed. Student representatives were also encouraged to seek student views of the resources developed, both in terms of the content of developed resources and which additional resources may be useful.

The aims of this project were:

1. to convert the module leader's library of resources for the face-to-face thesis workshops for a successful EdD thesis into resources for the new online site;
2. to develop a range of Web 2.0 resources to build on the original materials used in the classroom for the thesis workshop;
3. to explore tools to develop a sense of the EdD peer community for those who cannot make it to the face-to-face workshops; and
4. to consider the transferability of the resources developed for other research project modules within UCL, likely within social science and related areas in the first instance.

This chapter attempts to address point four, above, and to build on our experience of developing these resources and attempt to identify some broader design principles to help those developing online resources to support student dissertations and theses. This chapter also builds on an earlier presentation at the UCL teaching and learning conference (Hawkes 2016). While these resources were developed to support students at doctoral level this chapter will present the key design principles identified during this process. These provide general advice for developing online resources to support student research dissertations and theses at any level of study.

The chapter will proceed as follows: firstly, I set out how the EdD programme fits within the wider institution research-based education strategy, Connected Curriculum. Secondly, I present the context of the

ongoing rework of the programme in which the thesis workshops development occurred. Thirdly, I set out the development undertaken for the thesis workshops. And finally the chapter sets out the lessons learned from this project and presents student feedback on the development.

EdD and the Connected Curriculum

By its very nature as a professional doctorate, the EdD programme meets many of the Connected Curriculum ideals (UCL 2016), the institution's research-based education strategy, which, among other aims, seeks to bring research and education closer together, ensuring all students have opportunities to learn through research and enquiry. The EdD is designed to support experienced professionals within the broadly-defined education field, to facilitate the development of research skills and academic knowledge. It allows one to add to a body of research which makes a contribution to professional practice. Before the developments on the thesis resources, the EdD nicely mapped to the core principles and many of the Connected Curriculum dimensions (Fung 2017; Fung and Carnell 2017). That is, students learn completely through research and enquiry (core principle), with their work making real connections between their academic learning and their workplace (dimension 4). Our students are often very experienced professionals within education and related fields. The programme enables these experienced professionals to connect with UCL Institute of Education staff and their world-leading research, both through working with their research supervisor and engaging with the teachers and tutors on the taught modules (dimension 1). By its very nature the programme has a 'throughline' of research activity throughout the programme built through the taught modules and assignments (dimension 2). During the first year, the modules are designed to help these professionals develop the necessary academic and research skills to undertake their own independent research, which is first explored in the Institution-Focused Study. The students produce not just the thesis for the award of their doctorate but many produce publications for academic and practitioner journals. They therefore learn to produce outputs directed at a range of audiences (dimension 5).

EdD students are required to have a masters degree and at least four years' professional experience in education, although many have much more experience than this when they join the programme. Our students are seeking to extend their professional understanding and develop skills in research, evaluation and high-level reflection on

practice (UCL 2016). The student cohort provides an important element of the programme working as critical friends throughout the modules and thesis. This helps the students to develop their own support network of fellow research students, with these connections often lasting throughout the thesis stage and beyond the EdD itself (Hawkes and Taylor 2016).

General programme development

The thesis workshop development built on an increasing use of online resources on the EdD programme inspired by the Institutional Validation[2] in 2014. In this validation the programme team proposed the development of virtual alternatives for students who were unable to attend the face-to-face delivery as well as to build towards an online version of the EdD programme (Institute of Education 2014). This started with the development of online resources for the taught modules and the IFS.

The change was most dramatically found on the IFS workshops. In addition to the development of online resources for each face-to-face workshop, at the IFS stage the curriculum for the workshops was refocused away from knowledge of more research methods towards information of the research process especially around scale and scope of the project proposed. These developments led to more students designing valuable and feasible research projects which enabled them to complete their IFS on time, with significantly fewer extension requests made since the redesign (Hawkes and Taylor 2016). This development was important given the nature of the part-time and very busy student body.

Thesis workshop development

The EdD Thesis Workshops had run exclusively in a face-to-face mode with little supportive material on the Virtual Learning Environment (VLE) Moodle. The module leader had developed a range of resources which he used in his face-to-face thesis workshops to support the students with a range of issues. Only around 20 per cent of the eligible students actually attended the face-to-face delivery. Given the non-compulsory nature of the workshops, many students, especially those based overseas, often miss out on these workshops and the opportunity to benefit from peer community dialogue. With the programme team having developed enhanced Moodle sites for the taught phase and the

IFS workshops, it was timely to redesign the Moodle site for the thesis workshops, building on the face-to-face resources developed already.

The development enabled the enhancement of the mapping to the Connected Curriculum. EdD students develop their theses, drawing on the early programme taught provision and IFS, which connects academic learning with workplace learning. They write for their own practitioner publications so that the findings of their research are disseminated to other practitioners to ensure their research has a real-world impact on professional practice. They also write for academic journals as part of the research degree journey making contributions to academic knowledge. Both types of contribution draw heavily on the academic research skills taught on modules and their own professional experience. Writing for publications helps these experienced practitioners become researching professionals. The module leader had developed a range of resources to support the students in developing their thesis, make a contribution to professional practice and publishing their work. This project sought to build on the development of the online resources based on these face-to-face sessions and leading on from the IFS workshops development, which largely focused on the research process and management.

In addition to making online resources for the thesis stage, the development has built on the experience of the IFS workshops to provide a space for students to 'connect with each other, across phases and with alumni'. The thesis workshops are open to students from completion of their IFS in mid-year 3 of the programme to their completion of the programme within years 4 to 7. In the face-to-face sessions recent alumni are invited to share their EdD experiences with the current students. The development of online resources sought to develop tools that could enable those missing the face-to-face workshops.

Lessons learned from the Thesis Workshop Moodle Site development

The thesis workshop development was underpinned by Salmon's five-stage model (Salmon 2014), which gives a framework for a structured and paced programme of activities online. It provides a link between the degree of e-moderating the academic module leader needs to provide and the level of technical support needed for the learner to develop online learning skills. The development focused on the first two stages of Salmon's five-stage model as this was the initial development of

online resources for this module. Considering the EdD is a part-time programme completed over four to seven years, many of the current thesis stage students had experienced the taught phase of the programme before the IFS development and validation. As a consequence, they had little programme experience of online resources. In future developments, we will explore the next three stages of Salmon's model, as students who have experienced the enhanced programme in the IFS and taught modules reach thesis stage. Starting with stage one, access and motivation, it was important to think about the underlying organisation principle for the online site.

Stage one: explore key themes

The first design principle in the development of the Thesis Workshop Moodle Site was to think through with the module leader the key themes which would act as the organising principle for the online resources. The face-to-face sessions took an overarching design principle of a journey through the thesis, from the thesis proposal to the viva and beyond. It was thought by the module leader that this structure was helpful and so was mirrored for the online environment.

The key themes for the material were:

1. Moving from IFS to Thesis
2. Thesis Writing
3. Thesis Components
4. Contribution to Practice
5. EdD Viva
6. Entry to the Academic Community

It was very clear from experience on the face-to-face sessions that the signposting process really mattered. This also built on the IFS workshop development which moved from a focus on research methods to a more research-process focus. This shift was to acknowledge the role of the thesis workshops which was distinct from the role of the research supervisor, who was the academic lead and guide for the project. With the diversity of topics among the student body, the research process was the common theme which could promote discussion and engagement with peers. Of course subject-based discussion was not excluded but the organising principle was on research process.

Focusing on research process was also important as the thesis workshops are accessible by anyone at thesis stage, those working on the thesis proposal and those just completing their viva. Therefore, the focus on process and the research journey would enable students to get from the site what they need and enable those at different stages of the thesis to support each other. Within the broad community of EdD thesis-stage students, there are various communities of practice. Wenger (1999) defines a community of practice as a group of people who share a concern or a passion for something they do and learn how to do it better as they interact regularly. For EdD thesis students, communities of practice develop based on location (being based in London and beyond), by subject expertise, by work role, by institution of work and by year of study. Therefore, the online space needs to enable students to meet and discuss within, as well as across, cohorts. This interaction could be enhanced by the module team's use of online posts in face-to-face sessions. In short, the key principle of design focuses on the research process being as important as context/academic knowledge in supporting dissertations and theses.

Through monitoring the student access of the digitised resources we found that the main resources frequently accessed by students were those which focused more on demystifying the processes of how to actually write a thesis and the assessment process for the work when submitted, as well as materials on the viva. Student feedback suggested that the section on thesis components and contribution to practice were important in understanding supervisor feedback about the structure of their work. It seems that regardless of topic of study, the focus on process was found to be helpful.

Stage two: developing individual resources

There are three design principles in the development of resources for individual activities for the thesis workshop online: exemplar extracts, sharing experiences and certainty in process. In each example is a description of the resource developed and a discussion of why it was found to be useful based on student feedback and programme team reflection.

Exemplar extracts

One of the resources used in the face-to-face workshops is extracts from previous EdD theses. In one example an extract from the

introductory chapter is used to highlight how the student uses this chapter to highlight their contribution to practice as well as act as a map for the examiners with regard to the structure of the thesis. The extract shows how the student signposts the content of each chapter for the examiner and manages the scale and scope of the project so that the examiner is clear what is and is not included. This extract is used in the face-to-face class to facilitate discussion of the structure of the thesis, the need to signpost this for the examiner as well as a discussion of the scale and scope of an EdD thesis. In the online environment the resource is used to prompt discussion on a forum. Guided questions used in the lesson plan for the face-to-face sessions are amended for this online forum. The forum enables students across cohorts to communicate and share, with those later in the thesis writing stage providing different insights to those earlier in the process. The online environment can also be accessed by those who attended the face-to-face sessions and this provides an important link to discussions between the two modes of delivery.

The use of exemplar extracts from previous EdD theses helps our students to decode the research process vocabulary and supports the students to see what others have achieved, and provides hope that they can produce something similar (Lawrence and Zawacki 2016). As our students are experienced professionals they are very competent workers but are not necessarily academics. Therefore, they can feel 'lost in translation' between their strong professional knowledge and the requirements of the EdD thesis. Terms well known to academics, such as 'rationale' and 'theory', can be confusing. Sharing of exemplar extracts helps the translations through both the access to the document and the peer sharing of the examples. The students are able to have discussions both online and in face-to-face arenas; even good students need this reassurance of confirming the meaning of terms well known to academics. This translation is the toughest part of the EdD journey, that of the final transformation of the practitioner to the scholar-practitioner (Dailey et al. 2016).

In sum, exemplar extracts from previous theses and dissertations can be used as discussion points, in both face-to-face and online settings, to help students develop an understanding of terms common in academic writing. The sharing of these with peers in either mode helps the students to see that struggling with understanding is not unusual, and by developing this task it is also acknowledged as challenging. The role of students' peers is important in helping to understand the terms and the exemplar extracts can help to scaffold that discussion.

Sharing experiences

Thesis workshops provide those who attend with a safe environment to share concerns and experiences of the EdD thesis journey. Throughout the EdD the students are encouraged to share with their cohort their experiences during the workshops. At the thesis workshops there is an added dimension of being able to share between the cohorts with those at different stages on the EdD, as well as with alumni who are also encouraged to share their experiences. Moving to the online arena it was important to build on this tradition to give opportunities for online sharing. Successful EdD completers report that they were significantly supported by members of their cohort, and those who have these strong connections finish the EdD quicker than those who do not (Hawkes and Taylor 2014).

The sharing that was developed built on the notion of connectivism (Siemens 2004) as the EdD students have a strong bond after completing the taught phase of the programme. The online space needed to be both unstructured and structured. In the unstructured space the use of real-time chat and cohort forum were open for the students to share as they wished. Often sharing in this area was focused on things people were unsure of in terms of process and university services, for example library facilities and workshop dates. The more personal concerns seem to be shared outside of the university system and students develop their own networks through social media. Our light into this world comes from the student representatives who come to our programme team meeting. As part of the Connected Curriculum grant, we encouraged the student representatives to seek their peers' views of the resources developed and to ask which resources were found most helpful. We also exploited the Moodle site data which records how often and for how long resources in various parts of the site are accessed. The student representatives were often able to help us interpret the data from Moodle in terms of why resources were accessed, for example in terms of the students' perceived value of the resource. This link between the quantitative data from Moodle and the qualitative data of the student representatives' feedback helped us fine tune the online resources provided.

The more structured sharing is designed using forums through two main areas. Firstly, in the face-to-face sessions the module team had a series of questions to help facilitate small group discussion around common concerns and challenges. These lesson plan prompts were used as the material to develop these forums. These forums enable members of the cohort to act as each other's guides both online and face-to-face.

This linkage between students is highlighted in the Dissertation House model which suggests that moving away from the apprentice-master model to a more collaborative model is ideal for improving completions on the doctoral programme and reducing dropouts (Carter-Veale et al. 2016).

Secondly, the face-to-face environment was also an opportunity for peers to review each other's work and if they desired to present what they had for feedback. In the online environment it was possible to replace this with posts of a two-minute video and requests for feedback by forum message. This has worked well for those who previously had not come to the thesis workshops and appears to be prompting more engagement with the face-to-face sessions. In addition, the use of forums means that conversations in the past are recorded and can be used by new students when they face similar issues, which is a benefit beyond the face-to-face delivery. Student representative feedback suggested that this was well liked by those with good IT skills but not so well appreciated by those who struggled with making a two-minute video. We are exploring options of developing resources or linking to existing institution resources for those who lack these skills. Unfortunately, the willingness to try a new resource is a more challenging problem to resolve.

In sum, encouraging the use of both unstructured and structured discussions online enables the EdD students to share their concerns and knowledge. This sharing helps support the students' academic development through helping them to see their concerns are normal and addressable. This safe environment to ask what may be silly questions is vital to the EdD students and an important aspect of the thesis workshops. Making a virtual equivalent has enabled those who work on the EdD at a distance to experience this peer support too.

Certainty in process

By far the most used part of the online resources and the most requested by students are resources on the assessment (viva) and on processes (for example formal review prior to thesis and ethics application). Students often find the university processes difficult to navigate and are unclear about the expectations.

The key assessment for the EdD thesis is a viva and the viva can be a mystery which causes many concerns for the students. As it is unlike any other assessment they have completed on the programme, they often request more information on the viva. In the face-to-face sessions this is addressed through the alumni talks, who share their EdD journey

and experience of the viva. With the move to the online environment, a wider body of EdD alumni have been able to share their experience. Alumni focus on what the viva is like on the day, including feelings and preparation expected.

The most accessed material was a collection of the most common comments from examiners on EdD thesis. This was put together by a member of the EdD administrative team and has been used extensively by the module leader of the thesis workshops to show what the common concerns of examiners are. These thoughts have been drawn from the examiners' reports from EdD vivas, with the permission of the examiners.

In addition to demystifying the viva process, material on the site presented examples of good practice documents. These documents related to the university monitoring process on the thesis stage with notes on why this is so important. Information was also provided on how these processes are intended to be used by the student and supervisor. Annual reviews, for example, are a valuable opportunity to reflect on the year that has gone and set milestones for the year ahead, provided students actively engage with the process. Sharing assessment experiences and exemplar documents, together with text explaining the value of these processes are an important part of demystification which helps the student to engage with these processes productively.

In sum, not assuming that students understand assessment processes and university processes is an important part of demystifying the environment for the students and improving their confidence in working within university processes and regulations. This is especially true of processes for research students and the viva, which for many is different to any previous experience in higher education. This demystification can be enabled by making it possible for recent alumni to share their experience with current students and for the module team to both provide examples of good practice documents and share practical tips to navigate processes. These examples can be delivered face-to-face or online.

Conclusion

The EdD programme as a professional doctorate fits many of the characteristics of the Connected Curriculum, which at its heart seeks to promote learning through research and enquiry. Although a doctoral-level programme, insights from the development of thesis workshops can be

relevant to other programmes at any higher education level, with a particular focus on a dissertation or thesis. The first step in this development was to ensure that the online resources were presented in a logical way. We selected an approach linked to the journey through the thesis, as the organising design principle. This helped students access the resources appropriate to them. It is worth noting that the movement of resources to the online environment was not merely about replication, but rather translation. In addition, many of the developed resources exploited the principles of connectivism which were possible because of the strong community of practice within the EdD cohort.

There are three design principles for the content of the online resources. These are: Exemplar Extracts, Sharing Experiences and Certainty in Process. The underlying message is that processes and structure matters as much as academic knowledge development to students completing dissertations and theses. Many processes and structures need to be translated for our students, to make them understandable and useful. If the process is important, then, it is worth exploring with our students to enable them to develop an understanding of its value. As part of this project's development we actively sought feedback from student representatives. This helped to reassure our students that processes achieve their aims. The same translation exercise is important for the vocabulary and structure of the dissertation/thesis. Exemplar resources and room for discussion can be invaluable here.

The role of the thesis workshops, whether face-to-face or online, does not replace the role of the research supervisor. The thesis workshops in any mode provide students with hints and tips to develop their work and an opportunity to share concerns with peers and alumni. This function makes the focus on process and structure appropriate. This is not to replace the role of the thesis/dissertation supervisor who will lead on the academic content and support the student's academic development. Clearly both are needed for a successful research output.

Finally, in relation to the aims of the Connected Curriculum, the project has successfully converted the module leader's library of resources into resources for the online site. A range of Web 2.0 resources were designed to enable students to collaborate and share information online through peer discussion. Access to exemplar resources and discussion forums helped to develop a sense of the EdD peer community for those who face geographic restraints, unable to attend the face-to-face

workshops. This chapter and the presentation at the UCL Teaching and Learning Conference have started the process of considering the transferability of the resources developed for other research project modules within UCL, likely within social science and related areas in the first instance.

9

Connected disciplinary responses to the call to decolonise curricula in South African higher education

Lynn Quinn and Jo-Anne Vorster

Introduction

In South Africa 2015 and 2016 were marked by widespread student protests. One of the main issues underpinning the protests was students' anger with how little higher education has transformed since the official demise of apartheid in 1994. In particular, students argued that it is time for universities to reject the iniquitous influences of colonisation and to decolonise curricula so that what and how they learn is more clearly connected to their lived experiences and ways of being of their communities of origin (Mbembe 2015). Protesting students argue that the knowledge drawn on currently in curricula comes predominantly from the global North. There is little acknowledgement of the important contribution to disciplinary knowledge of scholars from the global South. The teaching methodologies, assessment strategies, examples used in class and the general culture of universities are all designed to ensure that middle-class white students feel at home while black students feel that their culture is inferior and that in order to 'succeed' they need to assimilate and become like white people.

The call to decolonise curricula has been met with a range of responses from academics in different disciplines. Some academics are perplexed by the demands from students; they feel protective of disciplinary boundaries and identities. Some have embraced the challenge

and have realised that they cannot continue to design curricula and teach as before. In general, it seems that few academics are sure exactly what it means to decolonise curricula in their disciplines.

As academic developers whose role it is to contribute to all aspects of teaching and learning in our institution (and nationally) we felt it was important for us to explore, with the academics with whom we work, what decolonising curricula could mean. For the purposes of this chapter we focus on how academics in a range of natural science and humanities/social sciences[1] disciplinary areas have responded to the calls to transform their curricula and their pedagogy. We were guided by the following question: What could it mean to 'decolonise' curricula in the natural sciences and the humanities? We were interested in investigating ways in which curricula in both disciplinary fields can connect more strongly to the lives of students, the global South and African contexts.

Understanding disciplinary differences

We decided to focus on the natural sciences and the humanities as they have, according to Bernstein, very different knowledge structures (2000). Bernstein argues that disciplines evince different knowledge structures that impact on curricula and pedagogy. The hierarchical knowledge structure of the sciences means that students need to build disciplinary knowledge systematically, from basic to more complex knowledge. Selection and sequencing of knowledge in a science curriculum is important if students are to develop a sense of the structure of disciplinary knowledge and ways of thinking.

In most humanities subjects there is less agreement about the nature of disciplinary canons. In fact, there is often contestation around the ontological and epistemological bases for knowledge production as well as around the adequacy of explanations of exactly which underlying mechanisms have resulted in which social situations. This is because the social world is an open system in which there is a complex interplay of multiple mechanisms, the outcomes of which can be explained in different, often competing ways. These disciplines thus exhibit a horizontal knowledge structure with more latitude around selection and sequencing. The freedom that academics from these disciplines have to design curricula places greater responsibility on them to make choices based on sound epistemological, ontological and axiological principles.

Disciplinary canons are built over time, using discipline-specific research traditions and through processes of agreement among powerful

disciplinary 'experts'. Although there are often contestations within disciplines or fields, and canons undergo change, they are largely stable. However, as we argue below, we believe that part of the decolonisation of higher education is to ask critical questions about canons.

Maton (2014) argues that in all disciplinary fields there is always knowledge and there are always knowers. Therefore, what constitutes legitimate knowledge in a field and who can claim to produce and/or have legitimate knowledge are important curriculum considerations. As well as the selection of knowledge, academics also need to consider the kinds of 'knowers' their curricula would shape. According to Maton, in science disciplines the focus is more on knowledge than on knowers whereas in humanities the focus is more on knowers and less on knowledge.

However, we would argue that despite different knowledge structures and different disciplinary foci on knowledge and knowers, academics across the disciplines need to ask questions about what knowledge they select for their courses and whether what counts as 'powerful knowledge' of the traditional canons in their disciplines is still appropriate for a decolonising context. In addition, in all disciplines academics need to ask questions about the nature of the knowers their disciplines set out to shape and whether these are the kinds of knowers needed in Africa and globally for the twenty-first century. It has also become increasingly important to make knowledge meaningful to students' lived experiences in Africa.

Context of study

The context of this study is Rhodes University, a historically white, advantaged university in Grahamstown, South Africa. Since the official demise of apartheid in 1994, the university has transformed, inasmuch as the majority of students (64 per cent) is now black although the academic staff complement remains predominantly white (75 per cent). Rhodes University has among the best overall undergraduate pass rates in the country. However, as brought home to us by the student protests, many students do not believe that real transformation has occurred. Students from across the disciplines are now calling for curricula (including pedagogy) to be decolonised.

Although there has been a strong call for curriculum transformation in South African universities since we became a democracy in 1994, few academics have engaged substantially with what kind of transformation is required. When the stronger discourse of decolonisation emerged,

many academics and academic developers felt even more uncertain as to how to respond. There were, however, some academics who were grappling with the challenges for transformation and decolonisation of their curricula so early in 2015 the Teaching and Learning Centre at our university began a series of *Curriculum Conversations* for the university community. At these fortnightly events, which are ongoing, academics share ways in which they have conceptualised and responded to the need for curriculum transformation and decolonisation in their disciplines. The purpose of these Conversations is to stimulate debate among academics about curriculum and in this way begin to formulate an overall response to the challenges we face.

In order to consolidate the ideas that have emerged from these Conversations and to ensure that more academics can learn from what their colleagues across a range of disciplines have done to decolonise their curricula and/or pedagogy, using the stories that emerged from the Conversations we compiled a teaching resource booklet. The booklet consists of an introductory chapter and 20 case studies, that is, the 'stories' told by the lecturers at the Conversations of ways in which they are responding to calls for decolonisation (Vorster 2016).

In our deliberations we encountered the work on Liberating the Curriculum at UCL, underpinned by the idea of 'making connections' – part of the larger research-based education enhancement initiative known as Connected Curriculum (Fung 2017; Fung and Carnell 2017). With the key principles of Connected Curriculum in mind we undertook an analysis of the case studies in the booklet that emanated from the Conversations. We found that the core principle that 'students learn through research and enquiry' is demonstrated in a number of the case studies. In addition, we argue that there are, *inter alia*, four key (overlapping) areas in which connections are made to respond to calls for decolonisation: 1) connections to research and knowledges beyond the traditional canons; 2) connections between the knowledge and pedagogy in a course to the lived realities of students; 3) connections which will enable students to navigate a supercomplex and ever changing world; 4) connections to a range of places, people and societies, including to students' local communities and beyond.

Connections to a range of knowledges

In the past, in our role as academic developers we asked academics to articulate their understanding of what counts as knowledge and to

describe how knowledge is created in their disciplines. We did not, however, push them to think deeply about the nature and appropriateness of the knowledge and how it connects to the lived realities and histories of students at this time and in this place.

Part of decolonising curriculum is to ask questions around whether the traditional disciplinary canon is the only form of powerful knowledge and if there are other knowledges, particularly those from the global South that are equally (or more) important for inclusion in curricula in both the sciences and the humanities. Establishing or including a canon of work by black scholars is an important strategy for decolonisation and offers the means for rethinking the relationship between the university and society.

A decolonised curriculum is one concerned with justice and knowledge-making processes within and beyond the academy. In both the selection of curriculum knowledge and research-based teaching, part of decolonising a curriculum is to engage students, particularly those from marginalised groups, in meaning-making activities to enable them to develop coherent accounts of their lived experiences (Anderson 2012).

For Mbembe decolonisation is a project of 're-centering'; it is about not assuming that the

> ... modern West is the central root of Africa's consciousness and cultural heritage. It is about rejecting the notion that Africa is merely an extension of the West ... [it is about rejecting] the endless production of theories that are based on European traditions; are produced nearly always by Europeans or Euro-American men who are the only ones accepted as capable of reaching universality. (2015: np)

There is evidence in some of the case studies of academics addressing some of these 'whose knowledge' questions. Vashna,[2] a History lecturer, developed an honours-level course on the history of what Gordon calls *Africana Intellectuals* (2014). The purpose of this course is to introduce students to Africans as intellectuals from across different time periods and from across different geographical regions of the world, from Africa to the Caribbean, to the United States. Vashna wanted to teach history that situated Africa as central to the emergence of ideas by and about Africans, the history of African (forced) migration over the centuries, the role of Africans in world religions – and in particular in the history of Islam. Furthermore, she wanted to show how current African thinkers

such as Thabo Mbeki have been influenced by the ideas of Africana intellectuals from across time and place. This course therefore *shifts the geography of reason* (Gordon 2014) from the global North to the global South. As a black intellectual herself, Vashna is able to use her research and her curricula in ways that do not reproduce society and the status quo, but that build different kinds of connections between peoples, places and knowledges.

Part of the reason for including black authors in courses is also to offer students exemplars of black intellectual life. Sally is a white lecturer teaching African politics to classes of mainly black students. Many of the theories about Africa and African politics have been developed by white, Western scholars. She makes a particular effort to include texts by African scholars in her curriculum. She attempts to compensate for her whiteness by including the voices and images of black scholars through the use of YouTube videos.

Both these case studies are examples of lecturers who have expanded their disciplinary archives to include the work of scholars from the global South to reduce the damage done to the psyches of generations of black students through the establishment of 'a hierarchy of superior and inferior knowledge and, thus, of superior and inferior people' (Grosfoguel 2007: 214).

To offer students opportunities to consider what it means to live good and ethical lives, Pedro and his team designed a course that connects knowledge from a range of disciplines. Students engage with a selected set of documentaries and films. Using students' responses to the films, he introduces them to concepts from philosophy, social psychology and many other fields, including Black Consciousness and post-colonial thinking, to stimulate in-depth conversations about issues such as how social pressures form minds, justice, morality, duties and responsibilities of individuals *vis à vis* society. In doing so Pedro encourages students to critically examine some of their long-held beliefs about important issues that speak directly to students' lives. This course bridges the gap between social psychology and moral philosophy and between classroom-based teaching and community-based service learning and between learning through printed text and other media. Crossing these boundaries offers opportunities to explore the complexity of the world and society.

In supervising postgraduate students who undertake research on sustainable water catchment practices in Southern Africa, Tally has come to realise that the kinds of problems her students research are complex and intractable and require participation from the communities who live in catchment areas. These problems can only be addressed through

interdisciplinary work that recognises the complex interplay of a multi-plicity of factors, including those related to the lives of the communities affected by the problems being investigated. The knowledge produced emerges from the context of application and requires knowledge sharing between the researchers and the community. Tally's students engage in scientific problem solving that makes use of the insights from a range of social sciences, the arts and knowledge held by communities.

In this section we have highlighted some issues related to the knowledge that academics select to include in their curricula. For some of the academics whose work we describe above, decolonising curriculum means critically rethinking issues around what and whose knowledge is taught and how this knowledge impacts on the lives of the students in front of them.

Connections to the lived realities of students

Higher education globally has become less elite and the diversity of the student body has increased. Many universities and academics have been slow to recognise the need for change to ensure that the lived realities of all students are acknowledged; that all students deserve to feel included and to thrive academically and as human beings.

In some of the case studies, lecturers show an awareness of the need to ensure that all students feel included and validated by their courses. Some have been aware of the urgent need to mitigate against the damage done by curricula which have contributed towards perpetu-ating a 'deficit model of Africa and Africans' (Alexander 2013 in Luckett 2016). For example, Susi in her Ecology course initiates students into research practices so that they see themselves as legitimate producers of new knowledge early on in their undergraduate programmes. She and her colleagues create many opportunities for students to 'do' science, by, for example, taking classes on field trips and field-based practicals in all years of undergraduate study. These field trips introduce students to the research process where they play an increasingly independent role in generating research hypotheses and testing them with the data they col-lect. In this way, students can experience what it means to be an African science graduate with the potential to make contributions to scientific knowledge production.

Vashna, in her History of Africana Intellectuals course, aims to erase the silence around African history and African thought that has characterised the history curriculum in most institutions. Vashna's

course contributes to students feeling validated and valued for who they are and where they come from. Similarly, Sally in her third year African Studies course encourages students, black and white, to reflect on how their own backgrounds have shaped their ideas about Africa and Africans and to be more critical of the way the continent is represented in the media and the academy. She requires students to critique and contrast ideas from mainstream (mainly white male) scholars with those of African scholars.

Although acknowledgement of student diversity is important, universities need to move away from the 'neoliberal diversity regime' where people are seen as consumers of knowledge and where differences between people are regarded as harmless and unimportant (Bilge 2013). In Natalie's second year Psychology course on Gender, Race and Sexualities she demonstrates that positionality and subjectivity need to be considered in curriculum decision-making processes. Positionality refers to how people are defined (race, gender, class, sexuality, etc.) and subjectivity refers to how social, cultural, economic and political factors shape students' lived experiences. By keeping these considerations in mind, academics can challenge the perpetuation of inequalities in society. Natalie creates opportunities for students to critically reflect on the implications of what they learn for promoting social justice and ethical being.

Paying attention to difference requires that teachers bring students' and their own experiences into the classroom (hooks 1994). For this they need pedagogic tools which allow them to embrace feelings of vulnerability and discomfort and to value not just academic knowledge but also personal and embodied knowledge. Thina, who teaches Statistics, shares with students her own experiences of growing up in a South African township, her feelings of confusion and alienation when she first went to an historically white university. She believes that students respond positively to teachers who connect with them on a human level. Because of her own struggles with the abstract nature of statistics, she makes connections to the contextual realities of her students' lives and shows them how statistics is embedded in everyday life and can be used to solve problems. For example, she refers them to a common township card game, *Unjiqa*, where they will have encountered the principles of probability, distribution and variance – important statistical concepts.

Luckett, in a study conducted at a South African university, found that the post-colonial university does not create enabling conditions for academic success for the majority of students. She suggests that 'At

the level of pedagogy, … there may be a "collective hermeneutic gap" between some academics and their students' (2016: 415). Corinne, who teaches the augmented curriculum for a Humanities Extended Studies programme, works with students most of whom find the pedagogic practices of the university alien. She uses a 'pedagogy of mutual vulnerability' to counteract the potential social, economic and epistemic violence that some students experience when confronted with knowledge and practices that are different to their own social, cultural and emotional norms. She reduces the power differences between her and her students by acknowledging the privileges and prejudices that her position affords her in the university context. She creates spaces for herself and her students to tell stories about their vulnerabilities. In addition, she makes explicit the often hidden norms and values underpinning academic practice. Viroshan addresses students' views of themselves as incapable of doing mathematics through engaging them in meta-thinking about how they have come to hold these negative views of themselves. He encourages students to construct a different relationship to mathematics by engaging them in creative mathematical problem-solving processes rather than focusing on formulaic problems that tend to reinforce student fragility in relation to mathematics.

Some of the pedagogic difficulties encountered by South African students are the result of stark differences in the quality of schooling for students from different economic and social backgrounds. There is an 'articulation gap' between what students have learned in high school, and what university learning requires of them (Scott, Yeld and Hendry 2007). Academic success and failure in South Africa is still racially skewed in favour of white and Indian students and those from middle-class families. The failure and dropout rate of black students, especially in the sciences, is unacceptably high. Karen, a lecturer on the Science Extended programme, is interested in curricula and pedagogies in the sciences that will contribute to students gaining 'epistemological access' (Morrow 1994). She has come to the conclusion that the articulation gap in the sciences exists at three levels: disciplinary knowledge, science literacies and what she calls 'being a science learner' (Ellery under review). In science curricula, especially at the first year level, attention needs to be paid to closing the gap in all three of these areas if students are to be given access to powerful science knowledge. Lecturers thus need to create opportunities to enable students to cultivate disciplinary knowledge, disciplinary literacies and ways of being both science knowers (scientists) and science learners that lead to academic success.

Environmental science is about learning to solve complex, non-linear environmental challenges that confront the world. An essential pedagogic strategy for this context is group work that enables learning through interaction, collaboration and sharing of ideas and experiences. However, as Gladman discovered, if group work is not well managed and students aren't taught how to do group work, it can impact negatively on learning and on how students view themselves. In common with most university classrooms, Gladman's students are diverse in terms of race, class, gender, ethnicity, language, personality, disciplinary backgrounds, etc. This diversity results in a multiplicity of ideological positions that can be the source of great tension. A challenge for Gladman has been to set up group work in ways that are conducive to learning and that offer safe spaces for all students. To do this he has embarked on 'courageous conversations' with his students in which they try to confront, in a dialogic manner, the possible tensions which may be created by the diversity of the groups (Thondhlana and Belluigi 2014).

It is axiomatic that it is through language that human beings make connections with one another. The role of language has been highlighted as a key instrument of oppression in colonised universities. According to Luckett, 'A key cultural resource for the emergence of human agency is language' (2016: 421). And yet the majority of students in South African universities are not given the opportunity to engage with conceptually difficult *higher* learning in their mother tongues. Black students 'will invariably experience a cultural system and curriculum that devalues and negates their home languages, cultures, histories and identities – thus positioning them as culturally deficient' (ibid.).

Alexander (2013, in Luckett 2016) argues strongly for the use of indigenous languages as resources in teaching and the building of languages for academic use. Monica, Deyi and Khaya use African languages as a pedagogic tool to facilitate student learning of disciplinary knowledges and practices. They use strategies such as multilingual exploratory classroom talk, and English for what is termed presentational talk. A strategy known as translanguaging in which African languages are used to develop and explore conceptual understandings is used to enable students to develop disciplinary knowledge. Switching between languages is about more than translating ideas and terminology; it involves higher order thinking and intercultural negotiation to draw on complex meanings of concepts in the multilingual classroom.

In this section the case studies draw attention to how curricula can pay attention to the diverse lived experiences of students – thus focusing on *being* and not only knowing. For students to benefit from university

learning they need to feel included and valued for who they are and for the societies from which they come. Pedagogies that pay attention to students' legitimate learning needs highlighted in this section include those that: reduce the power relations between students and their teachers; endeavour to make explicit academic practices; encourage connections between diverse students; bridge the articulation gap between school and university; and demonstrate to students that their home languages are a valuable resource for learning.

Connections to enable students to navigate a supercomplex world

It has long been argued that university curricula need to be responsive to the world and to society (Soudien 2015). However, as noted by Barnett (2000), this is extremely challenging in a constantly changing and supercomplex world. To prepare students for the future new epistemologies, as well as a radical reconsideration of what it means to be human in the twenty-first century are needed. Barnett therefore suggests that 'being overtakes knowledge as the key epistemological concept' (Barnett 2000: 418).

Facing up to the unknowability of a supercomplex world, which Journalism lecturers Gillian and Anthea have to prepare their students for, led them to focus more explicitly on the being of their students. Instead of coming into their teaching with a set agenda, they now ask students to work with them to navigate a new teaching and learning space. They harness the capabilities students bring with them by encouraging them to share with one another their knowledge and experiences of digital and social media and to use these to shape projects. They work collaboratively with their students to develop knowledge and storytelling practices. Gillian and Anthea are thus teaching students to be journalists who are responsive, reflexive and adaptable.

Leonie, a Pharmaceutical Chemistry teacher, decided to prepare her students for a future beyond the classroom by using problem-based, student-centred pedagogies and assessment methods. Formerly she taught declarative knowledge and then expected students to develop 'functioning' knowledge by solving integrated problems. Now she starts the course with a problem aimed at showing students from the outset what kinds of 'real' problems knowledge from the course could solve. She sequences the problems to become progressively more complex, thus providing scaffolding for incremental learning, internalisation of

difficult concepts and automation of functioning knowledge. Leonie also adopted an innovative assessment method that requires students to write 'stories' explaining how they go about solving problems. These innovations encourage metacognitive understandings about how science knowledge is used to solve problems and better prepares students for the complex world of work.

Nomalanga, a History lecturer, believes that many of the historical theories of the past are no longer adequate to deal with the questions and interests of contemporary students and nor are they adequate for enabling graduates to respond to challenges they will face when they enter the world of work. In her course on Economic History the socio-political, historical and economic context of South African social life is interrogated. Students learn the best of traditional political economy while also engaging with the language of contemporary economics of finance capital and its impact on society.

The strategies in the case studies in the section demonstrate attempts by lecturers to devise pedagogies that will enable students to better navigate the supercomplex world and help them to contribute to solving some of the vexing problems of our society.

Connections to a range of places, people and societies

Many black students have reported feeling alienated from the physical and cultural space of the university. This alienation impacts on their ability to connect at a deep level with what they learn (Mann 2001). One way of counteracting this sense of alienation and the distance between the university and society (and in particular the marginalised societies from which many students come) is to engage with and to minimise the absolute distinction between scientific knowledge and 'other kinds of knowledge' (Santos 2010: 278).

In a course for first year Journalism students on the importance of place for shaping thinking and experiences, Rod's students explore the diversity of peoples and places that make up South Africa. Each student writes about where they packed their bags to come to university. Students then examine a range of spaces and the people who occupy them on the university campus; they spend time in those spaces and get to know how the people in them think about important events on campus. They move into spaces in the town and get to know the people, aspects of their lives and their thinking. In this course, students produce and learn from short biographical texts, interviews, feature stories,

and so on. Through these exercises students become more engaged with each other and recognise and learn to value the differences and similarities among themselves, and between the campus and the town. It gives them an opportunity to see the conditions under which the majority of South Africans live and prepares them to work as journalists and to gather news from and write about topics emerging from many different contexts, places and people.

Susi's Ecology course demonstrates that what connects scientists from different times and places is the quest for solutions to real-world problems. She puts a human face to science by exploring scientists, the problems that exercised their minds as well as the science that enabled them to solve particular problems. Susi is especially interested in showing students that (South) African scientists, as a result of the economic constraints under which they have to work, are often able to provide unique solutions to problems.

In Kirstin's third year course on Information Systems Theory students learn about the influence of diverse worldviews and belief systems on how different people interpret and experience situations. Students reflect on the origins of their own value systems and how these can influence the way they approach information systems projects.

In teaching African languages to students engaged in professional studies, Pamela and her colleagues, Dion and Bulelwa, aim to break down the barriers between speakers of African languages and speakers of other South African languages. In these courses students discuss African culture; however, African students are often reluctant to discuss issues that they regard as taboo topics in a multicultural context. Through these discussions students come to recognise that many cultures share similar practices and values, albeit in different guises.

In this section the case studies have shown ways in which lecturers have found ways of ensuring that curricula connect to places, people and societies that are meaningful to students.

Conclusion

In this chapter we have worked with the 'stories' of academics grappling with decolonising their curricula. Through the Curriculum Conversations, the compilation of the case studies into a booklet as well as writing this chapter, we hope to have contributed to the ongoing conversations on how academics and academic developers can respond

to the students' urgent calls for the decolonisation of higher education. One of the main arguments that has arisen in decolonising debates is that students have felt alienated and disconnected from their university learning. The concept of 'Connected Curriculum' provided an organising framework to conceptualise how we can work with academics to design curricula and teach in ways which explicitly connect to the needs of all our students in a transforming (South) African higher education context. Although the chapter focuses on the South African context, we argue that the issues that we raise are relevant for academic developers and academics in other parts of the African continent, the global South generally, as well as the global North where student cohorts are becoming increasingly diverse.

Acknowledgements

We would like to thank the lecturers from Rhodes University who kindly agreed to allow us to use the ideas from their case studies for this chapter: Rod Amner; Natalie Donaldson; Karen Ellery; Ntombekhaya Fulani; Anthea Garman; Leonie Goosen; Monica Hendricks; Vashna Jagarnath; Corinne Knowles; Kirstin Krauss; Thina Maqubela; Pamela Maseko; Sally Matthews; Madeyandile Mbelani; Nomalanga Mkhize; Viroshan Naicker; Dion Nkomo; Bulelwa Nosilela; Tally Palmer; Gillian Rennie; Pedro Tabensky; Gladman Thondhlana; and Susi Vetter.

10

Connecting research and teaching through curricular and pedagogic design

From theory to practice

Elizabeth Cleaver and Derek Wills, with Sinead Gormally, David Grey,
Colin Johnson and Julie Rippingale

Introduction

This chapter focuses on one institutional strategic change programme
(Curriculum 2016+) and the journey from conception to realisation of
the programme's first stage: the process of curriculum and pedagogic
design and programme validation. To begin, we provide a brief overview
of the aims, scope and process of the Curriculum 2016+ programme. We
move on to discuss the new approach which lay at the heart of its curricu-
lar development activities and was embedded within curriculum design
processes and documentation. Finally, we explore how the curriculum
development process was executed in three disciplinary settings (Sport
Rehabilitation, Computer Science and Youth Work and Community
Development) to highlight the contrasting ways in which different pro-
gramme teams approached the challenge of redeveloping their peda-
gogies and curricula. To conclude, we offer some overall observations,
reflections and lessons learned that we hope will be helpful to others
undertaking similar curriculum development activities in the higher
education sector. While not directly structured around the Connected
Curriculum six dimensions of practice (see Editors' introduction and

Fung 2017), where activities reflect or resonate with aspects of these dimensions, these connections are highlighted and explored in the detail of the chapter.

Background

In 2013 the University of Hull embarked on a strategic journey involving complete curriculum and pedagogic redesign. Key to this strategic decision was a recognition of rising stakeholder (student and employer) expectations, the changing technological landscape and the growth of the digital knowledge economy, the increasing competition within the higher education sector (in both research and teaching) and a need for continued improvement in overall academic quality. It was recognised that these challenges may not be fully addressed through the usual incremental and risk-based continuous enhancement processes that underpin curriculum and teaching development in higher education. As such, a step change in the way the university met its educational mission was required. A major change programme, Curriculum 2016+ (C2016+), was established in December 2013 to coordinate this step change, comprising five interrelated projects and reporting to a programme board chaired by the Pro Vice Chancellor for Learning and Teaching. With the prime focus on improving the overall student experience, these included a holistic market-facing review and evaluation of the existing portfolio, the creation of a roadmap for the development of learning technologies and digital literacies and the development of a co-curricular employability award. However, key to the chapter presented here were two interrelated projects:

- Connecting Research and Teaching through Curriculum and Pedagogic Design – the promotion of whole institutional re-engagement with curriculum design and pedagogy as an academic endeavour; and
- Regulations, Responsibilities and Processes – the design of new approaches to quality assurance and enhancement to underpin curricular and pedagogic design work and to ensure responsiveness to new opportunities and future developments.

These two projects together developed a flexible end-to-end process for curricular and pedagogic design, reflecting the desire to maximise opportunities for innovation while acknowledging differences in resources, expertise and

epistemic starting points across disciplinary programme teams. Throughout the curriculum design process academic programme teams were supported in a range of flexible ways including a re-imagined developmental and dialogic programme validation process which prioritised the development of academic practice, understanding and knowledge throughout.

The change programme completed in July 2016 following the successful re-design and validation of over 680 undergraduate and postgraduate programmes, the majority of which demonstrated considerable change in their learning, teaching and assessment approaches. The phased introduction of this new academic portfolio and associated policies and processes began in September 2016 and wrapped up in September 2017. A second stage of the curriculum programme will assess the level and effectiveness of the planned changes in learning, teaching and assessment in practice.

At the heart of the design process was an underpinning vision and approach which was developed to encourage and support staff to make explicit the connections between their teaching and research within and across disciplinary communities and contexts and to engage staff in developing disciplinary and practice-based pedagogies and assessment practices that reflected real-world learning. These foci connect directly with dimensions 1, 3 and 4 of the Connected Curriculum framework, and it is to a discussion of them that the chapter now turns.

The C2016+ approach: connecting research, teaching and the real world

The C2016+ design approach was strongly influenced by the insights of Lee Shulman (1993) and Tony Wagner (2008), and was designed for Hull with two key aims in mind. First, to promote the recognition of the need for single rather than separate spaces and approaches to research and teaching in the university in order to ensure that students connect with and understand research and teaching in holistic 'disciplinary'[1] ways (see Shulman 1993) and second, to support staff and students to make explicit the now recognised connections between the skills of citizenship, work and learning in contemporary society (see Wagner 2008).

To achieve the first of these aims, programmes design teams, including wherever possible students, were asked to provide compelling pedagogic rationales as to *why* the chosen teaching, learning and assessment approaches were the most appropriate to use and how they would support students to achieve planned curriculum outcomes, in the

same way that a research methodology would be expected to provide the rigorous bedrock and process by which valid research outcomes could be achieved. This approach was led by the development of a university *Vision for Learning: Connecting Research and Teaching*, which is reproduced in part below:

> *The research, teaching and learning activities of our staff and students are fundamentally interconnected through academic disciplines, fields of study and areas of professional practice. Our understanding of this interconnectivity goes beyond simple research-teaching linkages [recognising] … the shared epistemic origins of research, teaching and learning practices in University settings.*
>
> *This approach helps us to recognise why teaching and learning take different forms and have distinctive characteristics across the institution and allows us actively to foster these differences. … Students from all programmes of study are encouraged and supported to articulate how the skills, knowledge and understandings that they have developed equip them for life in the world of work and prepare them to become active, responsible and reflective global citizens.*

In addition, a briefing note and diagram (see Figure 10.1) were developed to engage students and staff in understanding how the approaches to and processes of research *and* teaching (methodologies *and* pedagogies)

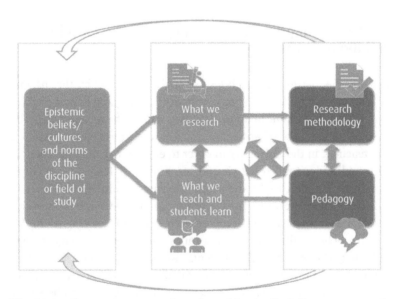

Fig. 10.1 Connecting research and teaching in disciplinary communities (Cleaver 2014)

are both informed by the epistemic underpinnings of the disciplines from which they emanate, and to which they actively contribute.

To realise the second of the aims – to make stronger connections between academic learning and the skills and practices of the real world – teams were asked to identify ways in which their academic programme and pedagogies could be meaningfully linked with the skills of the workplace and citizenship and how best to engage students in understanding these connections. Teams were also asked to identify how any attributes or skills that had been absent in the past, perhaps due to a perceived irrelevance to the academic discipline, might now be meaningfully incorporated. For example, how might enterprise and/or entrepreneurship be approached and developed within their disciplinary context? And how might traditionally text-based disciplines, such as English or Philosophy, meaningfully engage with quantitative approaches and skills?

This provided the foundations for the development of an approach where programme teams worked together to challenge and enhance curricula and pedagogies in ways that supported students to connect with staff and their research, to make connections out to the world and to connect academic learning with workplace learning. Key to this was an explicit focus on and exposition of the *big ideas* at the heart of each programme of study, the ways of 'knowing', 'thinking' and 'doing' or 'practising' in a discipline, field of study or area of practice (see Hounsell and Entwistle 2005) and the 'disciplinary habits of mind' that teams aimed to build and support in their academic and student communities (see Shulman 2005; Gurung et al. 2009). In addition, teams were asked to identify key programme-level threshold concepts (Meyer and Land 2003) that aligned to each programme's big ideas, ways of thinking and practising and disciplinary habits of mind.

Throughout, teams were asked to *make the implicit explicit,* to ensure that connections were made between academic skills and the skills of the workplace and society and that authentic formative and summative assessment tasks were developed to confirm that such 'ways of knowing, thinking and practising' had indeed been achieved. Teams were further encouraged to *think outside the module box*: to work together on and share their curricular and pedagogic designs to ensure that connections across and within programmes were explicit and that assessment strategies were coherent and planned.

A series of reflective questions was developed within institutional briefing notes, each articulating and supporting the achievement of a key curricular and pedagogic design theme and set of expectations. For

example, questions focused on whether programme and module aims and outcomes reflected an ethos of inclusion; whether the curriculum reflected a broad range of real-world examples and provided opportunities for students to draw on 'life-wide' experiences; whether students had opportunities to effect or contribute to positive change and development in communities (learning communities, local communities, workplaces) through action or research; whether curricula contributed to the enhancement of intercultural understanding and an international outlook; and whether clear connections were made between disciplinary manifestations of skills and attributes and wider graduate workplace skills.

As part of the end-to-end process of design and implementation, such questions and themes were integrated into the curriculum design phase of the university's quality assurance and enhancement framework and became central to the redesigned programme and module validation process. The new validation events themselves were reimagined as academic discussions rather than what had become perceived as a tick-box quality assurance hurdle to navigate. The new events were centred around critical dialogue between the programme design team, external and internal academic colleagues, students and external stakeholders, and learning from the development process was discussed and shared beyond the immediate attendees and at sharing and exchange events.

Connecting research and teaching in practice: some disciplinary reflections

To gain an insight into how this curriculum design approach was both interpreted and applied, we asked three programme areas – Sport Rehabilitation, Computer Science and Youth Work and Community Development – to discuss their C2016+ experiences.

Sport Rehabilitation – Colin Johnson

C2016+ enabled many of the thoughts, ideas and approaches previously discussed within the programme team to come to life. The opportunity to redevelop our programmes was met with a collective level of enthusiasm, motivation and desire to create student-centred, fit-for-purpose, curricula.

To add some background, the existing BSc Sport Rehabilitation was accredited by The British Association of Sport Rehabilitators and Trainers (BASRaT) with the profession recently approved as

an Accredited Register, administered by the Professional Standards Authority for Health and Social Care. Since 2013, Sport Rehabilitation has been formally recognised as a healthcare profession within the UK, which constitutes a huge step in terms of recognition and regulation within the field of neuro-musculoskeletal injury management. Such recognition brings the requirement of high levels of professionalism and competency to the fore for those working within the field: the Graduate Sport Rehabilitator (GSR).

Such standards were the catalyst for the programme team's initial approach, encouraged by the C2016+ ethos of a programmatic focus and making the implicit explicit. From a pedagogical perspective we were already implementing examples of good disciplinary practice including problem-based and peer-assisted learning, but often more at the modular level and without overall programme-level coordination. C2016+ gave us the opportunity to 'think outside the module box' and consider programme-level design in a progressive and coherent way.

The start point was the identification of the key graduate attributes and skills that characterise the practising GSR. These then became the inspiration for the *big ideas* underpinning the programmes: a*utonomy, working with others, competency* and *clinical specialism*. These ideas were mapped and developed across all programme stages enabling a clearer picture and shared understanding of the journey towards the development of the 'Hull GSR'. In the vast majority of cases these themes were apparent within the existing pedagogical approaches and module content but, importantly, were not always explicit, either within existing module descriptors or associated assessment strategies.

For example, problem-based learning (PBL) is a disciplinary pedagogic approach which is extremely relevant to the GSR in practice and clearly connects academic learning with workplace learning. However, the way this had previously been incorporated into our modules was highlighted by students as simply adding to their workload; the value of the real-world skills and understanding that it fostered was not evident to them. This informed a comparative exercise between the old and the new: how could we make our ideas come to life both on the page and from the page? From a personal perspective this period of time signalled the most significant indicator of the flexibility that the C2016+ design approach provided.

The reconsideration and streamlining of module focus, content and assessment from the programme perspective was coupled with the design of three end-of-stage thresholds for Levels 4, 5 and 6. Group PBL has been written into the curriculum at stage rather

than modular-level and students are now supported to work across the whole academic year on a given clinical case scenario, with the focus of the tasks based upon specific topics covered within modules during the year. The same case scenarios will be used throughout the three years of undergraduate study with layers of complexity added at each level. For example, at Level 4 students focus on anatomy and principles of injury assessment while at Level 6 students will consider neurological involvement coupled with the presentation of psychological issues. This new approach is designed to ensure that tasks culminate in an end-of-year presentation to peers from all years demonstrating aspects of *autonomy*, *working with others* and *competency*. This particular example enthused both staff and students who were consulted on the approach. Our students, although acknowledging the pressure of presenting in front of their peers, could see the real-life application of what was being proposed.

Students were involved in discussions and consultation throughout the C2016+ process and their input was particularly useful when consideration turned to the terminology employed by the programme team. C2016+ encouraged programme teams to design their programmes using student-relevant language, and student feedback from all year groups encouraged a hybrid of the old and some newly proposed terminology and helped the programme team to maintain their focus on making the programme aims, its pedagogies and its intended outcomes meaningful and explicit at all times.

A distinctive feature of the new Sport Rehabilitation portfolio is the introduction of a four-year Integrated Masters programme (MSci), the first of its kind within the field. This provides our students with the opportunity to follow a tailored pathway into postgraduate study and develop clinical specialism to further enhance their employability. This, as well as some of the examples highlighted earlier, has been acknowledged within the wider Sport Rehabilitation and Therapy education community and is testament both to the innovative approach, enthusiasm and foresight of the programme team and the freedom and ownership accorded to them by the C2016+ design approach.

Computer Science – David Grey

The broad, overarching intents of the new undergraduate and postgraduate programme portfolios in Computer Science were based on the applied ethos of the department and the key aim to develop computer science graduates that are capable of 'doing' and able to make an

immediate contribution in the world of work. The department identified two small staff teams, each of circa five individuals, to lead the development of the programme portfolios. The teams followed the design approach provided by C2016+, undertaking programme-level design rather than the modular content-led approach that had taken precedence in earlier development and redevelopment cycles. Each team worked to identify programmatic *big ideas* then shared these to crosscheck and evaluate their choices; they then worked on identifying the key threshold concepts (Land, Meyer and Baillie 2010) that would inform the programme narrative, aims and outcomes. Many of the programme *big ideas* (e.g. *learning by doing* and *the importance of real-world application*) and threshold concepts (e.g. *object orientation* and *object thinking*) were informed by the broad intents of the portfolios. A mapping to the programme professional body requirements (British Computer Society) was of key importance during this process to ensure continued future accreditation and national comparability of the programmes.

Following this initial design phase, a student focus group consisting of all course representatives from existing programmes was convened to discuss the proposed programme-level design, associated *big ideas* and possible delivery (module) structures. In parallel, the designs were shared with all academic staff to ensure that a common understanding of the programme design approach, and the choices made, was in place. All staff were then involved in the detailed design of the revised programmes and individual modules, with each staff member being involved in the design of at least one module.

The C2016+ approach differed from previous departmental approaches to programme design in a number of ways. From the outset it was more student-centred, involving more and regular student involvement in each of the design phases. There was also greater involvement of all academic staff and greater consideration of the pedagogies and assessment approaches to be used. Previously, programme design was largely undertaken by a small team and although colleagues had some involvement in contributing to specific module indicative content, often in isolation from one another, little consideration was given by all staff at the design stage to whole programme key themes, *big ideas* and outcomes and the pedagogic approaches that would lead to real-world student success. C2016+ offered a whole-team opportunity to consider learning and assessment approaches in detail at the design stage, to take stock of the approaches currently in use and to intentionally choose pedagogic approaches to benefit the students and to develop their employability skills.

As part of this process, we have particularly drawn on the insights of Christie (2009) who identifies signature pedagogies for Computer Science, which include:

- developing students' abilities in object thinking;[2]
- engaging students in *problem solving* and *learning through doing*;
- focusing on the *real-world applications* of computer science;
- emphasising the team-based and *collaborative* nature of the profession; and
- using *visual approaches* to explaining complex computer science concepts.

While these were already used to a greater or lesser extent within existing modules, we had not considered how they mapped across the programme to inform student development. For example, the new programmes now have a core focus throughout on group working. This is, in part, facilitated through increased placement learning opportunities which can be undertaken for a whole year or within modules, offering students real-world experience of the computer science profession and its collaborative approaches.

The language with which our programmes are communicated to our students has also changed. Legacy programme specifications and handbooks focused on technical professional body outcomes and the mechanics and structure of the programme. In the new programme documentation the *big ideas* of the programmes and associated teaching, learning and assessment approaches are articulated clearly and explicitly for a student audience.

The C2016+ experience significantly changed the approach to curriculum design taken by our programme teams and there have been many positive outcomes for our students. Staff have had new opportunities for development, with those involved in programme design encouraged and supported to reflect critically on existing and new pedagogic approaches and methods. Perhaps a lesson learned was that we could have benefited from more whole team involvement from the outset. The inclusion of further opportunities to pause, think, reflect and discuss developments throughout the project may have facilitated this collective creativity and ownership, reducing the number of changes that may now occur as the new programmes are delivered. It is important that, as the curriculum is rolled out, the collaborative and discursive approach that we have developed between staff, students and other stakeholders is fostered and expanded. This will not only be of benefit

to the new programmes but is also vital if we are to further model to our students the distinctive collaborative practices that lie of the heart of the Computer Science professional community.

Youth Work and Community Development – Julie Rippingale and Sinead Gormally

The BA Youth Work and Community Development programme has two Professional Statutory and Regulatory Bodies (PSRBs) and is staffed by a small team of four academics. In adopting the curriculum design approach at the heart of C2016+, the team developed and adopted a robust, highly participatory and transparent process which involved in excess of one hundred people. This included current students and past graduates, partner youth work and community development organisations from the statutory, voluntary and community sectors and legacy programme external examiners. The programme team facilitated the involvement of all stakeholders, collated the various viewpoints and utilised the findings throughout the process. Collectively, *the big ideas* and associated *ways of thinking and practising* within youth work and community development were developed. The following *big ideas* were formulated to incorporate programme-level threshold concepts (Meyer and Land 2003):

1. Developing critically informed educators equipped to work multi-disciplinarily in a range of environments, contexts and cultures.
2. Developing critically reflective practitioners and learners who can be self-directed and work as part of a team.
3. Connecting theory, policy, politics and practice.
4. Helping students to confidently articulate professional values and resolve conflicts between their professional and personal identities and values.

The programme team were all conversant with threshold concepts prior to the C2016+ development process and were therefore actively engaged in identifying and mapping programme threshold concepts to appropriate levels of the proposed new curriculum. These formed the framework for the entire curriculum design and provided an explicit focus for student learning and progression. By virtue of our PSRB requirements, the legacy programmes had also involved a range of stakeholders; however, a modular development approach had been previously used. *Thinking outside the module box* at programme level was empowering. The process

started with a clean page and an objective and contemporary view of the discipline as a whole. This ensured that modules did not reappear because they had always been taught and rather allowed new ways of thinking and doing to emerge.

Involving a relevant range of stakeholders throughout the process was key to the success of the curriculum design and modelled the participatory paradigm that is central to youth work and community development (Ledwith 2011). Practitioner symposiums were facilitated on the university campus and key questions were asked in order to gather valuable information that would relate to the creation of a meaningful curriculum. Students and graduates were involved in similar processes both in group sessions within the university and through an open space which displayed the curriculum development flip charts. Student participation was crucial in identifying where thresholds needed to be crossed in order to achieve higher level conceptual understanding, and which thresholds proved more difficult to navigate or were simply misplaced. For example, the previous programme of study taught a module entitled 'Ethics and Values' at Level 6 but students very clearly identified that this needed to be a Level 4 concept as it was foundational to their professional practice and academic learning. Similarly, students were directly involved in the process of naming new modules and testing out the terminology used. Students fed-back that a legacy Level 6 module 'Critical Pedagogy' needed to use more accessible terminology and be introduced earlier. The result was a new module 'Education and Social Change' (Level 4). Essential to this process was the commitment and feedback of our programme external examiners and the two PSRBs which had agreed to pilot the first undergraduate dual-accredited programme in Youth Work and Community Development.

Central to the development of teaching and learning strategies and the planning of resources was the ethos of critical pedagogy. This approach utilises mixed methods to ensure praxis between academic study and professional practice placements – both central tenets of the programme. As Cooper (2015: 44) states:

> Critical pedagogy ... offers a dialogical approach to generating criticality where tutor and student co-investigate the object of study. It is an approach that encourages students to explore and reflect dialectically the nature of social problems beyond traditional understandings invariably founded on positivist epistemological positions.

The legacy programme tended to 'bunch' assessments together at certain periods using an extensive and often uncoordinated range of assessment methods. A comprehensive audit of student experiences of assessment was therefore undertaken, supported by C2016+ and TESTA audit tools (Gibbs, Jessop and El-Hakim n.d.). The result of this audit was that assessments and assessment periods were distributed more evenly, with greater opportunities for formative and summative assessment across the year. Modes of assessment were directly linked to the threshold concepts and were made more relevant to the academic and professional skills reflected in the programme's *big ideas*.

Our approach to curriculum design changed dramatically as a result of this process and we would not hesitate to use this again in the future. We are strong advocates of the process and have engaged in national conferences within our discipline to share our experiences in addition to hosting visits from other institutions who have taken an interest in our approach. The C2016+ approach facilitated the inclusion of external stakeholders which, in turn, resulted in new scholarly knowledge within the team and a greater understanding of our disciplinary approaches to learning, teaching and assessment. We also believe that this process allowed us to achieve something that colleagues across the sector had deemed impossible: we became the first undergraduate programme in England and Wales to receive dual professional accreditation for youth work and community development.

For colleagues embarking on a similar journey, we believe that the following were key to our success:

- engaging in a clear, robust process;
- adopting a collective working ethos and practice;
- having visible, collective documentation of the process, e.g. flip charts;
- drawing on professional practice partner feedback, requirements and wishes; and
- using student and graduate feedback, experience and recommendations.

At the end of the first year of the new programme there is strong sense of ownership among stakeholders. We have a dynamic, exciting coherent curriculum which is highly relevant to the discipline and puts students at its heart. Moreover, there has been a significant increase in the number and quality of student applications and a vast increase in professional practice placement provision.

Concluding comments

As many across the sector will testify, the complete redesign of pedagogies and curricula across a whole institution is a mammoth undertaking and, to be successful, requires strategic direction and support as well as agility in its implementation. The consistent yet flexible design approach at the heart of C2016+ was key to providing direction for such changes at the University of Hull, while encouraging bespoke innovation and customisation within disciplines. As we hope is evident from the vignettes included above, each programme team adopted a locally relevant approach, reflecting both their disciplinary and organisational cultures as well as the needs of their external stakeholders and students. Thus, while there has been greater emphasis on top-down programme design, team development and partnership working with students and external stakeholders, flexibility has remained at the core of the design process. This has resulted in curricula that in a range of ways embody the values of the University of Hull, meet the expectations of relevant Quality Assurance Agency (QAA) Subject Benchmark Statements (QAA n.d.) and PSRBs, reflect the distinctive skills and approaches of each disciplinary team, reflect the skills of citizenship and meet the needs of employers.

Throughout the change programme, the end-to-end process for programme development and approval has undergone considerable development and adaptation. While we clearly needed a rigorous approvals process to meet QAA expectations, we also wished to ensure that the process was meaningful to academic teams. As such the new process was developed around critical dialogue between academics, students and other key stakeholders to ensure a meaningful, developmental, supportive and collegial approach. To ensure that the process was and remained fit for purpose, regular contact and discussions between quality assurance and academic colleagues was key, as was a willingness, where necessary and appropriate, to reflect on, review and adapt processes and academic regulations. At first this flexible approach created some uncertainty for academic colleagues who had, to date, perceived quality assurance and regulatory boundaries as non-porous and inflexible. However, as our vignettes testify, this agility ultimately provided us with the components necessary to build a culture which encouraged rather than curtailed pedagogic and curricular enhancement and innovation; something which is of paramount importance in the contemporary UK higher education environment. Moreover, the new programme designs resonate closely

with and demonstrate in practice three of the six dimensions of the Connected Curriculum framework, explicitly making connections between research and teaching, connections out to the world beyond the university and connections between academic learning and workplace learning.

Ultimately, the impact and success of the C2016+ programme can only be judged once the curriculum has been delivered in full, and further analysis has been conducted. However, it is already evident that across the disciplines there has been considerable change within curricular portfolios, increased emphasis on partnership working with students, external stakeholders and professional service colleagues and a stronger articulation and ownership of programme pedagogies and design. The process and organisational changes that have either taken place or have been recommended, provide a strong platform for future enhancement activities.

As a final point it is important to note that the completion and success of this programme to date would not have been possible without the open-mindedness, commitment and, at times, patience of colleagues. We therefore take this opportunity to thank all those who were involved in making this possible.

11

Connecting research, enquiry and communities in the creative curriculum

Alison James

Introduction

> Human-centered designers are doers, tinkerers, crafters and build-
> ers. We make using anything at our disposal, from cardboard and
> scissors to sophisticated digital tools. We build our ideas so that
> we can test them and because actually making something reveals
> opportunities and complexities that we'd never have guessed were
> there. (Ideo.org 2015)

This explanation of human-centred design has relevance for arts educa-
tion more widely, not just for physical making, but for mental, conceptual
and virtual practices as well. In considering the six dimensions of UCL's
Connected Curriculum (its framework for research-based education), it
is hard to think where connections between research, practice, teach-
ing, audience and outer world do *not* exist in creative disciplines (see
Fung and Carnell 2017). They permeate student–tutor interactions at
university in both simple and intricate ways. But design thinking is only
one approach to exploration. Others include the ways students model
behaviours on those of more prominent and experienced researchers
and the times when students take a lead in the learning of all. This
chapter will discuss innovations from different areas of creative arts

education which employ social models of investigation and evidence the pedagogic theories of constructionism, enquiry-based learning and Wenger's communities of practice framework (Wenger 1998). Vignettes from the University of the Arts London (UAL) illustrate student research practices which are about – and operate through – the arts, design and media. Countless examples can be found to illustrate all six Connected Curriculum dimensions; however, this chapter touches on 1 and 2 and concentrates on 3, 4, 5 and 6 (unpacked in depth below, but see also the Editors' introduction). The vignettes show how innovation in practice and enquiry combines with interests in identity, social responsibility and community. These surface connections which are internal (about individual growth, confidence and self-knowledge, as well as subject) and external, facing out into the world and linking with others. They underline the ripple effect of learning in creative communities which creates knowledge beyond the immediate subject and greater understanding of self and practice in context.

Clarifying terms: the creative arts and fashion

For brevity's sake this chapter will sometimes use 'creative arts' as shorthand to encompass not just the arts, but design and media. However, so doing recognises that all these referents hide worlds of nuance, difference and particularity. Within them, a specific referent such as fashion, for example, infers a field of cultural practice beyond the wearing of things that keep you warm, dry and modestly covered. It includes innovative design and creation, production and consumption and semiotic, sociological interests and psychological values that enable individuals to communicate and construct an identity in the world. Fashion is about the avant-garde and rare, as well as the everyday; about breaking scientific ground, as in the invention of new fabrics and cosmetics.

At the London College of Fashion (LCF), University of the Arts London (UAL) industry collaborations, projects, placements and partnerships are fundamental to student enquiry into fashion and vary widely in duration and commitment. While these are implemented at all levels of study, specific postgraduate collaborations include university-led partnerships with industry, student-led enquiries with external consultants and peer-led investigations between students across disciplines. In support of such investigations Cultural and Historical Studies (CHS) units are key course components which encourage students to 'make the familiar strange'[1] and to explore and question many aspects of

life and identity. Dissertation research into the abject, deviancy, gender fluidity, social norms, production and consumption, cosmetic surgery and cultural ideals of beauty are all ways in which students extend their understanding of fashion beyond external apparel and enter sociological territories of identity, self-construction and the Other.

What does research look like in arts-based education?

The word research in all fields has multiple interpretations, from the traditional and hypothesis-based, to the experimental and qualitative. As can be imagined, in the arts, design and media such types of enquiry are almost limitless. They include research that is industrial and commercial (e.g. prototyping and consultancy); conceptual and aesthetic; practice, craft and technological. The scale and range of pure and applied research which informs student enquiry is too great to be contained here, but illustrated in the section on principles 1 and 2 of the Connected Curriculum.

For artist and University of the Arts London Chancellor Grayson Perry, creative practice and research have a simple but deep purpose. In his address to the UAL Graduation Ceremony in London in July 2016 Perry asserted that the role of artists is to bring meaning into a meaningless world. Increasingly, as the vignettes show, this is concerned with the questions about human condition, social responsibility, wellbeing and sustainability. This is a critical and overlooked aspect of the activity of fashion education, illustrated by Professor Frances Corner (Corner n.d.), citing diverse initiatives to broaden knowledge and revitalise communities. These include regeneration projects in the East End of London; the *Cabinet Stories* travelling exhibition offering workshops and ideas about curation in unexpected places; the *Circle Collective* which promotes the acquisition of skills for permanent employment and the *Polyphonic Playground* which fuses dance, fashion, technological creativity and social interaction.

More often than not in undergraduate study, students conduct research to get to know their subject and its present limits; to go beyond these, to challenge positions and practices, find alternatives and create opportunities. Most of the vignettes in this chapter concentrate on this form of enquiry. One may argue that the line between independent study and research-based enquiry can become blurry. When students are identifying their own needs, posing the questions, challenging the scope of the answers, measuring them against what is already known, validating

and defining actions setting their own trajectories, independent study looks remarkably like research. The centrality of research and enquiry to cultivating a curious creative mind resonates with Brew's words:

> For the students who are the professionals of the future, developing the ability to investigate problems, make judgments on the basis of sound evidence, take decisions on a rational basis, and understand what they are doing and why it is vital. Research and enquiry is not just for those who choose to pursue an academic career. It is central to professional life in the twenty-first century. (Brew 2007: 7)

Increasingly the goal of such research is to meet a need which goes beyond aesthetics or consumption; to address politically and socially relevant issues and make a difference in the world. For students on courses with a creative business focus (and these come in all shapes and sizes) this might be about ethical and sustainable practices to do with production and supply chains, workforce conditions, the nature of products, reducing the carbon footprint and impact on the planet. Such forms of enquiry are often rhizomatic[2] in the ways that students can make multidirectional and unboundaried links between self, subject, outside world, creative practice and research.

Vignettes

Connected Curriculum dimensions 1 and 2

1. Students connect with staff and with the institution's research.
2. A throughline of research activity is built into each programme.

Connections to staff research activity happens in multiple ways – from those mentioned already to responses to industry requests or public engagement need. Many involve outreach to schools, organisations and communities; an example, combining fashion, science and environmental awareness, is the *Catalytic Clothing*[3] project, led by Professor Helen Storey and scientist Tony Ryan which used garments with a catalyst washed into them to help reduce pollution in the air and making it healthier and purer to breathe. The *Field of Jeans*[4] installation at Thomas Tallis School brought their ground-breaking enquiry into the secondary school arena, with jeans imbued with the catalyst staked out in the school grounds. Another work by Storey is *Dress for Our Time*, a garment

which digitally displays data from a major study highlighting 'global risks of future shifts in ecosystems' showing 'the impact of climate change' on the Earth. Such high-profile work, displayed in locations from St Pancras station in London to the Pyramid stage at Glastonbury, inspires student research and enquiry in a powerful but slightly more distant way.

In some cases, it is the student's activity which has the potential to be world leading, such as Renata Santos Beman's PhD research into the relationship between the 'born blind, and became blind' (her terms) and fashion. Beman addresses an area of invisibility and exclusion caused hitherto by the assumption that those without sight have no interest in the clothes they wear. External and internal research that challenges accepted views on beauty and fashion has been made accessible to students through the LCF *Better Lives* programme. This includes seminars on positive psychology and projects such as the *Beauty of Age*,[5] a series of which has been curated by students. As alluded to earlier, CHS offers both a throughline of enquiry, backed up by staff research and studied by students who explore fashion through theories of consumption and production, and the lenses of gender, identity, race, sexuality and religion. A first year unit introduces students to theories and key concepts, a second year unit invites exploration of select themes relevant to the course discipline and in the final year the dissertation is one way of exploring theoretical and cultural issues alongside a final major project which may be looking at the same subject but from a distinctly different perspective.

Connected Curriculum dimensions 3–6

3. Students make connections across subjects and out to the world.
4. Students connect academic learning with workplace learning.
5. Students learn to produce outputs – assessments directed at an audience.
6. Students connect with each other, across phases and with alumni.

For the most part the vignettes offered in this section embody aspects of the theoretical triad alluded to in the introduction, starting with enquiry-based learning, which Levy et al. define as follows:

> [Enquiry-based learning] describes a cluster of strongly student-centred learning and teaching approaches in which students' enquiry or research drives the learning experience. Students conduct small- or large-scale inquiries that enable them to engage actively with disciplinary or interdisciplinary questions and

problems. Learning takes place through an emergent process of exploration and discovery. Guided by subject specialists and those with specialist roles in learning support, students use the scholarly and research practices of their disciplines to move towards autonomy in creating and sharing knowledge. (Levy et al. n.d.)

As a supplement to this quote it is worth noting that peer-to-peer learning has a part to play in the development of enquiry and autonomy, in addition to specialist guidance. This may come in the form of mentors or student coaches, with higher year students typically supporting newer ones, although not always. Alumni often also contribute, either by being advisers on projects, acting as brokers between the educational and professional world, or through mentoring.

A rebalancing of power and authority through this sharing and developing of knowledge and expertise reflects the ebbs and flows of tacit understanding within a group. Such movement is evoked by Wenger in his Communities of Practice framework as 'changing participation and identity transformation' (Wenger 1998: 11). It is visible in the ways students see themselves and their worlds differently through research and enquiry. He cites 'three structuring elements of social learning systems: communities of practice, boundary processes among these communities and identities as shaped by our participation in these systems' (Wenger 2000: 1) and these evoke many aspects of creative activity. It is often socially situated; in a team, in a studio or centre with other practitioners, in apprenticeship models where the novice is learning from the expert and within relationships of acting as a guide for the community or serving it. His vision of learning as combining 'personal transformation with the evolution of social structures' (idem 4) aligns itself closely with the ways in which artists' identities are intertwined with both their creations and the context for their creating. This identification of self in practice and growth through creativity is noticeable in the vignettes for all participants.

In addition, creative and professional enquiry in the arts often evidence Papert's constructionist philosophy (Papert and Harel 1991): that humans learn best by making things, and that when this happens the outcomes are both an item and new knowledge. Constructionism, like communities of practice, is a social learning model which allows for connecting and generative thinking which goes beyond any resulting artifact. The importance of making something in order to prompt different insights or perspectives has been demonstrated in David Gauntlett and Amy Twigger Holroyd's workshops on creative research methods.[6]

One of these involved a collaborative knitting activity, in which knitting functioned as a form of participant observation, not just for the production of a finished piece. Other creative activities from the workshop helped generate questions around data and sense-making from a different perspective. In this example and in those which follow, participants walked away from the event knowing something unexpected about themselves and their fellow participants, as well as gaining knowledge about the subject.

The following section offers illustrations of the varied ways research, enquiry and communities are connected in the creative curriculum, rounded off with a personal reflection.

Shift

Shift[7] is an undergraduate online publication produced as part of the BA (Hons) Fashion Journalism at LCF. It is overseen by former course leader Josephine Collins and co-produced by staff and final year students. It was introduced in 2015 as part of a desire to ensure that all students had opportunities to engage in live journalism. In producing *Shift* all students have the opportunity to pitch for a role, write, edit and/or publish and experience how an editorial office works. This includes handling the pressures of tight turnaround times, rapid decision making and selecting, from the first editorial team meeting at the beginning of the week to publication on a Thursday afternoon.

As their course tutors are all practising journalists with major papers or media outlets, students are exposed to the priorities of the professional world and its artistry. They become skilled at making fast improvements to copy – spotting what is wrong with a piece, changing a headline, and understanding how to write a first sentence to entice a reader in. They learn how to make words fit a layout without losing impact, accuracy, mood or message, and develop the dexterity to do this so that the original author does not notice.

Students lead the production of the publication and make the key decisions as to content and layout and the editorial meetings on Monday afternoons are run by the student editor – giving instant and real experience of how to take charge of a meeting, review past issues (sometimes uncomfortable if a team did not work effectively or the final product did not turn out as hoped for) and respond to pitches of ideas/volunteers/suggestions for attendance at events and so on.

From then students communicate with each other via Facebook and perhaps liaise with students on other courses, such as Photography and Illustration, for collaborations on articles. Then on a Thursday the whole editorial team is expected to be present in the Newsroom to bring the publication to fruition – and anyone else who is interested who wants to join in. These have proved to be particularly appealing days for students who may not have been as engaged in other areas of their study.

The final 'publish' button is pressed by a member of the course team, once they are satisfied that the product is ready. This is part of assuring that while students have a responsibility to each other and to the project the actual quality and validity of their work is still signed off by a member of the teaching team. Not only are their outputs made public online, but they also contribute to formal assessment as part of a project proposal and in the final major project submission.

Shift evidences the theoretical triad introduced earlier in multiple ways; students work together in their community for a common objective and share tools and expertise along the way. They create both the online journal and also professional insights and self-knowledge about how they hone their skills and rise to the challenge of collaborating. They get to see their tutors performing in their professional capacity, not only teaching journalism, and learn from observation, emulation and the enquiry-based learning experience outlined by Brew earlier. They cross between boundaries of novice and expert and experience shifts in power and responsibility. They make judgement calls and learn from experience.

Social responsibility and prison projects

As Director of Social Responsibility at LCF, Claire Swift has substantial experience of projects which embody the principles of the Connected Curriculum. Three points of experience involve collaboration with prisons:

1. The *Fashion Education in Prisons Project*[8] brought students and staff together with inmates to design and deliver sewing and photographic workshops within a rehabilitation programme.
2. A Training and Manufacture initiative in Her Majesty's Prison Holloway, leading to level 1 ABC accreditation.
3. *The Beauty's Inside*,[9] a magazine produced by female inmates working under supervision with students on articles and visuals. This was a collaboration between staff and students at LCF, Her

Majesty's Prison Send and external expert advisers in law and criminal justice. In one roll-out of this initiative students visited the prison every week for 10 weeks to help inmates develop new skills and produce an outcome.

Such activities enable students to explore perceptions of social issues and differences in greater depth and increase their self-awareness. For the students it was in part about deepening their perspectives about the situations of others and how to help them effect positive change in their lives. For the inmates it was often expressed in terms of worth; they voiced this as having had everything taken away, including self-confidence and self-belief. Participation in the projects led to a feeling that they still had personal value, skills to offer and something to look forward to after prison. Many worked on themes to do with the self, expressing frustrations over having become a number not a person, a crime not an individual, and having lost voice and identity.[10] Barriers and preconceptions were also addressed through the activity; no knowledge of crimes committed was shared and everyone worked as a team (inmates were carefully selected to pose the minimum risk to other participants). As a group it was also about them belonging to a more positive community, a real team and developing new skills and knowledge through collaboration. Each project embodied the constructionist principle of creating items, which was accompanied by a resurgence in self-knowledge and hope for the future.

Sustainability

There are countless examples of the ways in which students at LCF have used enquiry-based learning approaches to address issues of obsolescence and reuse. One is the *Speedo LZR* project[11] where they were invited to create new cutting-edge fashion designs from swimsuit stock that no longer met competition regulations. Another was where students from design, media and business courses collaborated with Nike[12] to create new products that showed how sustainability could drive innovation. This venture included travelling to Portland USA to collaborate with a variety of organisations. A third involved the LCF Dye Garden in Mare Street, London, where plants are grown to revive and extend natural methods of dye production which are less harmful than current industrial practices. Inspired by the possibilities, a postgraduate student, Susie Wareham, focused her masters on experimenting with natural dyes and also ran staff workshops in how to use them. The impact of her research in the shape of a dye garden submitted for the RHS BBC Gardeners' World Live

2014 in Birmingham led to her winning a Silver Gilt medal. Her planting patterns were inspired by her exploration of the history of natural dyes in Birmingham and evoked a map of the city from 1731.[13]

Exploring human rights through design[14]

As already shown, partnerships are particularly fruitful when students work alongside staff on activities aimed at a public audience. Another example is the annual collaboration between Amnesty International and LCF students seeking to promote issues of human rights through design. This is an eight-day rapid fire project where 250 students all work in multidisciplinary teams (from design, media and business courses) in collaboration with academics and industry specialists. They work both at their university base as well as at the Amnesty headquarters and participate in bite-size rotational workshops led by practitioners (collage artists, consumer specialists, menswear designers and others) to help them create their designs. The campaigns are promoted to a global audience; the best ones go into production and then are used to raise funds for Amnesty across the world. There are three stages in this year-long collaboration: design, selection and production. Student designs are exhibited at Amnesty International Action Centre and presented at the Amnesty Student Conference where three outcomes are voted upon – the LCF choice, Amnesty Choice and public choice. In 2015 this focused on Amnesty's *People on the Move* campaign, with the student cohort split into two groups to consider people displacement through various lenses. These included the physical, conceptual and virtual: economic perspectives, gender, human rights violations, what home means, what space means. The winning three designs were selected to be sold by Amnesty online and in store.[15]

The connections made within this project were external, in terms of considering wider community issues and raising awareness of social injustice, and also internal. Students often went on difficult personal journeys in terms of grappling with human rights issues, and some had even lived through these in their own countries, which required sensitive navigation from the course team.

Digital creative practice for positive social change

The report *Discovering the Post-Digital Art School* (Deakin and Webb 2016), looks at ways in which professional creative practice is being

taught in a world where use of digital devices and the internet is increasingly embedded in everyday life. In the Foreword Professor Malcolm Garrett writes of the ways in which evolving technologies are catalysing collaboration and the development of skills:

> The new tools we now use also allow for faster trialing and prototyping of ideas, so design flow becomes more iterative, and is more able to absorb valuable input at crucial development points from diverse sources in a cyclical and non-linear way. Combine this with a rapid prototyping ethos, further enhance that with the multi-locational interconnectivity of the Internet and you have a creative workspace, part local and part regional, that was previously unavailable to us. (Deakin and Webb, 2016: 6)

In a series of workshops students came from many different disciplines, courses, levels, ethnicities and nationalities. They formed cross-disciplinary teams working both face-to-face (first iteration) and in cross-university online collaborations between UAL, Manchester and Falmouth Schools of Art. Communication was supported by the video-conferencing software Fuze and the messaging app Slack. During 'Modual', the third workshop iteration, week one involved preparatory lectures and exercises, while week two was an intensive production phase, where students worked on self-initiated projects with a positive social change agenda.

Students made connections out to industry and to their potential audiences/customers – both in terms of doing market research and producing three minute Kickstarter-style 'pitch videos' about their products, services or projects. These were directed at potential investors and/or users, and were presented to an audience at the pitch night, and streamed using Periscope. Many of the students had never produced a video before, with one girl teaching herself Adobe Premier overnight, so motivated was she by the project. There was a natural continuum between the students' course experience and workshop/team activity, sometimes resulting in additional successes such as winning competitions. Webb saw interdisciplinarity as a distinct benefit:

> It seemed to me that the more disciplinary diversity there was in a team, the easier it was for them to succeed (i.e. a team made up of a graphic designer, fine artist, interaction designer, film-maker, PR person and curator worked better than a team of two fine artists). (Personal communication to the author)

The collaboration did not necessarily end with the conclusion of the experience; some students continued working on their projects afterwards, while others became workshop leaders in the next phase of events. Their outputs were focused on some form of common, sustainable or socially responsible benefit:

- MANUAL – social network for recycling.
- FABRICUTORS – a way of selling second hand clothes with their history included.
- ENVIRON – a virtual environment for the disabled.
- VENTURETEERS – small-scale volunteering by students and young people – digital platform.

One participant commented: 'I learned how to listen before thinking and talking – it's all about problem solving, and that helped me a lot because I hadn't realised that before.'

Webb summarised the power of this initiative as fostering 'positive digital addiction showing students that platforms like Instagram and Twitter can be used in powerful and meaningful ways, rather than just for passive, mindless consumption'.[16]

Critical thinking with LEGO®: A personal reflection on practice

In writing this section I am suddenly aware of my own Connected Curriculum, or the steps I have taken and networks of people and practices which have enabled me to grow as an academic enquirer. This chapter's references include numerous publications, including my own, as detailed resources for using the LEGO® SERIOUS PLAY® methodology for complex exploration (Gauntlett 2007, 2010, 2011; James 2013, 2015; James and Brookfield 2014; Kristiansen and Rasmussen 2014; Nerantzi and Despard 2014; Nolan 2010). This system follows a set of applications and uses a metaphorical language in workshops where participants build, share and discuss models of complex issues and experiences. Physical connections (embodying virtual or intangible ones) can be built between these using bricks of various description and entire landscapes created which allow the in-depth exploration of questions to which there is no easy answer. Examples of my use of it have been with: international participants at an Erasmus convention, who constructed their ideas about successful and future Erasmus partnerships and activities; doctoral students, making models to critically reflect on their research

journey, alongside engagement with the Researcher Development Framework; postgraduate students, evoking their concepts of space and curation; and academics embodying threshold concepts from their own disciplines (Barton and James 2017). The impact of such activities was the engendering of new insights and possibilities, as well as bonds and understanding between participants. Building metaphorical models was either a reflective retrospective activity, a complement to traditional modes of enquiry or situated at a staging post on a journey.

Conclusion

In situating these vignettes within the framework of the Connected Curriculum (Fung 2017), the linkages are both implicit and explicit. Each one suggests a different point on the research spectrum, with emphasis on enquiry-based learning approaches in the creative arts. They all, however, share the driving force behind what research does and is intended to achieve. This is to create and extend knowledge and understanding in some way and to foster this further through building bridges between people and disciplines. In all of the examples students have been significant architects and users of these bridges.

12
Interprofessional education development at Leeds

Making connections between different healthcare students, staff, universities and clinical settings

Shelley Fielden and Alison Ledger

Introduction

Interprofessional education (IPE) is the term used in healthcare educa-
tion to describe opportunities when there are 'two or more professions
learning with, from and about each other to improve collaboration
and quality of care' (CAIPE 2002) and is a widely accepted means of
breaking down traditional hierarchies in healthcare and achieving
safer patient care (WHO 2015; Department of Health 2000a, 2000b).
It has become a mandatory requirement of healthcare courses in the
UK (Nursing and Midwifery Council 2008; General Medical Council
2009; Health Professionals Council 2012). While there is no guidance
from regulators on who should be involved, at what stage of training
nor how frequently, educators are expected to provide opportunities
for students to work with other disciplines as part of undergraduate
curricula.

Although IPE is mandatory in healthcare professional training,
interprofessional learning opportunities are notoriously difficult to
organise due to a number of logistical, practical and socio-cultural chal-
lenges (Carlisle, Cooper and Watkins 2004; Fook et al. 2013; Lawlis,
Anson and Greenfield 2014). Curriculum developers need to address

challenges to feasibility, such as varied timetable arrangements across programmes, different working practices between professional groups, variation in students' age, education level and experiences across programmes, institutional constraints, different cohort sizes and degree length between programmes and the impact of historical rivalries and entrenched cultural differences in how professional groups are perceived by others. In our experience, further challenges arise when curriculum developers wish to develop IPE that is grounded in current educational theory and healthcare practice.

To date, there is limited evidence on whether, and if so how, IPE contributes to students developing understandings about roles, responsibilities and multidisciplinary teamwork at undergraduate level and the impact this has on improving patient care (Reeves et al. 2010). We have also noted a lack of consensus in the IPE literature regarding appropriate educational content, format, timing and frequency. The best way of developing connections between professions remains unclear and educators are faced with difficult decisions when looking to meet regulatory requirements in relation to IPE.

In this chapter, we share tensions that have arisen in our development of two large-scale IPE initiatives at Leeds. The first initiative involves four universities, 13 health and social care programmes, and takes place in a range of clinical workplace settings in the region. The second initiative involves two universities, 10 health and social care programmes, and takes place on university campus. We highlight strengths and challenges of these initiatives and then present strategies for building collaborative and sustainable relationships between students, staff, universities and healthcare sites. These strategies will be helpful for curriculum developers who hope to build connections between students across subjects, and for healthcare educators in particular. Both authors have been involved in facilitating IPE at the University of Leeds, Shelley as the IPE coordinator with an education background, and Alison as a medical education researcher who previously worked in multidisciplinary teams as a music therapist.

Case study 1: Final year IPE

Background

This initiative was first implemented by Sue Kilminster and colleagues, who secured grant funding to develop and research IPE in Leeds, UK. A series of pilot workshops were designed to 'develop participants' understanding about each other's professional roles, to enhance

team-working, and to develop communication skills' (Kilminster et al. 2004: 717) and were informed by recent developments in workplace learning theory (Hager 2011). These theoretical developments emphasised the importance of work-based experiences for learning, a position akin to the core aims of the Connected Curriculum (Fung 2016; Fung 2017). It was deemed that the IPE initiative must be interactive and occur as close as possible to the clinical workplace. Pilot workshops were scenario based and the content was developed with input from academics, educators and practitioners from the three professions involved (medicine, nursing and pharmacy). More recently, patients and carers have contributed directly to the development of case scenarios and are involved in workshop delivery (Kilminster and Fielden 2009).

The pilot workshops were evaluated using observational methods and individual interviews with facilitators and participants (for further details about the pilot project and evaluation, see Kilminster et al. 2004). This evaluation confirmed positive benefits for participants, including improvements in communication and role awareness, so the workshops were extended to train final year students from a larger range of healthcare professions. These workshops are now in their twelfth year and we have over 10 years of evaluation data to draw upon and reflect on.

Workshop format and content

The three-hour long workshops are open to final year students from 13 different healthcare programmes, from four UK educational institutions across Yorkshire and Humber (audiology, clinical psychology, nutrition and dietetics, health visiting, medicine, midwifery, nursing, occupational therapy, pharmacy, physiotherapy, radiography, social work and speech and language therapy). The workshops are advertised via programme leaders, virtual learning environments or personalised emails, and students opt to participate by contacting the IPE coordinator (workshops are not compulsory). Workshops take place at established placement sites (normally training rooms in clinical workplaces). Each workshop is co-facilitated by two staff with different professional backgrounds, who are usually from different healthcare programmes and often from different institutions, in order to model collaborative practice. Each workshop is based around a case developed for its relevance to a variety of healthcare professions (themes include asking difficult questions, breaking bad news, and living with conditions such as autism, diabetes, postnatal depression or stroke). Two students are asked to interact with simulated patients (who play the role of a patient seeking help from a healthcare

professional or a carer of a person living with a particular condition, for example). Simulated patients are often chosen based on experience relevant to the case. The workshops are intended to be developmental – students only ever interact with others as themselves (as final year students rather than fully fledged professionals). This is important so that students do not go beyond their scope of practice and expected level of responsibility (paramount to achieving safe healthcare practice), and to enhance the authenticity of the interaction. Group sizes are limited to 12 students to allow for interaction, and active participation is encouraged throughout each session. Students who do not volunteer to interact with the simulated patient(s) are expected to provide constructive feedback to those students who do volunteer (in both verbal and written form). Facilitators and simulated patients are provided with the case scenarios and session plan (see Table 12.1) prior to each workshop and typically arrive early to begin establishing relationships and roles.

Table 12.1 Workshop plan (final year initiative)

	Activity	Lead
1	Welcome and introductions: state name, profession, current placement	Facilitators
2	Review workshop aims and objectives	Facilitators
3	Exercise – identify learning needs in relation to case scenario, communication skills development, understandings about multidisciplinary teamwork	Students working in multidisciplinary groups of 3–4
4	Exercise – establish ground rules	Facilitators and students
5	Overview of feedback model	Facilitators
6	Recruit a student volunteer to work with the simulated patient, develop an appropriate case scenario based on identified learning needs, student's role and level of training	Facilitators, students and simulated patient
7	Ten-minute interaction between the student and simulated patient	Student volunteer and simulated patient

(Continued)

Table 12.1 (Contd)

	Activity	Lead
8	Exercise – review of the interaction: How did you feel about that? What went well and why was that effective? What could have been done differently and how? (encouraging students from different professions to comment on their own role and approach)	Feedback provided firstly by student volunteer, then by student observers, then finally by the facilitators. All comments are put to the simulated patient to confirm, challenge assumptions and the simulated patient is directly asked to provide feedback in role.
9	Student volunteer re-runs a section of the interaction where a different approach was suggested	Student volunteer and simulated patient
10	Student volunteer identifies two areas of strength and one area for development based on feedback	Facilitators and student volunteer
11	Break – written feedback form completed for student volunteer	Facilitators, students and simulated patient
12	Repeat steps 6–11	
13	Invite the simulated patient to come out of role, offer general feedback and contribute to discussion	Facilitators and simulated patient
14	Summary: Re-visit aims and objectives and learning needs	Facilitator
15	Evaluation: Written feedback form completed for student volunteer	Facilitators, students and simulated patient

Connections formed

As workshop facilitators we have observed that students engage well with the workshop content, students and professionals from other disciplines and simulated patients. Key to the success of the workshops is the authenticity of the interaction with the simulated patients, along with the time allocated for peer and patient feedback. Although it is daunting and challenging for students to be the one in the 'hot seat' interacting with a simulated patient, the interactive and feedback elements

encourage students in the group to share how students or professionals in their own discipline would act in similar situations, to gain and offer helpful tips for working with patients and carers, and identify important similarities and differences between their professional approaches. As students only ever interact as themselves (at their current stage of training) and simulated patients play established roles in insightful and nuanced ways, students often become so immersed in the scenarios that they fail to recognise that the simulated patients are acting (despite this being made explicit at the start of each workshop). This level of immersion tells us that students' workshop experiences are relevant and authentic to real-life clinical practice.

Evaluation forms collected from the students at the end of each workshop indicate that students value the format and content of the final year workshops, with consistently high Likert scale ratings across the past 11 years (99 per cent have felt the teaching and learning methods were entirely or mostly effective, 95 per cent have felt that the workshop was entirely or mostly relevant to their work). Free text comments confirm that working with simulated patients and students from different professional groups is a highly positive experience for students. Simulated patients have been described as 'excellent at making [students] think about how we would respond appropriately' (dietetic student) and the opportunity to learn from others with different perspectives and experiences is seen as an 'eye opener' (midwifery student). Approximately 10 per cent of students go on to attend more than one workshop, in a busy final year when the priorities are demonstrating clinical competence, passing final assessments and securing employment after graduation. This is further evidence that students perceive the workshops as relevant for their ongoing clinical practice.

Limitations and obstacles to developing connections

Students who attend the workshops clearly benefit through developing connections with other healthcare students, staff, patients and carers. However, we strongly suspect that those students who are motivated to attend are already open to interprofessional collaboration and already demonstrate skills in building connections with others. Due to the voluntary nature of participation, there is a strong possibility that the workshops do not reach the students who most need to develop knowledge, skills and attitudes necessary for interprofessional healthcare practice.

This limitation is unlikely to be overcome while the workshops are not compulsory, assessed, nor assigned a particular module credit value.

The main obstacles to offering a compulsory programme are resource constraints. At present we run approximately 28 workshops per year. This requires teaching rooms at approximately 14 different healthcare sites, the involvement of 14 staff members (academia and practice based) and 10 simulated patients (who are paid for their time and expertise, along with travel expenses). Funding is provided by the medical school although partner universities support the initiative by contributing to scenario development and workshop delivery. Facilitators and simulated patients are provided with training, and workshop materials and refreshments are provided for the IPE workshops. This IPE initiative is therefore considerably resource intensive and work is required to sustain relationships with workshop venues, facilitators and simulated patients. The importance of relationships for sustainability became particularly apparent during the IPE coordinator's maternity leave, when it became increasingly difficult to recruit staff and students for the workshops.

Furthermore, we have noted different patterns of attendance between healthcare programmes. Over the years, midwifery and nursing students have attended most consistently, while only a small proportion of medical students have attended. In some cases attendance figures proportionally reflect the numbers undertaking training in a given profession, in other cases it reflects students' and supervisors' placement priorities (formal learning versus health service delivery), placement length, shift patterns or responsibilities of different professions undertaking training. Disproportionate medical student attendance is concerning for an educational initiative funded by the medical school and introduced to meet General Medical Council requirements. We are therefore working with placement sites to develop further ways of engaging medical students in interprofessional education and practice.

Case study 2: Early years IPE: Human factors in patient safety

Background

In the second initiative, the Schools of Healthcare and Medicine at Leeds (recently joined by the School of Pharmacy at the University of

Bradford) developed a large-scale IPE initiative focused on human factors[1] in patient safety (first piloted in 2011). Prior to this project, there were a number of small-scale IPE projects occurring within each School in both campus and practice settings. However, this was the first time that the schools had collaborated on such a large-scale, core IPE initiative that formed part of an assessed module. The compulsory nature of this initiative is one of its distinguishing features.

The initiative initially involved six programmes (medicine, midwifery, and four branches of nursing – adult, child, learning disability and mental health) and has expanded to include students training in assistant practitioner, audiology, pharmacy, physician associate, cardiac physiology, radiography and social work courses. The initiative is developed and supported by senior academic staff at each School and now involves 800 first year students each year.

The primary motivation for such a large-scale initiative was to ensure each School was meeting regulatory requirements regarding core IPE provision. Implementation was further facilitated by changing personnel within each School, and encouragement for IPE at management level and curriculum reviews that allowed reconsideration of how students were taught multidisciplinary teamwork skills within their own, uni-professional programmes. However, despite a track record of innovation in health professional education between the schools (Kilminster et al. 2004; Holt et al. 2010), this initiative took three years for us to agree on teaching format and content and put necessary structures in place (e.g. administrative support, room bookings, adjustments to timetables).

Workshop format and content

Teaching is delivered to students in the first year of their programmes (term two), as it was assumed that students were unlikely to have developed a strong professional identity at this stage, and be less likely to have negative stereotypes in relation to other professions. It was also anticipated that first year students would have varying degrees of practice experience and theoretical understandings from which to draw on, and that this would contribute to a rich discussion where students were able to learn with, from and about each other's experiences and perspectives in relation to patient safety.

Teaching materials were developed from content that had previously been delivered to medical undergraduates, as the focus on patient safety was felt to be of relevance to all health and social care

programmes. The format includes a presentation on human factors theory (Carthey and Clarke 2010), case studies and a number of small group tasks that are intended to encourage discussion, thus alerting students to their role within the multidisciplinary team in identifying and reporting concerns in patient safety. The intended learning outcomes are that students will develop appreciation and respect for the different roles and expertise within health and social care, be able to explain the contribution that effective interdisciplinary teamwork can make to safety in practice settings, and appreciate the impact that human factors theory can have on risk and safety. Learning is assessed via existing end-of-year summative assessment methods for each participating programme module or strand.

The teaching session is formally timetabled and supports a number of modules and strands in each programme that focus on communication skills, patient safety and teamwork (the module *Learning Together, Working Together* in Healthcare and the strand *Innovation, Development, Enterprise and Leadership* in Medicine). The format is a three-hour session taught on campus; students are divided into groups of approximately 25 and facilitated by two academic staff members from different disciplines (predominantly from those health and social care professions participating in the initiative and staff from biomedical science, education and National Health Service management). Facilitators attend training prior to involvement and are encouraged to meet with their co-facilitator before delivering the workshop. As the difference in programme cohort size ranges from 15–225 students, not all participating programmes are present in each student group. However, all groups have a minimum of five different programmes in attendance.

Connections formed

As workshop facilitators we have witnessed value in bringing students and staff together in such a large-scale IPE session. This annual event brings together 800 students and over 60 staff in a collaborative endeavour that would not otherwise occur. The initiative has had a positive impact on relationships between the School of Healthcare and School of Medicine, mellowing tensions that are typical when working across schools and leading to further collaborations in teaching, scholarship and research. Staff who have previously taught alone enjoy the opportunity to work with a co-facilitator from another professional background, saying it is 'great to work in a multidisciplinary environment'.

This second initiative has now been running for five years and student feedback highlights the perceived value of interprofessional learning; 89 per cent of students have felt that the session helped develop understandings about teamwork in relation to patient safety and 91 per cent have felt it increased their appreciation of different professional roles (2015 evaluation data). Students particularly value the opportunities to meet with students from different disciplines and learn about each other's programmes and placement experiences: '[The session] allowed me to learn more about their course and appreciate how eventually we will work as part of a team.'

Limitations and obstacles to developing connections

The development of a large-scale, core IPE initiative has raised a number of significant challenges for the staff responsible for developing the initiative and those recruited to facilitate the teaching. These challenges focus primarily on the logistics of implementing the session, the development of teaching materials that have relevance for large numbers of professions, and the challenges of facilitating interprofessional student groups.

Organising teaching for several hundred students across multiple programmes is no easy task. University systems such as timetabling (campus and placement) and room bookings are designed to support specific programmes and associated modules. Priority is given to programmes and modules that are taught at specific times on specific days. Ad hoc events such as large-scale IPE initiatives are not always scheduled at the designated module time and, as such, booking sufficient classroom space is problematic. Additionally, IPE by its nature is interactive and universities are unlikely to have sufficient classroom space to accommodate large amounts of small group teaching on the same site simultaneously. In this initiative, we deliver teaching across four buildings, two of which are unfamiliar to participating students and staff and many offer limited space for interactive teaching. Classrooms are typically set up for didactic teaching, with seats and desks in rows, which limits opportunities for interaction. A further logistical challenge lies in allocating students to groups given the differing cohort sizes of different programmes. While student numbers are proportionate to those working in practice, thought is given to ensure no single profession dominates a group. This is particularly challenging given medical students are trained in very high numbers (approximately 225

students per year) and are perceived to be the dominant, most powerful profession.

In the early stages of development, the planning team worked with programme leads to ensure teaching materials were relevant and appropriate for each profession involved and to acknowledge that this one-off IPE session needed to signpost students to relevant themes within each contributing module or strand. This was particularly challenging given no case study is relevant to every health and social care profession, as students have different roles, responsibilities and work with different groups in different settings. Furthermore, it quickly became apparent that the way patient safety was discussed within each profession differed. For example, the term patient was problematic for those who thought of themselves as working with 'clients', 'service users', or in the case of midwives, 'women'. A further challenge in developing materials was striking a balance between encouraging interaction, providing sufficient opportunities for students to learn with, from and about each other, and providing sufficient context and theoretical background to a discussion on patient safety. This was particularly challenging and continues to be so for facilitators who are delivering the teaching material. In facilitating the sessions ourselves, we have found it difficult to meet the dual objectives of students appreciating different health and social care roles, as well as developing their appreciation of human factors theory.

Managing professional hierarchies and responding to stereotypes and difficult situations can make facilitating IPE challenging. Academic staff responsible for delivering this initiative may not have experienced IPE as part of their own undergraduate or postgraduate training, nor facilitated IPE before, and so are unfamiliar with the unique challenges involved. Furthermore, our initiative involves a number of new healthcare professions (associate practitioners and physician associates) who the majority of staff have limited knowledge and experience of. Facilitators from a particular health and social care background are also more likely to most identify with students from that same background. This means that they may use language and examples that are unfamiliar to students who do not share their professional identity, and may be seen to share the views expressed by students from their own profession. This is particularly problematic when a student voices negative stereotypes of other professions that are not challenged by the facilitator, such as 'surgeons are less patient-centred'. Although we aim to minimise the risk of this

situation occurring through our facilitator training, the success of training relies on facilitators being open and willing to acknowledge their own biases and assumptions.

Discussion – strategies for building connections

In this chapter we have shared our experiences of developing and delivering two large-scale IPE initiatives. The first is a series of workshops for final year healthcare students that are optional, developmental, case-based, located in healthcare settings and grounded in workplace learning theories. The second is an IPE session for first year students, which is compulsory for students from a wider range of professions, located in university class rooms, and based on human factors theory. Both of these initiatives have, to an extent, been successful in connecting students and staff from different programmes, institutions and healthcare settings. However, neither has been perfect in its execution and IPE development has involved managing differences of opinion and reaching compromise. We have learned that all interests must be taken into account if we are to deliver IPE which is meaningful and useful – not only the interests of the different professions, but also those in different positions within each profession (research academics, teaching staff, university administrators, students, healthcare managers, healthcare professionals, patients, just to name a few). Each stakeholder has their own priorities, such as theoretical, educational, practical or patient safety concerns. While it may not be possible to match everyone's priorities all of the time, we have developed some strategies for ensuring our IPE is as collaborative as it can be. These include appointing an IPE co-ordinator, maintaining a learning attitude, embedding IPE into existing activities, organising facilitator training events, and acting on student feedback.

As evident in the two case studies, one of the biggest challenges of IPE is coordinating teaching across multiple programmes, institutions and healthcare sites. In our view, this teaching would not happen without the appointment of a designated IPE coordinator. At Leeds it is the coordinator's role to develop, deliver, evaluate and sustain IPE; her responsibilities include developing teaching content, organising teaching timetables, venues, facilitators and simulated patients, preparing teaching materials, arranging facilitator training, and maintaining relationships with everyone involved. It is through this work that the

various stakeholders can be consulted and different perspectives considered at every stage of IPE development and delivery. This level of collaboration would not be possible if the person coordinating IPE was doing this work alongside many other academic commitments. In our experience, it has also been helpful that the coordinator is not from a health or social care background herself, as she is less affected by historical tensions when building connections.

In working with people from multiple professions in various roles, we have observed large differences in the ways that people think about learning and the ways that facilitation (and healthcare) should be done. While we believe that IPE should be as authentic and close to real-life practice as possible, we have learned that this is not everyone's priority in IPE development. For some, meeting regulators' requirements is most important, for others, the priority is equality of experience across the professions, and some take a more pragmatic view, occupying themselves with the price of refreshments, for example. In developing IPE, we have discovered that all of these perspectives are valuable and it is important to try and understand where each person is coming from and learn from others' experiences and expertise. Although neither of us are medical doctors, we have come to realise that we are associated with medicine due to our employment within the medical school, and are located within the position of power that medicine has traditionally been afforded. In order to build relationships with staff from other professions, it has been important for us to listen to others' ideas and concerns rather than to dictate predetermined approaches. Often this has meant compromising on our desire for practice-based IPE, as in the case of the first-year initiative. However, this compromise has enabled us to meet the needs of the range of healthcare programmes involved.

One way that we have addressed logistical, practical and sociocultural challenges has been to embed IPE within existing activities. Instead of creating entirely new sessions and content, we have included IPE within existing modules or placement activities. The benefits of embedding IPE are three-fold. First, it minimises the amount of work needed for finding spaces in the timetable, rooms and facilitators. Second, it ensures that session content is relevant to the various professions involved, and third, it helps to secure the buy-in of senior academics within each programme, who are under increasing pressure whether working in a higher education or clinical context.

Co-facilitating IPE sessions is not the same as facilitating on your own, nor facilitating single discipline or other small group teaching. In the healthcare literature, it is well established that rivalries exist between the professions (Hoskins 2012; Ledger, Edwards and Morley 2013) and healthcare professionals maintain stereotypes that they may not necessarily be aware of (Joynes 2014). These rivalries and stereotypes are likely to influence the degree to which connections can be built between students and pose new challenges for facilitators who are experienced in teaching students within their own single profession. It is therefore essential that facilitators receive training, to highlight the idiosyncrasies of IPE facilitation and any unrecognised stereotypes, biases or assumptions. At Leeds, we invite facilitators to attend a training event prior to the IPE sessions and ensure that co-facilitators have each others' contact details so they can get to know one another before the teaching. Facilitator training helps to further promote an atmosphere of shared learning, as facilitators discuss how they understand terms such as interprofessional education and learning, raise concerns about facilitating student groups they have not taught before, and offer helpful tips and tricks based on experience from their own disciplines and previous IPE teaching.

Our final strategy is acting on student feedback. For example, first year students' evaluation responses have indicated that one of the most valuable aspects for them is the chance to interact with students from other healthcare professions. Through talking to other students informally, they learn about others' training, role and experiences, and are able to identify similarities and differences between professions themselves. This feedback has led us to allow greater time within the session for unstructured interaction, in which students can get to know other students and learn from each others' experiences.

Conclusions

Developing connections between different healthcare students, staff, universities and clinical settings is not an easy task. Our experience indicates that IPE is most successful and most relevant to practice when it is embedded in existing activities rather than added only to meet regulatory requirements. Furthermore, building relationships between all those involved in healthcare training and practice is critical to

developing meaningful IPE activities. Strategies we have found most effective include appointing a coordinator responsible for involving and building relationships between all relevant stakeholders, learning from others rather than dictating predetermined approaches, compromising on aspects which are not essential, providing facilitators with training, and acting on student feedback.

13
Digital education and the Connected Curriculum

Towards a connected learning environment

Eileen Kennedy, Tim Neumann, Steve Rowett and Fiona Strawbridge

Digital education at UCL

UCL is currently embarking on a major initiative to reshape its approach to teaching and learning to draw on its strengths in research while taking account of the current and future needs of students in a fast-changing, interconnected and globalised economy. The educational vision driving this is the Connected Curriculum (Fung 2017), outlined in the Editors' introduction. The Connected Curriculum has been defined as 'a plan for a joined up approach to education'[1] which will put research-based learning and teaching at the heart of UCL. Digital education will be at the core of the Connected Curriculum; in particular, it will be key support for dimension 6, 'Students connect with each other, across phases and with alumni'; it will also provide tools for dimension 5, 'Students learn to produce outputs – assessments directed at an audience'. As a result, UCL is in the process of creating a Connected Learning Environment (CLE) that will use digital education to support these and other dimensions of the Connected Curriculum. This chapter reports on the background to this project, the way we conceive of our anticipated digital environment and the rationale for its creation. While the CLE is not yet in place, the authors have spent the last two years undertaking a phased investigation to examine UCL's existing online learning environment, conducting individual and focus group interviews and workshops with staff

and students to gather their perspectives on current and future digital support, and exploring new developments in learning technology and online learning. Our conclusions have helped us identify what our CLE will look like and start the process of implementing our vision.

The future of online learning environments

Digital education at UCL currently supports a Virtual Learning Environment (VLE) (Moodle), supplemented by a selection of digital education tools, including a lecture recording system (Echo360) and a portfolio system (Mahara). VLEs, also known as Learning Management Systems (LMS), have had widespread – near total – adoption in higher education (Brown, Dehoney and Millichap 2015). As Brown (2010) observed, however, despite high expectations at their inception, implementations of VLEs have proved disappointing. For example, systems restrict student access to the courses in which they are enrolled and, while students can take part in discussions and collaborative activities created for them within a VLE, role permissions preclude the kind of active engagement enjoyed by the teacher. This has led to the sector developing a 'love/hate relationship' with the VLE since their 'design is still informed by instructor-centric, one-size-fits-all assumptions about teaching and learning' (Brown, Dehoney and Millichap 2015: 2). Such systems have begun to be understood as carrying values and imposing these on the way teaching and learning takes place within them. Code is not neutral: 'Classrooms, as one scholar puts it, are instances of built pedagogy, and the LMS, in a similar way, imposes a pedagogical model' (3). In this view, the transmission model of education imposed by typical VLEs clashes with emergent pedagogies within the sector emphasising active learning and personalisation, and has even led to calls for the death of the VLE (Wilson 2015).

However, there are other ways of using technology in learning. Tinmaz (2012: 239) has suggested that a connected network offers the potential for 'learners to increase their capacities, performances, and levels of knowledge while creating and reforming the information' and that social networking technologies 'have a superior potential to enrich learners' current knowledge, skills, and abilities'. A connected network might, therefore, be a vital part of what Brown, Dehoney and Millichap (2015) term the 'next generation digital learning environment (NGDLE)' to come after the LMS or VLE.

For Brown, Dehoney and Millichap (2015) the new generation of digital learning environments is unlikely to be a single application that

aims to do everything that the university requires. Instead, it may be more of a 'confederation' (3) of systems that prioritise certain features that allow it to work for users – interoperability, the capacity for personalisation, providing a cloud-like user experience and presenting a 'mash-up' of content from different places. A university may retain the traditional VLE or not, but may supplement or replace its features altogether with a confederation of components from many different systems. However, the capacity to allow integration at the level of data, platform and tools allow for the newly envisaged component-based approach to create a coherent and adaptive learning environment for students – one that leverages the power of learning analytics to provide feedback to students and inform learning design. Such a system would also ensure its design allowed for accessibility, employing 'Universal Design' principles to make it usable for all.

Where existing VLEs foreground their support for the transmission of content and the submission and management of assessment, the next generation systems emphasise 'collaboration, a true learning dimension' (7). Collaborative learning, where students actively work to construct knowledge together, is an essential part of the learning process (Laurillard 2012). The next generation learning environment can design in support for collaboration from the outset: 'a lead design goal, not an afterthought' (7). Further, in an interconnected world, students should not be restricted to their modules and classmates for collaboration:

> [students] can organize interinstitutional collaborations, discover content, and participate in MOOCs and other learning communities to augment their learning for a particular course. (Brown, Dehoney and Millichap 2015: 7)

The new systems would also have to find a way to resolve the 'walled garden' dilemma. The current LMS locks out all those not enrolled as members of the university or on a module or course, both for security reasons and in order to create a private environment for study, where students feel supported to make mistakes as they learn. However,

> The issue is that it is all too often viewed as a binary choice—a course is either public or private. A requirement for the NGDLE is to move past such an either/or view and instead enable a learning community to make choices about what parts are public and what parts are private. (7)

Such a system has greater potential to support the Connected Curriculum, since it would better facilitate students to connect with their peers across the university and with alumni and community outside. Students could more effectively choose to showcase the work they have created for external audiences and develop their digital capabilities necessary for work and leisure, as well as lifelong learning, by performing digital identity in a supported environment.

Such digital capabilities are required for life in social networks, which have become an increasingly important part of 'people's everyday lifeworlds' (Cook and Pachler 2012: 711). From this perspective, social networks might facilitate learning in informal contexts, including the kind of work-based learning envisioned by the Connected Curriculum. Since most work-based learning activities 'involve other people, eg, through one-to-one interaction, participation in group processes, working alongside others, etc', (714) the potential of social networks for supporting this kind of learning is considerable. However, while social networks may provide opportunities for connected learning, they are not without their own constraints, which the following studies on the use of Facebook in learning and teaching bear out.

Learning in social networks

Facebook has been associated with higher education since its origins, and is one of the most popular social networks among students: 'as many as 97% of college students have accounts, and they actively use those sites for nearly two hours daily' (Bowman and Akcaoglu 2014: 2). Donlan's (2012) review of social media use in education reported students' positive views of its capacity for 'knowledge- and information-sharing' (574), but both tutors and students see Facebook as a private social space and wish to safeguard that space from the teaching and learning world. Donlan's (2012) review indicated that when Facebook was used for learning, the most successful cases were student-initiated groups, despite some students not seeing this kind of peer-peer communication as learning. Students in Donlan's (2012) own study expressed a strong preference for teaching and learning communications via Facebook, but students made no posts on a tutor-created Facebook page. Some students were wary of reading materials posted on Facebook, preferring the authority of the class reading list. This uneven use led Donlan (2012: 581) to argue that students need help to develop 'the skills required to adapt their understanding of using social networking

sites to an academic context'. So, while the model of a social network may offer potential for a CLE, there are important considerations to bear in mind, such as those offered by Kirschner (2015) who suggests that, despite being called a social network, Facebook is more commonly used as a broadcast medium, promoting a narcissistic, virtual megaphone approach to communication, more to do with presentation of self than knowledge construction. Nevertheless, Facebook users reveal information about themselves to feel connected to a social group. Connections in Facebook are likely to be based on existing contacts offline and recommendations expand this group by suggesting new 'friends' with similarities to this group. Thus Facebook can produce 'groupthink' rather than airing divergent views, and the flat structure of the discussions in Facebook does not support complex interactions. It is possible that being a member of a group on a social network site, 'rather than participation in the discussion, is an important feature of Facebook as a persistent space for instruction' (Bowman and Akcaoglu 2014: 6).

There are other social networking platforms, however, that could be more effective in constructing a learning community. The use of the social networking platform Elgg was found to create a supportive learning community among undergraduates at a Hong Kong University, and this was partly due to the affordances of the technology for 'emotional, informal and personalized communication' (Lu and Churchill 2014: 412). Accordingly, the social network was seen to enhance social engagement but not necessarily cognitive engagement.

Existing technologies come both with potential and challenges for a CLE and awareness of both needs to inform the construction of technical support for the Connected Curriculum. An integrated assemblage of tools could form a next generation digital learning environment, transforming both the pedagogy of digital education as well as the spaces that we use for teaching and learning. According to Nordquist and Laing (2015) the new learning landscape combines physical, virtual, informal and formal spaces for education. This suggests that a learning environment that supports the Connected Curriculum would be flexible and adaptable: 'highly connective, permeable, and networked (physically and digitally)' (Nordquist and Laing 2015: 341). Such an environment would support students' 'freedom to access, create, and recreate their learning content; and ... opportunities to interact outside of a learning system' (Tu et al. 2012: 13).

However, to understand what will be required for this new system, we need to gather staff and students' current and future visions for digital education at UCL. The next section reports on the interviews,

workshops and focus group discussions we undertook with members of the UCL community to flesh out the requirements for the Connected Learning Environment.

Imagine: an ideal learning environment for UCL

The aim of the first phase of our investigation was to produce a detailed understanding of the requirements for a future online learning environment.

We consulted a variety of participants across the institution: eight senior management/Vice Deans of Education/Faculty Tutors, four seconded members of staff enabling the Connected Curriculum in their department/faculty (known as Connected Curriculum Fellows), ten innovative teaching staff/'horizon scanners', five students and five learning technology advisors, as well as two learning software representatives. We conducted nine individual interviews, a staff focus group and two workshops, one with staff and the other with students.

Staff were involved in a process of interpreting the Connected Curriculum in relation to their own teaching and learning practices, and as one participant acknowledged, the Connected Curriculum remained 'aspirational' for most staff. Participants considered that technology should support various lines of communication between teachers and students, researchers and students, students and each other, and between teachers, students and the outside world.

Despite some participants considering that the Connected Curriculum remained 'aspirational', there was widespread optimism about bringing everyone at UCL together as an academic community of learners, including students, teachers and researchers, and facilitating 'conversations between novice and experienced learners'. Moreover, this was seen to involve staff and students in an inclusive 'scholarly knowledge building community', and the role of the technological infrastructure was therefore viewed as enabling members to play an active part within it. Nevertheless, it was seen to be a challenge to get people 'out of their silos'. Participants described ideal online spaces as 'open and flexible', with 'permeable' and 'permissive' boundaries, making them accessible to a diversity of students and promoting connections with the world outside of UCL. It was considered that critical digital literacy skills would need to be developed to support students in engaging with technology, particularly technologies outside of the institutional provision, although it was thought that these should be rooted in the disciplinary context

of their studies (e.g. how to use the digital tools associated with their research community) and embedded in the curriculum. Overall, participants emphasised the need for technology to support communication and promote an effortless online user experience. These two important requirements for a CLE are further explored in the next section.

Communication and the online user experience

Communication was a central focus of participants' views of how technology could support the learner experience within the Connected Curriculum. Since face-to-face connection time was seen as precious, participants considered that technology should be a support for and supplement to face-to-face communication rather than a replacement. It was envisaged that in the future, students would still meet in person at UCL but online learning would grow in importance. Participants' comments, therefore, related to the use of technology to support both blended and fully online learning, but there was a different emphasis from staff and students working in each mode. Participants' observations are presented below in relation to discussion forums, audio-visual communication, interactivity and the lecture, the online/distance learning and staff digital education support needs.

Current communication systems, such as discussion forums, were seen to have a place – for example, in maintaining communication with large classes, where personal communication with each student would be unfeasible for tutors. Nevertheless, one tutor was concerned that the impact of the discussion on learning was not clear. It was also felt by staff that students expected tutors to supply all the answers to questions, and that more could be done to stimulate peer communication. Moodle discussion forums were criticised by staff for not being fit for purpose in the case of communicating mathematical symbols (sometimes it was easier to upload a photograph). Digital badges were seen as a potential motivator for CPD/short courses, but not necessarily for undergraduates.

From a student perspective, discussion forums in Moodle were 'not used', with preference given to informal communication using personal Facebook accounts. However, there were differences here for distance/ online students, who valued Moodle as the principal means of contact with the class. Many participants expressed a desire to use the systems that students were already familiar with, rather than 'forcing' a technology on them because it is supported by the institution. Staff were concerned that large volumes of peer and tutor communication produced

by the online learning system could become overwhelming. The capacity to manage notifications by pushing to a mobile phone was seen as a solution.

Some tutors had used social media (mostly Facebook but also WordPress) with students, either to maintain communication with prospective students prior to their arrival, or to supplement the capabilities of Moodle. In the latter case, Facebook was seen as a solution to students' collaboration (particularly their ability to share videos they had produced or to create imaginative media-rich webpages). In one case, were this capacity available, Moodle would have been the preferred option, whereas another tutor wanted to have the flexibility for students and tutors to install their chosen software on an in-house platform. Video production appeared to be growing in popularity as a form of student assessment, as was the creation of web portfolios/blogs. For the latter, Mahara was considered surprisingly effective, but did not allow for creative expression and alternatives were preferred (e.g. Omeka).

The kind of enquiry-based learning that staff envisaged for students within the Connected Curriculum involved students getting 'excited about learning', engaged in 'real science', possibly involved in data gathering in a local context and contributing to large data sets using the tools (including digital tools) that researchers use in their work and even analysing existing data sets.

Interactivity was also considered important for distance and blended programmes, where the teacher became more of a 'facilitator'. Students should be more active, including opportunities for creative construction (e.g. tasks involving digitally labelling body parts) and collaboration via wikis and Google Docs. However, group work was seen as disliked by students, and a problem for individual assessment. Feedback on assessment was seen as an area that was difficult to 'scale up' and which requires technological support enabling a single tutor to do much more. Voice feedback on assessments (possibly using Turnitin) was considered an option. Online/distance learning was envisaged as becoming more important for UCL. However, Moodle was not necessarily seen as the answer to online learning. Text-based online communication via Moodle was seen as limited and Skype had proved more effective. The capacity to engage students in a web conference or 'live chat' was viewed as highly desirable for distance/online programmes.

Personal communication with distance students was seen as important, but time consuming. However, teachers could – and should – learn from the interactions with students. An improved monitoring tools dashboard was seen as potentially useful for time management. The

integration of the online systems that deal with student registration, fee payment and teaching were seen to be a priority, especially for CPD and 'life learning' courses.

However, staff reported that not all of their colleagues were integrating technology into their teaching, and there were 'horror stories' of staff not uploading teaching materials themselves and creating confusing environments for students. It was observed that some staff were more 'IT literate' than others, but also that the current reward structure was very research driven which discouraged staff from prioritising teaching (Fung and Gordon 2016). There were many calls for more specialist support with technology – even an instructional designer per Faculty – since staff did not know the best way to deploy the technology that was available to them.

In summary, discussion forums were considered unsatisfactory particularly in blended learning environments, and the stream of communication that is produced by the online environment needed better management. This could involve social media and other technologies that students (and researchers) use in everyday life. The capacity for tutors and students to create and store media within the online environment was considered vital. Technology could make both blended and online/distance learning more interactive, but Moodle was not necessarily the means to do it. Workshop participants noted that the current online learning environment was perceived as an area that was welcome and functioning, but somewhat cumbersome and not aesthetically pleasing, segregated and locked-down. It was principally seen as being for the provision of course materials and some activities (which only the teacher controlled) and had additional weaknesses in the area of rich media use. The online environment needed to be more 'user friendly' to encourage enrolments for CPD and short courses. Solutions could also be found in support from specialist staff in using technology and designing courses.

Staff visions of the future

At the end of the staff workshop we invited participants to provide 'one connected activity a typical student in your discipline would be doing in an ideal learning environment in five years' time'. Two clear themes emerged from responses. The first theme focused attention on students' use of data, but in ways that put them in control. For example, students were envisaged as 'Working with real data, problems, and

research grade models. Building authentic skills' and 'Gathering rich data (images, video, sound) from field sites, curating and analysing it, then sharing a commentary across this with others'. Just as important, however, was students' capacity to manage that data in their 'own digital learning space', where they could choose what to share and what to hide. Participants anticipated mechanisms to protect students from digital distractions as well as having access to learning analytics 'that tell them when they are on track for a good result'.

The second theme that emerged involved students engaging with the world outside of UCL. This could mean seeing themselves 'as professionals from the time they arrive' or doing and sharing research on 'real-world' issues, for example by publishing PGCE action research projects …

> into an online community, [linking] staff, students, alumni and school staff who can collaboratively address issues affecting primary education.

Alternatively, it could mean 'doing more learning outside the current institution', running their own projects or sharing and teaching each other 'in a controlled/supported/moderated environment'. Other participants wanted to issue a word of caution – the future may not be so different from the present with students 'reading really hard papers, thinking about them, writing about them and sharing this with a tutor', printing them out as PDFs 'and highlighting them with a yellow highlighter pen'. Worse, the technological environment would result in students 'having their head in their laptop, rather than hanging on my every word', using sources without checking reliability and wanting 'more of my attention'.

The current online learning environment was perceived as an area that was welcome and functioning, but somewhat cumbersome and not aesthetically pleasing, segregated and locked-down. It was principally seen as for the provision of course materials and some activities under full tutor control and had additional weaknesses in the area of rich media use. Many elements of marginal relevance distracted from essential information, placing the full burden of information filtering on users with no help from the technology. This was seen as counterproductive to what the Connected Curriculum aims to achieve. The vision for technology was that it would become a supportive assistant, bringing information to users in an effective, flexible and enjoyable way.

Love or hate: students' attitudes to learning technology

One of our key aims was to understand how students currently use technology for learning and what their attitudes towards technology are. As a result, at the student workshop, we asked participants to list which technologies or tools they use for their studies, and then place them on a two-dimensional graph according to whether (1) use of the tool was elected by the student or imposed by the institution, and whether (2) students loved or hated using the tool for their studies. The outcome from the activity is replicated in Table 13.1 and provides interesting insights, some of which were explored further in a group discussion.

While the outcomes from the workshop cannot be representative for the whole student population, there are patterns that are useful for understanding technology use in the context of the Connected

Table 13.1 Student categorisation of tools used for learning. Bold entries appear more than once.

Elected	**Facebook** **Laptop** YouTube	Google Books Learning Designer	**Facebook Groups** **SPSS** **Email Client**	Laptop	**Email**	LinkedIn
	Wikipedia	Tablet	**Skype** **Mobile Phone** Google DocsGoogle Scholar	**Moodle** MS Office **Wikipedia**	**Wikis**	
Neutral	OneDrive (Cloud) Xmind iMovie Lynda	**Laptop** Digital Library Peerwise	**Tablet** **Skype** Forums		eBooks	
	Coursera Flash		**Mobile Phone**		**UCL** **Email**	**Wikis**
Imposed	Flipped Lectures	**Moodle** UCL Library (Explore)			Turnitin	**Moodle** My Portfolio Journals
	Love		**Neutral**			**Hate**

Curriculum. Certain tools were mentioned multiple times: the placement of Moodle, for example, showed the widest variety showing that students have very different opinions, preferences and needs, but also pointing to a high variability of quality in tutor use of Moodle, as our discussion uncovered: 'When a course page is good it is really good. On a bad page, nothing is visible or it is disorganised.' Students considered that the use of Moodle felt 'old fashioned', as did the portfolio tool, Mahara. A discussion about forums revealed that students did not find them appealing, but were happy to use them when asked, although forum discussions can create anxieties when some messages do not receive any replies, leading to suspicions of favouritism or rejection. Another pattern was related to audiovisual media: such tools never featured in the *hate* area, whether imposed or not. By contrast, the wiki, which was sometimes imposed, sometimes not, was not liked by students, but the discussion indicated that wikis might have been used in a limited, text-heavy way, corroborating the appeal of rich media. In one case, Coursera was mentioned as a somewhat imposed tool, which was well liked. Gently forcing students to connect with the outside world in this way could help them become autonomous.

The institutional provision of email received much negative feedback. It felt very imposed, and students were concerned that emails would be lost when the course was over. One student appreciated very much being contacted through personal email, and students generally criticised unclear instructions on how to forward emails to a personal account.

Students opted to use a wide variety of tools for their studies that interestingly did not automatically feature in the *love* area. In fact, students were often quite indifferent about a range of technologies, for example Skype and mobile phones, and there are also examples of institutional provision that was very popular, including Lynda.com or OneDrive. Generally, imposed tools generate an opinion, either positive or negative, whereas a very high proportion of elected tools do not. Students admitted that any imposed system would initially be met with a sceptical attitude.

Social media unsurprisingly emerged as a tool that the majority of, though not all, students use to communicate, and students pointed out that it was important to respect such decisions. Several students confirmed that some staff engaged via Facebook, and information in this channel would be much more likely to be seen than email. But students

were clear that they saw this as their own space, and they felt that staff who engaged via Facebook seemed to do so with a separate, dedicated account for professional purposes.

Students highlighted the need for consistency and integration in technology use. While Moodle was still seen as the primary source of course-related information, resources were spread over too many systems and in too many different formats. A built-in document reader function in Moodle, or having all resources in PDF format, would be highly useful. Finally, more lecture recording was highly desirable, because of the long delays (six months) between the lecture and related examinations.

Students had very defined and differentiated views on technology for their studies. The major themes that emerged were around integration, media use, consistency, design and usability, and issues of use (e.g. anxieties students experience in forums) were as important as criticisms of imposed core systems such as email. This calls for attention to the wider context of negative feedback on specific tools; for example, wikis were criticised primarily for how they were used, not for their functionality, and while students perceived Mahara as useful, it was relegated to the extreme *hate* position due to usability and aesthetics.

Towards a connected learning environment

On the basis of our investigations we drew together the characteristics of an online learning environment considered to be necessary to support the Connected Curriculum. We divided characteristics into five broad, intersecting criteria for an online learning environment: design, communication, integration of external technologies, student activity and support for learning design, technology and digital capabilities. While UCL's existing systems could meet these criteria in part, there were notable areas where they could not, particularly around design, important aspects of communication (such as supporting communication outside of course forums and with the outside world) integration and student activity. In other areas, however, Moodle in particular was seen as doing a good job of facilitating communication between teachers and students. It was clear, therefore, that we needed a new learning environment, albeit one that might seek to integrate components of our existing provision into a 'confederation' of systems to produce the Connected Learning Environment as a 'Next Generation Digital Learning Environment' (Brown, Dehoney and Millichap 2015: 3). The

final part of the chapter outlines the most recent phase of our investigations to identify the likely components of such a system.

UCL Together: creating a connected learning environment

Evaluation of UCL's current online learning environment in the light of the findings from our investigation presented two options. We could replace our current VLE with one with a more contemporary 'feel' which supports audio/video and enhanced communication (including media recording and integrated web conferencing), and the introduction of a new system might even be an opportunity for a 'culture shift' in learning design at UCL. However, in essence, one VLE appears very much like another, restricting student permissions and locking student access down to courses in which they are enrolled.

Alternatively, a confederation of systems would retain Moodle integrated with enhanced systems such as media creation, editing and storage capability, an educational wiki tool, the next generation video-conferencing tools, personalised student webspace and a means of fully integrating external technologies. Importantly, an integrated social network dedicated to UCL would facilitate communication between staff and students, and the provision of wikis and voting tools within community spaces would design in collaboration from the outset. Moreover, if the boundaries of the network were 'permeable' and allow in prospective students, alumni and business community contacts, we would really be supporting the Connected Curriculum at UCL. We began to envisage, therefore, a flexible, academic social network with a social media feel, with the working title 'UCL Together'.

Our ambition is that UCL Together would, over time, be used by all staff and students as a major communication channel, encompassing research, teaching and learning, and social/community groups. Within the network, students could be given the rights to create their own communities and communities need not be locked down, but feature permissive boundaries, and act as working studios for researchers to share their progress or student societies to show their activities. Such a system would allow access to networks outside of the institution, such as prospective and past students, and businesses, charities and local groups. Current students would benefit from contact with the vibrant, global network of UCL alumni, who could retain their connection with the university and engage in lifelong learning after graduation. Students would be able to develop digital capabilities in such a social network, making

mistakes in a more supportive environment than a public network. Students would have the capacity to experiment with digital outputs for assessments aimed at a broader audience than the traditional essay or examination, and choose when to share them with the prospective employers or the wider world.

Our vision for UCL Together is to support a range of distinctive and innovative teaching inspired by the Connected Curriculum initiative. It will also provide a new way for our staff and students to find each other, make connections, explore the depth of expertise at the university and encourage a sense of belonging and identity. UCL Together will be embedded in the institution's approach to research-based education helping to sustain collaborative active communities among current students and staff, including teachers and researchers, and with the wider community. UCL Together will be a platform for networked induction events and help new students make connections in the busy, distributed London campuses and feel a sense of belonging while working, studying or living elsewhere. UCL Together will help to create and maintain active and enduring relationships with alumni. It will also support a more open, networked and social student and staff body, enabling teaching and learning activities that cross discipline boundaries and connect with the outside world, in line with the aims of the Connected Curriculum. However, we do not expect to be able to achieve these aims with technology alone. The way we use the network will be central to its success. We will need to encourage a culture of use to embed the network in the everyday life of the university, its staff and students. This will require the pedagogy of the Connected Curriculum to be embraced at all levels. We will work with teaching staff to use the network to support innovative, connected, learning design, and with research staff and student societies to use the power of UCL Together to foster intra- and inter-institutional collaboration and productivity. A confederation of pedagogy and technology will create UCL's Connected Learning Environment.

14

Connecting students and staff for teaching and learning enquiry

The McMaster Student Partners Programme

Elizabeth Marquis, Zeeshan Haqqee, Sabrina Kirby, Alexandra Liu, Varun Puri, Robert Cockcroft, Lori Goff and Kris Knorr

Introduction

McMaster University (Hamilton, Canada) defines itself as a 'research-focused student-centered' institution, positioning research and enquiry as essential to high-quality educational experiences (McMaster Forward with Integrity Advisory Group 2012). Initiatives across campus contribute to the realisation of this identity by providing students at all levels (undergraduate and graduate) with opportunities to engage in research within or beyond the formal curriculum. This chapter will describe and analyse one such initiative, presenting student and staff perspectives on a novel 'student partners' programme designed to engage students as co-enquirers in the scholarship of teaching and learning (SoTL).

The student partners programme was developed collaboratively in 2013 by McMaster's central teaching and learning institute and the university's undergraduate Arts & Science programme. Resonating with calls to partner with students on learning and teaching initiatives (Healey, Flint and Harrington 2014; Cook-Sather 2014) and on the scholarship of teaching and learning specifically (Werder and Otis 2010; Felten 2013), the programme now engages students from across McMaster's campus as full members of SoTL (and other) project teams. Three times a year, students are invited to submit applications to become

involved in institute projects that interest them. All projects are vetted in advance to ensure they provide opportunities for students to contribute meaningfully to the intellectual direction of the work. They typically draw from a range of disciplinary approaches, and often involve additional partners from departments across campus. Successful applicants are subsequently paired with professional and/or academic staff and work for up to 10 hours a week on shared research. In the programme's pilot year, 13 undergraduates participated. It has since expanded to involve more than 50 undergraduate and graduate students annually. A number of these students have presented their research at local, national and international conferences, and several have co-authored publications with staff collaborators.

Despite these successes, we remain conscious of the difficulty of developing meaningful partnerships that push against traditional hierarchies and engage students as true collaborators in teaching and learning enquiry (see also Allin 2014; Weller et al. 2013). To that end, a group of students and staff collaborated in 2014 to conduct preliminary research examining the experiences of participants in the student partners programme (Marquis et al. 2016). Following Cook-Sather (2014), this research positioned student partnership as a threshold concept for teaching and learning (Meyer and Land 2006), and examined the extent to which participating staff and students successfully crossed this boundary. We posited that this threshold had two major components: *understanding* partnership (i.e., coming to view staff and students as collegial collaborators in teaching and learning endeavours) and *enacting* it (i.e., acting on that understanding in ways that realise partnership successfully). Drawing from systematic reflections and a focus group discussion, we found that most participants either initially espoused or came to develop a strong understanding of partnership, and that student participants in particular often demonstrated new conceptions of themselves as active, collegial contributors to teaching and learning. Traversing the 'enacting' portion of the partnership threshold proved somewhat more difficult, however, with participants describing challenges and uncertainties connected to navigating traditional roles, balancing guidance and self-direction, and finding time to realise partnership, even while noting successes in terms of sharing power and collaborating effectively.

The present chapter builds on this initial work, providing case studies of four recent projects included in the student partners programme and using the lens of threshold concepts to explore the experiences and outcomes of these projects for staff and student participants.

Methodology

This chapter was designed and conceived collaboratively by all eight authors. The first author invited the others to participate given their extensive experiences in the programme, and we subsequently worked together to develop a reflective case study template that would allow us to explore our experiences in a systematic manner. This template stipulated broad elements to be included in each case (e.g., a brief project description, sections for the partners to detail their experiences), as well as guidelines for the approximate length of each section. Once we came to consensus on the template, the student researchers took the lead on writing the cases for projects with which they were involved, and staff partners filled in sections focused on their own experiences. Once the cases were written, we worked as a team to code and analyse them, and to consider how the broad themes arising related to the theoretical frame of threshold concepts set out in previous research on the programme (Marquis et al. 2016). Ethics clearance for this work was received from the McMaster Research Ethics Board.

Below, we present the case studies in full, followed by a discussion of key points arising from our analysis. While some of the projects described involved student or staff collaborators beyond the group involved in this chapter, we focus our reflections on our own experiences, so as to ensure we are not speaking for or misrepresenting others. Nonetheless, we would like to highlight the important contributions of these other partners to the projects detailed here.

Case study 1: Science peer-mentoring partnership

Project and partnership description

Several studies have shown a strong link between peer mentorship and undergraduate academic success, where more-experienced senior students guide less-experienced junior students on how to overcome common challenges in academia (Dennison 2010). With regard to the impact of mentorship on mentors, Colvin and Ashman (2010) found that mentor–mentee relationships can indeed have a positive impact on mentors at various levels. However, the particular role of the mentorship programme and how its structure can affect the mentorship experience has not been examined. The goal of our study was to compare and contrast the benefits and challenges faced

by mentors between a goal-driven mentorship programme structured around a university course and a second, less goal-oriented mentorship programme that was purely voluntary. Survey data were collected from the mentors of these two programmes, assessing their satisfaction with the programme, as well as their judgements on how the programme structure either helped or hindered their mentorship experiences.

This project was pursued as a partnership between staff members Lori Goff and Kris Knorr, as well as student partner Zeeshan Haqqee. Our research partnership focused on the influence of the course structure on mentors' perceptions and experiences in mentorship.

Student experience: Zeeshan's reflection

This collaboration between myself, Lori and Kris has felt like a true partnership where every voice has had equal power on the direction of our research projects. We would meet regularly and have an open discussion on the outline of our project, short-term goals and steps to be taken to reach them, as well as any comments or criticisms of our current approach to things. We would always finish each meeting with an agreement on any tasks that needed to be done. While I would always look to my staff partners for guidance, they would always let me take the lead whenever possible, whether it came to writing abstracts or presenting at conferences. Having my own individual project has also given me a strong sense of responsibility over my work. Being the sole person involved in data analyses has put this responsibility into perspective, as the project cannot progress until I finish the tasks on my end. However, I was never left alone to troubleshoot every problem. My staff partners communicated with me during meetings and via email about project concerns as they came up, and I regularly sent updates on the status of my work. Any challenges faced are solved through discussion and brainstorming, rather than having the staff partners take full lead. This partnership has given me the chance to formulate my own research questions and problem solve with the mindset of a researcher, all while having two more-experienced researchers mentor me along the way.

Staff experience: Kris and Lori's reflections

In this partnership, we intentionally took an approach where we invited our student partner, Zeeshan, to guide and develop the project according

to his interests within a broadly conceptualised project description. We aimed to provide him with support and encouragement to define the scope and methodologies of the research that we conducted on peer mentors' experiences.

Early in the process, we faced some tensions and challenges with gaining momentum. The project topic was one in which we, as staff partners, had been engaged in for a couple of years. This past experience could have allowed us to drive the direction, but we consciously valued and prioritised Zeeshan's perspective in developing the project scope and direction. Rather than assuming roles as his supervisors or experts in the area of peer mentoring, we opted to adopt roles as facilitative guides. While this approach took longer to gain momentum, it was still important and worthwhile to us to have Zeeshan take on more of a leadership role in shaping the project. One of our contributions to this partnership came in the form of serving what Colvin and Ashman (2010) might refer to as 'connecting links' in the context of staff–student partnerships. In our context, we were able to connect Zeeshan with other students and staff engaged in peer mentoring research across campus, resulting in various additional collaborations for Zeeshan. Working with Zeeshan, as well as with other student partners with whom we have collaborated, we are continually impressed by the ideas that students bring to collaborative projects, and the interest and energy they have to bring those ideas to fruition.

Case study 2: Creativity across disciplines

Project and partnership description

In recent years, the significance of creativity has been increasingly recognised and discussed within higher education and beyond. As such, creativity is often viewed as an outcome that universities should develop in their students; however, the extent to which this objective is realised in educational practice has been called into question (Kleiman 2008). This study built upon previous work by Beth Marquis and others, which examined the importance of creativity to university instructors. It aimed to understand the ways in which creativity is positioned within undergraduate teaching across disciplines at one university by examining all 2013–2014 course syllabi at McMaster for explicit and implicit references to student creativity, using a modified version of an approach by Jackson and Shaw (2006). All partners within this phase of the project

(Beth Marquis, Alex Liu, and Kaila Radan) were involved in collecting publicly available course outlines, as well as in qualitative analysis.

Student experience: Alex's reflection

Partnership between students and staff involves the formation of a working relationship that is reciprocal, meaning that both parties stand to gain through learning and working together. This project that I worked on with Beth met this definition through allowing for all partners to contribute to shaping the analysis and direction of the project. While working with Beth, despite being an undergraduate student in the Health Sciences, with no previous experience with research in education or pedagogy, she consistently encouraged my immersion within the project, as well as my equal input and suggestions at each stage. This consistent encouragement and support allowed me to feel comfortable enough to suggest ideas, such as creating a coding protocol that would help to ensure better inter-rater reliability between the coders.

Although this project was already established in partnership with prior student collaborators (as opposed to one that we designed from the ground up), there was still room for my own ideas as a co-contributor to its further development. Additionally, I was able to take a lead on the coding and analysis of the course outlines, and felt comfortable in bringing any concerns or questions to Beth, or in presenting my own ideas in regard to questions that came up during our coding and analyses. Through this, both Beth and I were able to contribute towards solutions to coding uncertainties, as opposed to the staff partner taking the lead on this decision. Partnership in this project felt natural and left me feeling empowered to contribute my ideas as a student towards not just this research project, but in other projects at the institute, and throughout my undergraduate studies.

Staff experience: Beth's reflection

Initially, I was worried about attempting a partnership approach for this project, since it was already relatively well established and the design in place before Alex and her fellow student partner joined the team. Nevertheless, they quickly rose to the challenge and became active and valued collaborators on this research. Alex, for example, developed a coding protocol that shaped and supported our analysis, and also frequently took a lead on distributing tasks and keeping us on

track. Likewise, both students raised significant questions and ideas that enhanced the work and influenced its directions throughout. The perspectives they brought to bear as current undergraduates complemented my own interpretations of the course outlines that served as our central data source. While, at times, this meant additional work to come to consensus on our coding, the result was a richer analysis that accounted for both student and staff views. The project, and I, benefited considerably from Alex and Kaila's ideas and organisational skills.

Given that this study constituted the third phase of an ongoing research project I lead, a central challenge for me throughout was to resist assuming the position of 'expert', while simultaneously letting project partners know about the work done to date so it could inform our shared efforts. I am not sure I always got the balance exactly right. I was conscious of talking too much during the question and answer period of a conference presentation Alex and I gave together, for instance. Though I did not always feel on sure footing, this process itself has helped me reflect on and continue to build my partnership abilities, which I value immensely.

Case study 3: Collaborative testing in physics

Project and partnership description

During the 2015–2016 academic year, Robert Cockcroft and Sabrina Kirby began an investigation into the use of collaborative assessment in physics. Students enrolled in Rob's first-year, two-semester physics class in McMaster's Integrated Science Programme completed exams that included a mandatory collaborative assessment component, and were invited to participate in the pedagogical research project. The learning potential for students was expected to increase, as has been discussed in other studies. However, the question of whether or not retention of course content also increases is still largely unresolved in the literature (e.g., Leight et al. 2012; Cortwright et al. 2003) and was therefore the primary question on which we focused in this project. Both partners contributed to all stages of the project development. Together, they designed and adopted a crossover approach in which the class of approximately 60 students was divided and randomly assigned to one of two groups. In Group A, approximately one third of the students' first-term midterm examination time was dedicated to collaborative assessment. Group B spent the entire duration of the

midterm working individually. During the second-term midterm, the groups were reversed. After completing the collaborative portion of their exam, students were invited to complete a survey to report on their experiences. All students completed three retention tests (one day, one week and six weeks following the midterm) and an end-of-term examination in each term. At the time of this writing, the project is collecting the last data and is about to start the data analysis stage, with both partners again sharing that work equally.

Student experience: Sabrina's reflection

Working with Rob has been an extremely rewarding experience, and certainly a highlight of my undergraduate career. I feel that we have formed a genuine partnership that overcomes the traditional power dynamic between staff and students, in large part due to Rob's willingness to treat me as his equal. When I began working with him in 2014, I had only a small amount of first-hand exposure to post-secondary physics through my own coursework, and no background in pedagogical research. Despite this knowledge gap, Rob invited my feedback at every stage of the project, from the earliest brainstorming sessions through to implementation. My relative inexperience often necessitated background reading; however, this work proved fruitful because it simultaneously provided me with a learning opportunity and developed into a literature review for our project. Though our discussions about this research were extremely informative, I never felt as though Rob was 'instructing' me in the traditional sense. Instead, I felt as though an expert was sharing his knowledge and inviting me to engage with him. The result was that I have always felt empowered to make meaningful contributions to the project. This project has provided me with experience in both quantitative and qualitative analysis, and exposure to research opportunities I may not have had otherwise as an undergraduate.

Staff experience: Rob's reflection

The opportunity to work in collaboration with a student benefits both sides of the partnership as we share and learn from one another's strengths and different perspectives. I value Sabrina's abilities to eloquently summarise literature readings, succinctly express her opinion of

their merits and disadvantages, and comment on how each may be relevant to our own project. As Sabrina is not majoring in physics, she is able to provide a valuable non-specialist's perspective to the physics portion of our project, and help prevent potential problems with the students in my physics class before they arise.

One challenge that we continue to face is scheduling; matching schedules between a full-time student and a postdoctoral research fellow is not straightforward. However, together we can achieve more than I can get done by myself – not simply because we have two people working on the project, but because having a student partner on a time-limited contract means that I cannot push off work until the summer, and we can hold one another accountable to deadlines which helps prioritise and motivate the work.

Because the topic of group assessment has potential benefits for many different disciplines, the project has allowed us both to collaborate with other faculties also exploring collaborative testing on campus and disseminate our work at various conferences.

Case study 4: Filmic representations of higher education

Project and partnership description

Constructions of teaching, learning and the university within the media and popular culture can exert an important influence on public understanding of higher education, which can in turn influence expectations (Giroux 2008; García 2015). Combining film studies with the scholarship of teaching and learning, this project analysed representations of higher education within 11 films released in 2014. These 11 films were in the top 100 highest grossing films of the year and/or Oscar nominees in 2015, and prominently featured institutions of higher education as a setting. The result was an examination of themes that were identified across the texts, the ways in which they interacted, and the sociopolitical ramifications of their content.

The project was a collaborative venture between one staff member (Beth Marquis) and two students (Katelyn Johnstone and Varun Puri), each equally contributing to its design with regard to scope, approach and execution. All three members viewed and analysed the texts involved. As the project developed into a cohesive manuscript, we assumed responsibility for writing individual sections based on each

partner's interest and came to a group consensus on all major decisions regarding the paper (including but not limited to formatting, inclusion criteria for content, and final editing). Current outcomes include a manuscript submitted for publication, and an accepted proposal to present at an international conference.

Student experience: Varun's reflection

Working in partnership on this project has been a rewarding, empowering experience. Prior to beginning our project on filmic representations of higher education I had already co-authored a published manuscript with Beth – an experience that provided me with a sense of familiarity regarding her personal approach towards partnerships.

The project was intentionally open-ended at its outset in order for us to have the opportunity to collaborate on developing its initial design. The establishment of a specific goal at the outset of the project – publishing in a peer-reviewed journal – also provided us with a shared direction. Throughout the early stages of the project, we contributed equally to the development of our methodology while meeting on a consistent, bi-weekly basis. At every point, Beth played the role of an equal participant in discussions despite her staff status, and occasionally made practical suggestions that aided the project's feasibility, scope and outcomes.

Although I was enthusiastic about the potential of the work, I found myself with lingering concerns regarding my lack of experience in film theory at the initial stages of the project. In response, Beth was very understanding in presenting abridged versions of her lectures on basic theory. She also provided me with access to resources (including an introductory textbook) and recommended specific portions that would be helpful for this project. This initial orientation to the relevant fundamentals was the only point in the entire project in which Beth took on a role that resembled a more traditional power formation, and I felt that this was both appropriate and very helpful.

I believe that our group successfully developed a working relationship that allowed each member to contribute in a meaningful way. Most importantly, I believe that we both navigated and crossed the threshold studied in our earlier paper, and were able to create a collegial atmosphere that felt natural and consistently productive. The collaborative

nature of each stage of the project was enjoyable as each of us assumed the role of co-contributor; it reflected the respect each partner had for the others' unique capabilities and potential.

Staff experience: Beth's reflection

I echo Varun's comments about the collaborative nature of this project, and the extent to which we have been able to develop a meaningful research partnership in which we are able to contribute and debate ideas. As someone who continues to struggle with when to 'lead' partnership experiences and when to step back, I appreciated Varun and Katelyn's willingness to let me know when they needed more guidance or support, and I think this openness has helped to solidify our collaboration and move the project along. I also found our shared analysis and writing consistently enriching, as the ideas and insights the students contribute have offered compelling perspectives that enhanced my own thinking while clearly demonstrating the amount they have learned about filmic analysis.

One potential challenge worth noting connects to the initial lack of clarity about the project and its goals. While the nascent status of the research at the moment the team formed was key in allowing us to develop a sense of shared ownership, it did mean that we had to work quickly to build trust and establish a plan for moving forward. I'm grateful for Varun and Katelyn's patience, flexibility and willingness to contribute during this process, which could have otherwise devolved into extended uncertainty or the assumption of a much less collaborative approach.

Discussion

Each of these cases gives the sense that partnerships between students and staff can be both beneficial and challenging. As successful partnerships between students and staff develop, a movement from uncertainty toward transformation often occurs, suggesting there is a threshold through which the partners pass (Cook-Sather 2014; Marquis et al. 2016). As indicated in our previous research (Marquis et al. 2016), partnership requires difficult negotiations of understanding and identity that unfold as partners attempt to navigate and cross the partnership threshold.

First, in that previous research, partners developed new *under-standings* of their own roles and began to see themselves as active, valued collaborators in specific teaching and learning initiatives and teaching and learning more broadly. The cases described above like-wise indicate shared perspectives on partnerships, resonating with what has been discussed in the literature (e.g., Cook-Sather, Bovill and Felten 2014). For example, the cases indicate that partners largely had a sense that successful partnerships were grounded in a sense of shared responsibility, collaboration, mutual work and collective benefit.

Second, the partners in the pilot study faced challenges in apply-ing their new perspectives or understandings of partnership as they embarked on the 'process of developing and enacting collegial, recip-rocal relationships' (Marquis et al. 2016: 8). While many of these chal-lenges were discussed within the cases above, there is evidence of some positive processes and outcomes that helped the partners with some of these issues, specifically with navigating the power dynamics within the relationship and finding ways to enable meaningful and equal inclusion of both student and staff voices.

Navigating power dynamics

Each of the cases described the negotiation and navigation of power dynamics in some way. Kris and Lori chose not to drive the project, but 'consciously valued and prioritised Zeeshan's perspective in developing the project scope and direction' and Zeeshan recognised that he was encouraged to take the lead whenever possible [Case 1]. Despite having no experience in pedagogy, Alex felt encouraged to be immersed in the project and provided equal contributions throughout, taking the lead during some stages [Case 2]. Sabrina described a 'genuine partnership that overcame the traditional power dynamic between staff and stu-dents, in large part due to Rob's willingness to treat [her] as an equal' and noted her ability to provide feedback at every stage of the project, from brainstorming to implementation [Case 3]. Varun described the development of shared direction for the project where each member assumed the role of co-contributor and respected the other partners' unique capabilities and potential, regardless of their role [Case 4]. In each case, the partners were faced with and overcame some of the chal-lenges in navigating their traditional roles and power dynamics to form genuine partnerships.

Enabling meaningful and equal inclusion of student and staff voices

While not inextricable from the concept of power in relationships, the process and outcomes of enabling equal inclusion of each partner's voice emerged as a particularly important theme from the case descriptions. For example, Zeeshan described the collaboration with his staff partners as feeling 'like a true partnership where every voice in the partnership has equal power on the direction of [the] research projects' [Case 1]. Beth similarly described developing 'a meaningful research partnership in which [each partner is] able to contribute and debate ideas,' and noted the ideas contributed by Varun and Katelyn 'enhanced [her] own thinking' [Case 4]. Such comments suggest a degree of success in meaningfully enacting partnership, despite the challenges attached to this portion of the threshold.

We acknowledge that the four cases discussed here may not be representative of all projects included in the student partners programme; many others have likely struggled more emphatically with enacting partnership and remained in the liminal state. Nonetheless, we focus on these four comparatively successful examples to illustrate the potential of such work and to highlight strategies for navigating the challenges of partnership that might be useful to others.

Moving towards success

Successfully navigating the challenges of embracing non-traditional roles in partnership became possible when all partners first recognised issues around power and inclusion of voices. Partners then need to be willing to behave in ways that reflect their shared understandings of power and inclusion. Strategies to do so are exemplified in the case descriptions. Students and staff met regularly and engaged in conversations and discussions frequently. Some of the cases refer to the importance of developing a strong working relationship early on that is grounded in mutual respect and recognition of the unique contributions of each partner. In these cases, staff partners purposefully refrained from taking on a supervisory role and elected to be a facilitative guide and a contributing member of the team. They encouraged students to take a lead role on a variety of aspects of the project, especially in the early stages of shaping the vision, direction and scope, even though this may contribute to an initial lack of clarity. The practicalities around

time and scheduling need to be considered when forming a partnership, so that all participating partners have equal opportunities to meet and engage in discussions, and position the partnership for success. While we have made progress in enacting partnerships, it continues to be challenging, yet rewarding, work.

15

A jigsaw model for student partnership through research and teaching in small-group engineering classes

Chris Browne

Context

Engaging students in active learning should be straightforward in a practical discipline, such as engineering. Engineering, being the application of science, lends itself naturally to a hands-on workshop model of learning. However, although these experiences afford students the opportunity for physical interactions, students' minds are often inactive as they plod through a series of step-by-step instructions, often without thought (Martinez and Stager 2013).

This commonplace experience aligns with Trevalyan's (2010: 384) observation that the predominant pedagogy reported in engineering education literature reflects a misguided belief that the professional practice of engineering is a solitary, technical exercise. The important skills required in professional practice are not learned at university, such as lifelong learning (Trevelyan 2014).

A preoccupation on teaching technical content without context is not a new problem in engineering education. Forrester (1970) argued that students should be agents in problem definition, and be excited by new and unsolved problems. However, the prevailing actions of the educational system that creates engineers almost 50 years later still focuses on training students to repeat the work of last year's students.

Further, learning without context is not only a problem in engineering education. Boulton and Lucas (2008) note that university teaching is too often concerned with the transfer of information, absent of the context. Indeed, they argue that failing to engage students with the uncertainty that navigating issues arising from the context is a missed opportunity in his or her education.

In this case study, I outline the *jigsaw classroom*, a process for course delivery that I have developed with second-year engineering students at the Australian National University across two sequential professional engineering courses over the last five years. These courses teach processes for navigating engineering design and analysis problems in a group-based professional context.

In the partnership, students are both engaged in the process of learning and teaching, and enhancing the practice of learning and teaching (Healey and Harrington 2014: 23), and are involved in all four areas of partnership at different times: learning, teaching and assessment; curriculum design and pedagogic consultancy; subject-based research and enquiry; and the scholarship of teaching and learning (Healey and Harrington 2014: 25). The jigsaw classroom provides the structure for both course delivery and scaffolds assessment tasks, with students as active partners in enquiry-based learning, moving through identifying, producing, authoring and pursuing modes (Levy 2011). Individuals within groups become experts on different topics in the course, and in turn contribute to the class by creating and running tutorial sessions.

Situating the model

The jigsaw classroom was assimilated from a number of philosophies and strategies. Primarily, this approach draws upon active and experiential learning (Kolb 1984), the creation of knowledge in the learner's mind (Piaget 1973) and by using physical objects (Papert 1980; see also Kador et al., this volume). More advanced learners on an expert topic assist less advanced learners (Vygostsky 1978; 1986), and the activities themselves are designed to encourage double-loop learning (Argyris and Schön 1974).

At the core of the delivery is the jigsaw approach (first described by Aronson 1978). In this delivery mode, individuals leave their home group to become an expert on a given topic, by working in a short-lived group with 'experts' from other groups. They return to their home group with the relevant insights for their area of expertise. This approach

encourages individuals to become accountable for their learning and at the same time broadening their home group's perspectives on a problem.

The jigsaw approach here is used across the entire semester's learning. The delivery in the jigsaw classroom can be divided into three major phases: an introductory phase (two weeks) sets the scene for the course, assessment and expectations; a jigsaw phase (seven weeks), where students in expert groups facilitate tutorials on a topic and contribute to their home group project on a different topic – all members holding different pieces of the jigsaw; and individual research (four weeks), where students conduct a small research project bringing together the content from the jigsaw phase.

The primary focus of this chapter is to describe the interactions around the student-facilitations in the tutorials during the jigsaw phase. The tutorial activity is the main face-to-face interaction in these two courses. The size of the class is somewhat challenging to deliver consistently in a partnership model, with approximately 200 students divided into eight tutorials. The student-run component of a tutorial is assessed, and typically takes place over 90 minutes, with some additional time reserved for tutor sense-making and housekeeping. To assist with consistency of delivery, student-researchers have co-designed a series of ready-to-go activities that the student-facilitators can use as part of their facilitation.

In the jigsaw classroom, the traditional roles assigned to people are challenged. The role of the lecturer shifts from instruction to enabling student-facilitators to run the best tutorial possible. Student-tutors, often excellent course alumni, support and assess student-facilitated tutorials, alongside typical duties of a tutor, such as mentoring and marking. Student-researchers, often honours-year students not enrolled in the course, design and assess the implementation of a learning activity for use in the class. Student-facilitators take turns to act as 'experts' on a topic, designing a tutorial with other topic experts for their peers. The students in the course prepare for the tutorial by completing a homework activity, and then attend and participate in the tutorial.

Goodyear (2005) describes the problem space of educational design as a feedback process between a pedagogical framework and an educational setting, within an organisational context. The pedagogical framework is broken into four layers of activity: the pedagogical philosophy, high-level pedagogy, pedagogical strategy and pedagogical tactics. These four layers of activity provide a useful framework to situate the jigsaw classroom.

Pedagogical philosophy

The pedagogical philosophy used in this model draws upon the principles of a partnership – a students-as-partners – approach, where students are involved in various activities such as the design, improvement and practice, of learning, teaching and research (Healey and Harrington 2014; see also Marquis et al., this volume). Ramsden (2008) argues that the most effective learning environments in higher education are when students are active partners with academic staff.

The partnership approach as the pedagogical philosophy has clear intentions about the way that people behave and are treated. As a partnership, the relationship is framed around a number of principles and values: authenticity, inclusivity, reciprocity, empowerment, trust, challenges, community and responsibility (HEA 2014).

High-level pedagogy

There are two high-level pedagogies applied in this model. The first concerns the creation of the activities used in the class. The activities are designed to allow students to apply a constructionist approach to learning. Martinez and Stager (2013) describe constructionism as the best way to 'do' constructivism (see Piaget 1973). Papert's constructionist approach (1980) is a modern manifesto for the maker movement, where learning is done through social interaction, alongside physical and digital building materials (Stager 2005).

This leads to the second high-level pedagogy, which concerns the approach used to define roles in the class. Vygotsky (1978; 1986) recognised learning and reasoning as a product of both a practical and social activity. The relationship between the learner's context and the learner's interaction within that context is fundamental to Vygotsky's sociocultural philosophy. An important part of this is the interaction between learners at different stages of development. More advanced learners can assist less advanced learners through situating learning just outside of their immediate capability, a location he described as the Zone of Proximal Development. In the jigsaw classroom model, all members of the learning community are assisting and being assisted by others, including the lecturer.

Pedagogical strategy

The pedagogical strategy employed in the model could be loosely described as a flipped mode of teaching. A common tactic in a flipped mode includes requiring students to engage in a learning resource

before class, and to employ more interactive methods of teaching during face-to-face time. However, there is no clear definition of the tactics employed in a flipped mode, nor has long-term systematic research on it been conducted on its effectiveness (Abeysekera and Dawson 2014). Nevertheless, it is seen as a strategy for increasing interactivity and improving the learning experience (O'Flaherty and Phillips 2015).

In the jigsaw classroom, the student's normal role as learner is also reversed, and the student has a central role in the teaching process. Peer-to-peer teaching further encourages students to engage in the learning process, such as the student-planned and facilitated tutorials (Baker 1996; Smith and Browne 2013). These learning environments allow students to become active stakeholders in the quality of their learning.

Pedagogical tactics

It is at the pedagogical tactic level that the activities in jigsaw classroom are situated. Involving student partnerships in both teaching and research is challenging at a large scale. A jigsaw approach (Aronson 1978), allows for short-lived partnership interaction. In this pedagogical tactic, individuals leave their home group to become an 'expert' on a given topic, by working in a short-lived group with 'experts' from other groups. They return to their home group with the relevant insights for their area of expertise, making individuals more accountable for their learning and at the same time broadening their home group's perspectives on a problem.

A novel aspect in the jigsaw classroom is that the jigsaw approach is applied at a course level. Students within tutorials of about 24 students are divided into project groups of about six people. Members within the project groups take turns completing different activities in each course topic, of which a tutorial facilitation is one. In this way, students within the group become relative experts on different topics for the benefit of their peers.

Course design is an iterative process, involving four stages with continuous feedback processes: decision, design, development and delivery (Faulconbridge and Dowling 2009). In presenting this model, I am primarily focusing the description around the mechanisms involved in the delivery stages, with necessary connections to the design and development stages. Even within these stages, there are important distinctions between the *official curriculum* and the *curriculum in use* (Johns-Boast 2016). What is detailed here is not found entirely in the official curriculum, as various activities and roles within the model are situated outside any one course.

Design and delivery of the jigsaw classroom

Setting the expectations of a tutorial is done as a collaboration with the students in the first class. The whiteboard is divided into two halves. On one half is 'What makes a tutorial awesome?', and on the other, 'What makes a tutorial awful?'. Students grab a whiteboard marker, and put up a response based on their personal experience. This simple activity is extremely revealing, and instantly develops a rapport and expectation among the students. Typical responses include:

> 'What makes a tutorial awesome?' Interactive and lively discussion; prepared students who want to be there; prepared tutors who know their stuff; meaningful interactions between students; variety – not the same format each week; food; breaks; making improvements each week based on feedback.
>
> 'What makes a tutorial awful?' Tutorials that are just lectures; silence; unprepared students; unprepared tutors who just read their notes or write stuff on the board; no interaction; conversations that are dominated by one person; *that* mature-age student; not having time for breaks; no opportunity for feedback; no food, starting the tutorial before lunch time.

This list of shared learned experience becomes the basis for a discussion and a virtual contract with students in the class. The take-away message is two-fold: that tutorials should be facilitated in a way that encourages active learning, and that the students themselves are active agents in this experience. This is even more so when students take on the role of student-facilitators for the tutorial. The tutorial facilitations in the jigsaw classroom are dynamic, and have many moving parts. Here I briefly describe the key mechanics of the process.

Developing engaging learning activities

The student-researchers are tasked with designing a learning activity as part of their research project that meet four broad requirements:

1. Encourages students to 'learn by doing', based on constructionist pedagogy.
2. Conveys an engineering concept clearly in a real-world context.

3. Has no 'correct' answer, and encourages higher-level thinking and group dialogue.
4. Can be easily run by other students in a consistent way without compromising research data.

It is important to note that student-researchers are also learning through this process in three areas: the pedagogical approach, the content topic and their chosen research topic. The student-researchers are given a primer in the constructionist pedagogical approach through reading Martinez and Stager's *Invent to Learn* (2013). Student-researchers are also given the course syllabus and supplementary reading on the topic. From here, the student-researcher negotiates a research topic of interest to them, with the condition that the design of the learning activity would allow them to explore that question.

One of the major challenges for the student-researcher is that the learning activity has to deliver course learning objectives. Further, their research methodology needs to be simple and robust, as the activity is delivered as a core component of a tutorial that they do not design or run. Data is usually collected during the activity and via a concluding survey, and used to guide their research.

The activities that the student-researchers present are often more developed and creative than I could imagine. Some examples include a card game that gets students to build a bicycle based on customer requirements, creating instructions to build small structures, an activity that tests and evaluates different robot configurations, an interactive recycling knowledge test, and wearing empathy suits to simulate disabilities. All of these activities are now a core part of the course, and continue to be tweaked by student-researchers and student-facilitators.

Timing of classes

One week before student-facilitated tutorials, the allocated student-facilitators attend a required workshop. During the workshop, I give an outline of the key concepts from the theory on the week's topic, and then a run-through of the student-researcher's learning activity. This activity has been developed earlier as part of the student-researcher's project. All of the resources that the student-researcher designed are shared with student-facilitators, and the student-facilitators are able to discuss the topic and learning activity with both the lecturer and

the student-researcher. Time in the workshop is allocated to help student-facilitation groups to develop their plan for the tutorial, and groups are invited to seek feedback on their plan from the student-tutors and me before their facilitation. Before attending the tutorial, all students are required to complete a preset homework task that builds into their individual research project in preparation for the student-facilitated lesson, and the student-facilitators are encouraged to build on this task.

At the tutorials, student-facilitators execute their lesson plan. Student-researchers attend, collect data and provide some background information about their research. Student-tutors use the remaining time in class to reiterate key concepts and offer any further insights. Students are invited to provide a small amount of written feedback, which is passed back to the student-facilitators after the student-tutor has used them for consideration in the marking of the facilitation. Marks and compiled feedback are typically returned at the following tutorial. This process repeats itself through the weeks of the semester, with each topic expert facilitating a tutorial on their area of work.

Resources provided to the student-facilitators

In addition to the learning activity, student-facilitators are given a number of resources, related both to the theory content and the process of delivering a tutorial. The resources are developed specifically for the course and take the form of a 'toolkit'. The primary purpose is to orientate the student to the key concepts and methods that are required to be covered in their facilitation, and link to core readings and supplementary resources.

Students are also advised on how to design their tutorial through constructing a lesson plan. This exercise is useful for student-facilitators, who often have not run a tutorial before. Their plan should include a title, a take-home message about the content, a team goal for the delivery of the tutorial, a schedule of timing, materials and responsibilities, a detailed description of each activity within the tutorial, and an indication of how the tutorial will be modified if running short or long on time. The suggested format over 90 minutes includes an icebreaker, small-group activity building into a larger activity prepared by the student-researcher, followed by a discussion and conclusion.

The lesson plan is developed during the workshop ahead of the tutorial, and given to the student-tutor at the start of the tutorial. The lesson plan is used to understand how the student-facilitators are planning to run the tutorial. The lesson plan is not supposed to be a constraining document. Student-facilitators are free to drift from the lesson plan or make their lesson plan public, as long as it is indicated in the plan that this is what they are going to do.

Assessment of student-facilitators

One of the key roles of the student-tutor is to assess student-facilitations during the tutorial. As there are multiple student-tutors in multiple tutorials, it is important to establish a consistency between tutorials. This is done initially through direct moderation, and then through weekly discussion with student-tutors, shared observations of facilitations, continued monitoring, and through a marking guide. Student-tutors are encouraged to write feedback comments against the marking criteria during the tutorial, which are expected to be returned to the student-facilitators the following week.

A student-facilitation typically contributes between 10–15 per cent of the final grade. The assessment criteria for the student-facilitated tutorials typically cover: content, such as explanation of the topic and relevant methodologies; communication of the topic in an engaging and informative way; integration of a relevant activity in a way that helps peers to understand the topic; and preparation, the use of an effective lesson plan that assists in the above points.

As the student-facilitation is completed in groups, there can, at times, be unequal contributions between team members. At the end of the tutorial, the student-tutor will remind the student-facilitators that there is a process for group member moderation, if required. This moderation is rarely invoked, and this process encourages students to contribute in useful ways to the group.

Lessons from the jigsaw classroom model as a partnership

The various dimensions of involvement in the jigsaw classroom demonstrate how a partnership philosophy is appropriate for this approach. However, partnerships require work, and are full of compromises and frustration. Here I outline some of these reflections.

More partners equals more work

Occasionally I receive student feedback about how little I, as the lecturer, do in a course. This is, of course, an artefact of the traditional mode of lecturing, where the presence of a lecturer is an overt representation of authority and contribution. In the jigsaw classroom, the teaching is done by different peers each week. The student-facilitator might only interact with me in a more traditional teacher-student class one time a semester, which is the observation in the feedback.

However, behind the scenes, as the number of partners increase, the amount of work increases too. Student-tutors must be informed about the dynamics of the classes and requirements for the lessons, student-researchers require a significant time commitment, and student-facilitators need high-quality resources and timely feedback on their ideas. Students also need an opportunity to meet outside of class to discuss ideas that they are unsure about after the facilitation.

Student partners can be all care and no responsibility

Providing student-researchers and student-facilitators with the task of designing learning activities and whole classes is an opportunity, not a responsibility. Even though both are, at some point, assessed for their contribution, the expectations of students can vary wildly. I am reminded of one student-researcher who diligently attended all of the tutorials when their activity was running, but promptly misplaced the worksheets and surveys that their research project needed, which alongside requiring a major shift in their research project meant that we could not learn about how the activity ran in the class.

Balancing learning experiences and research activities

Often in early discussions with student-researchers the design of interesting research questions constrains the design of engaging learning experiences. Likewise, engaging learning experiences can constrain the types of data collected. Finding the balance can be a challenge, especially when this is often the first time that the student-researcher has created a learning activity.

With the involvement of a student-researcher in the activity, student-facilitators can feel constrained in their delivery of a tutorial,

or feel that their success is intimately linked to the quality of the pre-defined activity. Students are free to adapt the learning activity or create a new one, but rarely do.

Being prepared to lose control

A major concern with a partnership model in the delivery of teaching is that the lecturer loses control of the delivery of the content. A more interesting way to think about this is to challenge the idea that the lecturer ever had control. Taking into consideration the higher-level pedagogies of constructionism and sociocultural theory, learning is not the result of knowledge transmission but rather through the nego-tiation of ideas, and it is not always possible to do this with a large number of students.

Letting go of control can also be a great enabler for students. In a different course I convene using this approach, I had one instance where a tutor had forgotten to attend a student-facilitated tutorial. Instead of the class sitting idle or perhaps dispersing, the students agreed that they would send me a message, and forge ahead without the tutor. When I arrived towards the end of class, the students offered me a video recording of the tutorial from a smartphone, and individual feedback sheets so that I could assess the facilitation. The students had become powerful advocates for their own learning. The power of a distributed learning approach turned what could have been an awful mistake into a fantastic learning experience.

Empowering students as partners can lead to impressive results, and facilitations are often prepared in a more active, creative and rel-evant way than I can imagine. I would encourage someone thinking of adopting these processes into their classroom to consider how to best address the following ideas in their course design.

Take time to explain the partnership to students

This mode of delivery requires a discussion with students about the mechanics of the activities they are responsible for. Students appreciate a clear list of timings, requirements and expectations. In larger courses, I get groups to sign a contract, where students take ownership of partic-ular topics within their home group. I take time to explain both what I'm asking them to do, and why. In an engineering context, the 'why' comes down to the idea that, as part of professional practice, graduate engineers will be required to explain their ideas in engaging ways to a variety of stakeholders.

Work in the partnership should be packaged in similar-sized chunks

For the jigsaw weeks to be seen as equal commitments between group members, the content should be approximately the same size, with approximately equal readings and resources. I try to do this in my engineering class by presenting three smaller subtopics as one topic, and requiring student-facilitators to engage with at least two subtopics. Each subtopic has a bullet list of three or four key points that student-facilitators should cover. This allows a degree of flexibility for the student-facilitators, and allows good students to engage further in the readings.

Expect different partnerships to evolve in different ways

The first tutorial in each tutorial group will set the scene for the remaining classes. Try to encourage students that appear to be outgoing and onboard with the process to take the first tutorials, as later students will model their behaviour to some extent. In an attempt to counter this, I have found that encouraging student-facilitators to reflect on previous facilitations, and to share experiences and ideas during the workshop to be an effective way of getting good ideas out to the whole class.

Treat the process as a worthwhile partnership

As with any partnership, there needs to be some give and take. Some topics might need more attention than others, and some student-facilitators might need more assistance to deliver a high-quality experience for their peers. Because the facilitations occur over several weeks, I often extend more leniency to facilitators of earlier weeks and I encourage facilitators of later weeks to learn from previous weeks and not settle into the emergent routine.

Reflection on the jigsaw model as a partnership for learning

Healey and Harrington's (2014: 25) overview model describes four areas of student partnership: *learning, teaching and assessment, curriculum design and pedagogic consultancy, subject-based research and enquiry,* and *scholarship of teaching and learning.* These four areas

provide a useful framework to reflect on the jigsaw classroom. The activities around the student-facilitations fit into this model of partnership in different ways for different roles, at different stages of the course.

Learning, teaching and assessment

Students are learners, are involved in teaching, and inform assessment through peer feedback. Student-facilitators and student-researchers contribute to learning through the co-development of learning activities in the classroom. Student-tutors take on a mentor role in the teaching of content, and ensure that assessment is fair and consistent.

Curriculum design and pedagogic consultancy

Student-tutors drive the feedback process that informs the redesign and tweaking of tactics related to the jigsaw classroom each semester. For example, one semester it was clear that students were not reviewing the comments on their homework. The following semester, we set up a peer review process for the homework so that students spent the first half-hour of class providing comments on other students' homework.

The student-researchers are required to research relevant pedagogy and strategies for teaching their content topic, and construct the learning activity along with evaluation and research mechanisms. Student-facilitators make a scaffolded contribution to curriculum design through the creation of tutorials for their peers. Good activities are absorbed into the course design for the following year, so the course is constantly being improved through the contribution of the student-researchers and student-facilitators.

Subject-based research and enquiry

Students are encouraged to understand the topic through researching relevant case studies and by understanding the theory at a deeper level. Student-researchers are required to undertake their research project in the context of a learning and teaching activity, although their research focus may be in a different area. Student-researchers are also required to share their research approach and results with students.

Scholarship of teaching and learning

The student-researchers are encouraged to engage with the learning and teaching literature in order to design their learning activity, from general introductory concepts such as Bloom's taxonomy and philosophies referenced in this chapter, to specific discipline-centric research and methodologies. Where there is an opportunity, the student-researchers are invited to also contribute back to the literature (see Browne and Rajan 2015). Students are also exposed to key ideas in the SoTL literature as a rationale for the delivery mode and assessment tasks, and student-facilitators are encouraged to engage with resources that can help them prepare learning environments.

The activities around the student-facilitations as a whole provide a variety of partnerships for a variety of students. For the individual student enrolled in the course, however, the student-facilitation is not adequate to cover the learning journey through a course. To conclude, it is worthwhile reflecting on the individual student's journey through all phases of the course, using Levy's (2011: 43) modes for enquiry-based learning, where students move through the modes of *identifying, producing, pursuing* and *authoring*, throughout the semester. This highlights how the jigsaw activities support other activities in the class.

Identifying

Each student is required to complete a small homework task before coming to the student-facilitation. This homework task typically asks the student to apply the week's topic to their individual research project. Many students have trouble with the sequencing of this task, as they have to identify the relevant existing knowledge before they have been shown what to do. This is, of course, an important skill to develop, and over the weeks the homework tasks, if done well, provide a solid foundation for the individual research project.

Producing

The primary activity in the course that fits into the producing quadrant is the group student-facilitation. Good student-facilitators will not just adopt the student-researcher's activity, but will seek out relevant case studies, techniques and other knowledge to build their own activities to supplement or replace the student-researcher's activity.

This producing activity often leads to an assimilation of something back into the course, or becomes a future student-researcher partnership.

Pursuing

Each student is part of an open-ended group project for a client. Students negotiate the scope and nature of the project, and apply the course content to create a report. This is also a jigsaw task that runs concurrently to the student-facilitations, with each student taking turns to write a draft of their expert topic for their group project. At the conclusion of the jigsaw phase, groups provide a briefing document with recommendations back to the client.

Authoring

Each student authors a 15-page research project by the conclusion of the course. This activity often ties the whole course together for a student. Students are required to choose a research topic of interest to them, and apply the techniques from the jigsaw topics in a useful way. Students choose all sorts of topics, from examining emerging technologies, to creating solutions for family businesses, to tackling global environmental problems. Students are encouraged to extend their research beyond the scope of the course topics if they can see opportunities to do so. A good student will extend into the authoring quadrant, whereas a student who fails this task will typically stay within the identifying quadrant.

Conclusion

The contribution of the jigsaw classroom here is that it is a model that requires students to move through these modes during a single course, setting students up with tools for managing research projects in later years. Students move through these modes, as Levy suggests, either in a sequential progression or a spiral progression. I have found that good students will move through the modes in a spiral progression once or twice over the semester, whereas the best students will move through these modes in a spiral progression many times over the semester, constantly revising their work in their research project as new knowledge is discovered through the course.

The reflection on the jigsaw classroom has shown how a single mechanism can be used to engage students at various stages of their studies in multiple different partnership relationships. As with any partnership, clear expectations and ongoing negotiations are required to make the partnership effective. For educators thinking of adopting a jigsaw model incorporating student-facilitations, time should be taken to explain how the delivery model works and why it is being used, as well as considering the size and progression of content each week. Careful attention should also be paid to ensuring that students can see how the pieces of the jigsaw fit together, with incorporation of other tasks to move individual students through different modes of enquiry-based learning.

Acknowledgement

The development of the jigsaw classroom came out of experiences I had as a tutor for Professor Richard Baker, where student-facilitated tutorials are used in an extraordinary set of interdisciplinary courses, called the Vice-Chancellor's courses. I would also like to acknowledge the rich discussions about educational pedagogy that took place in the now-defunct Educational Development Group, involving Dr Malcolm Pettigrove, Dr Kim Blackmore, Lauren Thompson and Jeremy Smith. Finally, I acknowledge my partners in learning for their willingness to contribute: the dozens of student-tutors and student-researchers, and over a thousand student-facilitators.

16
Vignettes of current practice

Introduction

The following 12 short case studies, or vignettes, highlight current practices across a range of university disciplines that reflect the dimensions of the Connected Curriculum framework, as well as its general ethos of encouraging research and enquiry, and the related drive that sees students as partners in the development of their education.

A. Learning through research and enquiry: A graduate certificate for working professionals – a research-based education, with flexibility and online learning

A part-time certificate in teaching in higher education has run for over 10 years at the UCL Institute of Education, which provides development for mostly inexperienced lecturers. The programme has aimed to model a high-quality and flexible curriculum design (Ryan and Tilbury 2013) with variable duration, different start times and a choice of routes through the curriculum, with selection from workshop options. Flexibility is essential for the busy professionals taking the programme who also wish to pursue learning that is relevant to their disciplinary needs.

While the flexible programme has been very successful and has run with large numbers of satisfied students (over 100 students per year), the administration of the programme is very complex and it is time consuming to keep track of individual routes through the programme. Students also found the choices of content and different timings

confusing resulting in large volumes of emails to the programme leader and administrator asking for clarification.

A programme redesign raised a dilemma. A unified cohort-based curriculum over one year would reduce the administrative burden, but a pre-planned curriculum without a choice of routes and attendance dates would not suit the participants. A solution was to combine research-based and online education to give high quality and flexibility within a single route through the programme.

Research-based education provides flexibility of curriculum content as participants can select a professional area of interest to research. Another advantage of research-based learning is that students can engage at a range of levels and the programme can now attract more experienced participants who wish to develop leadership of teaching at the module or programme level, or move into institutional learning and teaching roles. A new Postgraduate Certificate in Professional Education and Training was designed with both aims in mind.

The redesigned programme not only has a single cohort but also has flexibility of attendance with fixed attendance reduced to two blocks of two days and the remaining six days equivalent taking place in supported online professional learning groups. Online sessions are asynchronous and synchronous and session timing will be negotiated with students. Students will work on developing a rationale and plan for a piece of research into their teaching practice that aims to enhance learning. They will then execute the plan and evaluate the outcomes. Their research findings will be discussed and disseminated with peers on the programme, with local colleagues and with other students from a partnering university interested in the development, Aarhus University, Denmark. The assessment follows the research process consisting firstly of the plan and secondly, the evaluation and dissemination of the innovation. Thus, in the new programme design, the quality of the programme is raised to target more specialised professionals and the curriculum is flexible to accommodate their busy lives, but the simplicity of the overall design means that administration requirements are minimised.

Gwyneth Hughes is Reader in Higher Education and a Connected Curriculum fellow. She is currently setting up a global engagement link with Aarhus University, Denmark and providing consultancy on research-based online learning to the University of London International Programmes.

B. Using social media to equip students with research skills to improve stakeholder engagement in the energy and resources sector

Postgraduate MSc students at UCL Australia learn about what a 'Social Licence to Operate' (SLO) is and how extractive industries such as the energy and resources sectors can better engage with the community. Over and above any formal legal permission, an SLO is increasingly important for many industries but, surprisingly, the role of virtual interactions with stakeholders is not very well understood yet. Focusing on websites and social media, students do several research-based exercises as part of their coursework, to examine broad concepts about stakeholder engagement that are then critically discussed in class to assess how virtual interactions can be effectively used for engagement. Students' main task is to review how real companies interact with virtual stakeholders via their websites, with each student producing a 'consultants' report' for a different port or renewable energy development. In a second group exercise, students then quantitatively review what social media companies are using to communicate with stakeholders, how long they have been on different channels, how frequently they interact, etc. Each year the students, in partnership with the module coordinator, run a different survey – in 2013 it was the top 100 Australian energy companies, the top 100 minerals companies in 2014 and then 100 conservation groups in 2015. Each student is assigned a set of companies/organisations which they assess using a pre-defined list of questions and data collated at the end of the exercise. Along the way a 'wiki' is used to collate information about scoring decisions and ongoing research dissemination.

While the main points of the exercises are to get the students to consider whether and how social media can be used for communicating with stakeholders, a sizeable database on social media use in the energy and resources sectors has been generated – providing a unique benchmark for industry to consider, which has been motivating for students to be involved in. Subsequently, several students have volunteered to work in partnership with the module coordinator after the course to work up the data into a full written paper, some of which was presented at an international conference on Social Responsibility in Mining in late 2015 (Styan et al. 2015). Students value the opportunity to engage in research, work in partnership with an academic member of staff, and produce assessments aimed at audiences which include industry sectors that students are interested in joining.

Craig Styan is a Senior Lecturer at UCL, based in Adelaide at UCL Australia. A marine scientist, Craig has worked in both academia and the oil and gas industry and strives to equip his students with the research skills needed by industry and government to solve future environmental issues.

C. Developing students' understanding of historical practice through connections with the university's research

Following on from the UCL 'Meet your researcher' activity (UCLa), which begins to enable dimension 1 of the Connected Curriculum framework, a similar but distinct activity has been designed into a second-year undergraduate History module at University College Dublin. Its core aims are to introduce students to the university's research culture. The exercise was embedded in a module concerned primarily with historical theory and methodology. It also explores the notion of public history, understood as being the activities of professional historians outside the academic environment, with the purpose of informing, educating and empowering a general audience. The principal aim is to further student understanding of professional historical practice through direct interaction with staff research projects.

The exercise was undertaken in three distinct stages. The first stage focused on research and information capture. Small student groups of five or six were assigned a staff researcher and tasked with investigating their research projects. Much of this work was conducted online. Students were directed to consult the relevant staff profiles, including their academia.edu and researchgate pages, online interviews and podcasts. After familiarising themselves with their researcher's field they were then instructed to read some of their recent publications. This task was sub-divided, with each student taking responsibility for one source. The students organised this themselves, but as they were required to post summaries of work completed on the virtual learning environment the module coordinator was able to monitor progress. The second stage focused on the interview with the member of staff. In preparation each group agreed a format and a list of questions on the basis of the research conducted in Stage 1. They were expected to incorporate aspects of public history as appropriate into the questions. Recording protocols were established and interview roles assigned. To assist in preparation students were advised to consult recordings and transcripts of interviews with well-known historians archived on the Institute of Historical Research's 'Making History' website. The groups then interviewed their

researcher for around 30 minutes. The third and final stage involved the students collaborating in a group presentation focusing on the work of their assigned researcher. Staff researchers attended and contributed feedback. Each individual student was then required to write a 2,000-word essay on the main historiographical trends in their assigned area, locating the work of their researcher in this context. Students were assessed both on their contributions to group work and the essay.

The principal outcomes of the exercise successfully allowed students to engage with the institution's research activity, enhance their understanding of the practice of professional history, provide insights into historical methodology, raise appreciation of the role and value of public history, and promote communication and digital learning skills. Students valued the curriculum design activity and have offered very positive feedback.

Edward Coleman teaches Medieval History in University College Dublin. He recently completed a Diploma in Teaching and Learning and is Director of Teaching in the School of History. His approach to curriculum design (which has been nominated for a National Academy for the Integration of Research, Teaching and Learning award) seeks to embed research in undergraduate teaching, to encourage student-led projects and to promote the use of educational technology.

D. Speech and Language Therapy students learn through scaffolded research development and turn their final dissertations into a journal article

Empirical research projects form a key role in facilitating active learning and in developing students as researchers (Healey et al. 2010). To provide these benefits for our students, we have systematically moved our final year dissertation module towards a more research-based education model, where students learn through research and enquiry, and write up their work as a journal article. In line with the principles of the Connected Curriculum, and the various stages of Healey and Jenkins's characterisation of the research-teaching nexus (Healey and Jenkins 2009), the programme begins as research-tutored and research-led, with emphasis on the research content of the discipline. In the later years, education is research-oriented, whereby students learn the skills and techniques necessary for research, such as critical analysis, research methods and statistics. The programme culminates with a research-based dissertation, usually empirical, whereby students undertake a large piece of research using their previously gained skills and knowledge.

Although students score well on their dissertations, there are a number of challenges associated with providing research-based projects for a relatively large number of students (circa 40 students annually), especially when students are simultaneously undertaking clinical work, and staff workloads are high. Students often find a research-based project intellectually challenging, may not see the relevance to their future careers, can find time management difficult, and must negotiate the ethical challenges involved in empirical work in this field. In addition, staff must balance the demands of supervision with their own teaching, research and administration, and the supervision of research-based projects can be substantially more demanding and time-consuming than supervising a literature review, or other project not involving data collection and analysis. As explained by Knight and Botting (2016), we have addressed these difficulties by moving to an 'academic-led' model of pairing students and supervisors for dissertations. We provide a catalogue of available projects, suggested by members of staff, and students choose their preferred projects. Thus, students are not faced with the prospect of developing a feasible and credible research idea themselves, can see the full range of research being conducted across the division and can conduct valuable and needed research relevant to ongoing staff interests. This allows for motivation and interest to be maintained at optimum levels (Hidi and Renninger 2006). The feedback from students and staff has been highly positive. Students value the opportunity to experience authentic research first-hand, to connect with research-active academics, and to produce an assessment in the form of a journal article. Although there are challenges for all in providing this type of final-year research-based education, the rewards for students and staff are high.

Rachael-Anne Knight, Lucy Myers and Professor Nicola Botting work in the Division of Language and Communication Science at City University of London, a leading provider of Speech and Language Therapy education. Rachael-Anne Knight is a National Teaching Fellow, and Principal Fellow of the Higher Education Academy.

E. Designing a throughline and a research-culture in Biochemistry

The Molecular Biosciences teaching hub at UCL is responsible for the delivery of BSc degrees in Biochemistry, Biotechnology and Molecular Biology. In 2015–2016, in response to student demand and the increasing need for masters-level qualifications as a prerequisite for many PhD programmes, a new degree began accepting students, the four-year

undergraduate MSci Biochemistry degree. The MSci Biochemistry was explicitly designed as a research-focused stream run independently of the BSc Biochemistry degree. The first two years of the MSci degree share the curriculum with the BSc Biochemistry degree, but the final two years are unique to the MSci and provide extensive research experience. This is achieved with an extended research project and practical and written research skills modules in year 4, and through data analysis and advanced practical modules in year 3 (based solely on practical work in a specific field, providing subject area technical expertise required for the extended research project in the final year). These modules are specifically aimed at providing a hypothesis-driven, project-based context in which students can become familiar with a particular set of research techniques. As the subject area is based on the current research of an academic in the department, students are able to have the experience of real experimentation in the subject area, extensive opportunity to acquire the requisite technical skills and the rare and exceptional opportunity to use equipment at the forefront of signalling technology.

The first two advanced practicals to be developed are 'Advanced Practical in Molecular Biology 1' and 'Advanced Practical in Cell Signalling 1'. The former uses the UCL Genomics Next Generation Sequencing facility to identify the microbial population present in a sample of soil. An important element of this practical is the bioinformatics and computer programming that students learn for the sequence analysis. The latter practical takes advantage of UCL's high-throughput calcium imaging device and other high-throughput plate readers of the kind used by pharmaceutical companies. Both modules have the potential to generate novel publishable data. This innovation in the delivery of laboratory practical work uses technology that is not routinely used in the undergraduate curriculum and has provided MSci Biochemistry students with a unique opportunity to engage in scientific research as part of their undergraduate degree, through an extended throughline and in a research-rich culture.

Andrea Townsend-Nicholson is a research-active professor of molecular biology and biochemistry who is strongly engaged in connecting research and teaching. Michael Baron is a teaching fellow particularly interested in embedding advanced techniques in the Molecular Biosciences curriculum. Both have received several awards for their research and teaching work and have created a variety of learning resources that are used internationally.

F. A throughline of research in a music programme

Undergraduate Musical Theatre students at Trinity Laban Conservatoire of Music and Dance engage with a research development strand to support practice-based learning. They connect research skills with creative practice (including performance) and technical development in singing, acting and dancing: as such, the strand is intended to facilitate increasingly complex connections between practical experiences within the programme and the musical theatre sector. Research is initially characterised by recognising students' embodied knowledge. Two first year modules scaffold the connected approach: firstly, students create programme notes that are linked to their end of term performance project, and produce a written reflection on their own learning processes; secondly, critical analysis is introduced via reflection on their collaborative process in a cross-institutional, cross-disciplinary module where they undertake mentor-led creative projects. This process is contextualised in a portfolio that, through systematic enquiry methods, develops an understanding of 'the creative artist' by producing an evaluative analysis of 'who's who' in the industry and how the industry operates, reflections on individual creative processes, strategic analysis of individual career and life goals, and consideration of the implications of industry practices for creative artists. At Level Four, this enables practitioners to engage with tasks that connect to their kinaesthetic experience of creative practice, performance and learning, while starting to engage with fundamental research skills. Practice-led research methods are introduced at Level Five to support research development through practical assessments where students choose a role as a creative or a writer, and explore that role through the creation of a short piece of work that evidences understanding of what the role involves. Creatives explore the shaping of a performer's rehearsal and preparation of a short monologue, dance or song. Writers create music or lyrics for a song, or the dialogue for a scene (leading to a song). A correlative written element on the process asks them to consider the extent to which relevant theories of practice have informed their own experience, how their experience in practice enables them to consider theories of practice, and how their experience informs their role as a creative artist. Following this, more traditional scholarship is introduced. They utilise their experience on the parallel Acting Through Song module to create an article exploring what informs performer choice and, to produce a second article, they choose a topic relating to their first Level Five Performance Project. As well as holistically developing students' readiness to transition into

Level Six, these processes specifically prepare for the higher intensity practice-based modules and a Creative Research Project, the culmination of this strand that replaces the traditional dissertation where students must demonstrate how their research develops their creative practice in a large-scale project.

Louise Jackson is Head of Learning Enhancement and a National Teaching Fellow. Victoria Stretton is Programme Leader for the BA in Musical Theatre Performance and Head of Musical Theatre. Trinity Laban Conservatoire of Music and Dance is a specialist institution, focused on the advancement of creative artistic practice and delivers predominantly practice-based programmes, with c.1000 students studying Music, Contemporary Dance and associated disciplines.

G. History students researching their university and engaging an audience

In a second-year undergraduate module in the History and Classical Civilisation programmes at the University of Roehampton students initially learn about the (two) histories of the university and the campus that goes back well before the university moved to the site. Students use the extensive and varied resources of the university for their research projects, including: archival collections from the university, the buildings and artworks themselves, many of them listed. These allow undergraduate students to work with original historical sources that are unmediated by editorial processes, a benefit few other students get to enjoy so early in their education. Close investigation of neoclassical architecture and art on campus gave Classical Civilisation students numerous possibilities for the research of classical reception. The written, pictorial and material sources, many of them unpublished and under-researched, have great potential for new research questions and specialised research training.

Students in these programmes benefit from engaging staff at the university they might not encounter otherwise, such as archivists, the heritage officer, chaplains and tutors from other departments. This deeper comprehension of the roles of a university and their place as students in it not only deepens the students' sense of belonging but also gives them a better understanding of the purpose of university research. Because of the wide range of possible research projects, the format of their assignments is not prescribed. It is only stipulated that the results have to be presented to a public audience that could be reached either digitally with a website or a video or in a physical setting like a

presentation to a local history society, a guided tour of a school class, or, among other options, a study day for fellow students and staff members. In conclusion, the module enhances research skills training while at the same time challenges the students to think creatively about realisation and presentation of their projects (for more on this case study see Behr and Nevin forthcoming).

Charlotte Behr is a Reader in Roman and Early Medieval History at the University of Roehampton. She has a long-standing interest in designing innovative ways for the integration of research and employability skills into the curriculum and has published on various aspects of continual curricular developments that are aimed at enhancing students' transferable skills while helping them to gain growing confidence in their abilities.

H. E-portfolio assessments: Creating connections

Medical schools across Australia but also globally are looking into designing, developing and implementing a programmatic assessment approach (Van Der Vleuten et al. 2012) to their medical curricula. This approach is often part of a continuum which begins with the development of specific capabilities for graduates, necessary to get accredited as doctors or other healthcare professionals, and then align this with learning activities and measurable assessment opportunities across a programme of study. The use of an electronic portfolio tool, the provision of longitudinal tutorial support and credible feedback are often the key design challenges for programmatic assessment (Bok et al. 2013). At Macquarie University the Faculty of Medicine and Health Sciences designed, developed and implemented a pedagogically sound and technologically workable and sustainable solution to programmatic assessment using an e-portfolio tool for its newly established Bachelor of Clinical Science – a two-year accelerated undergraduate programme. The curriculum includes a professional practice stream integrated across the entire programme. It was in this stream that the students were introduced to the concept of an e-portfolio as way to help them join the dots between learning and professional capabilities across all the modules of study in their programme but also from other aspects of their lives (work or volunteering experiences). The curriculum design included clear guidelines, scaffolded reflective templates and a set of specific capabilities to facilitate the collection of evidence and showcase learning. Students collected all their evidence into their private portfolio space, and a workbook structure was developed to facilitate

the assembly into meaningful learning statements. Students were asked to link such statements with the capability framework (New South Wales Public Service Commission). An auto-submit function was enabled to allow timely feedback. Most importantly it was made sure through the learning design process that the portfolios reflect as far as possible the requirements of postgraduate training and future career paths. This was perhaps one of the most important buy-ins for the students. An evaluation of the first-year implementation suggested that the use of an electronic portfolio to enhance programmatic assessment was an invaluable component of the programme. The following quotes are illustrative:

> I found myself reflecting on everything and not because I had to but because I wanted to. Reflection has actually now become a large part of the way I work and has allowed me to truly understand my ambitions, values and principles.
>
> While the portfolio at first seemed quite tedious, as I progressed through the session being equipped with the skills to reflect effectively I was able to draw personal meaning and the process of reflection became easier. I have come to enjoy the ePortfolio experience and would strongly encourage this resource to be continued with all cohorts.

Panos Vlachopoulos is Associate Professor and Associate Dean Quality and Standards in the Faculty of Arts at Macquarie University in Sydney, Australia. During 2016 Panos was acting Associate Dean Learning and Teaching in the Faculty of Medicine and Health Sciences in the same university, where he led the implementation of an innovative curriculum for the Bachelor of Clinical Sciences.

I. Using graduate attributes to link academic learning with the world of work

Leeds Beckett University, in consultation with staff, students and employers, has generated three graduate attributes (GAs) that need to be embedded in every undergraduate course. Our students' futures are likely to be increasingly shaped by the changing nature of the workplace and society, requiring them to *have a global outlook, be enterprising and be digitally literate* – these three GAs are all key elements in being an employable graduate.

All our students must be aware of how GAs are shaped through their course, how they add value to their degree and help them become effective citizens. Students need to be able to reflect upon them and articulate them to others, specifically prospective employers. Initially, a working group with cross-university representation devised guidance for staff on the embedding, delivery and visibility of each GA. This written guidance included practical examples of how to embed the GA into each level learning outcome so appropriate summative assessment could take place. The publication of the written guidance was supplemented by informal support workshops for staff as they designed their modules and courses. We sought real examples from staff in the form of their GA-focused assessment ideas and films explaining how they embedded the GAs in their module assessment.

The Centre for Learning and Teaching also interviewed students about their assessment experience and their workplace, volunteering and enterprise activity asking them to link their experience in the workplace to their academic course, highlighting how at least one GA had been addressed, delivered and executed in their course. From these interviews, we generated a student resource called the *Little Book of Graduate Attributes*. This resource contains diverse case studies and explores how students can evidence their GA-related activity to potential employers. In addition, examples of how the GAs might be visualised by students at each academic level are included. This *Little Book* also contains case studies from staff about how each GA is visible in their modules, outlining innovative assessments, real-world projects and workplace links with our students in our partner universities. A hard copy of the *Little Book* was issued to every new first year student and is accessible as a digital resource for all students.

Susan Smith is Head of Curriculum Development and Review in the Centre for Learning and Teaching at Leeds Beckett University. She is a Principal Fellow of the Higher Education Academy and a National Teaching Fellow. She is widely published with research interests in curricular activity, inclusive practice and student metacognition.

J. An Alumni Mentoring Network enabling student connections with alumni and career mentoring

UCL Alumni Mentoring Network – re-launched in 2016 (UCLc) – provides a platform for students to find out more about a role, organisation or sector one is interested in. It is designed to give

students the facility to discover this information for themselves by connecting them with alumni already working in the sector. The network takes advantage of the wide range of existing UCL alumni, allowing students to connect with alumni and each other; further, it provides alumni with a means of keeping in touch with their cohort, individual department and UCL more generally. The network synchronises with other social media, such as LinkedIn, and it is expanding all the time. In total, there were over 1,800 alumni signed up on the network by mid-December 2016; with vast increases in specific areas in a short period of time, e.g. the Bartlett Faculty of the Built Environment's alumni increased from 110 to over 160 within one month.

Alumni provide details on the network of the ways in which they are happy to help students. The network allows one to search through its members in a variety of ways, for example by organisation name, UCL department, industry sector and/or other keyword. Students then message alumni through the network, which prompts the student to explain why they are getting in touch. Students have already used the network for a variety of purposes, including the following: contacting alumni to obtain assistance scoping subjects for their dissertation; introducing themselves to others within alumni workplaces; seeking out feedback on CVs; obtaining help in preparation for interviews; and securing long-term mentoring. The Network provides a powerful tool for the institution's students and graduates, particularly as it is only available to those who have studied at UCL, empowering students to think early on about their career options and ultimately stand out in the competitive application process.

Mark De Freitas is a Careers Consultant at UCL where he has worked with students and academics across the university.

K. Student–staff partnerships: Students partnering with staff to improve education

UCL ChangeMakers is designed to further the university's aim of students being full partners in the university's future (UCLb; UCLd). The original idea was to empower students to develop and carry out their own educational development projects, by providing funding and central support for student-initiated projects. All the projects enhance the student learning experience but their remit varies widely. For example, one project developed a series of tutorial videos on 3D printing, while another organised Skype calls with

a South American university to allow students to practise their language skills, and yet another considered how to optimise the module selection process.

All the projects involve an element of enquiry – either by investigating the demand for a change, how it is best implemented, or by evaluating a pilot. Students are offered training on research ethics, research methods, project management and leadership. As well as being supported centrally, students are required to work with a member of UCL staff, who provides disciplinary support for the project, ensuring its relevance and utility for the context in which it will be implemented. As such, students learn through enquiry, connect with staff and have to produce outputs, such as reports, to persuade their audience of the utility of the change. The students are also all encouraged to present their work at UCL's annual education conference.

UCL ChangeMakers had a successful pilot year in 2014–2015, with lead students reporting that undertaking a project had empowered them and given them a greater sense of belonging to the institution (see videos at http://www.ucl.ac.uk/changemakers/projects/projects-info). However, the scheme's ambition has grown and it now aims to contribute to normalising staff/student partnerships in educational development work across UCL. In 2015–2016 the scheme introduced staff-initiated projects which forward the aims of the Connected Curriculum (see http://www.ucl.ac.uk/changemakers/projects/projects-info for a list of projects).

UCL ChangeMakers also introduced an institution-initiated strand, whereby UCL decides on an educational priority each year on which students work in partnership with their department. In 2015–2016 the focus was on assessment and feedback, with 26 students working with 18 departments to develop resources for both staff and students to aid assessment literacy, fairness of assessment, and the quality and use of feedback. Examples include students running focus groups for the Transforming the Experience of Students Through Assessment process (www.testa.ac.uk), and developing feedback proformas.

Student Reviewers of Teaching was added to the UCL ChangeMakers programme in 2016–2017, whereby staff and students pair up to investigate an aspect of the staff member's teaching practice. The investigation is based around a series of dialogues, with the pair discussing their different perspectives on three hours' worth of classroom teaching, how a virtual learning environment supports course aims and the merits of an assignment brief. This part of the scheme strengthens

the relationship between staff and students; it encourages critical thinking and introduces students informally to observational research methods (both physical and virtual).

Jenny Marie leads UCL ChangeMakers, which supports students and staff across the whole of UCL to work in partnership on educational enhancements. She has worked in educational development for 10 years, mainly in the areas of skills development, facilitation and adult learning.

L. Establishing an individual and peer coaching support network for an MSc dissertation in Voluntary Sector Policy and Management in UCL's School of Public Policy

Every year between three and six of the dissertation students are invited to an initial meeting, prior to the end of the spring term, where we discuss the coaching approach to dissertation supervision. At this meeting students learn that the purpose of the coaching approach to the MSc dissertation is to collectively contribute to each other's learning, in a safe, structured and supportive environment of critical friends. A contract, which is discussed at the outset, establishes the coaching relationships not only between the MSc dissertation supervisor and each student, but also between students, as peer coaches.

At this initial 'contracting' meeting, the following specifics are agreed: a set of mutually convenient dates and times to meet for coaching sessions in the following term; the amount of time each day that each student will devote to their dissertation; the requirement to come to every coaching session with work, issues or concerns to discuss; and that there is always extra time available, should students require individual advice or tutoring.

The aims of establishing a peer coaching dissertation support network are twofold. First, it builds both individual and joint capacities in relation to research: supervision, methodologies, strategies and skills. Second, since dissertations are due in September and the formal supervisory relationship with each student concludes by the end of June, by building their individual and collective capacities both in relation to research as well as coaching, they feel confident not only in their abilities to progress with their individual dissertations, but also to seek and give advice, support and coach one another.

Not only does this assist students' development as independent researchers, but by building a coaching culture and peer network, they feel supported and enriched, rather than isolated or unduly concerned

about the fact that their supervisor is no longer available to them. This approach sets students up with the skills and confidence to engage each other in the writing of their dissertations.

This approach has been employed over several years and works extremely well, with unanimously positive student feedback. Two examples follow.

> Thank you very much for all your guidance, patience and support during this … [coaching] … process. It has been a real pleasure and honour to have been accompanied by you … [and my peer coach] … during our journey and above all to get to know one another better.
>
> I really want to thank you again for all the guidance, support and coaching you gave me which I didn't expect at all before we met. I feel so lucky to have had the chance to work with you and my peer coach. Every session was not only extremely helpful but also very enjoyable.

This example of scaffolded peer support is no doubt relevant to many other research-based educational contexts.

Sarabajaya Kumar is a Senior Teaching Fellow in Voluntary Sector Policy at UCL's School of Public Policy and is the lead on researcher development at London School of Economics and Political Science. She trained as a coach through a staff development initiative at UCL; and as a passionate advocate of coaching she has introduced coaching approaches into many aspects of her work with students.

Afterword

Brent Carnell and Dilly Fung

This collection has offered windows into the ways in which a research-based education strategy and framework can operate in practice. The 15 contributed chapters and 12 shorter vignettes illustrate a good *range of disciplines* from art history through to veterinary science. Each contribution illustrates an innovative approach suited to a particular programme, discipline or institution, and many can be applied to different national, institutional and departmental contexts. However, while the applications of these educational developments are already wide-reaching, more work is needed to show how the connective approaches promoted by the Connected Curriculum framing could play out in and across even more disciplines and fields of learning. Given the challenges of inspiring busy academic colleagues, researchers and institutional leaders, who may be working within academic 'microclimates' (Roxå and Mårtensson 2011), having a dossier of localised and disciplinary case studies to draw on will be a valuable tool.

Similarly, as editors we have attempted to bring together a range of research-based education in practice from a spread of *national* contexts. However, here the collection is more limited. As this is an English publication, it is perhaps not surprising that the scholars who stepped forward to contribute were from the Commonwealth countries (or in the case of the Chinese example, were part-based in England). In the future, it will be important to draw together an even wider range of case studies from many regions and national contexts. We are especially keen to draw on the expertise of colleagues working across the continent of Africa, from those working across the Indian sub-continent, from South America and East Asia, and indeed from academics, professionals and practitioners from all areas of the world whose perspectives, research and practices are not represented here.

Despite these limitations, with this collection we hope to call to action others working in and beyond the growing body of scholarship on research-based education to help take this vision forward. Already colleagues from around the world are collaborating to inspire educators to develop their offering by shifting to a more enquiry-driven and research-based learning approach that connects learning more effectively to local and wider communities. Those who want to see higher education as a fairer, more open and more effective ecosystem of activity are also inspiring researchers to connect even more readily with students, teachers, practitioners and policy makers, finding new ways to communicate with the wider world and even raising questions for the higher education sector about the ways in which job roles, evaluations of 'excellence' and systems for reward and esteem need to be revisited (Fung and Gordon 2016; Locke 2014). Policies such as these, as well as educational practices that affect students more directly, need to change if research-based education is to fulfil its promise. It is promising therefore to see that institutional leadership teams and those whose political and economic decisions affect higher education as a sector are being brought into this debate.

Collective efforts to re-think the relationships between our various missions and activities in higher education are surely worth it. The integration of research and education, whereby students connect through dialogue with the production of knowledge, has the very real potential to make a difference to the lives of people around the world. As Fung argues (2017: 17), higher education institutions achieve extraordinary advancements of knowledge through research, both within and across disciplines. Our many complex global challenges are being addressed across the disciplines by researchers who produce new knowledge that 'enhances our culture and civilisation and can be used for the public good' (Nurse 2015: 2). Connecting education with research is not just a matter of educating individuals. It is about creating a more effective and more explicitly values-based ecosystem of activity in higher education that is explicitly directed at contributing to 'the global common good' (UNESCO 2015).

In a volatile era of political instability, global conflicts, economic inequalities and innovative technologies, the imperative to take a fresh look at the ways in which all of the goals and activities of higher education relate to one another is clear. Bringing students more explicitly into the landscape of research is not just about creating advanced learning opportunities, and not just about enhancing knowledge production by

enhancing research through teaching (Harland 2016), although these are important aims. It is about developing communities, local and global, that are increasingly able to evaluate and make research-based arguments, learn from diverse groups and individuals and communicate effectively across cultural and national borders. We hope that this volume has made a small contribution to this cause.

Notes

Chapter 1

1. An extended set of case studies (Humanities, Law, Criminology, Earth Sciences and Physics) is available at http://www.coronyedwards.co.uk

Chapter 4

1. Different collections refer to their material in different terms. The most commonly employed are objects, artefacts, items, artworks and specimens. For ease of discussion we will employ the term 'object' to refer to all these categories.
2. https://www.youtube.com/watch?v=YQ_lS_8-ZDE
3. https://www.youtube.com/watch?v=IKPnxnEM98o
4. https://www.youtube.com/watch?v=HPvLQ2o3vHY
5. https://www.youtube.com/watch?v=ZhpQkFJBQYc

Chapter 8

1. The Connected Curriculum – UCL's approach to research-based education – is discussed in more depth below. See also the introduction to this collection.
2. The Institutional Validation is a standard quality assurance procedure found in most universities. This process is used by programme leaders/team to make significant changes to the curriculum, learning outcomes and modes of delivery of a programme of study.

Chapter 9

1. Referred to as 'humanities' in this chapter.
2. Ethical clearance was obtained for the use of case study data and individuals whose case studies are cited gave permission for the use of their ideas and names for the purposes of this chapter.

Chapter 10

1. It is important to note that while C2016+ used the term *discipline* as shorthand to describe the subject areas or areas of practice fundamental to each programme of study, it recognised that many programmes do not draw on a discrete discipline, but rather a field of study and/or areas of practice which build on a range of disciplinary and practice-based knowledges and understandings.

2. If the traditional approach to software development is expressed in terms of thinking like a computer then Object Thinking can be expressed as thinking like an object (West 2004). In designing a computer program to solve a problem, the problem is deconstructed into objects which communicate and collaborate together to produce a solution; objects correspond to things found in the real world. Object Thinking applies to all stages of the software development lifecycle, from conception to execution and provides a way of both describing and solving a problem abstracted away from the physical computer and its associated constraints.

Chapter 11

1. A phrase with diverse attributions.
2. The concept of a rhizome relates to the root structures of plants, which can go in multiple directions, rather than being linear or hierarchical (Deleuze and Guattari 1987).
3. http://www.catalytic-clothing.org.
4. http://helenstoreyfoundation.tumblr.com/post/103115842655/field-of-jeans-at-thomas-tallis-school-greenwich.
5. A cosmetic science project on managing the effects of age on the skin (see http://www.eudelo.com/2011/03/04/the-beauty-of-age-research-project/).
6. https://creativeresearchmethods.wordpress.com/workshop-2-london/.
7. www. http://shiftlondon_org.
8. http://blogs.arts.ac.uk/fashion/2013/11/29/lcf-prison-project-wins-times-higher-education-outreach-award/?_ga=1.150227061.292333858.1473002046.
9. *The Beauty's Inside.* Issue 4.2. Available online: http://sirjohncassfoundation.com/projects/the-beautys-inside/.
10. Swift, in conversation with author, May 2016.
11. http://www.arts.ac.uk/fashion/business-and-innovation/industry-projects/speedo-reinventing-the-lzr-racer-suit/.
12. http://www.arts.ac.uk/fashion/business-and-innovation/industry-projects/nike-sustainable-materials/.
13. http://blogs.arts.ac.uk/fashion/2014/06/16/ma-fashion-futures-student-wins-at-rhs-bbc-gardeners-world-live-with-natural-dyes/.
14. Details of this project were provided in an interview with Suzanne Rankin.
15. http://www.arts.ac.uk/fashion/business-and-innovation/industry-projects/amnesty-international/.
16. Email to author, September 2016.

Chapter 12

1. Human factors is the science of understanding human behaviours within a system (in this case, healthcare) (Catchpole et al. 2011).

Chapter 13

1. *Connected Curriculum* from www.ucl.ac.uk/connectedcurriculum

References

Editors' introduction

Barnett, R. (ed.) (2005). *Reshaping the University: New Relationships between Research, Scholarship and Teaching*. Maidenhead, UK: McGraw-Hill/Open University Press.

Blair, A. (2015). *From Learning by Transmission to Learning by Doing: Engaging Students in Research-Led Teaching and Learning Practices*. York: Higher Education Academy. Available online: https://www.heacademy.ac.uk/sites/default/files/alasdair_blair_-final.pdf. Accessed 23 March 2017.

Blessinger, P. and J. M. Carfora (eds) (2014). *Inquiry-Based Learning for the Arts, Humanities and Social Sciences: A Conceptual and Practical Resource for Educators: 2*. Innovations in Higher Education Teaching and Learning. Bingley, UK: Emerald.

Bovill, C., A. Cook-Sather and P. Felten (2011). 'Students as co-creators of teaching approaches, course design, and curricula: Implications for academic developers.' *International Journal for Academic Development* 16, no. 2: 133–45.

Brew, A. (2006). *Research and Teaching: Beyond the Divide*. London: Palgrave Macmillan.

Chang, H. (2005). 'Turning an undergraduate class into a professional research community.' *Teaching in Higher Education* 10, no. 3: 387–94.

Dunne, E. and R. Zandstra (2011). *Students as Change Agents: New Ways of Engaging with Learning and Teaching in Higher Education*. Bristol, UK: A joint publication from University of Exeter/ESCalate/ Higher Education Academy. Available online: http://escalate.ac.uk/8064. Accessed 23 March 2017.

Elken, M. and S. Wollscheid (2016). 'The relationship between research and education: Typologies and indicators: A literature review.' Oslo, Norway: Nordic Institute for Studies in Innovation, Research and Education (NIFU).

Fung, D. (2017). *A Connected Curriculum for Higher Education*. London: UCL Press.

Fung, D. and B. Carnell (2017). *UCL Connected Curriculum: Enhancing Programmes of Study*. Second edition. University College London.

Fung, D. and C. Gordon (2016). *Rewarding Educators and Education Leaders in Research-Intensive Universities*. York: Higher Education Academy. Available online: https://www.heacademy.ac.uk/sites/default/files/rewarding_educators_and_education_leaders.pdf. Accessed 20 January 2017.

Fung, D., J. Besters-Dilger and R. van der Vaart (2017). 'Excellent education in research-rich universities.' Position Paper. League of European Universities (LERU). Available online: http://www.leru.org/files/general/LERU%20Position%20Paper%20Excellent%20Education.pdf. Accessed 23 March 2017.

Healey, M. and A. Jenkins (2009). *Developing Undergraduate Research and Inquiry*. York: Higher Education Academy. Available online: https://www.heacademy.ac.uk/node/3146. Accessed 23 March 2017.

Healey, M., A. Flint and K. Harrington (2014). *Engagement Through Partnership: Students as Partners in Learning and Teaching in Higher Education*. York: Higher Education Academy. Available online: https://www.heacademy.ac.uk/system/files/resources/engagement_through_partnership.pdf. Accessed 23 March 2017.

Kreber, C. (ed.) (2009). *The University and its Disciplines: Teaching and Learning within and beyond Disciplinary Boundaries*. London: Routledge.

Levy, P. and R. Petrulis (2012). 'How do first year university students experience inquiry and research, and what are the implications for the practice of inquiry-based learning?' *Studies in Higher Education* 37, no. 1: 85–101.

Spronken-Smith, R. and R. Walker (2010). 'Can inquiry-based learning strengthen the links between teaching and disciplinary research?' *Studies in Higher Education* 35, no. 6: 723–40.

UCLa (University College London) (2017). UCL Education Strategy 2016–2021. Available online: https://www.ucl.ac.uk/teaching-learning/education-strategy. Accessed 23 March 2017.

UCLb (University College London) (2017). Liberating the Curriculum. Available online: https://www.ucl.ac.uk/teaching-learning/education-initiatives/connected-curriculum/liberating-curriculum. Accessed 23 March 2017.

UNESCO (2015). *Rethinking Education: Towards a Global Common Good?* Paris: United Nations Educational, Scientific and Cultural Organization.

Walkington, H. (2015). *Students as Researchers: Supporting Undergraduate Research in the Disciplines in Higher Education*. York: Higher Education Academy. Available online: https://www.heacademy.ac.uk/sites/default/files/resources/Students%20as%20researchers_1.pdf. Accessed 23 March 2017.

Wieman, C. and S. Gilbert (2015). 'Taking a scientific approach to science education, part I – research and part II – changing teaching.' *Microbe* 10, no. 4: 152–6 and 10, no. 5: 203–207.

Wood, J. (2010). 'Inquiry-based learning in the arts: A meta-analytical study.' CILASS (Centre for Inquiry-based Learning in the Arts and Social Sciences). University of Sheffield. Available online: https://www.sheffield.ac.uk/polopoly_fs/1.122794!/file/IBL_in_Arts-FINAL.pdf. Accessed 23 March 2017.

Chapter 1

Abrandt Dahlgren, M. and L. O. Dahlgren (2002). 'Portraits of PBL: Students' experiences of the characteristics of problem-based learning in physiotherapy, computer engineering and psychology.' *Instructional Science* 30, no. 2: 111–27.

Biggs, J. (2003). *Teaching for Quality Learning at University – What the Student Does*. Buckingham, UK: SRHE/Open University.

Boyer Commission on Educating Undergraduates in the Research University (1998). *Reinventing Undergraduate Education: A Blueprint for America's Research Universities*. New York, USA: State University of New York–Stony Brook.

Brew, A. (2003). 'Teaching and research: New relationships and their implications for inquiry-based teaching and learning in higher education.' *Higher Education Research and Development* 22, no. 1: 3–18.

Brew, A. (2006). *Research and Teaching: Beyond the Divide*. London: Palgrave Macmillan.

Brew, A. (2010). 'Imperatives and challenges in integrating teaching and research.' *Higher Education Research & Development* 29: 139–50.

Chan, E.T.Y. (2016). '"Being an English major, being a humanities student": Connecting academic subject identity in literary studies to other social domains.' *Studies in Higher Education* 41(9): 1656–73.

Cleaver E., M. Lintern and M. McLinden (2014). *Teaching and Learning in Higher Education: Disciplinary Approaches to Educational Enquiry*. London: Sage.

Department for Business, Innovation and Skills (2016). *Success as a Knowledge Economy*. London, UK: Crown Copyright. Available online: www.gov.uk/government/publications. Accessed 30 December 2016.

Fung, D. (2017). *A Connected Curriculum for Higher Education*. London: UCL Press.

Fung, D. and B. Carnell (2017). *UCL Connected Curriculum: Enhancing Programmes of Study*. Second edition. London: University College London.

Griffiths, R. (2004). 'Knowledge production and the research-teaching nexus: The case of the built environment disciplines.' *Studies in Higher Education* 29, no. 6: 709–26.

Healey, M. (2005). 'Linking research and teaching: Exploring disciplinary spaces and the role of inquiry-based learning.' In *Reshaping the University: New Relationships Between Research, Scholarship and Teaching*, edited by R. Barnett, 67–78. Maidenhead, UK: McGraw-Hill/Open University Press.

Jenkins, A. (2004). *A Guide to the Research Evidence on Teaching-Research Relations*. York, UK: The Higher Education Academy. Available online: https://www.heacademy.ac.uk/system/files/id383_guide_to_research_evidence_on_teaching_research_relations.pdf. Accessed 30 December 2016.

Jenkins, A. and M. Healey (2005). *Institutional Strategies for Linking Teaching and Research*. York, UK: The Higher Education Academy. Available online: https://www.heacademy.ac.uk/resource/institutional-strategies-link-teaching-and-research-full-report. Accessed 30 December 2016.

Land, R. and G. Gordon (2015). *Teaching Excellence Initiatives: Modalities and Operational Factors*. York, UK: The Higher Education Academy. Available online: https://www.heacademy.ac.uk/system/files/resources/teaching_excellence_initiatives_report_land_gordon.pdf. Accessed 30 December 2016.

McLinden, M. and C. Edwards (2011). 'Developing a culture of enquiry-based learning in a research-led institution: Findings from a survey of pedagogic practice.' *International Journal for Academic Development* 16, no. 2: 147–62.

McLinden, M., C. Edwards, J. Garfield and S. Morón-Garcia (2015). 'Strengthening the links between research and teaching: Cultivating student expectations of Research-informed teaching approaches.' *Education in Practice* 2, no. 1: 24–9. Available online: https://intranet.birmingham.ac.uk/staff/teaching-academy/documents/public/eip-dec15/mclinden.pdf. Accessed 30 December 2016.

Neumann, R. (1994). 'The research-teaching nexus: Applying a framework to university students' learning experiences.' *European Journal of Education* 29, no. 3: 323–39.

Polias, J. (2010). 'Pedagogical resonance: Improving teaching and learning.' In *Language Support in EAL contexts. Why systemic functional linguistics?* NALDIC Quarterly 8, no. 1 (Reading, UK: NALDIC): 42–9.

Quality Assurance Agency (2008). Subject Benchmark Statement for Physics, Astronomy and Astrophysics. Available online: http://www.qaa.ac.uk/en/Publications/Documents/Subject-benchmark-statement-Physics-astronomy-and-astrophysics.pdf. Accessed 30 December 2016.

Quality Assurance Agency (2015). Subject Benchmark Statement for Law. Available online: http://www.qaa.ac.uk/en/Publications/Documents/SBS-Law-15.pdf. Accessed 12 July 2017.

Robertson, J. (2007). 'Beyond the research-teaching nexus: Exploring the complexity of academic experience.' *Studies in Higher Education* 32, no. 5: 541–56.

Spronken-Smith, R. and R. Walker (2010). 'Can inquiry-based learning strengthen the links between teaching and disciplinary research?' *Studies in Higher Education* 35, no. 6: 723–40.

Trigwell, K. and S. Shale (2004). 'Student learning and the scholarship of university teaching.' *Studies in Higher Education* 29, no. 4: 523–36.

Tsai, C. (2000). 'Relationship between student scientific epistemological beliefs and perceptions of constructivist learning environments.' *Educational Research* 42, no. 2: 193–205.

Wallace, M. (1991). *Training Foreign Language Teachers: A Reflective Approach*. Cambridge, UK: Cambridge University Press.

Chapter 2

Arthur, M. (2014). 'From research-led to research-based teaching.' *Research* Professional. Available online: www.researchresearch.com/news/article/?articleId=1343435. Accessed 20 January 2017.

Boyer Commission (1998). *Reinventing Undergraduate Education: A Blueprint for America's Research Universities*. Available online: http://eric.ed.gov/?id=ED424840. Accessed 20 January 2017.

Comprehensive Institutional Plan (2016). Available online: http://www.provost.ualberta.ca/en/~/media/provost/Documents/2016_UAlberta_CIP_FINAL.pdf. Accessed 20 January 2017.

CWUR (2016). *World University Rankings*. Available online: http://cwur.org/2016.php. Accessed 20 January 2017.

Department of Biochemistry. *Always to Excel*. Available online: http://biochem.med.ualberta.ca/Documents/Chair's%20Message.pdf. Accessed 20 January 2017.

Donald, J. (2004). 'Clarifying Learning.' In *Rethinking Teaching in Higher Education: From a Course Design Workshop to a Faculty Development Framework*, edited by A. Saroyan and C. Amundsen, 53–70. Sterling, VA: Stylus Publishing.

Ferreira, C. and A. Arroio (2009). 'Teacher's education and the use of visualizations in chemistry instruction.' *Problems of Education in the 21st Century* 16: 48–53.

Fung, D. (2017) *A Connected Curriculum for Higher Education*. London: UCL Press.

Fung, D. and C. Gordon (2016). *Rewarding Educators and Education Leaders in Research-Intensive Universities*. Higher Education Academy. Available online: https://www.heacademy.ac.uk/sites/default/files/rewarding_educators_and_education_leaders.pdf. Accessed 20 January 2017.

Habraken, C. L. (2004). 'Integrating into chemistry teaching today's student's visuospatial talents and skills, and the teaching of today's chemistry's graphical language.' *Journal of Science Education & Technology* 13, no. 1: 89–94.

Henard, F. (2010). *Learning Our Lesson: Review of Quality Teaching in Higher Education*. Washington, DC: Organisation for Economic Co-operation and Development.

Loppato, D. (2010). 'Undergraduate research as a high-impact student experience.' *Peer Review* 12, no. 2 (Spring): 27–30.

NSSE (2015). *High-Impact Practices*. Available online: http://nsse.indiana.edu/2015_Institutional_Report/pdf/NSSE15%20High-Impact%20Practices%20(NSSEville%20State).pdf. Accessed 20 January 2017.

QS World University Rankings. Available online: http://www.topuniversities.com/university-rankings/world-university-rankings/2016. Accessed 20 January 2017.

Riddell, J. (2016). 'One size does not fit all with promotion, tenure and review.' *University Affairs* (March). Available online: http://www.universityaffairs.ca/opinion/adventures-in-academe/one-size-does-not-fit-all-with-promotion-tenure-and-review/. Accessed 20 January 2017.

Sadler, T. D. and L. McKinney (2010). 'Scientific research for undergraduate students: A review of the literature.' *Journal of College Science Teaching* (May–June): 43–49.

Schonborn, K. J. and T. R. Anderson (2010). 'Bridging the educational research-teaching practice gap: Foundations for assessing and developing biochemistry students' visual literacy.' *Biochemistry & Molecular Biology Education* 38, no. 5: 347–54.

Sundberg, M. D. and M. L. Dini (1994). 'Decreasing course content improves student comprehension of science and attitudes towards science.' *Journal of Research in Science Teaching* 31, no. 6: 679–93.

Times Higher Education Supplement World Rankings, 2010–2011. Available online: https://www.timeshighereducation.com/world-university-rankings/2011/subject-ranking/clinical-pre-clinicalhealth. Accessed 15 January 2017.

UAlbertaFacts. Available online: https://www.ualberta.ca/about/facts. Accessed 20 January 2017.

UCL Teaching and Learning Portal: Connected Curriculum. Available online: https://www.ucl.ac.uk/teaching-learning/education-initiatives/connected-curriculum. Accessed 20 January 2017.

University of Alberta Students' Union (2016). *A Brief Analysis of Arguments for and Against Creation of a Teaching-Only Stream*. Available online: http://www.governance.ualberta.ca/en/GeneralFacultiesCouncil/CommitteeontheLearningEnvironm/~/media/Governance/Documents/GO05/LEA/16-17/NO-02/CLE-NO-02-Agenda-and-Materials.pdf. Accessed 20 January 2017.

University of Toronto (2015). *Policy and Procedures on Academic Appointments*. Available online: http://www.governingcouncil.utoronto.ca/Assets/Governing+Council+Digital+Assets/Policies/PDF/ppoct302003.pdf. Accessed 20 January 2017.

Chapter 3

Al-Atabi, M., M. M. Shamel and R. (X.Y.) Lim (2013). 'A blueprint for research-led teaching engineering at schools: A case study for Taylor's University.' *Journal of Engineering Science and Technology* 4 (special issue): 38–45.

Arthur, M. (2014). 'From research-led to research-based teaching.' *Research Fortnight* (April 30). Available online: http://www.researchresearch.com/news/article/?articleId=1343435. Accessed 8 August 2016.

Blessinger, P. and J. M. Carfora (eds) (2015). *Inquiry-Based Learning for Science, Technology, Engineering, and Math (STEM) Programs: A Conceptual and Practical Resource for Educators.* Wagon Lane, UK: Emerald.

Boyer Commission on Educating Undergraduates in the Research University (1998). *Reinventing Undergraduate Education: A Blueprint for America's Research Universities.* Stonybrook, NY: State University of New York.

Freebody, P. (2006). *Qualitative Research in Education: Interaction and Practice.* London: Sage.

Fuller, I. C., A. Mellor and J. A. Entwistle (2014). 'Combining research-based student fieldwork with staff research to reinforce teaching and learning.' *Journal of Geography in Higher Education* 38, no. 3: 381–99.

Fung, D. (2016). 'Engaging students with research through a connected curriculum: An innovative institutional approach.' *Council on Undergraduate Research Quarterly* 38, no. 2 (Winter): 30–35.

Fung, D. (2017) *A Connected Curriculum for Higher Education.* London: UCL Press.

Fung, D. and B. Carnell (2017). *UCL Connected Curriculum: Enhancing Programmes of Study.* Second edition. London: University College London. Available online: http://www.ucl.ac.uk/connectedcurriculum. Accessed 25 November 2016.

Gibbs, G. (2014). 'Research can help student learning.' *53 Powerful Ideas All Teachers Should Know About (Idea Number 17).* September. Available online: http://www.seda.ac.uk/resources/files/publications_164_17%20Research%20can%20help%20student%20learning.pdf. Accessed 22 December 2015.

Healey, M. and A. Jenkins (2009). *Developing Undergraduate Research and Inquiry.* York: The Higher Education Academy. Available online: https://www.heacademy.ac.uk/system/files/developingundergraduate_final.pdf. Accessed 22 December 2015.

Healey, M., A. Jenkins and J. Lea (2014). *Developing Research-Based Curricula in College-Based Higher Education.* York, UK: The Higher Education Academy. Available online: https://www.heacademy.ac.uk/system/files/resources/developing_research-based_curricula_in_cbhe_14.pdf. Accessed 22 December 2015.

Henderson, R. (ed.) (2016). *Problem-Based Learning: Perspectives, Methods and Challenges.* Hauppauge, NY: Nova Science Publishers.

Huijser, H. and M. Y. C. A. Kek (2016). 'PBL and technology-supported learning: Exploring the right blend.' In *Problem-Based Learning: Perspectives, Methods and Challenges*, edited by R. Henderson, 149–64. Hauppauge, NY: Nova Science Publishers.

Jenkins, A. and M. Healey (2005). *Institutional Strategies for Linking Teaching and Research.* York, UK: The Higher Education Academy. Available online: http://www.ipd.gu.se/digitalAssets/1345/1345048_institutional_strategies.pdf. Accessed 22 December 2016.

Jin, L. and M. Cortazzi (2011a). 'Introduction: Contexts for researching Chinese learners.' In *Researching Chinese Learners: Skills, Perceptions and Intercultural Adaptations*, edited by L. Jin and M. Cortazzi, 1–18. Houndmills, UK: Palgrave Macmillan.

Jin, L. and M. Cortazzi (2011b). 'More than a journey: "Learning" in the metaphors of Chinese students and Teachers.' In *Researching Chinese Learners: Skills, Perceptions and Intercultural Adaptations*, edited by L. Jin and M. Cortazzi, 67–92. Houndmills, UK: Palgrave Macmillan.

Katkin, W. (2003). 'The Boyer Commission Report and its impact on undergraduate research.' *New Directions for Teaching and Learning* 93: 19–38.

Li, X. and J. Cutting (2011). 'Rote learning in Chinese culture: Reflecting active Confucian-based memory strategies.' In *Researching Chinese Learners: Skills, Perceptions and Intercultural Adaptations*, edited by L. Jin and M. Cortazzi, 67–92. Houndmills, UK: Palgrave Macmillan.

Murdoch-Eaton, D., S. Drewery, S. Elton, C. Emmerson, M. Marshall, J. A. Smith, P. Stark and S. Whittle (2010). 'What do medical students understand by research and research skills? Identifying research opportunities within undergraduate projects.' *Medical Teacher* 32, no. 3: e152–e160.

Rui, Y. (2015). 'China's entry into the WTO and higher education.' *International Higher Education* 24: 9–10.

Russell, S. H., M. P. Hancock and J. McCullough (2007). 'Benefits of undergraduate research experiences.' *SCIENCE* 316: 548–9.

Ryan, J. (ed.) (2011). *Education Reform in China: Changing Concepts, Contexts and Practices.* Milton Park, UK: Routledge.

Schapper, J. and S. E. Mayson (2010). 'Research-led teaching: Moving from a fractured engagement to a marriage of convenience.' *Higher Education Research and Development* 29, no. 6: 641–51.

Seah, W. T. (2011). 'Ten years of curriculum reform in China: A soft knowledge perspective.' In *Education Reform in China: Changing Concepts, Contexts and Practices,* edited by J. Ryan, 161–84. Milton Park, UK: Routledge.

Wang, J. (2013). 'Understanding the Chinese learners from a perspective of Confucianism.' In *Researching Cultures of Learning: International Perspectives on Language Learning and Education,* edited by M. Cortazzi and L. Jin, 61–79. Houndmills, UK: Palgrave Macmillan.

Wang, L. and M. Byram (2011). '"But when you are doing your exams it is the same as in China" – Chinese students adjusting to Western approaches to teaching and learning.' *Cambridge Journal of Education* 41, no. 4: 407–24.

XJTLU Xi'an Jiaotong-Liverpool University (2016). 'Learning and teaching.' Available online: http://www.xjtlu.edu.cn/en/study-with-us/learning-and-teaching. Accessed 8 August 2016.

Yuan, Y. and Q. Xie (2013). 'Cultures of learning: An evolving concept and an expanding field.' In *Researching Cultures of Learning: International Perspectives on Language Learning and Education,* edited by M. Cortazzi and L. Jin, 21–40. Houndmills, UK: Palgrave Macmillan.

Chapter 4

Bonacchi, C. and J. Willcocks (2016). *Realities and impacts of museum-university partnerships in England.* Bristol: National Co-ordinating Centre for Public Engagement.

Bonwell, C. C. and J. A. Eison (1991). *Active Learning: Creating Excitement in the Classroom.* Washington, DC: ASHE-ERIC Higher Education Reports.

British Dyslexia Association (2016). *Dyslexia Research Information.* Available online: http://www.bdadyslexia.org.uk/common/ckeditor/filemanager/userfiles/Dyslexic/Dyslexia_Research_Information.pdf. Accessed 10 January 2017.

Buchli, V. (2002). *The Material Culture Reader.* Oxford: Berg.

Candlin, F. (2008). 'Museums, modernity and the class politics of touching objects.' In *Touch in Museums: Policy and Practice in Object Handling,* edited by H. J. Chatterjee, 9–20. New York: Berg.

Challis, D. (2013). *The Archaeology of Race: The Eugenic Ideas of Francis Galton and Flinders Petrie.* London: Bloomsbury.

Chatterjee, H. J. (ed.) (2008). *Touch in Museums: Policy and Practice in Object Handling.* Oxford: Berg.

Chatterjee, H. J. and L. Hannan (eds) (2015). *Engaging the Senses: Object-Based Learning in Higher Education.* Farnham, Surrey: Ashgate.

Chatterjee, H. J., L. Hannan and L. Thomson (2015). 'Introduction to object-based learning and multisensory engagement.' In *Engaging the Senses: Object-Based Learning in Higher Education,* edited by H. J. Chatterjee and L. Hannan, 1–20. Farnham, Surrey: Ashgate.

Duhs, R. (2010). 'Learning from university museums and collections in higher education: University College London (UCL).' *University Museums and Collections Journal* 3: 183–6.

Fung, D. (2017). *A Connected Curriculum for Higher Education.* London: UCL Press.

Fung, D. and B. Carnell (2015). *Connected Curriculum: A Distinctive Approach to Research-based Education.* University College London.

Fung, D. and B. Carnell (2017). *UCL Connected Curriculum: Enhancing Programmes of Study.* Second edition. London: University College London.

Galton, F. (1884). *The Anthropometric Laboratory.* London: William Clowes and Sons.

Galton, F. (1907). Probability, the Foundation of Eugenics: The Herbert Spencer Lecture. Delivered on 5 June. Oxford: Clarendon Press.

Gardner, H. (1993). *Frames of Mind.* New York: Basic Books.

Hein, G. (1998). *Learning in the Museum.* London: Routledge.

Ingold, T. (ed.) (2011). *Redrawing Anthropology: Materials, Movements, Lines.* London: Routledge.

Kador, T., L. Hannan, J. Nyhan, M. Terras, H. J. Chatterjee and M. Carnall (forthcoming). 'Object-based learning and research-based education: Case studies from the UCL curricula.' In *Transforming Learning and Teaching in Higher Education*, edited by J. Davies and N. Pachler. London: Trentham Books.

Kearns, L. (2015). 'Subjects of wonder: Toward an aesthetics, ethics, and pedagogy of wonder.' *Journal of Aesthetic Education* 49, no. 1, 98–119.

Kolb, D. A. (1984). 'Experiential learning: Experience as the source of learning and development.' Englewood Cliffs, NJ: Prentice-Hall.

Meyer, J.H.F. and R. Land (2003). 'Threshold concepts and troublesome knowledge: Linkages to ways of thinking and practising within the disciplines.' In *Improving Student Learning: Theory and Practice Ten Years On*, edited by C. Rust, 412–24. Oxford: Oxford Centre for Staff and Learning Development.

Meyer, J.H.F. and R. Land (2005). 'Threshold concepts and troublesome knowledge (2): Epistemological considerations and a conceptual framework for teaching and learning.' *Higher Education* 49: 373–88.

Nyhan, J., M. Terras and S. Mahony (2014). 'Digital humanities and integrative learning.' In *Integrative Learning: International research and practice*, edited by D. Blackshields, J. Cronin, B. Higgs, S. Kilcommins, M. McCarthy and A. Ryan, 235–47. London: Routledge.

Paris, S.G. (2002). *Perspectives on Object-centered Learning in Museums*. Mahwah, NJ: Lawrence Erlbaum Associates.

Pennington, B.F. (1991). *Diagnosing Learning Disorders*. New York: Guilford.

Riddick, B. (2009). *Living with Dyslexia: The Social and Emotional Consequences of Specific Learning Difficulties / Disabilities*. London: Routledge.

Roberts, J.L. (2013). 'The power of patience: Teaching students the value of deceleration and immersive attention.' *Harvard Magazine* (December–November): 40–43.

Rowe, S. (2002). 'The role of objects in active, distributed meaning-making.' In *Perspectives on Object-centered Learning in Museums*, edited by S.G. Paris, 19–36. Mahwah, NJ: Lawrence Erlbaum Associates.

Sharp, A., L. Thomson, H. J. Chatterjee and L. Hannan (2015). 'The value of object-based learning within and between higher education disciplines.' In *Engaging the Senses: Object-Based Learning in Higher Education*, edited by H.J. Chatterjee and L. Hannan, 97–116. Farnham, Surrey: Ashgate.

Tiballi, A. (2015). 'Engaging the past: Haptics and object-based learning in multiple dimensions.' In *Engaging the Senses: Object-Based Learning in Higher Education*, edited by H.J. Chatterjee and L. Hannan, 57–75. Farnham, Surrey: Ashgate.

Vygotsky, L. S. (1978). *Mind in Society: The Development of Higher Psychological Processes*. Cambridge, MA: Harvard University Press.

Vygotsky, L. S. (1986). *Thought and Language*. Cambridge, MA: MIT Press.

Willcocks, J. (2015). 'The power of concrete experience: Museum collections, touch and meaning making in art and design pedagogy.' In *Engaging the Senses: Object-Based Learning in Higher Education*, edited by H.J. Chatterjee and L. Hannan, 43–56. Farnham, Surrey: Ashgate.

Zabell, C. and J. Everatt (2002). 'Surface and phonological subtypes of adult developmental dyslexia.' *Dyslexia* 8, no. 3: 160–77.

Chapter 5

Adedokun, O. A., A. B. Bessenbacher, L.C. Parker, L. L. Kirkham and W. D. Burgess (2013). 'Research skills and STEM undergraduate research students' aspirations for research careers: Mediating effects of research self-efficacy.' *Journal of Research in Science Teaching* 50: 940–51.

American Veterinary Medical Association (2016). 'COE accreditation policies and procedures: Requirements, April 2016, 7.' *Requirements of an Accredited College of Veterinary Medicine* 7.5. Standard 5 (Information Resources). Available online: https://www.avma.org/ProfessionalDevelopment/Education/Accreditation/Colleges/Pages/coe-pp-requirements-of-accredited-college.aspx. Accessed 29 December 2016.

Andrew, N., D. Tolson and D. Ferguson (2008). 'Building on Wenger: Communities of practice in nursing.' *Nurse Education Today* 28: 246–52.

Baxter-Magolda, M. (2009). 'Educating students for self-authorship: Learning partnerships to achieve complex outcomes.' In *The University and its Disciplines: Teaching and Learning Within and Beyond Disciplinary Boundaries*, edited by C. Kreber, 143–56. New York: Routledge.

Bell, C., J. Paterson and S. Warman (2014). 'Tips for small group teaching.' *Practice* 36: 424–426.

Dwyer, C. (2001). 'Linking research and teaching: A staff-student interview project.' *Journal of Geography in Higher Education* 25: 357–66.

Eraut, M. (2000). 'Non-formal learning and tacit knowledge in professional work.' *British Journal of Educational Psychology* 70: 113–36.

Grindlay, D. J. C., M. L. Brennan and R. S. Dean (2012). 'Searching the veterinary literature: A comparison of the coverage of veterinary journals by nine bibliographic databases.' *Journal of Veterinary Medical Education* 39: 404–12.

Higher Education Academy and Quality Assurance Agency (2014). *Education for Sustainable Development: Guidance for UK Higher Education Providers*. Gloucester: The Quality Assurance Agency for Higher Education. Available online: http://www.qaa.ac.uk/en/Publications/Documents/Education-sustainable-development-Guidance-June-14.pdf. Accessed 29 December 2016.

Healey, M. (2005). 'Linking research and teaching: Exploring disciplinary spaces and the role of inquiry-based learning.' In *Reshaping the University: New Relationships Between Research, Scholarship and Teaching*, edited by R. Barnett, 30–42. Maidenhead: McGraw-Hill/Open University Press.

Healey, M. and A. Jenkins (2009). *Developing Undergraduate Research and Inquiry*. York, UK: The Higher Education Academy. Available online: https://www.heacademy.ac.uk/system/files/developingundergraduate_final.pdf. Accessed 29 December 2016.

Healey, M., F. Jordan, B. Pell and C. Short (2010). 'The research–teaching nexus: A case study of students' awareness, experiences and perceptions of research.' *Innovations in Education and Teaching International* 47, no. 2: 235–46.

Hughes, C. and S. Barrie (2010). 'Influences on the assessment of graduate attributes in higher education.' *Assessment and Evaluation in Higher Education* 35: 325–34.

Lave, J. and E. Wenger (1991). *Situated Learning: Legitimate Peripheral Participation*. Cambridge: Cambridge University Press.

Levy, P. and R. Petrulis (2012). 'How do first-year university students experience inquiry and research, and what are the implications for the practice of inquiry-based learning?' *Studies in Higher Education* 37: 85–101.

Linn, M. C., E. Palmer, A. Baranger, E. Gerard and E. Stone (2015). 'Undergraduate research experiences: Impacts and opportunities.' *Science* 347, 6222 (Feb 6): 1261757.

Royal College of Veterinary Surgeons (2015). *RCVS Standards and Procedures for the Accreditation of Veterinary Degrees*. London: Royal College of Veterinary Surgeons. Available online: http://www.rcvs.org.uk/document-library/rcvs-accreditation-standards/. Accessed 29 December 2016.

Royal College of Veterinary Surgeons (2016). *Continuing Professional Development (CPD) for Vets*. London: Royal College of Veterinary Surgeons. Available online: http://www.rcvs.org.uk/education/lifelong-learning-for-veterinary-surgeons/continuing-professional-development-cpd-for-vets/. Accessed 29 December 2016.

Sambell, K. (2008). 'The impact of enquiry-based learning on the first-year experience of studentship: Student perspectives.' Paper presented at the *European First Year Experience Conference*, 7–9 May. Wolverhampton, UK. Available online: http://nrl.northumbria.ac.uk/id/eprint/1544. Accessed 29 December 2016.

Scottish Credit and Qualifications Framework (2016). *SCQF levels*. Available online: http://scqf.org.uk/the-framework/scqf-levels/. Accessed 29 December 2016.

Schön, D. A. (1991). *The Reflective Practitioner: How Professionals Think in Action*. Aldershot, UK: Ashgate Publishing.

Spronken-Smith, R. and R. Walker (2010). 'Can inquiry-based learning strengthen the links between teaching and disciplinary research?' *Studies in Higher Education* 35, no. 6: 723–40.

Trigwell, K. (2005). 'Teaching-research relations, cross-disciplinary collegiality and student learning.' *Higher Education: The International Journal of Higher Education and Educational Planning* 49: 235–54.

University of Edinburgh (2016). *Vision and mission*. Available online: http://www.ed.ac.uk/governance-strategic-planning/strategic-planning/strategic-plan/vision-and-mission. Accessed 29 December 2016.

Wenger, E. (1998). *Communities of Practice: Learning, Meaning and Identity.* New York: Cambridge University Press.

Zimbardi, K. and P. Myatt (2014). 'Embedding undergraduate research experiences within the curriculum: A cross-disciplinary study of the key characteristics guiding implementation.' *Studies in Higher Education* 39: 233–50.

Chapter 6

Anderson, T. R. and J. M. Rogan (2011). 'Bridging the educational research-teaching practice gap: Curriculum development, Part 1: Components of the curriculum and influences on the process of curriculum design.' *Biochemistry and Molecular Biology Education* 39, no. 1: 68–76.

Balmer, A.S. and K. J. Bulphin (2013). 'Left to their own devices: Post-ELSI, ethical equipment and the International Genetically Engineered Machine (iGEM) Competition.' *BioSocieties* 8, no. 3: 311–35.

Borg, Y., A. M. Grigonyte, P. Boeing, B. Wolfenden, P. Smith, W. Beaufoy, S. Rose, T. Ratisai, A. Zaikin and D. N. Nesbeth (2016). 'Open source approaches to establishing Roseobacter clade bacteria as synthetic biology chassis for biogeoengineering.' *PeerJ* 7, no. 4: e2031.

Benè, K. L. and G. Bergus (2014). 'When learners become teachers: A review of peer teaching in medical student education.' *Family Medicine* 46, no. 10 (Nov–Dec): 783–7.

Bruner, J. (1960). *The Process of Education.* Cambridge, MA: Harvard University Press.

Campbell, A. M. (2005). 'Meeting report: Synthetic biology jamboree for undergraduates.' *Cell Biology Education* 4, no. 1: 19–23.

Campos, L. (2012). 'The BioBrick road.' *BioSocieties* 7, no. 2: 115–39.

Carrió, M, L. Agell, J. E. Baños, E. Moyano, P. Larramona and J. Pérez (2016). 'Benefits of using a hybrid problem-based learning curriculum to improve long-term learning acquisition in undergraduate biology education.' *FEMS Microbiology Letters* 363, no. 15: pii: fnw159.

Coelho, C. S. and D. R. Moles (2016). 'Student perceptions of a spiral curriculum.' *European Journal of Dental Education* 20, no. 3: 161–6.

Collier, J. (2010). 'Wiki technology in the classroom: Building collaboration skills.' *The Journal of Nursing Education* 49, no. 12 (Dec): 718.

Dolmans, D., H. Wolfhagen, A. Scherpbier and C. van der Vleuten (2003). 'Development of an instrument to evaluate the effectiveness of teachers in guiding small groups.' *Higher Education* 46, no. 4: 431–46.

Fung, D. (2016). 'Engaging students with research through a Connected Curriculum: An innovative institutional approach.' *Council on Undergraduate Research* 37, no. 2: 30–35.

Fung, D. (2017) *A Connected Curriculum for Higher Education.* London: UCL Press.

Gaudet, A. D., L. M. Ramer, J. Nakonechny, J. J. Cragg and M. S. Ramer (2010). 'Small-group learning in an upper-level university biology class enhances academic performance and student attitudes toward group work.' *PLoS One* 5, no. 12: e15821.

Harden, R. M. and N. Stamper (1999). 'What is a spiral curriculum?' *Medical Teacher* 21, no. 2: 141–43.

Jones, G. (2005). *Gatekeepers, midwives and fellow travellers: The craft and artistry of adult educators.* London: Mary Ward Centre.

Kim, H.J., D. Huh, G. Hamilton and D. E. Ingber (2012). 'Human gut-on-a-chip inhabited by microbial flora that experiences intestinal peristalsis-like motions and flow.' *Lab on a Chip* 12, no. 12: 2165–74.

Kwok, R. (2010). 'Five hard truths for synthetic biology.' *Nature* 463: 288–90.

Lartigue, C., S. Vashee, M. A. Algire, R.-Y. Chuang, G. A. Benders, L. Ma, V. N. Noskov et al. (2009). 'Creating bacterial strains from genomes that have been cloned and engineered in yeast.' *Science* 325, no. 5948: 1693–96.

McNamara, J., S. B. Lightfoot, K. Drinkwater, E. Appleton and K. Oye (2014). 'Designing safety policies to meet evolving needs: iGEM as a testbed for proactive and adaptive risk management.' *ACS Synthetic Biology* 3, no. 12: 983–85.

Micari, M. and D. Drane (2011). 'Intimidation in small learning groups: The roles of social-comparison concern, comfort, and individual characteristics in student academic outcomes.' *Active Learning in Higher Education* 12, no. 3: 175–87.

Nesbeth, D. N. (ed.) (2016). *Synthetic Biology Handbook*. London: CRC Press/Taylor & Francis Group.

Neville, A. J. (1999). 'The problem-based learning tutor: Teacher? Facilitator? Evaluator?' *Medical Teacher* 21, no. 4: 393–401.

Nicholls, G. (2002). 'Programme and course design.' In *Developing Teaching and Learning in Higher Education*, 51–75, G. Nicholls. London: Routledge.

Norman, G. R. and H. G. Schmidt (2016). 'Revisiting effectiveness of problem-based learning curricula: theory, practice and paper darts.' *Medical Education* 50, no. 8: 793–97.

Ostermayer, D.G. and R.I. Donaldson (2015). 'The Wiki: a key social media tool.' *Annals of Emergency Medicine* 65, no. 4: 466.

Sampaio-Maia B., J. S. Maia, S. Leitão, M. Amaral and P. Vieira-Marques (2014). 'Wiki as a tool for microbiology teaching, learning and assessment.' *European Journal of Dental Education* 18, no. 2: 91–97.

Scheufele, E. L., C. Blesius and W. T. Lester (2007). 'Facilitating group learning and dialogue between neighboring academic institutions using a collaborative web application framework.' *AMIA Annual Symposium Proceedings* 11: 1107.

Shamlou, P. A., P. Dunnill, M. Hoare, A. P. Ison, E. Keshavarz-Moore, G. J. Lye, N. J. Titchener-Hooker, M. K. Turner, J. M. Woodley and B. C. Buckland (1998). 'UCL biochemical engineering.' Biotechnology and Bioengingeering 60, no. 5: 527–33.

Singaram, V. S., C. P. van der Vleuten, F. Stevens and D. H. Dolmans (2011). '"For most of us Africans, we don't just speak": A qualitative investigation into collaborative heterogeneous PBL group learning.' *Advances in Health Science Education* 16, no. 3: 297–310.

Willis, S. C., A. Jones, C. Bundy, K. Burdett, C. A. Whitehouse and P. A. O'Neill (2002). 'Small-group work and assessment in a PBL curriculum: A qualitative and quantitative evaluation of student perceptions of the process of working in small groups and its assessment.' *Medical Teacher* 24, no. 5: 495–501.

Chapter 7

Bradley, L. (2009). 'Curricular connections: The college/university art museum as site for teaching and learning.' *CAA Reviews* 8: 1–8.

Chan, P. (ed.) (2010). *Krikey! Kentemporary Prints*. Kent Print Collection Fourth Exhibition. Canterbury, UK: University of Kent.

Chatterjee, H. J., L. Hannan and L. Thomson (2015). 'An introduction to object-based learning and multisensory engagement.' In *Engaging the Senses: Object-Based Learning in Higher Education*, edited by H. J. Chatterjee and L. Hannan, 1–20. Farnham, UK: Ashgate.

Chiverton, F. and L. Dickens (eds) (2014). *Underexposed: Female Artists and the Medium of Print*. Canterbury, UK: University of Kent.

Cross, S. (2009). *Adult Teaching and Learning: Developing your Practice*. Maidenhead, UK: Open University Press.

DCMS (Department for Culture, Media & Sport) (2016). *The Culture White Paper*. edited by Department for Culture, Media & Sport. London: Her Majesty's Stationery Office.

Grindle, N. and A. Fredericksen (2010). 'Creating curators: Using digital platforms to help students learn in art collections.' York, UK: Higher Education Academy. Available online: https://www.heacademy.ac.uk/resource/creating-curators-using-digital-platforms-help-students-learn-art-collections. Accessed 31 December 2016.

Hallett, R. (2016). 'Students online: Creative bricolage or surfing in the shallows?' paper given at *Digital Art Histories* conference, Paul Mellon Centre for Studies in British Art, London, 9 November.

Hammond, A. (2006). 'The role of the university art museum and gallery: A roundtable discussion with Anna Hammond, Ian Berry, Sheryl Conkelton, Sharon Corwin, Pamela Franks, Katherine Hart, Wyona Lynch-McWhite, Charles Reeve and John Stomberg.' *Art Journal* 65, no. 3: 20–39.

Hein, G. E. (1999). 'The constructivist museum.' In *The Educational Role of the Museum*, edited by E. Hooper-Greenhill, 73–79. London: Routledge.

Knight, P. and M. Yorke (2003). *Assessment, Learning and Employability*. Maidenhead, UK: Society for Research into Higher Education (SRHE).

Lave, J. and E. Wenger (1991). *Situated Learning: Legitimate Peripheral Participation*. Book Series: *Learning in Doing: Social, Cognitive and Computational Perspectives*, edited by R. Pea, C. Heath and L. Schuman. Cambridge, UK: Cambridge University Press.

Littlewood, R. and S. Wyatt-Livesley (2016). 'Degree show learning curves.' *Spark: UAL Creative Teaching and Learning Journal* 1, no. 1: 41–45.

Marstine, J. (2007). 'What a mess! Claiming a space for undergraduate student experimentation in the university museum.' *Museum Management & Curatorship* 22, no. 3: 303–15.

McDowell, L., K. Sambell, V. Bazin, R. Penlington, D. Wakelin, H. Wickes and J. Smailes (2006). *Assessment for Learning: Current Practice Exemplars from the Centre for Excellence in Teaching and Learning*. Newcastle, UK: Northumbria University.

Obrist, H. U. (2015). *Ways of Curating*. London: Penguin.

Pringle, E. (2006). *Learning in the Gallery: Context, Process, Outcomes*. London: Engage.

Ramsden, P. (2003). *Learning to Teach in Higher Education*. Second edition. London: Routledge Falmer.

Rodgers, S. (2015). 'Toward a pedagogy for faculty and student co-responsibility in curating college museum exhibitions.' *Arts and Humanities in Higher Education: An International Journal of Theory, Research and Practice* 14, no. 2: 150–65.

Thomas, B. (ed.) (2007). *Dreams and Nightmares: Kent Print Collection second exhibition*. Canterbury, UK: University of Kent.

Thomas, B. (ed.) (2008). *The Art of Comedy: An Investigation of Humour through Prints*. Canterbury, UK: University of Kent.

Tishman, S., A. McKinney and C. Straughn (2007). *Study Center Learning: An Investigation of the Educational Power and Potential of the Harvard University Art Museums Study Centers*. Cambridge, MA: Harvard University Press.

Willcocks, J. (2016). 'Judy Willcocks – Head of museum and study collection.' Central St Martins. Available online: http://www.arts.ac.uk/csm/people/teaching-staff/other-staff/. Accessed 20 July 2016.

Woodall, A. (2015). 'Rummaging as a strategy for creative thinking and imaginative engagement in higher education.' In *Engaging the Senses: Object-Based Learning in Higher Education*, edited by H. J. Chatterjee and L. Hannan, 133–55. Farnham, UK: Ashgate.

Chapter 8

Carter-Veale, W. Y., R. G. Tull, J. C. Rutledge and L. N. Joseph (2016). 'The dissertation house model: Doctoral student experiences coping and writing in a shared knowledge community.' *CBE Life Sciences Education* 15, no. 3: ar34.

Dailey, A., M. Harris, B. Plough, B. Porfilio and P. Winkelman (2016). 'Dissertation journeys of scholar-practitioners in an educational leadership for social justice program.' *Journal of Inquiry and Action in Education* 7, no. 1: 36–49.

Fung, D. (2017) *A Connected Curriculum for Higher Education*. London: UCL Press.

Fung, D. and B. Carnell (2017). *UCL Connected Curriculum: Enhancing Programmes of Study*. Second edition. London: University College London. Available online: www.ucl.ac.uk/connectedcurriculum. Accessed 1 February 2017.

Hawkes, D. (2016). 'Effective online resources to support student research dissertations and theses.' UCL Teaching and Learning Conference Presentation. University College London, London UK, April.

Hawkes, D. and S. Taylor (2014). 'So who wants to do an EdD anyway? Evidence from the Institute of Education EdD Completions 1996-2013.' *Work Based Learning e-Journal International* 4, no. 1 (December): 1–10.

Hawkes, D. and S. Taylor (2016). 'Redesigning the EdD at the Institute of Education, London, England: Thoughts of the incoming EdD program leaders.' In *International Perspectives on Designing Professional Practice Doctorates: Applying the Critical Friends Approach to the EdD and Beyond*, edited by Valerie Anne Storey, 127–42. Basingstoke, UK: Palgrave Macmillan.

Hawkes, D. and S. Yerrabati (forthcoming). 'Professional doctorates: A systematic literature review.' *London Review of Education*.

Institute of Education (2014). *EdD Validation Document*. London, UK.

Lawrence, S. and T. M. Zawacki (2016). 'Special issue on writing center support for graduate thesis and dissertation writers.' *WLN: A Journal of Writing Center Scholarship* 40, no. 5–6: 1.

Mellors-Bourne, R., C. Robinson and J. Metcalf (2016). *Provision of professional doctorates on English HE institutions*. HECFE, UK. Available online: http://www.hefce.ac.uk/media/HEFCE,2014/Content/Pubs/Independentresearch/2016/Provision,of,professional,doctorates/Professional_doctorates_CRAC.pdf. Accessed 1 February 2017.

QAA (2011). *Doctoral Characteristics*. Quality Assurance Agency. Gloucester, UK. Available online: http://www.qaa.ac.uk/en/Publications/Documents/Doctoral_Characteristics.pdf. Accessed 1 February 2017.

Salmon, G. (2014). *E-tivities*. Second edition. London: Routledge.

Siemens, G. (2004). *Connectivism: A Learning Theory for the Digital Age*. Elearnspace. Available online: http://www.elearnspace.org/Articles/connectivism.htm. Accessed 1 February 2017.

UCL (2016). *Connected Curriculum*. Available online: https://www.ucl.ac.uk/teaching-learning/education-initiatives/connected-curriculum. Accessed 1 February 2017.

UCL Institute of Education (2016). *Doctor in Education (EdD)*. Available online: https://www.ucl.ac.uk/ioe/courses/graduate-research/education-edd. Accessed 1 February 2017.

Wenger, E. (1999). *Communities of Practice: Learning, Meaning, and Identity*. Cambridge, UK: Cambridge University Press.

Chapter 9

Alexander, N. (2013). *Thoughts on the New South Africa*. Auckland, New Zealand: New Jacana Media.

Anderson, E. (2012). 'Epistemic justice as a virtue of social institutions.' *Social Epistemology* 26, no. 2: 163–73.

Barnett, R. (2000). 'University knowledge in an age of supercomplexity.' *Higher Education* 40: 409–22.

Bernstein, B. (2000). *Pedagogy, Symbolic Control and Identity*. Lanham, MD: Rowman and Littlefield.

Bilge, S. (2013). 'Intersectionality undone: Saving intersectionality from feminist intersectionality studies.' *Du Bois Review* 10: 405–24.

Ellery, K. (under review). 'Legitimation of knowers in science: A close-up view.'

Fung, D. (2017) *A Connected Curriculum for Higher Education*. London: UCL Press.

Fung, D. and B. Carnell (2017). *UCL Connected Curriculum: Enhancing Programmes of Study*. Second edition. London: University College London.

Gordon, L. (2014). 'Disciplinary decadence and the decolonisation of knowledge.' *Africa Development* XXXIX, no. 1: 81–92.

Grosfoguel, R. (2007). 'The epistemic decolonial turn.' *Cultural Studies* 21, no. 2–3: 211–23.

hooks, b. (1994). *Teaching to Transgress. Education as the Practice of Freedom*. New York: Routledge.

Luckett, K. (2016). 'Curriculum contestation in a postcolonial context: A view from the South.' *Teaching in Higher Education* 21, no. 4: 415–28.

Mann, S. (2001). 'Alternative perspectives on the student experience: Alienation and engagement.' *Studies in Higher Education* 26, no. 1: 7–19.

Maton, K. (2014). *Knowledge and Knowers: Towards a Realist Sociology of Education*. London: Routledge.

Mbembe, A. (2015). 'Decolonizing knowledge and the question of the archive.' Public lecture. Johannesburg: Wits Institute for Social and Economic Research (WISER).

Morrow, W. (1994). 'Entitlement and achievement in education.' *Studies in Philosophy and Education* 13, no. i: 33–37.

Santos, B. (2010). 'The university in the twenty-first century. Toward a democratic and emancipatory university reform.' In *The Routledge International Handbook of the Sociology of Education*, edited by M.W. Apple, S.J. Ball and L. A. Gandin, 274–82. London: Routledge.

Scott, I., N. Yeld and J. Hendry (2007). 'A case for improving teaching and learning in South African higher education.' *Higher Education Monitor* 6 (Pretoria, RSA: Council on Higher Education): 20–22.

Soudien, C. (2015). 'Of false-starts, blind spots, cul-de-sacs and legitimacy struggles: The curriculum debate in South African higher education.' *Southern African Review of Education* 21, no. 1: 19–38.

Thondhlana, G. and Z. Belluigi (2014). 'Group-work as "terrains of learning" for students in South African higher education.' *Perspectives in Education* 32, no. 4: 40–55.

Vorster, J. (ed.) (2016). *Curriculum in the Context of Transformation: Reframing Traditional Understanding and Practices.* Grahamstown, South Africa: Rhodes University. Available online: http://tinyurl.com/z4hqh8h. Accessed 24 January 2017.

Chapter 10

Christie, D. (2009). 'Signature pedagogies and SoTL practices in computer science.' In *Exploring Signature Pedagogies: Approaches to Teaching Disciplinary Habits of Mind*, edited by R.A. Gurung, N.L. Chick and A. Haynie, pp. 244–59. Sterling, VA: Stylus.

Cleaver, E. (2014). *Curriculum 2016+ Briefing Note B: Developing Disciplinary Pedagogies.* Learning Enhancement and Academic Practice C2016+ Briefing Note Series. Hull, UK: University of Hull.

Cooper, C. (2015). 'Critical Pedagogy in Higher Education.' In *Socially Just, Radical Alternatives for Education and Youth Work Practice: Re-Imagining Ways of Working with Young People*, edited by C. Cooper, S. Gormally and G. Hughes, pp.39–64, Basingstoke, UK: Palgrave Macmillan.

Fung, D. (2017) *A Connected Curriculum for Higher Education.* London: UCL Press.

Fung, D. and B. Carnell (2017). *UCL Connected Curriculum: Enhancing Programmes of Study.* Second edition. London: University College London.

Gibbs, G., T. Jessop and Y. El-Hakim (n.d.). *TESTA Manual: A Practical Guide to Improving Student Learning.* Winchester, UK: University of Winchester. Available online: http://www.testa. ac.uk/index.php/resources/research-tool-kits/category/11-researchtoolkits#. Accessed 5 December 2016.

Gurung, R.A.R., N.L. Chick and A. Haynie (eds) (2009). *Exploring Signature Pedagogies: Approaches to Teaching Disciplinary Habits of Mind.* Sterling, VA: Stylus.

Hounsell D. and N. Entwistle (2005). *Enhancing Teaching-Learning Environments in Undergraduate Courses.* Final Report to the Economic and Social Research Council on TLRP Project L139251099. Available online: http://www.etl.tla.ed.ac.uk//docs/ETLfinalreport. pdf. Accessed 5 December 2016.

Land, R., J.H.F. Meyer and C. Baillie (2010). *Threshold Concepts and Transformational Learning.* Rotterdam: Sense Publishers.

Ledwith, M. (2011). *Community Development: A Critical Approach.* Second edition. Bristol: The Policy Press.

Meyer, J. and R. Land (2003). *Threshold Concepts and Troublesome Knowledge.* Occasional Report 4. ETL project. Available online: http://www.etl.tla.ed.ac.uk//docs/ETLreport4. pdf. Accessed 10 June 2016.

QAA (n.d.). *The UK Quality Code for Higher Education: Subject Benchmark Statements.* Quality Assurance Agency. Available online: http://www.qaa.ac.uk/assuring-standards-and-qual-ity/the-quality-code/subject-benchmark-statements. Accessed 5 December 2016.

Shulman, L.S. (1993). 'Teaching as community property: Putting an end to pedagogical soli-tude'. *Change: The Magazine of Higher Learning*, 25 (6), pp. 6–7.

Shulman, L. (2005). 'Signature pedagogies in the professions'. *Daedalus* 134, no.3, pp. 52–59.

Wagner, T. (2008). *The Global Achievement Gap.* New York: Basic Books.

West, D. (2004). *Object Thinking.* Washington: Microsoft Press.

Chapter 11

Barton, G. and A. James (2017). 'Threshold concepts, LEGO SERIOUS PLAY and systems think-ing: Towards a combined methodology.' *Practice and Evidence of Scholarship of Teaching and Learning in Higher Education (PESTLHE)* 12, no. 2: 249–71. Available online: http://com-munity.dur.ac.uk/pestlhe.learning/index.php/pestlhe/index Accessed 16 July 2017.

Brew, A. (2007). 'Approaches to the scholarship of teaching and learning.' In *Transforming a University: The Scholarship of Teaching and Learning in Practice*, edited by A. Brew and J. Sachs, 1–10. Sydney: Sydney University Press.

Corner, F. (n.d.) 'Frances Corner: Beautiful, yes – but that's not all: When is the myopic view of the fashion industry – worth a direct contribution of £26billion to the UK economy – going

to stop?' University of the Arts London. Available online: http://www.arts.ac.uk/about-ual/press-office/ual-voices/frances-corner-beautiful-yes--but-thats-not-all/. Accessed 29 December 2016.

Deakin F. and C. Webb (2016). 'Discovering the post-digital art school.' Available online: https://s3-us-west-2.amazonaws.com/ualreportpdf/PostDigitalArtSchool_Report.pdf. Accessed 29 December 2016.

Deleuze, G. and F. Guattari (1987 [1980]). *A Thousand Plateaus: Capitalism and Schizophrenia*. Trans. B. Massumi. Minneapolis: University of Minnesota Press.

Fung, D. (2017) *A Connected Curriculum for Higher Education*. London: UCL Press.

Fung, D. and B. Carnell (2017). *UCL Connected Curriculum: Enhancing Programmes of Study*. Second edition. University College London.

Gauntlett, D. (2007). *Creative Explorations: New Approaches to Identities and Audiences*. London: Routledge.

Gauntlett, D. (2010). *Open Source: Introduction to LEGO SERIOUS PLAY*. Available online: http://davidgauntlett.com/wp-content/uploads/2013/04/LEGO_SERIOUS_PLAY_OpenSource_14mb.pdf. Accessed 13 January 2017.

Gauntlett, D. (2011). *Making is Connecting: The Social Meaning of Creativity, from DIY and Knitting to YouTube and Web 2.0*. Cambridge, UK: Polity.

Ideo.org (2015). *The Field Guide to Human-Centered Design*. IDEO.org. Available online: http://d1r3w4d5z5a88i.cloudfront.net/assets/guide/Field%20Guide%20to%20Human-Centered%20Design_IDEOorg_English-ee47a1ed4b91f3252115b83152828d7e.pdf. Accessed 1 October 2016.

James, A. (2013). 'Lego serious play: A three-dimensional approach to learning development'. *The Journal for Learning Development in Higher Education* 6 (November). Available online: http://www.aldinhe.ac.uk/ojs/index.php?journal=jldhe&page=article&op=view&path%5B%5D=208&path%5B%5D=154. Accessed 29 December 2016.

James, A. (2015). 'Learning in three dimensions: Using Lego serious play for creative and critical reflection across time and space'. In *Global Innovation of Teaching and Learning in Higher Education: Transgressing Boundaries*, edited by P. Layne and P. Lake, 275–294. London: Springer.

James, A. and S. Brookfield (2014). *Engaging Imagination: Helping Students Become Creative and Reflective Thinkers*. San Francisco: Jossey-Bass.

Kristiansen, P. and R. Rasmussen (2014). *Build a Better Business with the Lego Serious Play Method*. Hoboken, NJ: Wiley.

Levy, P., S. Little, P. McKinney, A. Nibbs and J. Wood (n.d.). *The Sheffield Companion to Inquiry-based Learning*. The University of Sheffield. Sheffield, UK: Centre for Inquiry-based learning in the Arts and Social Sciences (CILASS). Available online: https://www.shef.ac.uk/polopoly_fs/1.122757!/file/Sheffield_IBL_Companion.pdf. Accessed 13 January 2017.

Nerantzi, C. and C. Despard (2014). 'LEGO® models to aid reflection. Enhancing the summative assessment experience in the context of professional discussions within accredited academic development provision'. *Journal of Perspectives in Applied Academic Practice* 2, no. 2 (July): 31–36.

Nolan, S. (2010). 'Physical metaphorical modelling with LEGO as a technology for collaborative personalised learning'. In *Technology-Supported Environments for Personalized Learning: Methods and Case Studies*, edited by J. O'Donoghue, 364–85. Hershey, NY: Information Science Reference.

Papert, S. and I. Harel (1991). *Situating Constructionism*. Norwood, NJ: Ablex Publishing Corporation. Available online: http://www.papert.org/articles/SituatingConstructionism.html. Accessed 29 December 2016.

Wenger, E. (1998). *Communities of Practice: Learning, Meaning and Identity*. New York: Cambridge University Press.

Wenger, E. (2000). 'Communities of practice and social learning systems.' *Organization* 7, no. 2 (May): 225–46.

Chapter 12

Carlisle, C., H. Cooper and C. Watkins (2004). '"Do none of you talk to each other?": the challenges facing the implementation of interprofessional education.' *Medical Teacher* 26, no. 6: 545–52.

Carthey, J. and J. Clarke (2010). *Implementing Human Factors in Healthcare: 'How to' guide*. London: Patient Safety First.

Catchpole, K., A. Mishra, A. Handa and P. McCulloch (2008). 'Teamwork and error in the operating room: Analysis of skills and roles.' *Ann Surg* 247, no 4: 699–706.

Centre for the Advancement of Interprofessional Education (CAIPE) (2002). Available online: www.caipe.org/. Accessed 26 January 2017.

Department of Health (2000a). *A Health Service for all the Talents: Developing the NHS Workforce.* London: Department of Health.

Department of Health (2000b). *The NHS Plan: A Plan for Investment, a Plan for Reform.* London: Department of Health.

Fook, J., L. D'Avray, C. Norrie, M. Psoinos, B. Lamb and F. Ross (2013). 'Taking the long view: Exploring the development of interprofessional education.' *Journal of Interprofessional Care* 27, no. 4: 286–91.

Fung, D. (2016). 'Engaging students with research through a connected curriculum: An innovative institutional approach.' *Council on Undergraduate Research Quarterly* 38, no. 2: 30–35.

Fung, D. (2017) *A Connected Curriculum for Higher Education.* London: UCL Press.

General Medical Council (2009). *Tomorrow's Doctors.* London: General Medical Council.

Hager, P. (2011). 'Theories of workplace learning.' In *The Sage Handbook of Workplace Learning,* edited by M. Mallock, L. Cairns, K. Evans and B. O'Connor, 17–31. London: Sage.

Health Professionals Council (2012). *Standards of Education and Training.* London: Health Professionals Council.

Holt, J., C. Coates, D. Cotterill, S. Eastburn, J. C. Laxton, H. Mistry and C. Young (2010). 'Identifying common competences in health and social care: An example of multi-institutional and inter-professional working.' *Nurse Education Today* 30: 264–70.

Hoskins, R. (2012). 'Interprofessional working or role substitution? A discussion of the emerging roles in emergency care.' *Journal of Advanced Nursing* 68, no. 8: 1894–903.

Joynes, V. C. T. (2014). *Exploring the Professional Identity of Health and Social Care Staff via Experiences of Interprofessional Education and Collaborative Practice.* PhD diss. Leeds, UK: University of Leeds.

Kilminster S. and S. Fielden (2009). 'Working with the patient voice: Developing teaching resources for interprofessional education.' *The Clinical Teacher* 6, no. 4: 265–68.

Kilminster, S., C. Hale, M. Lascelles, P. Morris, T. Roberts, P. Stark, J. Sowter and J. Thistlethwaite (2004). 'Learning for real life: Patient focussed inter-professional workshops do offer added value.' *Medical Education* 38, no. 7: 717–26.

Lawlis, T. R., J. Anson and D. Greenfield (2014). 'Barriers and enablers that influence sustainable interprofessional education: A literature review.' *Journal of Interprofessional Care* 28, no. 4: 305–10.

Ledger, A., J. Edwards and M. Morley (2013). 'A change management perspective on the introduction of music therapy to interprofessional teams.' *Journal of Health, Organisation and Management* 27, no. 6: 714–32.

Nursing and Midwifery Council (2008). *The Code: Standards of Conduct, Performance and Ethics for Nurses and Midwives.* London: Nursing and Midwifery Council.

Reeves, S., M. Zwarenstein, J. Goldman, H. Barr, D. Freeth, I. Koppel and M. Hammick (2010). 'The effectiveness of interprofessional education: Key findings from a new systematic review.' *Journal of Interprofessional Care* 24, no. 3: 230–41.

World Health Organisation (WHO) (2015). *WHO Global Strategy on Integrated People-Centred Health Services 2016–2026 Executive Summary.* Last modified 24 July. Available online: http://apps.who.int/iris/bitstream/10665/180984/1/WHO_HIS_SDS_2015.20_eng.pdf?ua=1&ua=1. Accessed 31 December 2016.

Chapter 13

Bowman, N. D. and M. Akcaoglu (2014). '"I see smart people!": Using Facebook to supplement cognitive and affective learning in the university mass lecture.' *Internet and Higher Education* 23: 1–8.

Brown, M., J. Dehoney and N. Millichap (2015). 'The next generation digital learning environment initiative.' *Educause.* Available online: https://library.educause.edu/resources/2014/9/next-generation-digital-learning-environment-initiative. Accessed 29 December 2016.

Brown, S. (2010). 'From VLEs to learning webs: The implications of web 2.0 for learning and teaching'. *Interactive Learning Environments* 18, no. 1: 1–10.

Cook, J. and N. Pachler (2012). 'Online people tagging: Social (mobile) network(ing) services and work-based learning.' *British Journal of Educational Technology* 43, no. 5: 711–25.

Donlan, L. (2012). 'Exploring the views of students on the use of Facebook in university teaching and learning.' *Journal of Further and Higher Education* 38, no. 4: 572–88.

Fung, D. (2017) *A Connected Curriculum for Higher Education.* London: UCL Press.

Fung, D. and C. Gordon (2016). 'Rewarding educators and education leaders in research-intensive universities.' York, UK: Higher Education Academy.

Kirschner, P. A. (2015). 'Facebook as learning platform: Argumentation superhighway or dead-end street?' *Computers in Human Behavior* 53: 621–25.

Laurillard, D. (2012). 'Teaching as a design science.' New York & Abingdon, Oxon: Routledge.

Lu, J. and D. Churchill (2014). 'The effect of social interaction on learning engagement in a social networking environment.' *Interactive Learning Environments* 22, no. 4: 401–17.

Nordquist, J. and A. Laing (2015). 'Designing spaces for the networked learning landscape.' *Medical Teacher* 37, no. 4. *Informa*: 337–43.

Tinmaz, H. (2012). 'Social networking websites as an innovative framework for connectivism.' *Contemporary Educational Technology* 3, no. 3: 234–45.

Tu, C.-h., L. Sujo-montes, C.-J. Yen, J.-Y. Chan, and M. Blocher. (2012). 'Personal learning environments and open network learning environments.' *TechTrends* 56, no. 3: 13–19.

Wilson, I. (2015). 'Is the VLE dead?' Wilson Waffling. Available online: http://wilsonwaffling.co.uk/is-the-vle-dead/. Accessed 29 December 2016.

Chapter 14

Allin, L. (2014). 'Collaboration between staff and students in the scholarship of teaching and learning: The potential and the problems.' *Teaching & Learning Inquiry* 2, no. 1: 95–102.

Colvin, J.W. and M. Ashman (2010). 'Roles, risks, and benefits of peer mentoring relationships in higher education.' *Mentoring & Tutoring: Partnership in Learning* 18, no. 2: 121–34.

Cook-Sather, A. (2014). 'Student-faculty partnership in explorations of pedagogical practice: A threshold concept in academic development.' *International Journal for Academic Development* 19, no. 3: 186–98.

Cook-Sather, A., C. Bovill and P. Felten (2014). *Engaging Students as Partners in Learning and Teaching: A Guide for Faculty.* San Francisco: Jossey Bass.

Cortwright, R.N., H.L. Collins, D.W. Rodenbaugh and S.E. DiCarlo (2003). 'Student retention of course content is improved by collaborative-group testing.' *Advances in Physiology Education* 27, no. 3: 102–108.

Dennison, S. (2010). 'Peer mentoring: Untapped potential.' *Journal of Nursing Education* 49, no. 6: 340–42.

Felten, P. (2013). 'Principles of good practice in SoTL.' *Teaching and Learning Inquiry* 1, no. 1: 121–25.

García, J. (2015). 'Learning from bad teachers: The neoliberal agenda for education in popular media.' *Critical Education* 6, no. 13. Available online: http://ices.library.ubc.ca/index.php/criticaled/article/view/184935. Accessed 30 December 2016.

Giroux, H. (2008). 'Hollywood film as public pedagogy: Education in the crossfire.' *Afterimage* 35, no. 5: 7–13.

Healey, M., A. Flint and K. Harrington (2014). *Engagement through Partnership: Students as Partners in Learning and Teaching in Higher Education.* York: Higher Education Academy. Available online: https://www.heacademy.ac.uk/engagement-through-partnership-students-partners-learning-and-teaching-higher-education. Accessed 30 December 2016.

Jackson, N. and M. Shaw (2006). 'Subject perspectives on creativity.' In *Developing Creativity in Higher Education*, edited by N. Jackson, M. Oliver, M. Shaw, and J. Wisdom, 89–108. New York: Routledge.

Kleiman, P. (2008). 'Towards transformation: Conceptions of creativity in higher education.' *Innovations in Education and Teaching International* 45, no. 3: 209–17.

Leight, H., C. Saunders, R. Calkins and M. Withers (2012). 'Collaborative testing improves performance but not content retention in a large-enrollment introductory biology class.' *CBE – Life Sciences Education* 11: 392–401.

Marquis, E., V. Puri, S. Wan, A. Ahmad, L. Goff, K. Knorr, I. Vassileva and J. Woo (2016). 'Navigating the threshold of student-staff partnerships: A case study from an Ontario teaching and learning institute.' *The International Journal for Academic Development* 21(1): 4–15.

McMaster Forward with Integrity Advisory Group (2012). 'Forward with integrity: The emerging landscape.' Available online: http://www.mcmaster.ca/presidentsoffice/priorities/ag_report.html. Accessed 30 December 2016.

Meyer, J.H.F. and R. Land (eds) (2006). *Overcoming Barriers to Student Understanding: Threshold Concepts and Troublesome Knowledge*. London: Routledge.

Weller, S., G.K. Domarkaite, J.L.C. Lam and L.U. Metta (2013). 'Student-faculty co-inquiry into student reading: Recognising SoTL as pedagogic practice.' *International Journal for the Scholarship of Teaching and Learning* 7, no. 2. Available online: http://digitalcommons.georgiasouthern.edu/ij-sotl/vol7/iss2/9/. Accessed 30 December 2016.

Werder, C. and M.M. Otis (eds) (2010). *Engaging Student Voices in the Study of Teaching and Learning*. Sterling, VA: Stylus.

Chapter 15

Abeysekera, L. and P. Dawson (2014). 'Motivation and cognitive load in the flipped classroom: Definition, rationale and a call for research.' *Higher Education Research & Development* 34, no. 1: 1–14.

Argyris, C. and D. Schön (1974). *Theory in Practice: Increasing Professional Effectiveness*. San Francisco: Jossey Bass.

Aronson, E. (1978). *The Jigsaw Classroom*. Oxford: Sage.

Baker, R. M. (1996). '"Supertutes", "Yes Minister" and action research: Methods to assist geography teaching.' *International Geography Congress*. The Hague, Netherlands.

Boulton, G. and C. Lucas (2008). *What are Universities For?* League of European Research Universities. Available online: http://www.leru.org/files/general/%E2%80%A2What%20are%20universities%20for%20(September%202008).pdf. Accessed 3 October 2016.

Browne, C. A. and T. Rajan (2015). 'Using distributed constructionism in engineering tutorials: Requirements engineering.' Presented at the AAEE Conference, Torquay, Australia. *Proceedings of the 26th Annual Conference of the Australasian Association for Engineering Education*. Available online: http://www.aaee.net.au/index.php/resources/category/6-2015. Accessed 13 January 2017.

Faulconbridge, R. I. and D. Dowling (2009). 'A conceptual framework for the development of engineering courses.' Presented at the AAEE Conference, Adelaide, Australia. *Proceedings of the 20th Annual Conference of the Australasian Association for Engineering Education*. Available online: http://eprints.usq.edu.au/5887. Accessed 3 October 2016.

Forrester, J. W. (1970). 'Engineering education and engineering practice in the year 2000. In *Engineering for the benefit of mankind. A symposium held at the third autumn meeting of the National Academy of Engineering*, 129–144. National Academy of Engineering, Washington, DC.

Goodyear, P. (2005). 'Educational design and networked learning: Patterns, pattern languages and design practice.' *Australasian Journal of Educational Technology* 21, no. 1: 82–101.

Healey, M., A. Flint and K. Harrington (2014). *Engagement through Partnership: Students as Partners in Learning and Teaching in Higher Education*. Higher Education Academy. York, UK. Available online: https://www.heacademy.ac.uk/engagement-through-partnership-students-partners-learning-and-teaching-higher-education. Accessed 3 October 2016.

Higher Education Academy (2014). *Framework for Partnership in Learning and Teaching in Higher Education*. Higher Education Academy. York, UK. Available online: https://www.heacademy.ac.uk/students-partners-framework-action. Accessed 3 October 2016.

Johns-Boast, L. (2016). 'Curriculum: A proposed definitional framework.' Paper presented at *2016 ASEE Annual Conference and Exposition, Conference Proceedings*. New Orleans, Louisiana. Available online: https://www.scopus.com/inward/record.uri?partnerID=HzOxMe3b&scp=84983371646&origin=inward. Accessed 3 October 2016.

Kolb, D. A. (1984). *Experiential Learning: Experience as the Source of Learning and Development*. Upper Saddle River, NJ: Prentice-Hall.

Levy, P. (2011). 'Embedding inquiry and research into mainstream higher education: A UK perspective.' *Council on Undergraduate Research Quarterly* 32, no. 1: 36–42.

Martinez, S. L. and G. Stager (2013). *Invent to Learn: Making, Tinkering, and Engineering in the Classroom*. Torrance, California: Constructing Modern Knowledge Press.

O'Flaherty, J. and C. Phillips (2015). 'The use of flipped classrooms in higher education: A scoping review'. *The Internet and Higher Education* 25: 85–95.

Papert, S. (1980). *Mindstorms: Children, Computers, and Powerful Ideas.* New York City: Basic Books.

Piaget, J. (1973). *To Understand is to Invent: The Future of Education.* New York City: Grossman Publishers.

Ramsden, P. (2008). *The Future of Higher Education Teaching and the Student Experience.* Higher Education Academy. York, UK. Available online: https://www.heacademy.ac.uk/resource/future-higher-education-teaching-and-student-experience. Accessed 3 October 2016.

Smith, J. I. and C. A. Browne (2013). 'Pieces of the puzzle – impacts of using the jigsaw classroom within peer-facilitated tutorials on engineering design projects.' *Proceedings of the 24th Annual Conference of the Australasian Association for Engineering Education*, Gold Coast, Australia.

Stager, G. (2005). 'Papertian constructionism and the design of productive contexts for learning'. *EuroLogo X.* Available online: http://www.stager.org/articles/eurologo2005.pdf. Accessed 3 October 2016.

Trevelyan, J. (2010). 'Mind the gaps: Engineering education and practice'. *Proceedings of the 21st Annual Conference for the Australasian Association for Engineering Education.* Sydney, Australia.

Trevelyan, J. (2014). *The Making of an Expert Engineer.* London: CRC Press/Balkema.

Vygotsky, L. S. (1978). *Mind in Society: The Development of Higher Psychological Processes.* Cambridge, MA: Harvard University Press.

Vygotsky, L. S. (1986). *Thought and Language.* Cambridge, MA: MIT Press.

Chapter 16

Behr, C. and S. Nevin (forthcoming). 'The Roehampton Campus Project: Using campus, collections and memories of the university as a learning and teaching resource for Humanities students.' *Arts and Humanities in Higher Education.*

Bok, H. G. J., P. W. Teunissen, R. P. Favier, N. J. Rietbroek, L. F. H. Theyse, H. Brommer, J. C. M. Haarhuis, P. van Beukelen, C. P. M. van der Vleuten and D. A. D. C. Jaarsma (2013). 'Programmatic assessment of competency based workplace learning: When theory meets practice.' *BMC Medical Education* 13: 123.

Healey, M. and A. Jenkins (2009). *Developing Undergraduate Research and Inquiry.* York: Higher Education Academy. Available online: https://www.heacademy.ac.uk/node/3146. Accessed 23 March 2017.

Healey, M., F. Jordan, B. Pell and C. Short (2010). 'The research–teaching nexus: A case study of students' awareness, experiences and perceptions of research.' *Innovations in Education and Teaching International* 47, no. 2: 235–46.

Hidi, S. and K. A. Renninger (2006). 'The four-phase model of interest development.' *Educational Psychologist* 41, no. 2: 111–27.

Knight, R-A. and N. Botting (2016). 'Organising undergraduate research projects: Student-led and academic-led models.' *Journal of Applied Research in Higher Education* 8, no. 4: 455–68.

New South Wales Public Service Commission. The Capability Framework. Available online: https://www.psc.nsw.gov.au/workforce-management/capability-framework/the-capability-framework. Accessed 12 February 2017.

Ryan, A. and D. Tilbury (2013). *Flexible Pedagogies: New Pedagogical Ideas.* York: Higher Education Academy. Available online: https://www.heacademy.ac.uk/flexible-pedagogies-new-pedagogical-ideas. Accessed 24 March 2017.

Styan, C.A., W. Trott, C. Bartley, O. Sharpe, H. Wu, A. Tubb and D. Simons (2015). 'Adoption of social media in the Australian energy and resources sectors.' SRMINING 2015 – 3rd International Conference on Social Responsibility in Mining. 4–6 November, Antofagasta, Chile.

UCLa (University College London) (2017). Meet the Researcher. Available online: https://www.ucl.ac.uk/teaching-learning/case-studies/jan/2016/meet-researcher-programme. Accessed 24 March 2017.

UCLb (University College London) (2017). UCL 2034. Available online: https://www.ucl.ac.uk/2034/. Accessed 24 March 2017.

UCLc (University College London) (2017). UCL Alumni Online Community. Available online: https://uclalumnicommunity.org/. Accessed 24 March 2017.

UCLd (University College London) (2017). UCL ChangeMakers. Available online: https://www.ucl.ac.uk/changemakers. Accessed 24 March 2017.

Van der Vleuten, C. P. M., L. W. T. Schuwirth, E. W. Driessen, J. Dijkstra, D. Tigelaar, L. K. J. Baartman and J. Van Tartwijk (2012). 'A model for programmatic assessment fit for purpose.' *Med Teach* 34, no. 3: 205–14.

Afterword

Fung, D. (2017). *A Connected Curriculum for Higher Education.* London: UCL Press.

Fung, D. and C. Gordon (2016). *Rewarding Educators and Education Leaders in Research-Intensive Universities.* York: Higher Education Academy. Available online: https://www.heacademy.ac.uk/sites/default/files/rewarding_educators_and_education_leaders.pdf. Accessed 15 May 2017.

Harland, T. (2016). 'Teaching to enhance research.' *Higher Education Research & Development* 35, no. 3: 461–472.

Locke, W. (2014). *Shifting Academic Careers: Implications for Enhancing Professionalism in Teaching and Supporting Learning.* York: Higher Education Academy. Available online: https://www.heacademy.ac.uk/system/files/resources/shifting_academic_careers_final.pdf. Accessed 15 May 2017.

Nurse, P. (2015). 'Ensuring a successful research endeavour.' *The Nurse Review of UK Research Councils.* Department of Business, Innovation and Skills. BIS/1/624.

Roxå, T. and K. Mårtensson (2011). *Understanding Strong Academic Microcultures: An Exploratory Study.* Lund University. Available online: https://www.lth.se/fileadmin/lth/genombrottet/swednet2011/ReportAcademicMicrocultures.pdf. Accessed 15 May 2017.

UNESCO (2015). *Rethinking Education: Towards a Global Common Good?* Paris: United Nations Educational, Scientific and Cultural Organization.

Index

Bold page numbers indicate figures, *italic* numbers indicate tables.

information and communication technologies. *see* digital learning environments; digital practice and social change; online resources
information literacy skills 80–1
institutional implications, University of Alberta, Canada, biochemistry at 41–5
integration of research. *see* embedding of research
interdisciplinary connections
 Connected Curriculum dimension 5
 creative arts education 164–71
 History and Classical Civilisation, University of Roehampton 241–2
 International Genetically Engineered Machines (iGEM) competition 90–4
 'Object Lessons,' UCL 66
 Royal (Dick) School of Veterinary Studies, Research Skills course 86
 Summer Undergraduate Research Fellowship (SURF) at XJTLU 56–7
 synthetic biology 66
 see also interprofessional education (IPE), Leeds University
International Genetically Engineered Machines (iGEM) competition
 activities 93–4
 alumni collaboration
 at UCL 101
 assessment of students 98–9
 autonomy of groups 101–2
 basics of 89
 BioBrick™ standard 94, 95
 biochemical engineering 92
 BioHackspace collaboration 103
 collaborations across UCL 97–8, 101
 Connected Curriculum approach 89–90
 context, defined by students 98
 context, local, provision of 101
 group-work and collaboration 94
 Human Practices 102–4
 interdisciplinary connections 90–4
 inter-team collaboration 102
 Jamboree events 99
 Masters of Engineering (MEng) 92
 Millichap, N. 189–90, 200
 'Mind the Gut' UCL team 97–8, 103–4
 molecular biology curriculum in UCL 95
 participants 93
 partnerships, student/staff 99–102
 'Plastic Republic' UCL team 103
 principles emerging from 104–5
 production of outputs 98–9
 societal impacts of work 102–4
 'Spotless Mind' UCL team 97
 staff/student connections
 at UCL 96–8
 student-led research at UCL 96–7
 supervision of teams at UCL 100–2
 synthetic biology 90, 92, 95
 throughline of synthetic biology in UCL programme 94–6
 UCL activities 93
 UCL teams 91
international schemes
 Summer Undergraduate Research Fellowship (SURF) at XJTLU 54
 see also International Genetically Engineered Machines (iGEM) competition

interpersonal skills development
 graduate attributes (GAs) 243–4
 Royal (Dick) School of Veterinary Studies, Research Skills course 88
 see also workplace skills
interprofessional education (IPE), Leeds University
 biases and assumptions, dealing with 183–4
 challenges to organising 173–4
 co-facilitation 186
 collaboration 184
 compromise 185
 as compulsory, obstacles to 178–9
 connections formed by students and staff 177–8, 181–2
 embedded in existing modules 185
 evaluation by students 178, 186
 final year students 174–9
 first year students 179–84
 format and content of workshops 175–6, 176–7, 180–1
 in healthcare education 173–4
 human factors in patient safety 179–84
 IPE coordinator, need for 184–5
 limitations and obstacles 173–4, 182–4
 logistical challenges 182–3
 materials, challenges in developing 183
 patterns of attendance 179
 pilot workshops 174–5
 priorities, differing 185
 session plan for workshops 176–7
 stereotypes, dealing with 183–4, 186

Jenkins, A. 3, 49–50, 52, 78
jigsaw classroom
 assessment of student-facilitators 225
 balancing learning and research 226–7
 behind the scenes work involved 226
 constructionism 220
 course level 221
 delivery of 218–19
 design and delivery 222–5
 different evolution of partnerships 228
 equal-sized chunks of content 228
 expectations of students 226
 expectations of tutorials 222
 explanation of partnership to students 227
 flipped mode of teaching 220–1
 give-and-take across whole process 228
 high-level pedagogies 220
 learning activities, design of by students 222–3
 as learning partnership 228–31
 lessons from model 225–8
 loss of control 227
 partners, students as 220
 pedagogical philosophy 220
 pedagogical strategy 220–1
 pedagogical tactics 221
 phases 219
 philosophies/strategies based on 218
 resources provided to student-facilitators 224–5
 roles, defining 220
 timing of classes 223–224
 traditional roles, challenges to 219
 tutorial activity 219
Jin, L. 48

Katkin, W. 52
Kent Print Collection
The Art of Comedy exhibition 113
Beautifully Obscene: The History of the Erotic Print exhibition 115
Double Take: The Art of Printmaking exhibition 114
Dreams and Nightmares exhibition 113
effectiveness of 115
exhibitions run 113–15
Krikey! Kentemporary Prints exhibition 113–14
legacy left by students 115–16
materiality of the activity 117
origins of 110–11
stages and tasks for students 111–13
Underexposed: Female Artists and the Medium of Print exhibition 114
wider impact on curriculum 116
work experience via 115
Kirschner, P.A. 192
knowledge
and knowers 133
legitimate 133
range of, connection to 134–7
structures 132
Kolb, D.A. 62
Krikey! Kentemporary Prints exhibition 113–14
Kuh, George 34–5

laboratory skills course, biochemistry, University of Alberta, Canada 38–9
Laing, A. 192
language, decolonisation of curricula 140
Lave, Jean 109
Law
design of learning 24
discipline, learning 24
experience, learning 24–5
pedagogic resonance case study 24–5
learning, research-based education and 3–4
'Learning Our Lesson: Review of Quality Teaching in Higher Education' (Henard) 42
Learning Partnerships Model 77
Leeds Beckett University 243–4
Leeds University. *see* interprofessional education (IPE), Leeds University
LEGO® SERIOUS PLAY® methodology 171–2
Levy, P. 81, 82, 85, 164–5
Liberating the Curriculum 134
lived realities of students, connections to 137–41
London BioHackspace 103
London College of Fashion (LCF). *see* creative arts education
Lucas, C. 218
Luckett, K. 138–9, 140

Macquarie University, Australia, e-portfolio assessments in medical programmes 242–3
Marstine, Janet 110
Martinez, S.L. 220
Masters of Engineering (MEng) 92
material culture 61, 62
see also object-based learning

materiality of activities 117
Maton, K. 133
Mbembe, A. 135
McDowell, Elizabeth 109
McKinney, L. 39
McLinden, M. 17, 19, 29
McMaster Student Partners Programme
behaviour reflecting power and inclusion 215–16
case studies 205–16
creativity across disciplines 207–9
development 203
equal inclusion of each partner 215
filmic representations of higher education 211–13
initial research into experiences in 204
mentoring 205–7
methodology for case studies 205
peer-mentoring 205–7
physics, collaborative testing in 209–11
power dynamics 214
project/partnership descriptions 205–6, 207–8, 209–10, 211–12
science peer-mentoring 205–7
staff experiences 206–, 208–9, 210–11, 213
structure and process 203–4
student experiences 206, 208, 210, 212–13
medical curricula, e-portfolio assessments in 242–3
mental health 103–4
mentoring 205–7
Alumni Mentoring Network, UCL 244–5
peer coaching support network, UCL 247–8
'Mind the Gut' UCL iGEM team 97–8, 103–4
molecular biology curriculum in UCL 95
Moodle. *see* digital learning environments
multiple intelligences, theory of 62
Murdoch-Eaton, D.S. 52
museum collections 63–4
campus-based, growth of 108
constructivist pedagogy 106–7
curation as learning model 108–10
pre-modern museums 108
music programme at Trinity Laban Conservatoire of Music and Dance 240–1

National Survey on Student Engagement (NSSE) 34
Neville, A.J. 99
Nordquist, J. 192
nursing. *see* interprofessional education (IPE), Leeds University

object-based learning
availability of objects as key 71–2
benefits 73–4
Brain and Behaviour module, BA/BSc psychology, UCL 68–70, **69**
Connected Curriculum approach 66–7, 71
culture shift involved 67–8
curation as learning model 108–9
curiosity, appeal to 63
defined 61
engagement with objects 62–3
museum collections 63–4
'Object Lessons,' UCL 64–8, **65**